*This book was inspired by the compassion
and wisdom of Dilgo Khyentse Rinpoche.
May he be a source of well-being to
living beings without number.*

This book is the work of

MATTHIEU RICARD
DANIELLE & OLIVIER FÖLLMI
BENOÎT NACCI

With the collaboration of

HIS HOLINESS THE 14TH DALAI LAMA

MONISHA AHMED
MATTHEW AKESTER
PHILIPPE CORNU • JIGME DOUCHE
MIREILLE HELFFER
DAVID JACKSON
CORNEILLE JEST • CLAUDE B. LEVENSON
FERNAND MEYER
JAMYANG NORBU • CLARA OSEL
JETSUN PEMA
FRANÇOISE POMMARET
JANET RIZVI • GALEN ROWELL
LOBSANG SANGYE
E. GENE SMITH

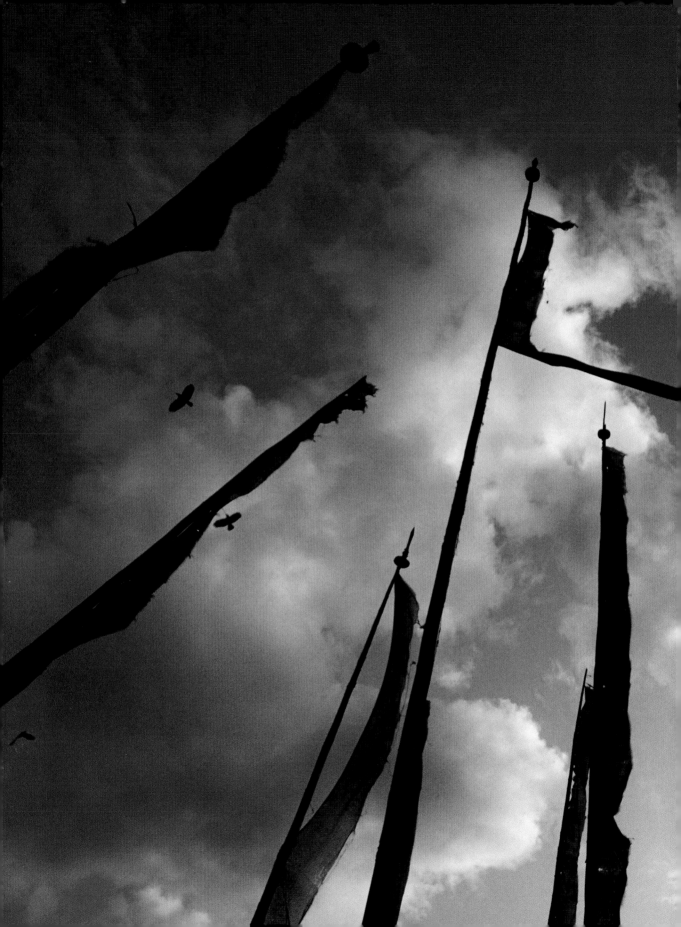

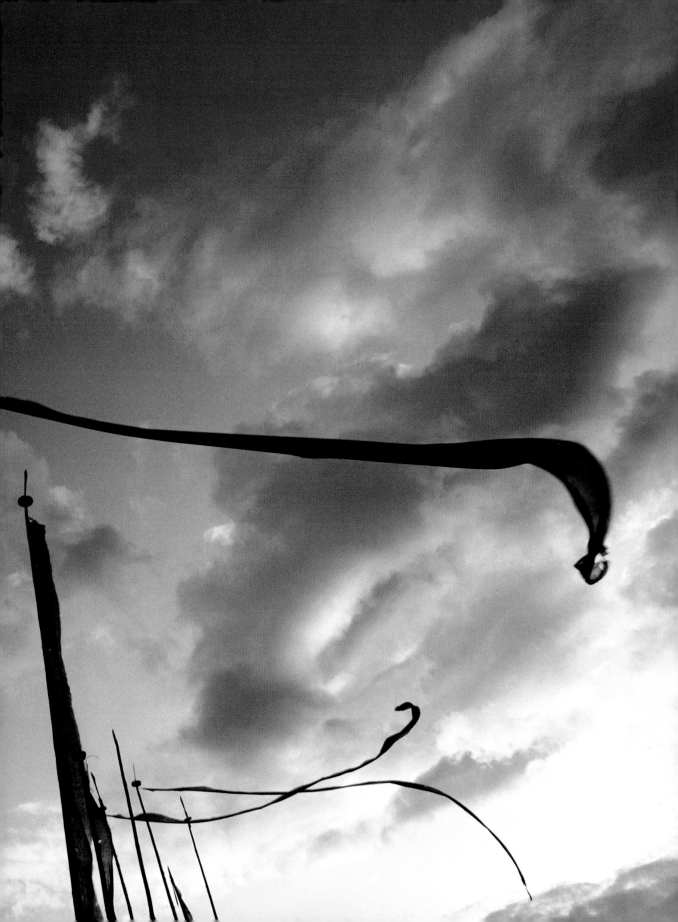

BUDDHIST

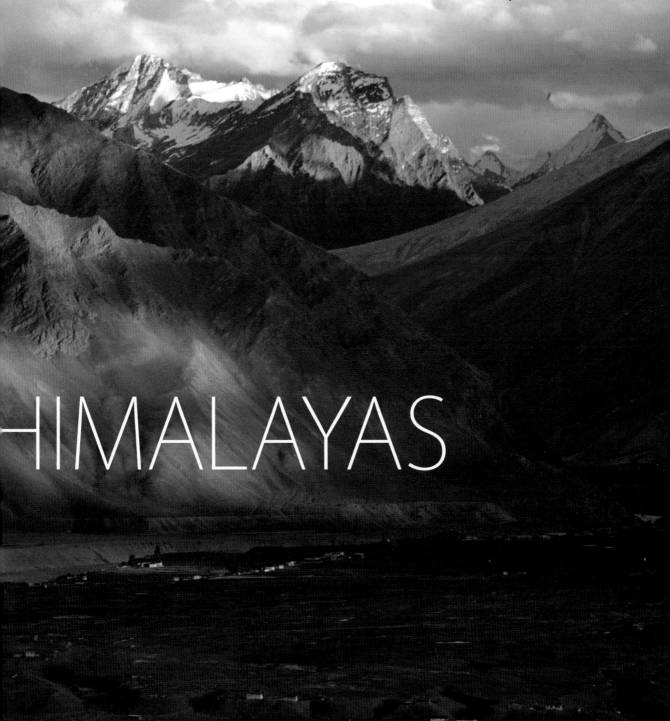

Photographs by Olivier & Danielle Föllmi and Matthieu Ricard

With a contribution by the Dalai Lama

HIMALAYAS

Contents

*T*he Himalayas were born when the continent of India drifted up
to join the Tibetan plateau, raising up the roof of the world. Buddhism
was born on the hot, dry plains of northern India, and later, although it
disappeared from that country, it sought refuge in the Land of Snows and
was passed along via the secular paths of the nomad caravans. A bountiful
citadel where the greatest rivers of Asia are born, the Buddhist Himalayas
extend over several countries: Tibet, India, Nepal and Bhutan. Their
boundaries are drawn by nature: this is the land of yak, barley and salted
butter tea. A fortress in the heart of Asia, the Buddhist Himalayas are home
to a civilization built on two thousand years of teachings,
with one vision: to attain Enlightenment, the state of the Buddha.

This book was born of a wish: to let shine the soul, the wisdom,
the love, the strength, the beauty, the faith, the message, the tragedy,
the nobility, the joyfulness and the indomitable spirit of the people
of the Buddhist Himalayas.

Twenty-one authors of six different nationalities have taken part
in this endeavour, to honour an unparalleled cultural heritage.
Spiritual, scientific, artistic and political scholars, they have each tried
to share the soul of their knowledge with us, turning this book into
a mosaic that reflects the depth and richness of Tibetan civilization
and the beauty of its envoys: the people of the Buddhist Himalayas.

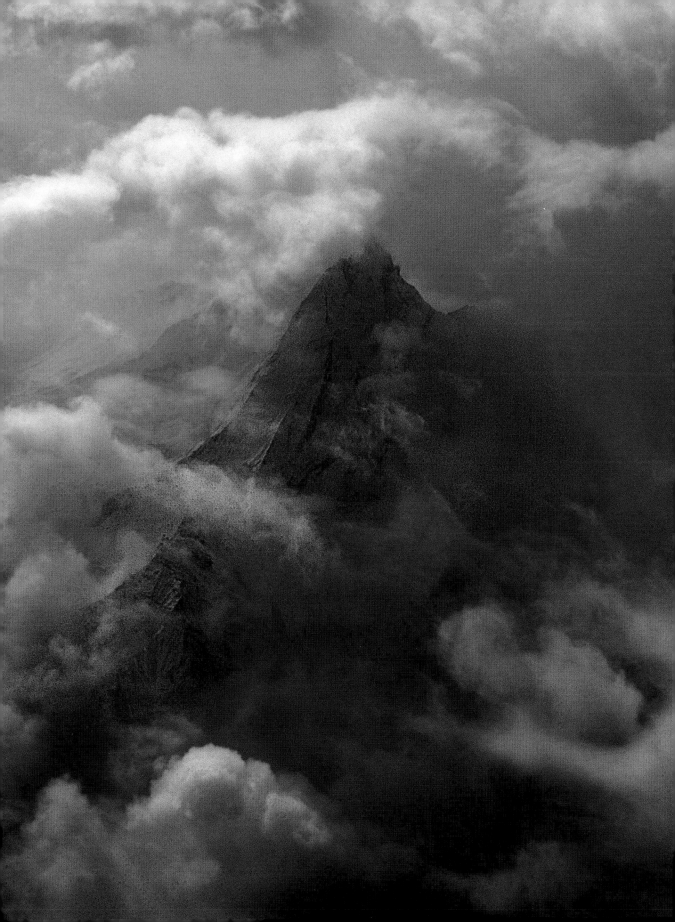

Spiritual Teachers
A Source of Inspiration

Meeting a person who does not just have an intellectual knowledge of Buddhist teachings but is a living embodiment of them is an extraordinary experience. Buddhism has produced several such remarkable men and women, real-life examples of perfection, who show us what we could become and remind us of the Buddha's words, 'I have shown you the path, it is for you to travel it'.

Ideally, those who become aware of the limitations of worldly life begin by looking for a true spiritual teacher and then dedicate themselves seriously to study and meditation in a monastery or mountain retreat. If they have families, they practise at home, in the long periods of free time still afforded by the traditional way of life which has survived in many parts of the Himalayas. After long years of practice, some become ready in turn to devote themselves to the well-being of others, because the aim of any student is to transform himself and thus become more able to transform the world.

In the teacher–student relationship, the teacher expects nothing in return for what he gives the student. It is not one of those dominant relationships so common in everyday life. The teacher welcomes the disciple spontaneously, just as we would when helping a lost traveller find his way. The teacher shares his experience of eradicating ignorance and negative emotions and the suffering they cause. As an expert in every spiritual method, he can tell which methods will be most suited to the person concerned. These are qualities that can only come from deep inner spiritual realization. That realization and the knowledge and compassion that go with it are evident in the teacher's simplest gestures and his most profound teachings.

Meeting an exceptional person, even if only briefly, provides guidance and inspiration that can stand us in good stead for the rest of our lives.

Guru Yoga

In Tibetan Buddhism, Guru Yoga is considered an essential exercise. The term literally means 'union with the teacher's nature', because this spiritual exercise enables us to merge our own minds with the teacher's enlightened mind.

In absolute terms, the teacher is one with the true nature of mind, the essence of Buddhahood. But it is through an outside master and his teachings that one finds one's inner master, pure awareness. Dilgo Khyentse Rinpoche explains in *The Wish-Fulfilling Jewel*:

'He is the great vessel that carries beings across the ocean of life; he is the unerring captain who guides them to the land of liberation; he is the rain that extinguishes the fire of passion. Like the brilliance of the sun and the moon, he rips away the darkness of ignorance; he is the solid ground that can bear the weight of good and evil at the same time. Like a father and a mother, he loves all beings with the same love. A great river of compassion, a mountain soaring above all earthly concerns, unshaken by the winds of emotion, he is the equal of all he Buddhas.

To make any connection with him, whether by seeing him, hearing his voice, remembering him or being touched by his hand will lead us towards liberation. To have full confidence in him is the best way to progress towards Enlightenment. The warmth of his wisdom and compassion will melt the ore of our being and release the gold of Buddha-nature within.'

DILGO KHYENTSE RINPOCHE
THE REMARKABLE LIFE OF A SPIRITUAL TEACHER

Dilgo Khyentse Rinpoche was the archetypal spiritual guide. A master among masters, he was one of the 14th Dalai Lama's teachers. His spiritual journey led him to extraordinary depths of knowledge and he became a true fount of love, wisdom and compassion for all who came into contact with him. He radiated a clear and uncompromising goodness that allowed his followers to see into themselves clearly, without any pretence and self-deception. A rigorous and honest approach to one's self are essential for any genuine spiritual transformation.

Khyentse Rinpoche, born in eastern Tibet in 1910, showed a desire to devote himself to the spiritual life at a very early age. He wrote of his principal teacher, Shechen Gyaltsap, 'While he was giving initiations I was overwhelmed by the splendour and magnificence of his expression and his eyes, with a gesture pointing in my direction, he introduced the nature of mind. I felt that, apart from my own feeble devotion that made me see the teacher as an ordinary man, he was in fact exactly the same as the great Guru Padmasambhava. My confidence grew stronger and stronger, and when again he would gaze and point at me, asking, "What is the nature of mind?", I would think with greta devotion, "This is truly a great yogi who can see the absolute nature of reality!", and began to understand myself how to meditate.'

After the death of his master, Khyentse Rinpoche, still only fifteen at the time, spent most of the next thirteen years in silent retreat. In isolated caves and retreats, on the slopes of the wooded hills in the Denkhok valley where he was born, he meditated ceaselessly on love, compassion and the desire to lead all beings to Enlightenment and liberation.

After completing his cycle of retreats at the age of twenty-eight, Khyentse Rinpoche spent many years with his second main teacher, Dzongsar Khyentse Chökyi Lodrö (1896–1959). One day, he told his master that he wanted to spend the rest of his life in solitary meditation. But Khyentse Chökyi Lodrö was adamant. 'Your mind and mine are one,' he said. 'The time has come for you to teach and transmit to others the countless precious teachings you have received.' So, from then on, Khyentse Rinpoche worked tirelessly for the benefit of all beings.

As Long As Space Endures
An Intimate Portrait of the Dalai Lama

The village of Dharamsala in India slumbers peacefully at the foot of the dark and imposing mass of the Himalayan peaks. A few dim lights appear at the top of a wooded hill. It is 3.30 in the morning. The 14th Dalai Lama, the spiritual and temporal leader of the Tibetan people and one of the most remarkable men of our times, wakes up and starts his day with prayers and meditation. Wherever he is and whatever the circumstances, every morning he meditates for four hours. His meditation is mainly a heartfelt prayer for the good of all beings.

The room, panelled in varnished wood, is quite simple, with none of the lavish decoration usually found in Tibetan temples. A statue of the Buddha, photos of his teachers and sacred texts are arranged on a small altar. At around 6 a.m. the Dalai Lama eats a hearty breakfast while listening to the BBC news, because like all Buddhist monks he does not eat an evening meal. Then he carries on meditating until 8 or 9 a.m.

The Dalai Lama always follows this routine, come what may. It gives him the strength he needs to carry on his tireless campaigning on behalf of the Tibetan cause. When he was awarded the Nobel Peace Prize in 1989, journalists turned up early in the morning, keen to be the first to get the Tibetan leader's reactions. The only response they received from the friendly and discreet monk who has looked after the Dalai Lama faithfully for over thirty years, was, 'He hasn't heard the news yet. We never disturb him while he is meditating'.

'I go to my office at about 9 a.m. if I have people to see,' the Dalai Lama told us. 'Otherwise I work on texts. I refresh my memory of the works I have studied in the past and then look more closely at the commentaries by the great teachers from the various schools of Tibetan Buddhism. I think about the teachings and meditate a little. I have lunch at about 2 p.m.

Then I deal with routine matters until 5 p.m. I meet representatives of the Tibetan people, ministers of the government-in-exile and other officials, and I receive visitors. I have tea at about 6 p.m. If I feel hungry, I ask the Buddha's permission and munch a few biscuits (he laughs). Finally I say my evening prayers and go to sleep at about 9 p.m. That is the best moment of the day! I sleep peacefully until 3.30 the next morning'.

His meetings with visitors recently arrived from Tibet are particularly moving. To see the Dalai Lama, even if only once in their lifetimes, Tendzin, his wife and their two children have crossed snow-covered passes 5,000 metres up in the mountains, dodging the Chinese soldiers who control the borders and stop Tibetans crossing into India. Some of Tendzin's companions have had to have their frostbitten toes amputated. They have arrived at last, their faces bathed in tears, trying somehow to control their emotions and reply to the Dalai Lama when he asks, in his resonant voice, about their personal odyssey and the situation in Tibet. He asks Gedun, a monk tortured several times during his twenty years in prison, 'Were you ever afraid?' Bowing his head, the monk replies, 'My greatest fear was that I would feel hatred towards my torturers.'

The Dalai Lama's residence overlooks the vast plains of India, stretching away into the distance under his windows. A few lofty peaks to the north are a reminder that Tibet is only about a hundred kilometres away as the crow flies: so near and yet so far.

The residence is pervaded by a quiet atmosphere and a benevolent calm. People speak in low voices, conscious of the futility of unnecessary speech and the inexorable march of time, that precious asset that diminishes with every moment of our lives. No gesture or word is wasted. This golden silence is only broken by a sudden burst of laughter from Kundun, 'the

Presence', the Tibetans' affectionate and respectful name for the Dalai Lama: the one who is never absent when you are with him and always present when you are away from him. His joyous laugh is sometimes replaced by a quiet smile, when he goes into retreat for a month or a few weeks every year. Then his only words are prayers and he communicates only through gestures or in writing.

The Path to Compassion

This typical day in the Dalai Lama's Dharamsala home seems uncomplicated and peaceful. But for several months of the year, his well-ordered routine is interrupted by giving teachings in India and abroad, sometimes to crowds of several hundred thousand believers, and by whirlwind trips around the world. The need to meet everyone's hopes and support the cause of Tibet, caught in the totalitarian grip of the Chinese Communist regime, stops this tireless peace campaigner from snatching more than a few minutes' rest. But despite the almost intolerable pace of his life, Kundun maintains his serenity and sincerity. He is fully and immediately there for everyone, whether it is a visitor or someone he passes at the airport. His face overflows with a goodness that cuts straight to the heart, leaves a smile in it, and retreats again quietly.

But goodness is not the same as weakness, and his power as a speaker can be suddenly unleashed whenever required. At the Paris Bar, where he was given a warm welcome, he said, 'My fight for the Tibetan people is not one of those battles that ends with a winner and a loser or, more often, two losers. What I am trying with all my strength to achieve is the victory of truth.'

But this does not mean that he lacks humour or simplicity. I have often seen him taking his leave of a president or minister, and then going to shake the hand of a gatekeeper in his box or a telephonist behind her window. Or he will take a sly pleasure in giving a hearty slap on the back to a magnificently uniformed guardsman, standing motionless with his sword drawn, amazed but gratified that someone is treating him like a human being.

The Dalai Lama's message is always the same and he repeats it to anyone willing to hear it. 'Anyone, even if they are hostile, is a living being like me who fears suffering and aspires to happiness. They have every right to be spared suffering and to achieve happiness. That thought makes us feel deep concern for the happiness of others, whether friends or enemies. It is the basis of genuine compassion.'

The inexplicable power of compassion is never more evident than in a chance meeting. I remember one evening when the Dalai Lama was leaving a meeting with students at Bordeaux University and was walking through the solid crowd of people who had not managed to find a place in the lecture theatre. An old couple were standing to one side, afraid of getting caught up in the crush. The husband was standing behind his frail wife, who was in a wheelchair. The Dalai Lama's ever-alert gaze lighted on them. He broke through the crowd and went and took the old lady's hands in his and looked at her closely, smiling. His only words were inexpressible words of unbounded love. After those few minutes, which seemed like an eternity, the old man said to his wife, 'You see, he is a holy man.'

When asked why people respond to him so warmly, the Dalai Lama says, 'I have no special qualities. Perhaps it is because all my life I have meditated on love and compassion with all the strength of my mind.'

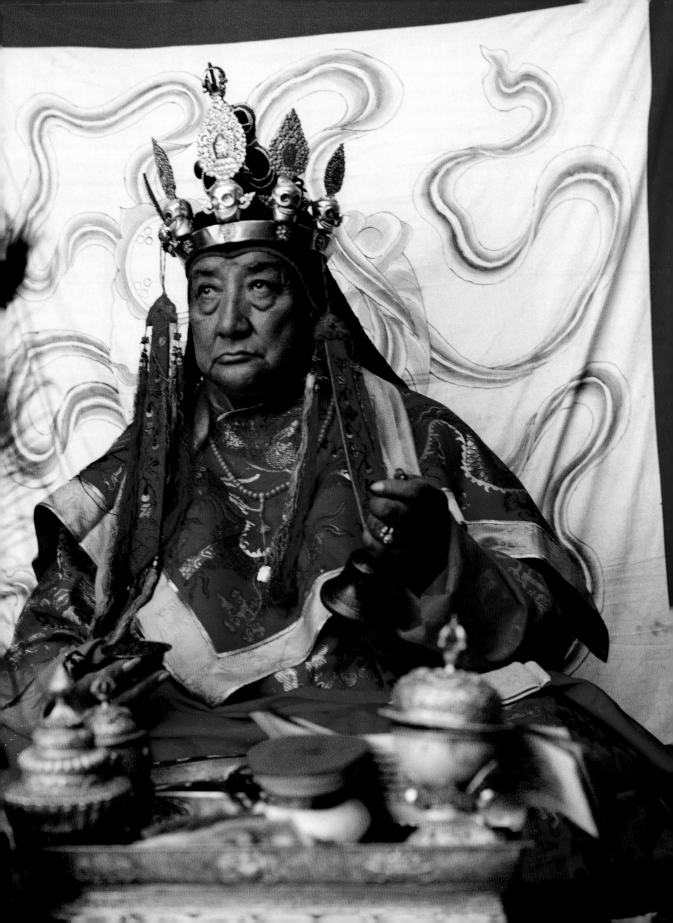

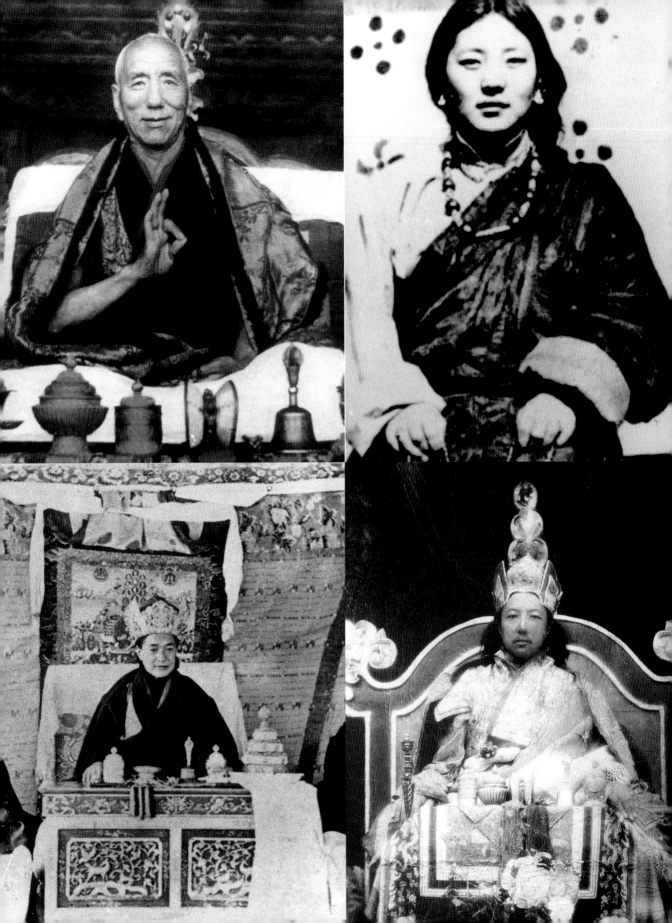

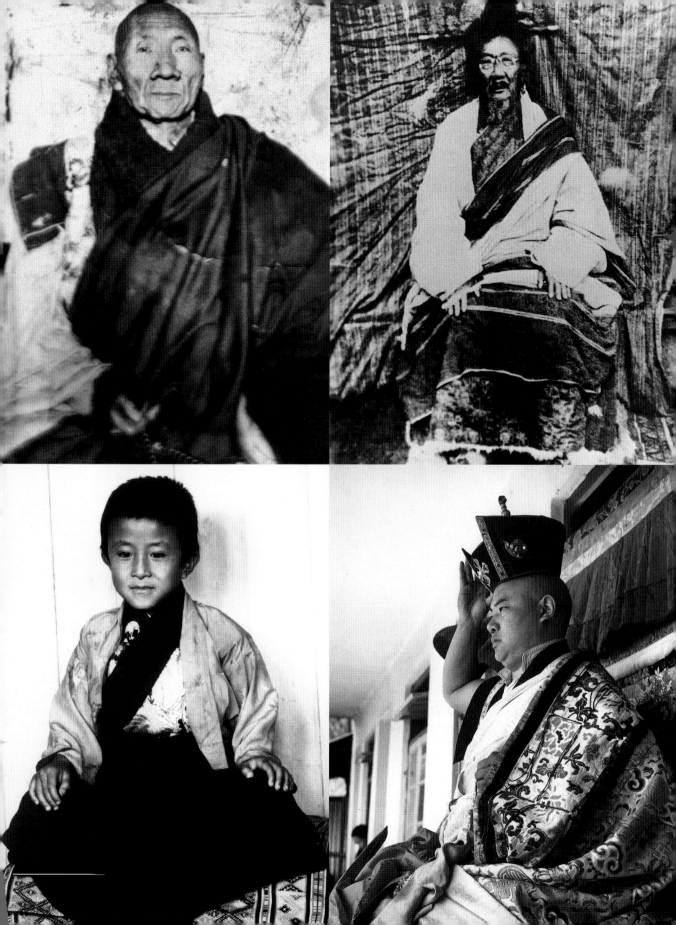

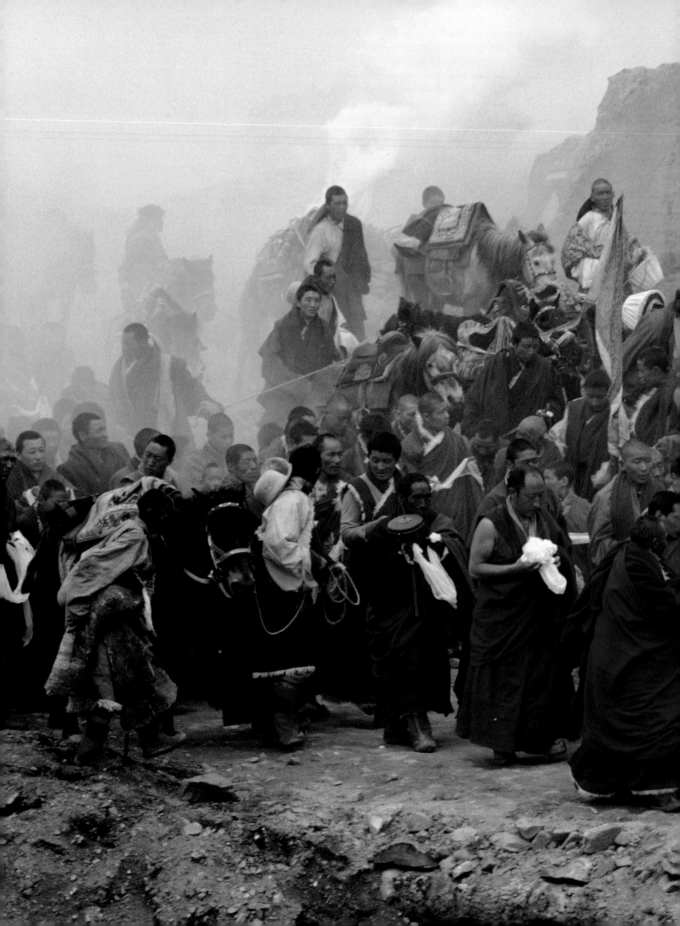

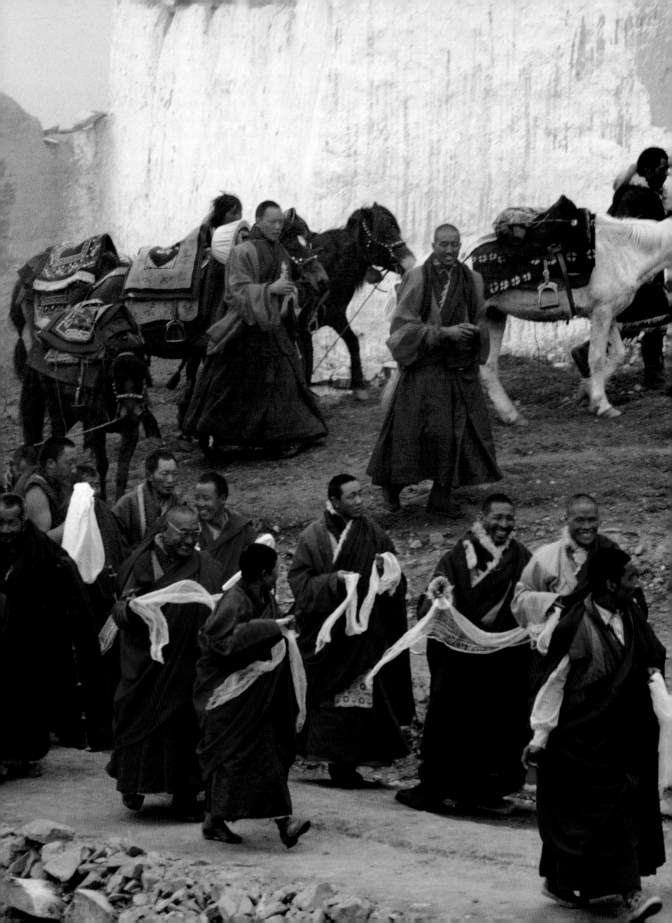

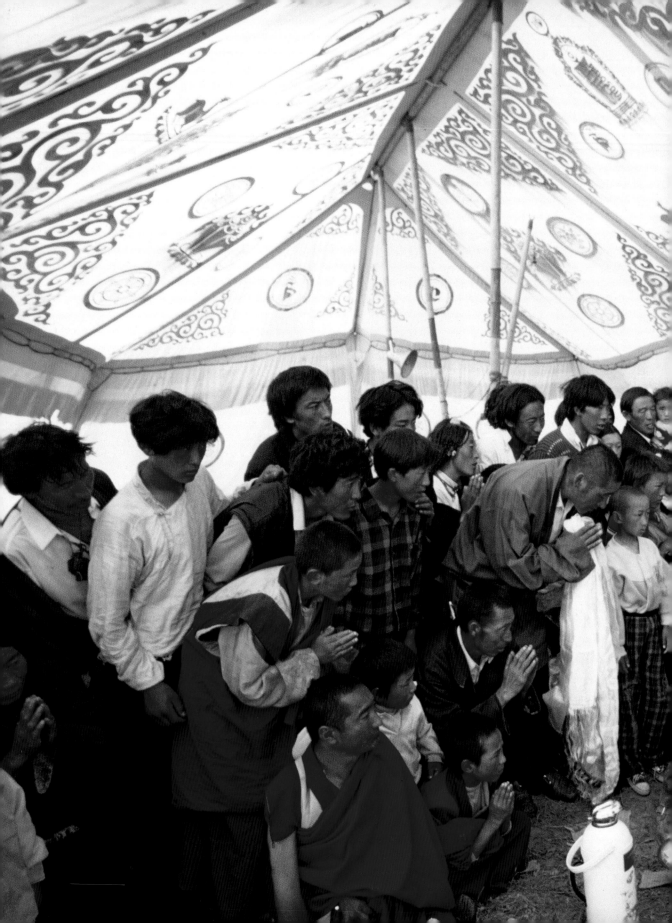

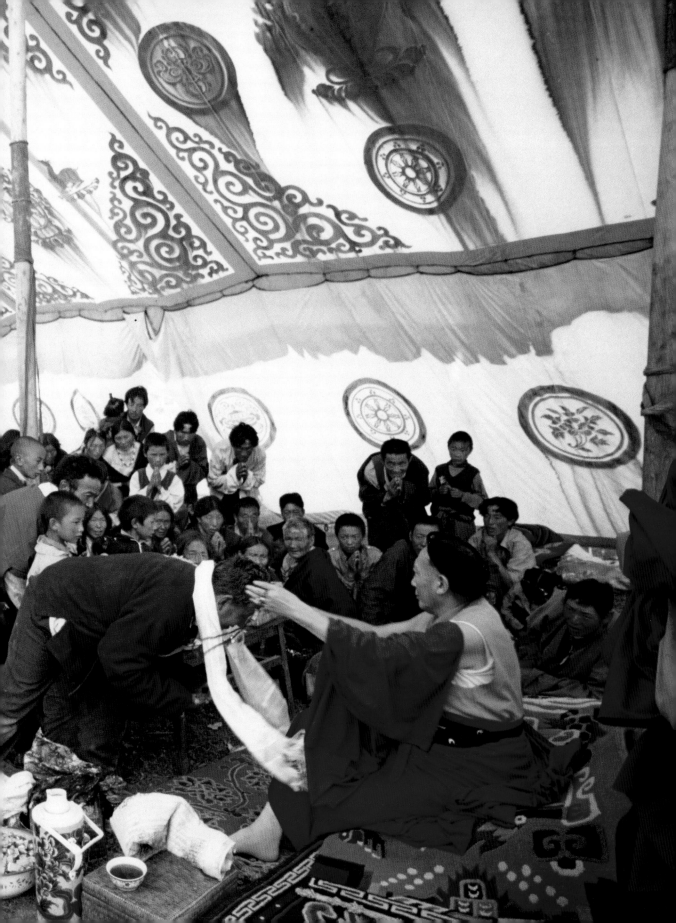

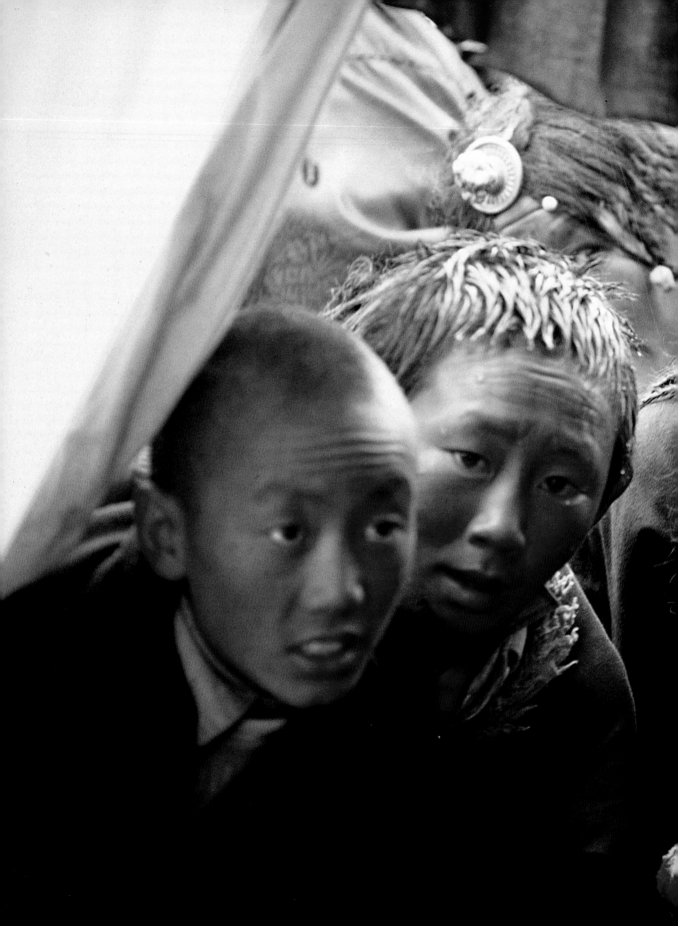

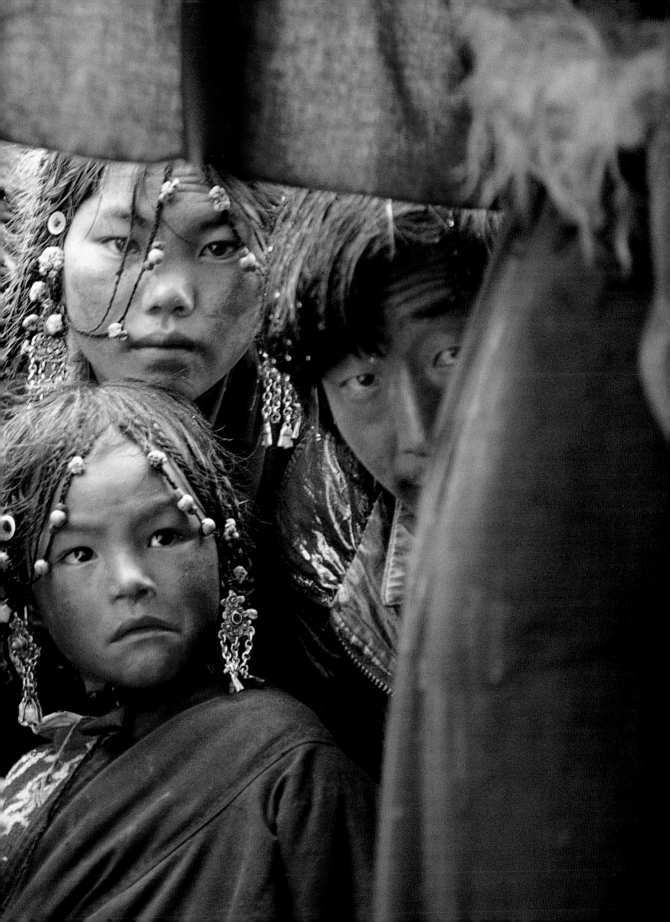

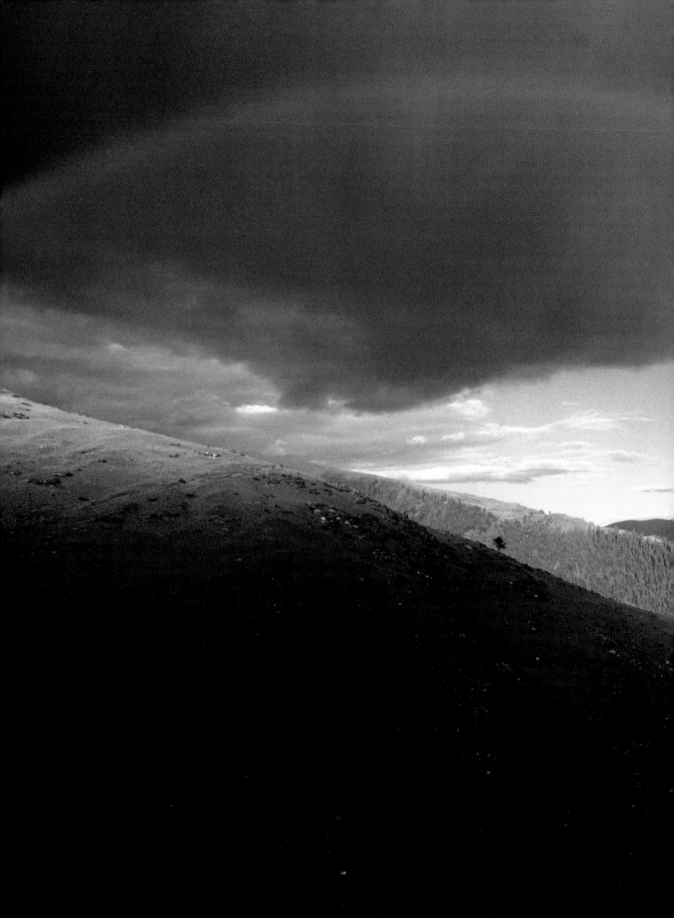

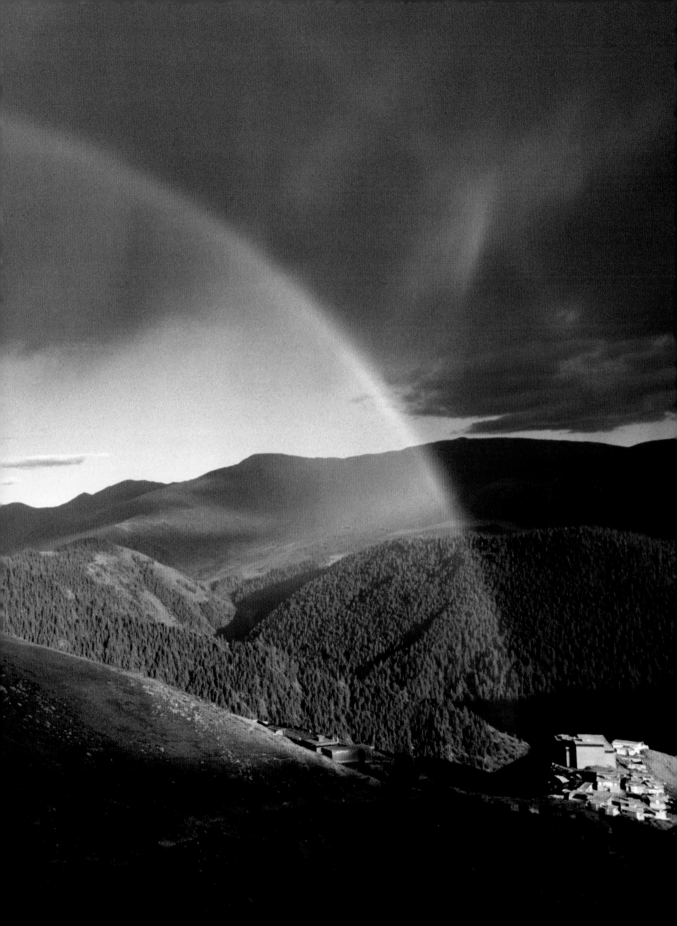

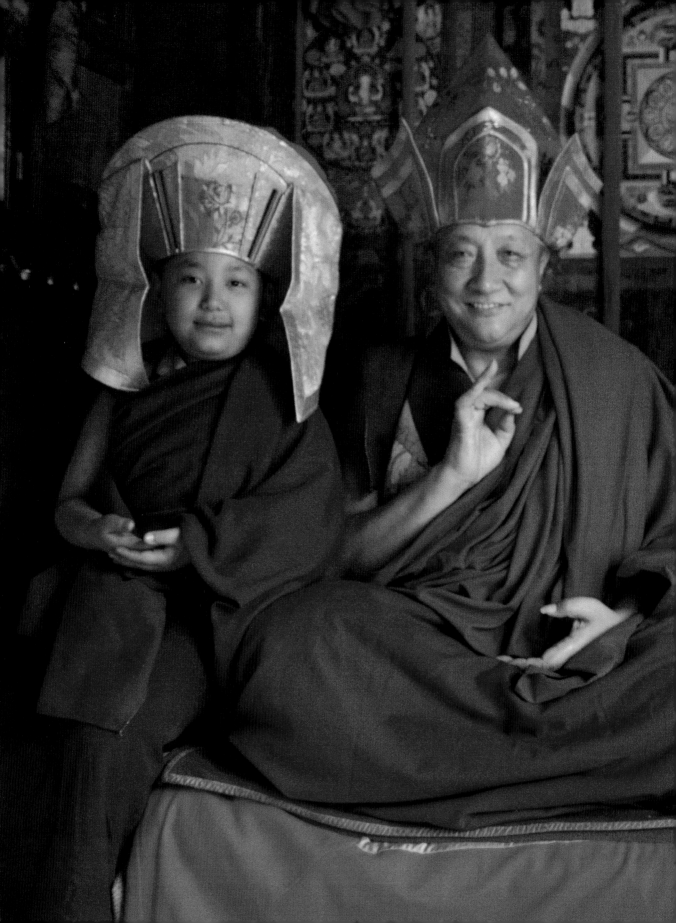

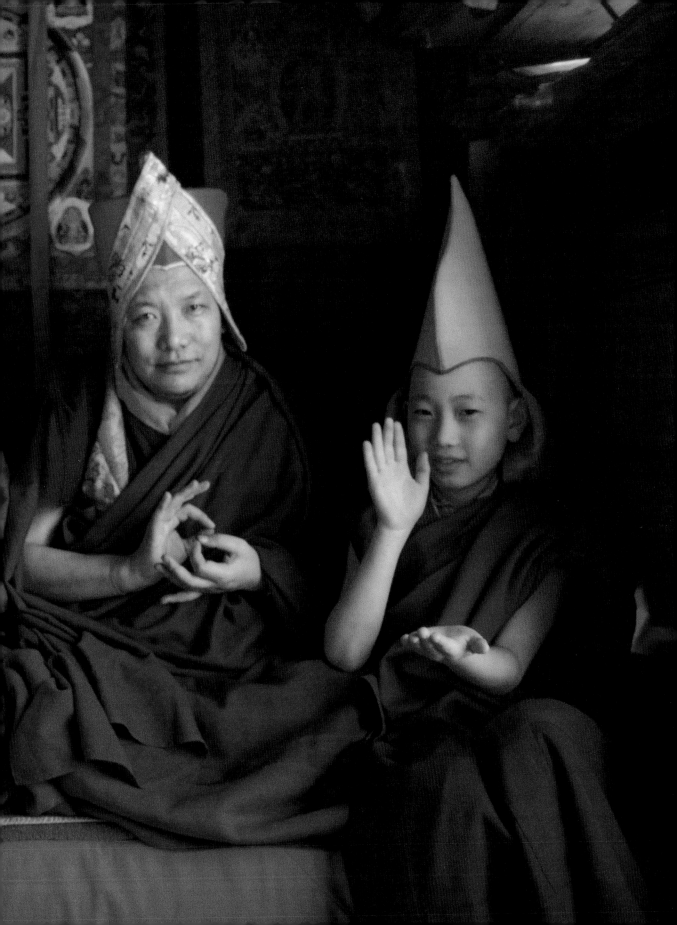

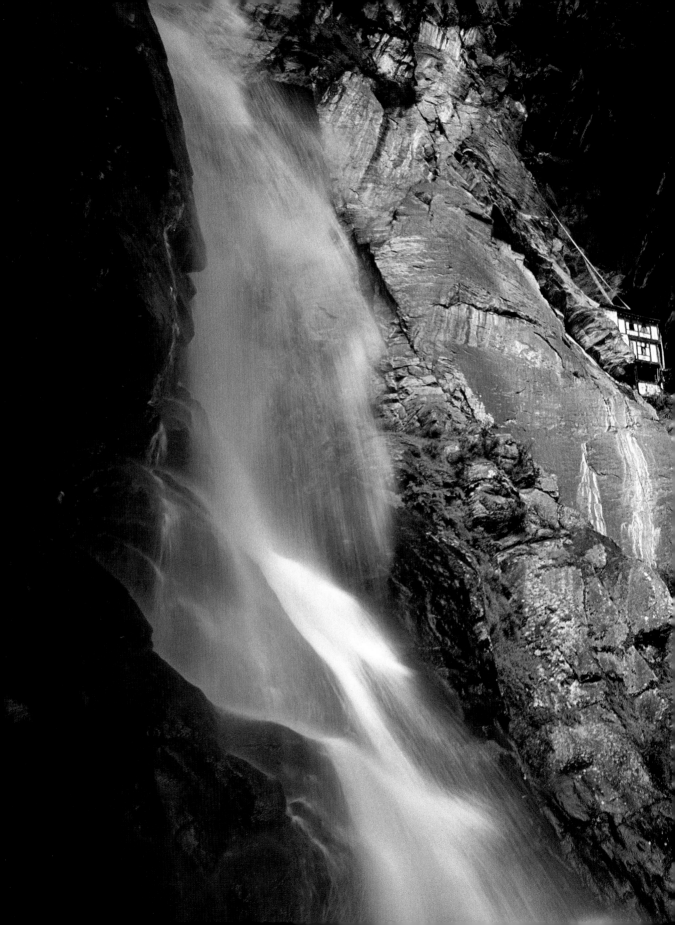

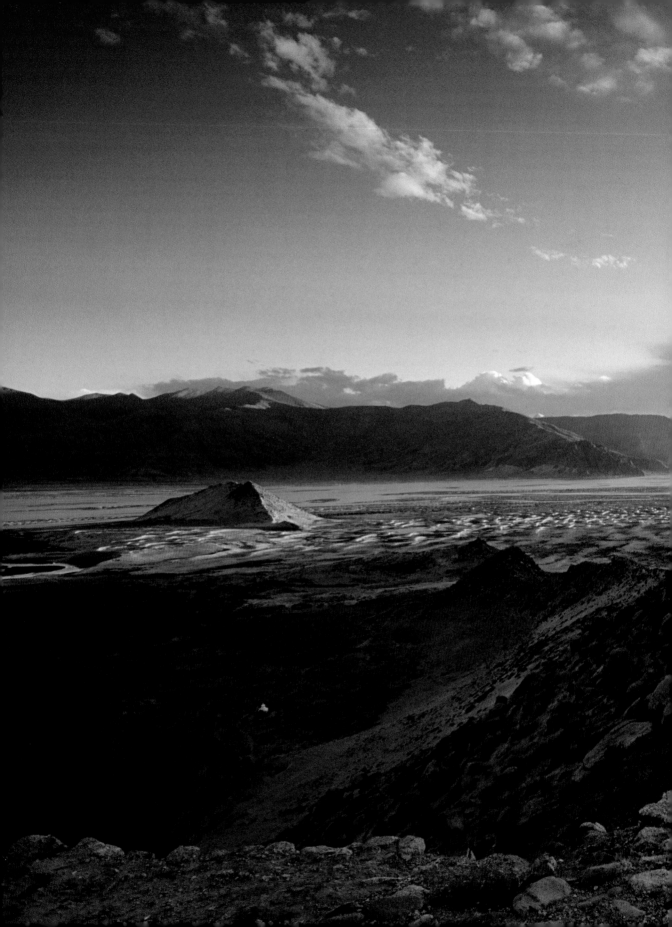

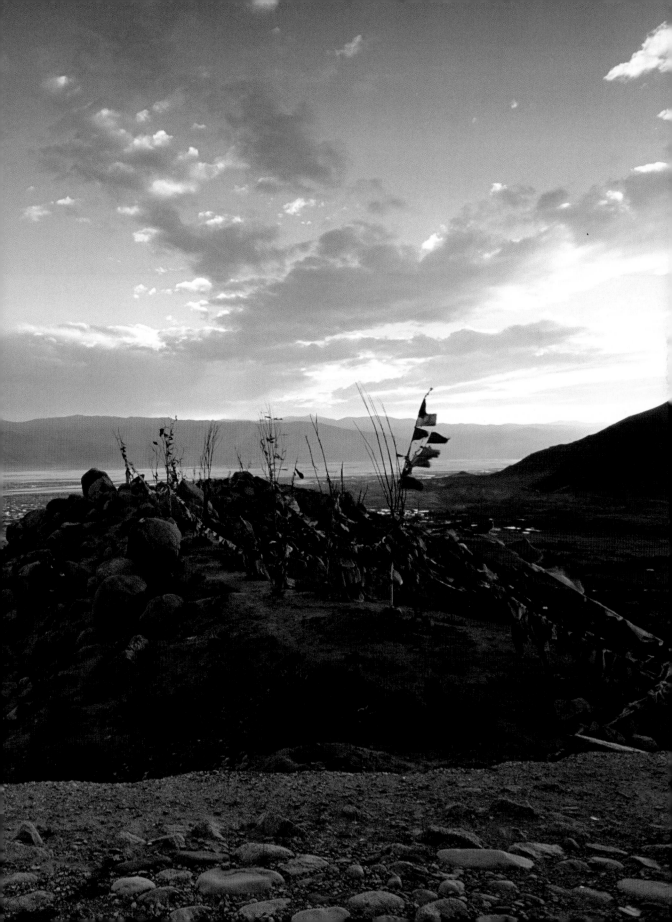

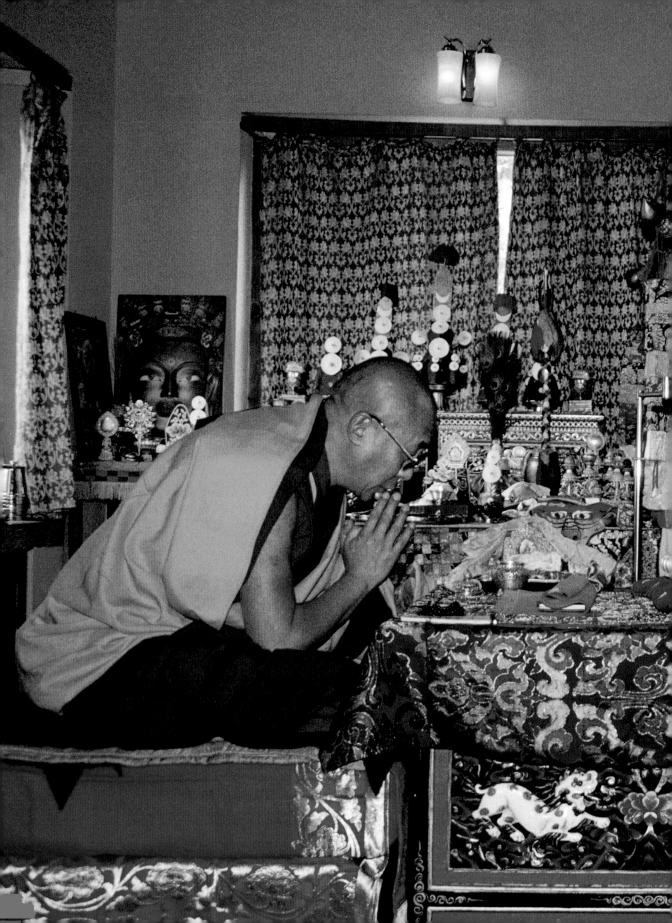

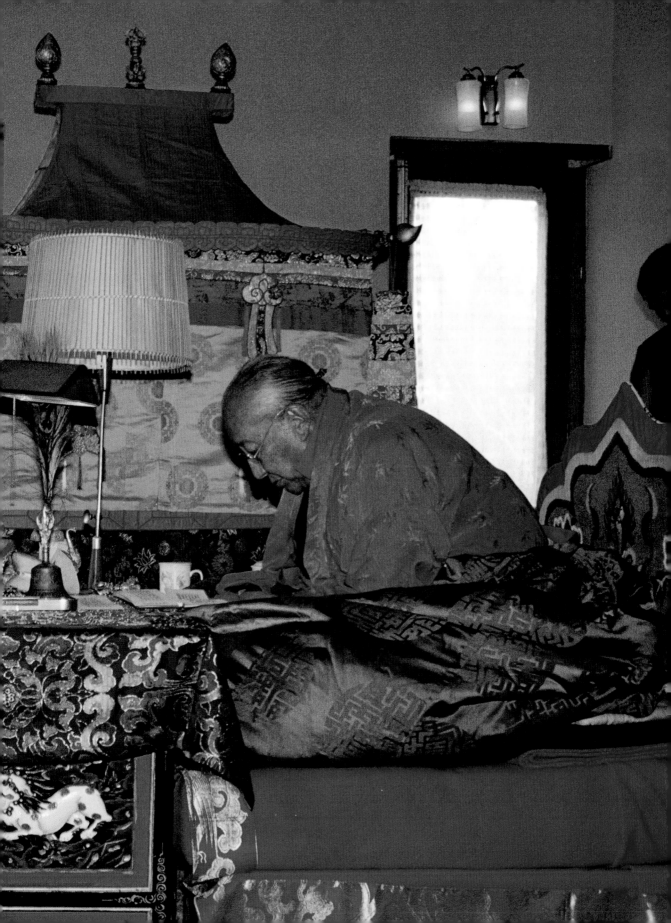

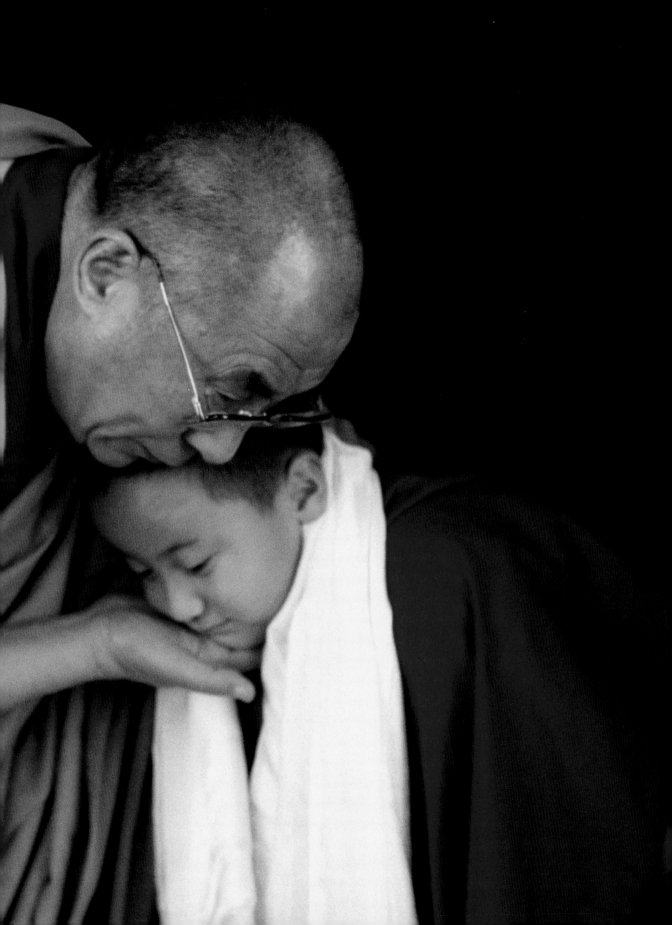

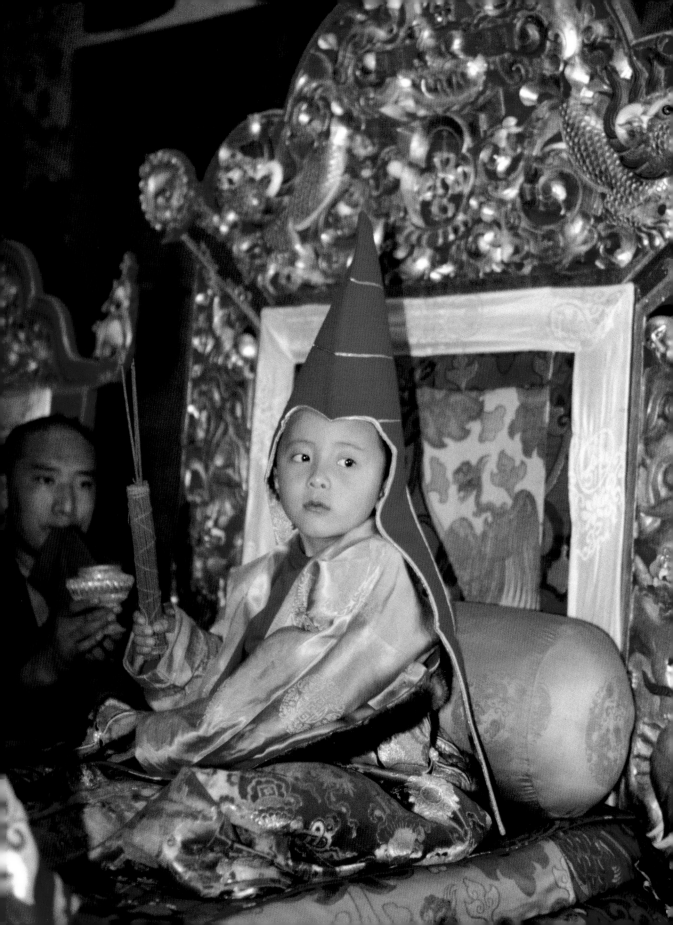

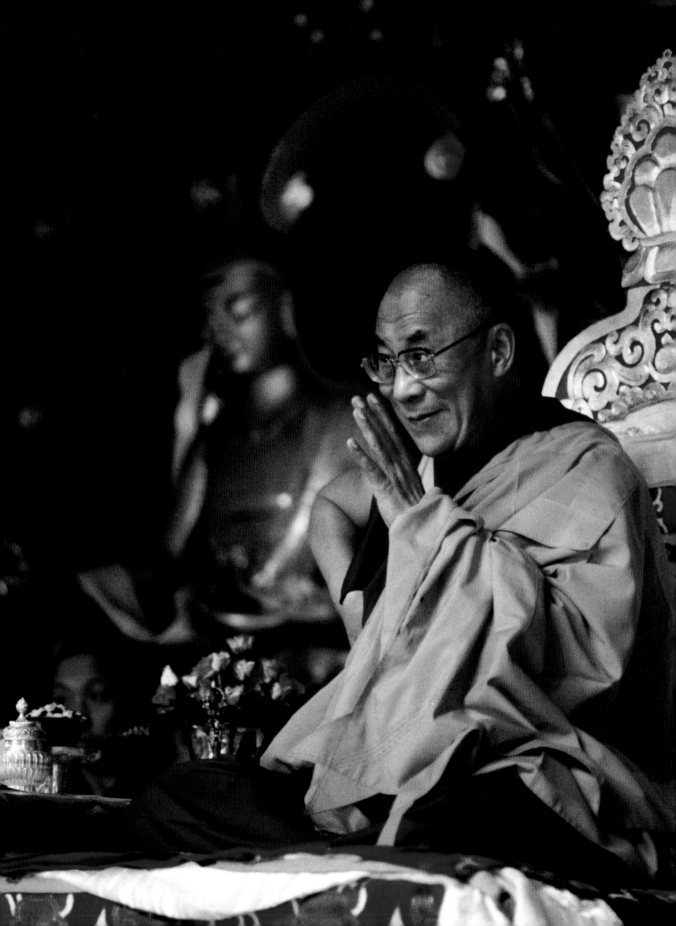

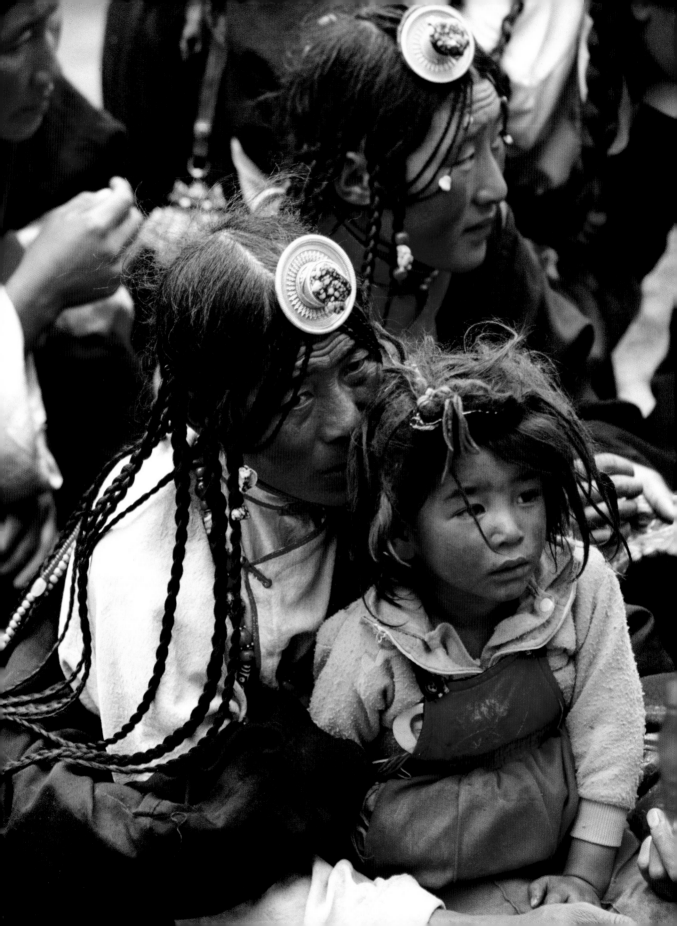

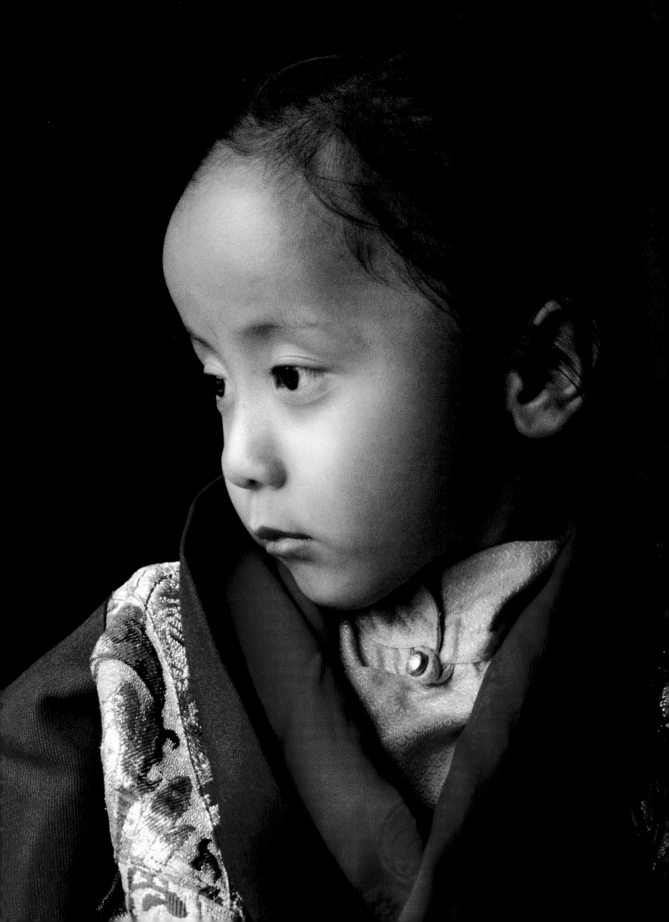

A Nugget of Gold Amongst Stones
The Value of Life

In Buddhism, all life is extremely precious. The reason for this is simple. All living beings have within them an inestimable potential to achieve the perfection of Enlightenment, the state of Buddha, in their present or a future existence. This potential can of course be hidden, buried in ignorance, stifled by egocentricity, hemmed in by the flames of hatred and other mental poisons, but it is present in every being, just as the smallest sesame seed is impregnated with oil.

Ignorance simply means not being aware of that fact. We are like a beggar who does not realize that he has a pot of gold buried under his shack. To take the Buddhist path is to regain possession of this forgotten treasure, for our own good and the good of others.

But even if it is hidden in this way, the mere existence of that potential waiting to be realized gives life an incomparable value. Without it we would struggle in vain to attain perfection. If you work hard, you can extract a nugget of pure gold from a stone, but you would strive in vain for a hundred years to wash a piece of coal clean. It can never be restored to whiteness because that is not its natural colour.

The obstacles to be overcome vary a great deal from one person to another, one type of living being to another. Take animals, for example. Their ignorance (in the sense used above) is so impenetrable and any means of communication that might enable them to escape it so limited that they will only be able to realize their potential for Enlightenment in a future life.

If we think of all the different living species in the universe, we understand how rare and precious the human condition is. Human beings are in a unique situation: a feast, a banquet held only one day in a hundred, a privilege only to be enjoyed in one life amongst innumerable others.

As the great Tibetan teacher Khyentse Rinpoche explains, 'If we do not take the opportunities that are offered to us, we will be like a beggar who picks up a jewel, clasps it in his hand for a moment and then throws it down in the dust, mistaking it for a piece of glass.' But more seriously still, the master goes on to say, If we are fully aware of the value of human life, then to squander it in distractions and the pursuit of vain ambitions is the height of confusion. If a traveller returns from the treasure island empty-handed, then the incredible efforts he has made to cross the seas are all for nothing'.

To be aware of the price of human life is to be like a beggar who suddenly realizes that what he is holding in his hand is not a piece of glass but a diamond, and decides straight away to use it for noble purposes. Although, through the force of their intelligence, human beings are capable of perpetrating an immense amount of evil, they are also the only beings able to achieve an immense amount of good. Thus the jewel that is human life can fulfil all our aspirations. All we need to do is aspire to Enlightenment, to knowledge, love and compassion, rather than to selfishness, hatred and confusion.

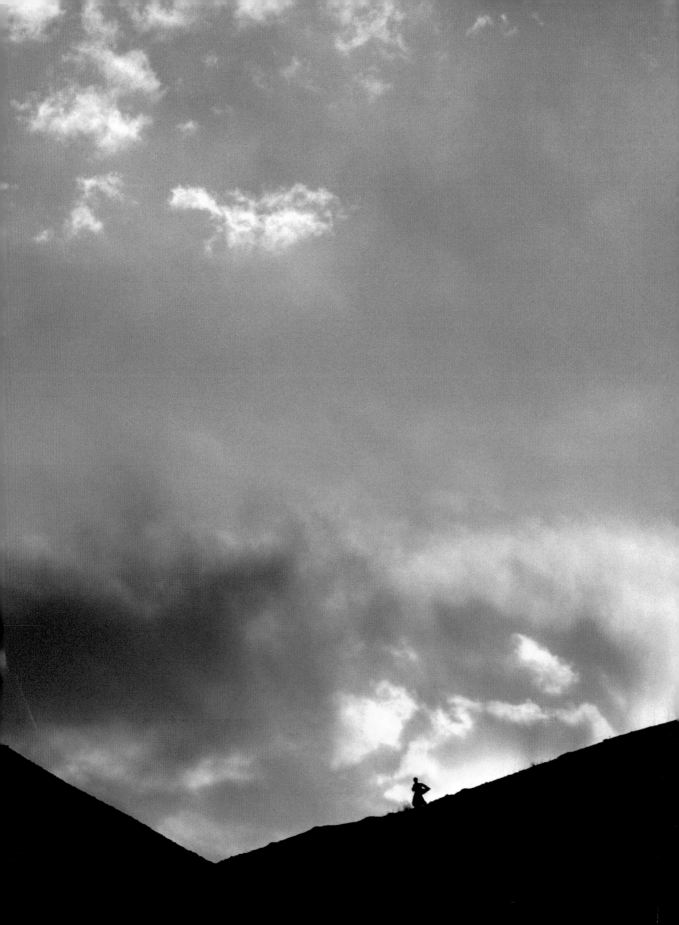

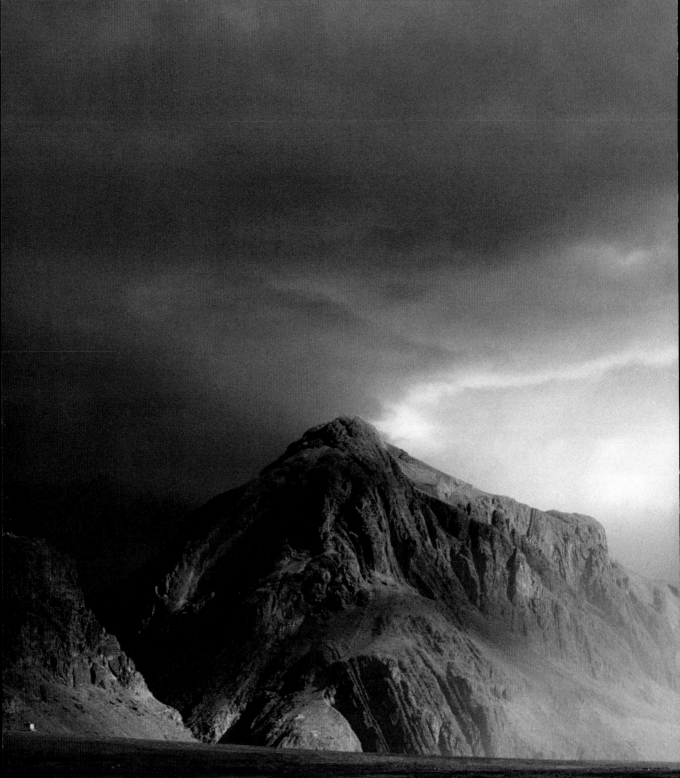

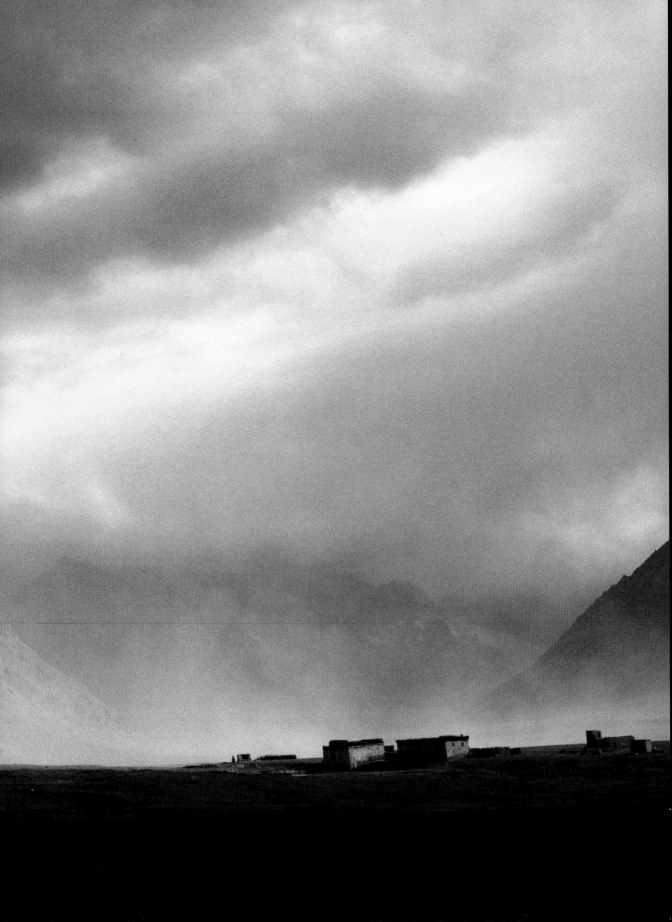

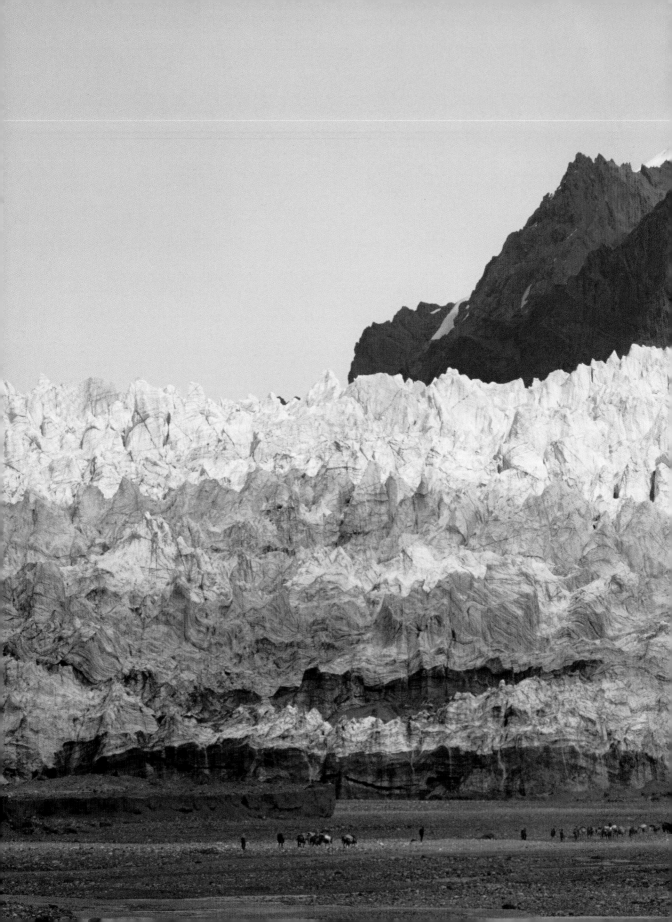

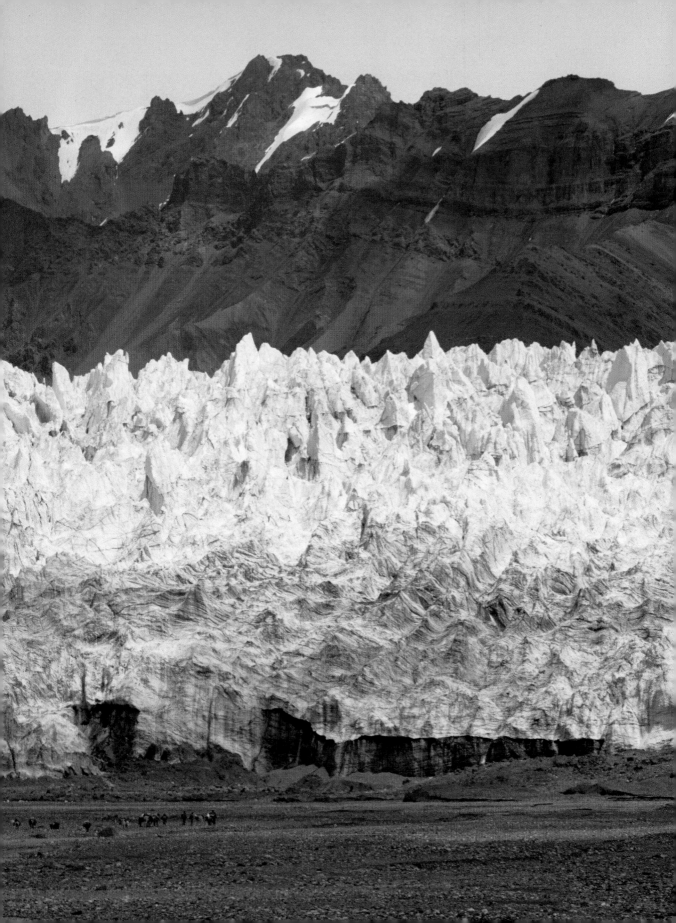

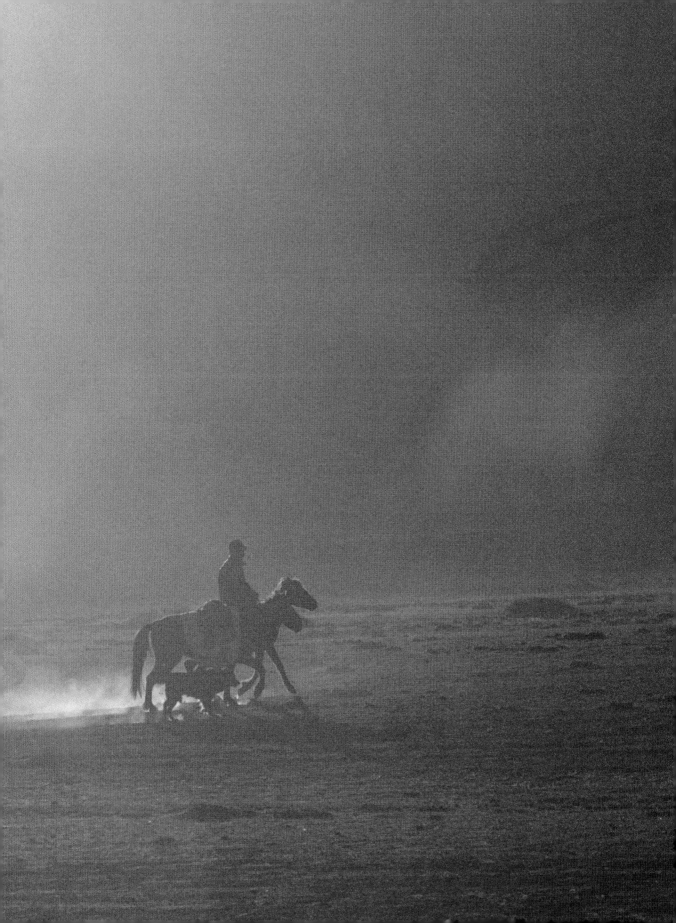

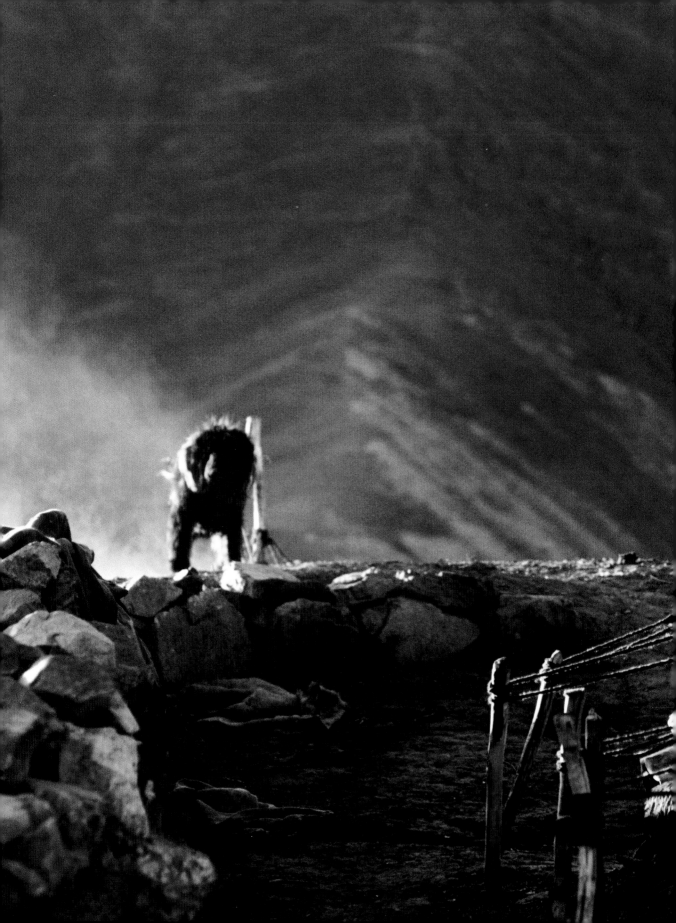

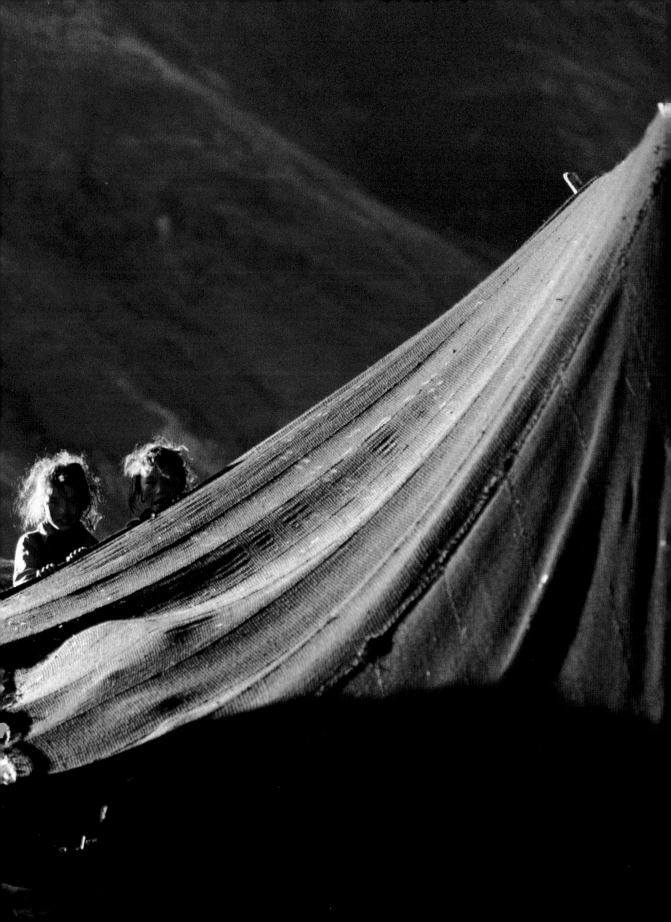

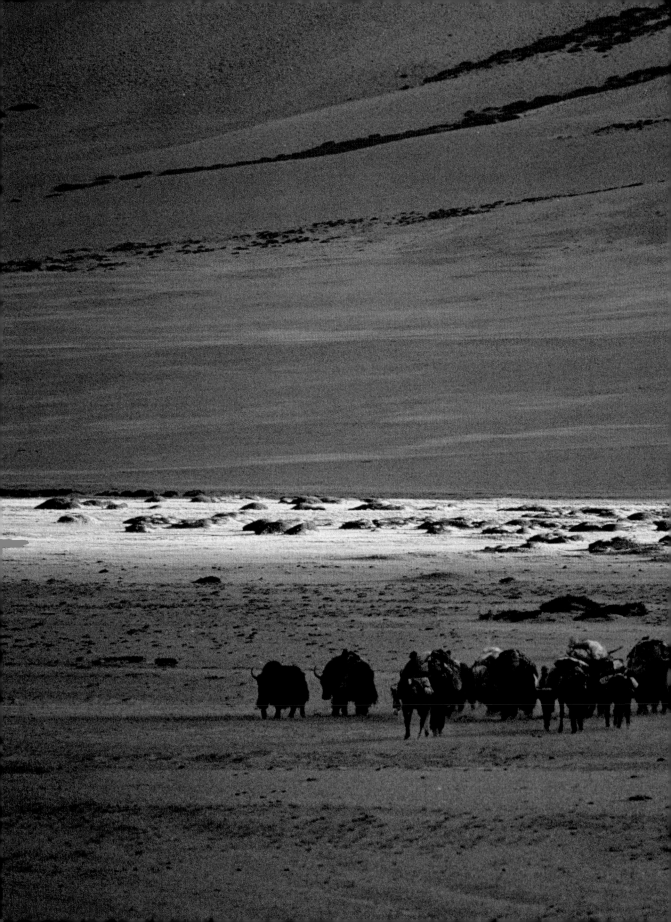

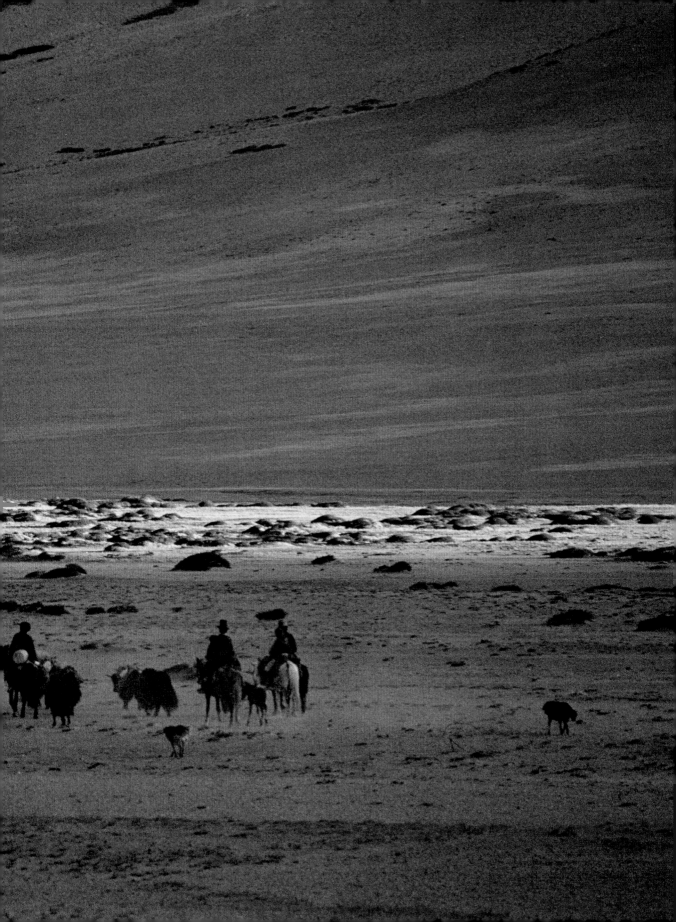

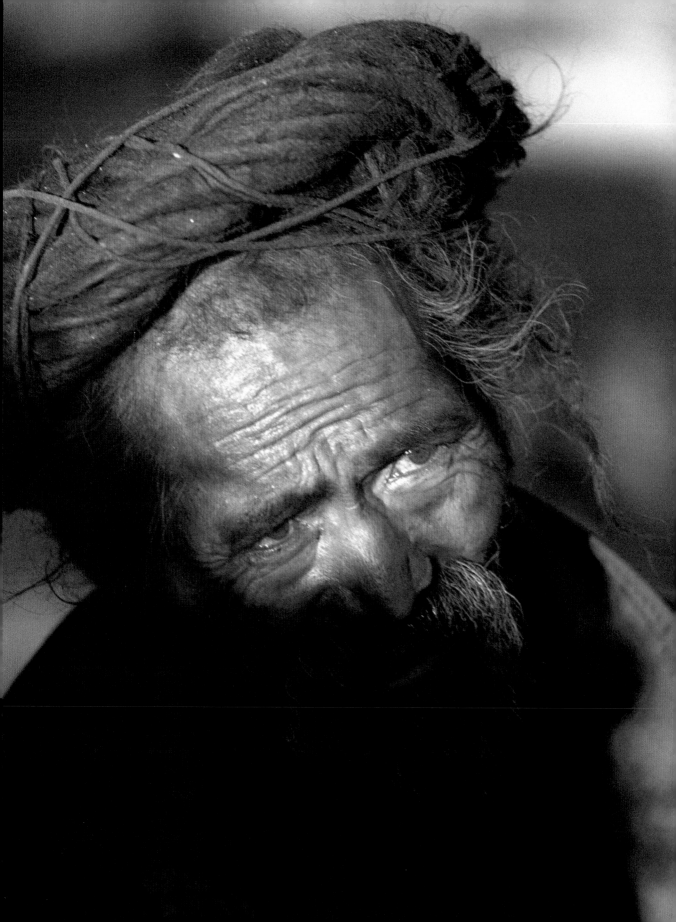

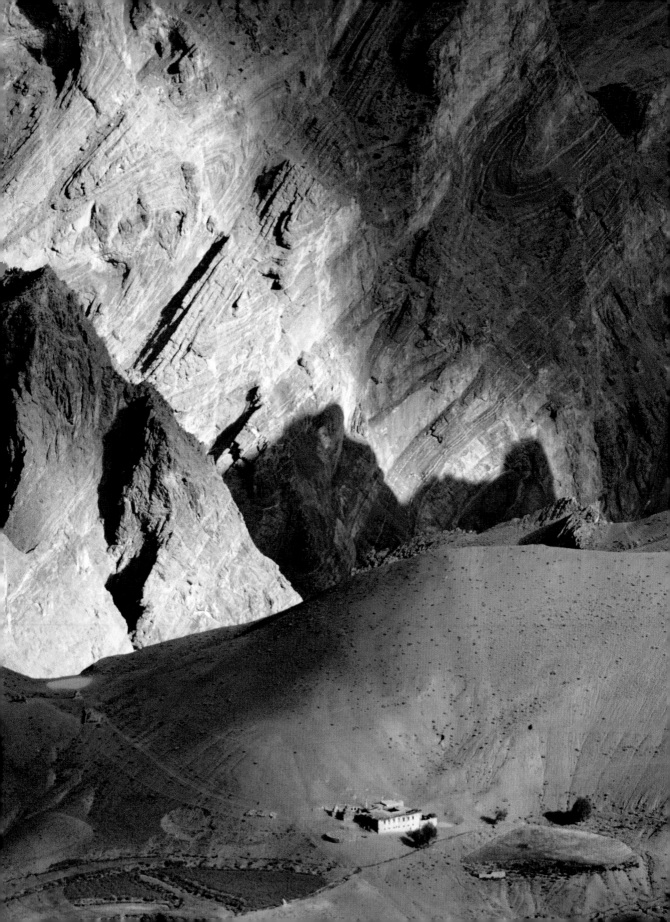

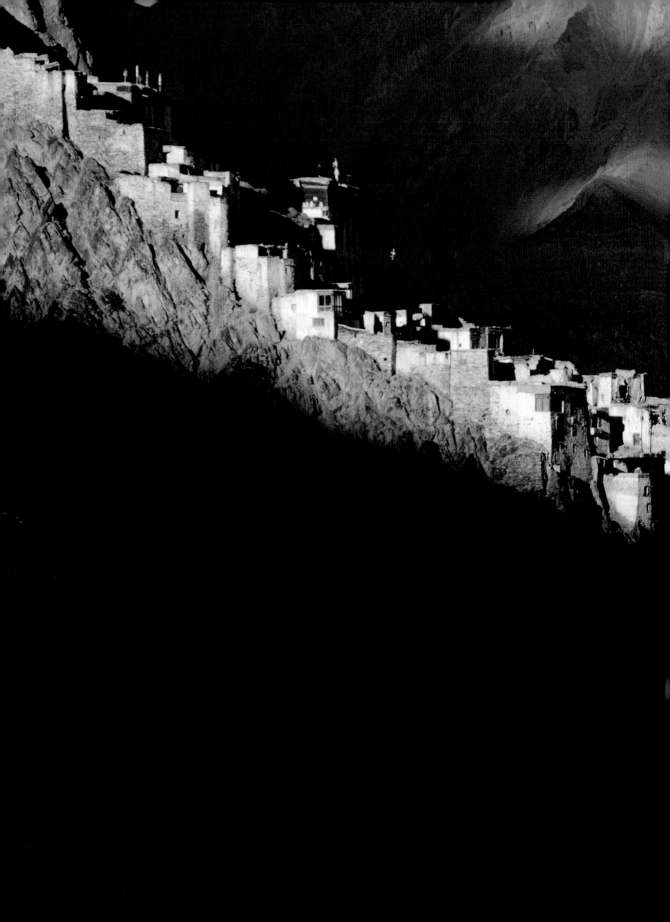

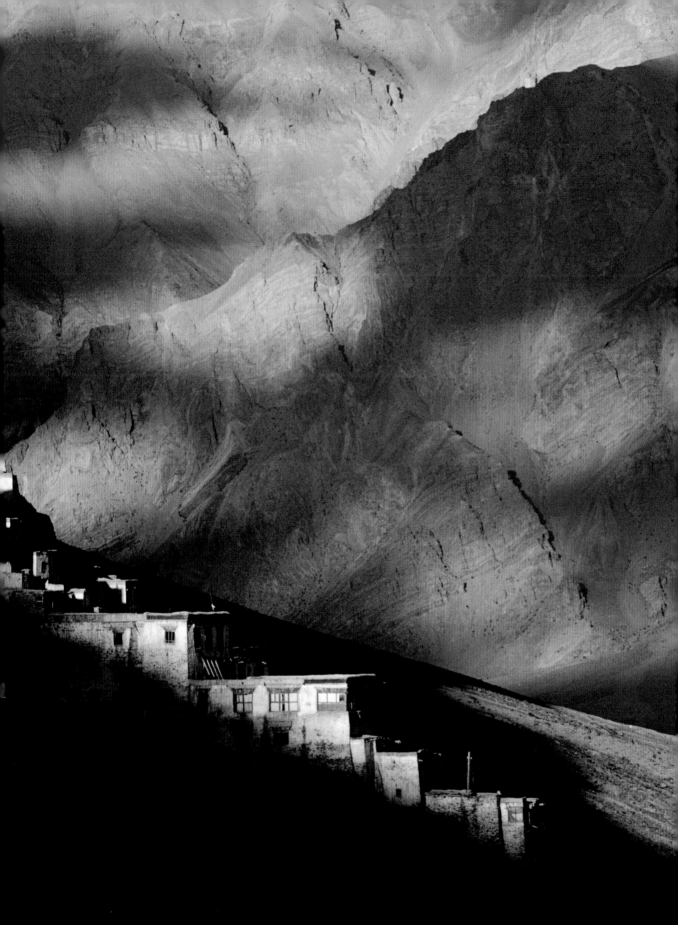

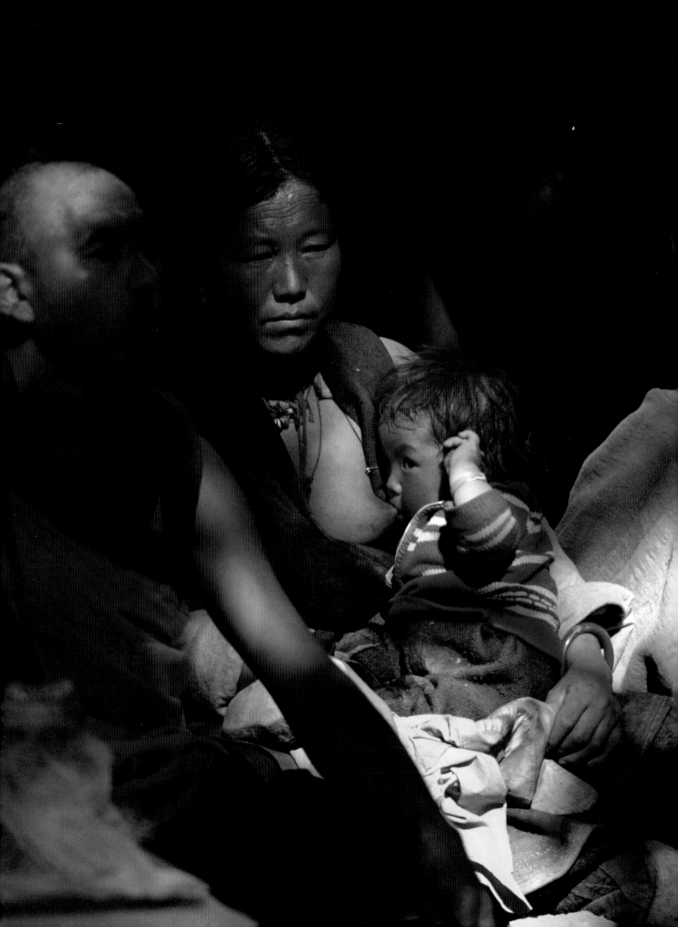

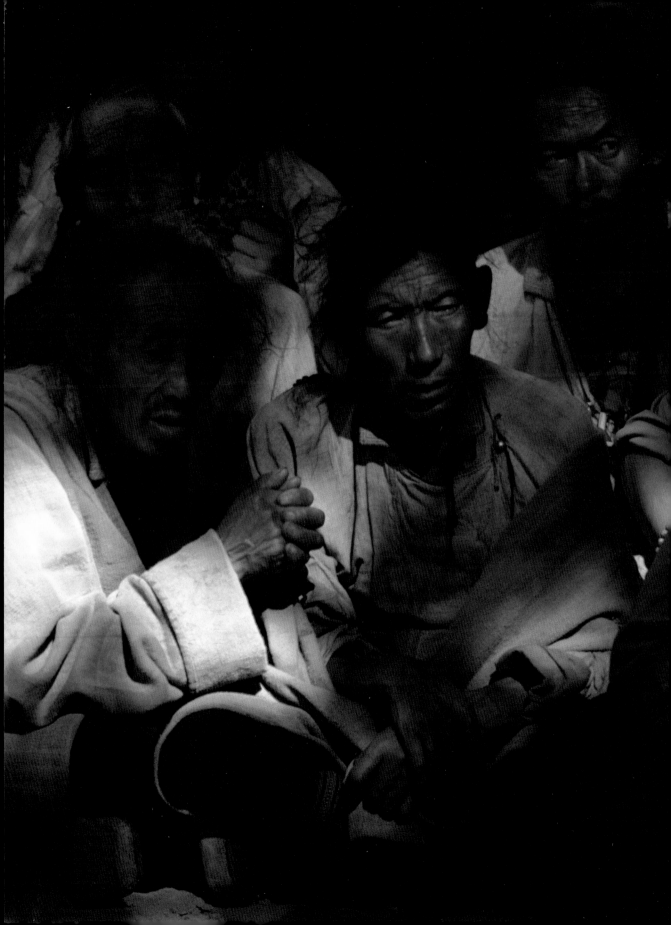

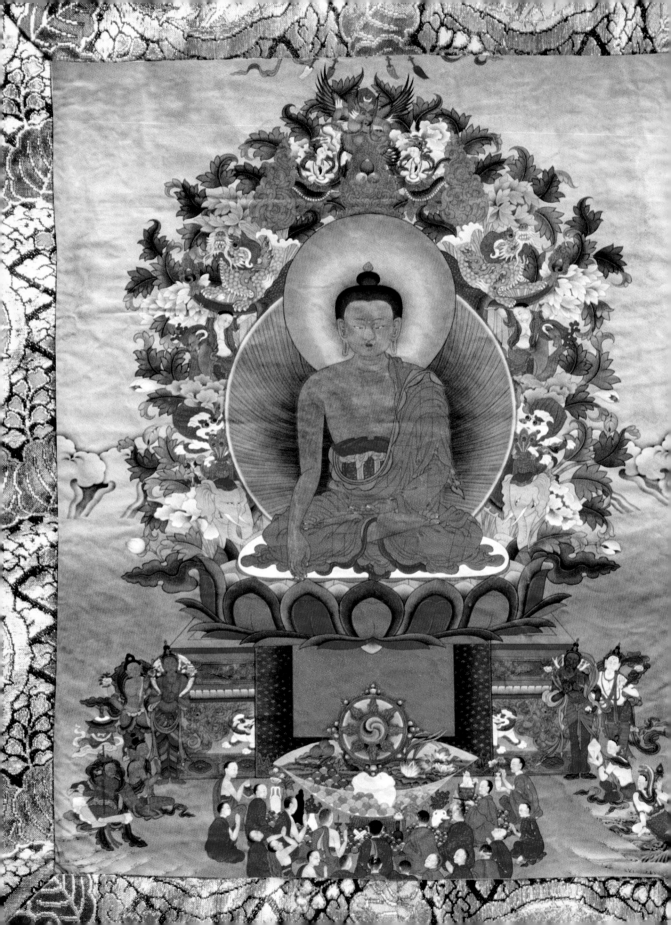

The Enlightenment of the Buddha

The Buddha represents the possibility of achieving Enlightenment. He is the ultimate example of what we can become, the culmination of internal transformation. The Buddha is not a saint, or a prophet, or a god: he is an enlightened being. He renounced the world, but not because his life as a prince was not splendid enough, nor because of disappointed ambitions or thwarted pleasures. In short, he renounced not what is truly good in human life – who would do something so absurd? – but only suffering.

The Buddha was born about 2,500 years ago (estimates of his date of birth vary between 569 and 451 B.C.), in the grove of Lumbini near the town of Kapilavastu, in what is now the south of Nepal. He was the son of Suddhodana, King of the Sakya, and his wife Queen Mayadevi.

At his birth a holy man foretold that he would be either a sage who would enlighten the world or a great ruler. This alarmed the King, who wanted Siddharta to succeed him, and he decided to create for the young prince an ideal environment from which all suffering would be banished. This was a wasted effort, symbolic of all the utopias of those who seek happiness where it is not to be found, because in a forest encircled by fire no one can escape the flames.

So Siddharta spent his youth in luxury and pleasure. But no long lectures were required to make him renounce it. Four images, four meetings, were enough: an old man, a sick man, a dead man and a wandering hermit. This was a striking encapsulation of samsara, the cycle of existence, and how it can be escaped. Birth, old age, sickness and death are 'the four great rivers of human suffering'. Weary of futility, disgusted with vanity, conscious that every moment that passes takes part of our lives with it, Siddharta decided to leave his earthly kingdom and seek out the kingdom of wisdom.

He renounced pleasure not to deprive himself of happiness but to find it. The bliss that he would experience with Enlightenment was beyond any form of suffering, because it had eliminated the very causes of suffering.

He went away in the night, leaving behind him the sleeping palace and the attractions of courtly life. His entourage would not have understood his ambitious plan to put an end to the world's misery. His family would have tried to dissuade him with all kinds of narrow-minded arguments, so he had to leave without telling them. The only way to break away from the unremitting activity of courtly life was to leave it behind, 'like spittle in the dust'. The prince fled into the forest. At dawn he cut off his long hair and joined some itinerant hermits. Then he visited two of the greatest teachers of his age. He quickly mastered their teachings, but he was still unsatisfied because they did not touch on the root causes of suffering.

Siddharta Gautama then dedicated himself to physical deprivation, spending six years in unimaginable hardship. But he realized that extreme asceticism was not the right way. It was the mind, not the body, that had to be understood and tamed. Ignoring the scorn of his five ascetic companions, he renounced austerity and went to a place now known as Bodhgaya. He sat at the foot of the Bodhi tree and resolved not to get up until he had achieved supreme wisdom. That night marked the culmination of a long search through life after life and was one of the most remarkable in the history of mankind, a sublime moment when the ripe fruit finally dropped from the tree.

In the four watches of the night, Gautama, brushing aside the last snares of Mara and the last gasps of the demon of the ego,

realized that ignorance, the cause of the attachment to the 'self', was also the root of suffering. He passed through the final barriers to the contemplation of absolute truth. Nothing exists by itself, there is only a dynamic flow of interdependent events, with no existence of their own. Form is emptiness, emptiness is form.

This was the supreme freedom. He announced that he had found a truth that was deep, serene, luminous, non-created and free from any mental fabrications, a truth like a nectar of immortality.

At dawn, in this place that would from then on be known as *vajrasana*, 'the Diamond Throne', he understood all that was to be understood, purified all that needed to be purified, developed all that could be developed. All that remained was to contemplate 'that where there is nothing to be seen', to remain effortlessly in the non-duality of Enlightenment, beyond notions of subject and object.

He believed it was impossible to communicate this profound truth to those trapped in the world of illusion. For seven weeks he remained silent, in the deep absorption of *samadhi*. Then he took a momentous decision and agreed to a request to set in motion the 'Wheel of the Dharma'.

He rejoined his five ascetic companions in the Deer Park in Sarnath near Benares. Marvelling at the changes in him, they realized that the person in front of them was now the Buddha, the Enlightened One. For his first sermon, the Buddha taught them the Four Noble Truths: suffering, the causes of suffering, the cessation of suffering and the path which leads to the cessation of suffering.

So the Buddha became a guide. His teaching, the Dharma, is a path, and its practitioners are companions on the journey. Those worn out by their ceaseless wanderings in samsara can thus find a door to pass through, a field to cultivate, a ship on which they can reach the continent of liberation.

The Buddha carried on teaching each person according to their abilities until the age of eighty. When the time came, he gave the final lesson of impermanence. He left his body for the peace of *parinirvana* at Kushinagara in the north of India.

The mere fact that a man has managed to attain the ultimate Enlightenment shows that Enlightenment is possible. Every being has the potential to become a Buddha, just as every sesame seed contains oil. To extract the oil, all you need is hard work, confidence, love and wisdom.

BEYOND SUFFERING
THE FOUR NOBLE TRUTHS

Buddhism is essentially the quest for Enlightenment. Its purpose is to eliminate suffering and the ignorance that causes suffering. In order to do that, it is necessary to understand the ultimate nature of mind and of the world of phenomena, and the potential for perfection that is in every being.

The Buddha taught the Four Noble Truths in his first sermon in the Deer Park near Benares. The first is the truth of suffering. Not just the suffering that we normally call suffering, the kind that is obvious, but also the more subtle suffering of change. The false happiness that turns to anguish. The even more subtle suffering that is latent in every creature as long as ignorance has not been eradicated.

Thus the fundamental cause of suffering is ignorance, the ignorance that makes us take the self for a separate reality. The distinction between self and others leads to hatred, desire, pride and jealousy, and many other thoughts that destroy our happiness and poison our lives and those of others. So the second truth is the causes of suffering.

These mental poisons can be eliminated because they are transitory and stem from a variety of causes which can be remedied. The third truth, the end of suffering, is then possible.

It is the fourth truth, the truth of the path, that makes this possibility a reality. This is the process of transformation, using any method necessary to eliminate the root causes of suffering.

The Four Noble Truths were taught during what is known as the 'first turning of the Wheel of the Dharma'. But the Buddha taught at various levels. Depending on the type of audience and their level of understanding, he spoke to them in terms of relative or absolute truth.

To some, he showed the imperfections of the everyday world. To others, he revealed the perfection that is the essential nature of phenomena. To some he explained emptiness, to others the infinite compassion that is its essence. He showed that every being contains within itself, like an indestructible nugget of gold, the potential to become a Buddha. He pointed to the path that anyone can take to realize that potential.

The essence of Buddhism is the union of wisdom and compassion. Wisdom enables us to recognize our innermost nature and compassion shows us that the happiness and suffering of others are more important than our own.

The Buddha's teaching is not just an object of intellectual curiosity. It can only have value if it is put into practice. Buddhism is a path to Enlightenment. Right from the start it tries to make us understand the mechanisms of happiness and suffering and shows us how to free ourselves from negative emotions and reveal the immutable joy within us.

The Diamond Throne of India
Bodhgaya, Scene of the Buddha's Enlightenment

Five hundred years before the birth of Christ, an emaciated ascetic rose from the place where he had been meditating after six years' extreme hardship in the forest and walked unsteadily towards the river Niranjana. On the way he collapsed. He revived with the help of a village girl who brought him rice cooked in milk. After regaining his strength and bathing in the waters of the tropical river, edged with silver sand and fringed with palm trees, he realized that mortification of the body is not the way to Enlightenment.

He walked to a majestic *ficus religiosa* tree and sat in its shade, vowing not to get up until he had understood the ultimate nature of mind and reality. All night he sat under the tree, which from then on was called the Bodhi tree. The place, now Bodhgaya, became known as the Diamond Throne of India, and the man was none other than Siddharta Gautama, who at dawn became the Enlightened One, the Buddha.

Two thousand five hundred years later, a few days before the third millennium, tens of thousands of people, including two thousand Westerners, assembled in Bodhgaya to hear teachings on compassion by the 14th Dalai Lama, spiritual leader of the Land of Snows. For over a week he spent five hours a day explaining one of the most inspired poems on the altruistic love and fundamental goodness of man, *The Way of the Bodhisattva* by Shantideva, the great 7th-century teacher.

The speech was not passionate rhetoric. It expressed a calm and profound philosophy, interspersed with practical advice and real humour, showing how to become a better human being. The Dalai Lama's teaching is sensitive and pragmatic, but since the simple things he talks about come from his direct experience and a life devoted to the spiritual, it never becomes banal. When he says that to have a good heart is the most precious quality one can develop, it never seems like a cliché because he himself is overflowing with infinite goodness. When these verses from *The Way of the Bodhisattva*:

'May I be the protector for those
 without one
A guide for all travellers on the way
May I be a bridge, a boat, a ship
For all who wish to cross the water
May I be an island for those who seek one
And a lamp for those desiring light,
May I be a bed for all who wish to rest
And a slave for all who want a slave

Just like space and the great elements
 such as earth,
May I always support the life of all the
 boundless creatures
And until they pass away from pain,
 may I also be the source of life
For all the realms of varied beings that
 reach until the end of space.'

bring tears to the Dalai Lama's eyes, he stops for a moment and simply waits until he can speak again. This calm expression of his feelings is far from an ostentatious display of emotion.

Sometimes he illustrates his words with anecdotes or notices something unusual in the crowd and then he spontaneously bursts out laughing, expressing the freedom of one detached from all worldly preoccupations.

After the teaching session a consecration verse is chanted:

> 'As long as space endures
> And as long as living beings endure
> May I too remain
> To dispel the misery of the world.'

Before dawn and just after dusk thousands of pilgrims, remembering this promise, walk round the Bodhi tree and the monumental temple that stands behind it. They murmur mantras, tell their beads, sing the Buddha's words or praise his wisdom. Mountain people from the remote Himalayan valleys, still dressed in skins and thick woollen clothes, rub shoulders with believers from Sri Lanka in spotless white cotton garments, Thai monks in saffron robes, Chinese nuns in blue, black-clad Japanese and strolling Westerners, dressed in a motley range of clothes. Old monks sitting in the shade turn large prayer wheels unceasingly.

Hundreds of pilgrims, most of them Tibetan, prostrate themselves in front of the temple. They are not worshipping a god but demonstrating their respect for the ultimate wisdom of the Buddha. The two to three thousand prostrations they make a day, sliding on smooth planks of wood, are a powerful homage to the Buddha's body, word and mind of Enlightenment. They pray in order to purify their own bodies, words and minds of all confusion. In that respect ignorance is the enemy, samsara – the world of conditioned existence – is the battlefield and winning means freeing oneself from suffering.

It is said that, besides the Buddha Shakyamuni, the thousand and two Buddhas of this age have achieved and will achieve Enlightenment at this spot, regarded as a 'hanging garden' in the midst of this dark age. The Buddhist poet Asvagosha called Bodhgaya 'the navel of the world'.

The emperor Ashoka is thought to have built the first monument commemorating the Buddha's Enlightenment near the Bodhi tree in around the 3rd century B.C. According to detailed accounts by Hieun Tsang, the renowned Chinese pilgrim and scholar, a larger building was erected in the 7th century. A community of several thousand monks was founded near the monument. The waves of Muslim invaders in the 12th century wiped out Buddhism in India and the building was also destroyed. The Burmese kings restored the great temple in the 14th century, but it fell into ruins again. Over the centuries it was partially covered over by the sand deposited by floods and winds, until, in the 19th century, the Burmese and a determined Englishman called Alexander Cunningham began to restore it to its present condition. This was how the great temple came back to life.

Thirty years ago, very few pilgrims came to Bodhgaya, then a peaceful site in the heart of the Bihari countryside. Now it is a scene of intense and inexpressible serenity, a striking contrast to the chaotic bustle of the nearby town of Gaya. Over twenty monasteries for all the Buddhist countries have been built a few kilometres from the main monument to accommodate the ever-growing number of pilgrims.

Two hundred thousand believers, including the leading spiritual teachers of the various Tibetan Buddhist traditions, came together in 1985 to hear the Dalai Lama when he initiated them into the *Tantra of the Wheel*

of Time, the Kalachakra. Thousands of people had travelled from Tibet, crossing high snow-covered passes and braving the border guards to escape for a few weeks from the harsh repression of the Chinese Communist regime. Some lost their lives on the hazardous journey.

It was extraordinary to see these Tibetans sitting at the front of the crowd, their dreams fulfilled beyond anything they could have imagined. Not only could they see the leader and teacher they loved so much, they could sit in front of him all day for a week! In the Indian heat they were still wearing their felt boots, sheepskin coats and torn Chinese jackets, which had been barely enough to protect them against the biting cold as they crossed the Himalayas. They looked at things very differently from the Tibetans who had fled to India over thirty years ago. For these new arrivals everything was new, especially freedom. Among this attentive crowd were faces of striking beauty. With a fervour that came from deep down in their hearts, they gazed at the Dalai Lama with eyes as clear as the sky.

In the West an event like this would have taken months of preparation and involved complicated logistics. Here, thousands of tents, used as restaurants during the day and dormitories at night, had sprung up like mushrooms in the space of a week or two. The Indian traders were there too. Two hundred thousand people turned up, stayed and then left without much disturbance. When the teaching was over, the crowd disappeared as quickly as it had arrived, a reminder of these lines by the Tibetan yogi Shabkar:

'We came here from different provinces,
 east and west
We have assembled for a brief moment
And will now disperse, like all phenomena
This is impermanence!

Like autumn clouds, this life is transient.
Our parents, our relatives
Are like passers-by met in a marketplace.
Like the dew on grass-tips
Wealth is evanescent
Like a bubble on the surface of water
This body is fragile and ephemeral
The dharmas of this samsaric world
 are futile
The sacred Dharma alone has value
The chance to practise this Dharma
Is occurring just once: right now.'

THE THREE JEWELS

The three main objects of trust and respect in the practice of Buddhism are known as the Three Supreme Jewels, the Buddha, the Dharma and the Sangha.

The Buddha is the one who has awoken from the sleep of ignorance and developed all the qualities of Enlightenment. He is regarded as a guide. The Dharma is the body of teachings by the Buddha showing the way to Enlightenment. This is regarded as the path. The Sangha is the community of those who follow the path, our companions on the journey. According to the Vajrayana, the Diamond Vehicle of Tibetan Buddhism, the Three Jewels are united in the spiritual teacher. His mind is the Buddha, his word the Dharma and his body the Sangha.

The Buddha has two aspects, the 'formal' body, such as the historic Buddha Shakyamuni, and the 'absolute' body which is the ultimate nature of Enlightenment. The Dharma consists of the 'Dharma of transmission', the writings and teachings, and the 'Dharma of realization', represented by the qualities practitioners develop on the path to Enlightenment. The Sangha is the community of all who practice the Dharma and the supreme assembly of those who, without having yet achieved Buddhahood, have already gained a true understanding of the true nature of phenomena. This includes in particular the Arhats and the Bodhisattvas.

Taking refuge in the Three Jewels is regarded as the gateway into Buddhism. It is common to all forms of Buddhism and the basis of any practice. However there are different reasons for taking refuge. It might be done out of fear of suffering, to ensure one's own salvation. That is a lower motivation. Or it might be done from a desire to liberate all beings from the sufferings of samsara and lead them to Enlightenment. That is the noble and wide-ranging attitude of the Greater Vehicle (Mahayana).

Confidence must be absolute if the refuge is to be genuine. The commentaries describe four levels in the evolution of faith: clear faith, aspiring faith, confident faith and unshakeable faith. When the disciple becomes aware of the qualities of the Buddha and his teaching, his mind becomes light and joyful. That is the first degree of faith. Then, when he realizes that these qualities can enable him to achieve Enlightenment and help a large number of beings, he begins to want to acquire them. Clear faith has turned into aspiration. When the follower becomes sure, from his own experience, that those qualities can be developed and are as sublime as described in the writings, he acquires a deep conviction. Finally when, through spiritual accomplishment, his faith has become so much part of his mind that he would not be able to renounce it, it is irreversible. The Buddha has always warned his disciples against blind faith. 'Do not believe what I say simply out of respect for me. Discover from your own lives the truth of what I am teaching you'.

Buddhahood might seem a distant goal, virtually unachievable. But the true nature of our mind is actually Buddha-nature. Not realizing that, we see it as a goal to be attained outside ourselves. Buddha-nature is fundamentally pure and unchangeable, like gold. Ignorance might obscure it temporarily, just as mud might hide a nugget of gold but cannot penetrate it. So the spiritual path does not mean 'creating' Buddha-nature but making it a reality. If ignorance actually existed there would be no way of eradicating it, any more than coal can be whitened by washing it. To understand this is the most profound way of taking refuge. Thus the ultimate nature of mind, emptiness, is the Buddha, his radiant aspect is the Dharma and the compassion emanating from him is the Sangha.

Three Hundred Thousand Pilgrims to See One Man

On being awarded the Nobel Prize for Peace, the Dalai Lama responded with humility: 'It is not the monk who should be rewarded, but his motivation.'

At Gaya, on the plain of Bihar in India, the trains from Delhi and Calcutta are full to overflowing. Thousands of refugees are flooding in from southern India, their bags bulging with green bananas. After an exhausting journey of many weeks, thousands of Himalayan villagers surge in from the remote Dolpo region in multicoloured shawls, from Mustang, from Ladakh in woollen robes, from Khinor, from Lahaul in little flat embroidered caps, from Bhutan, and from Arunalchal Pradesh. Hundreds more come from Switzerland, Germany and the United States. Five thousand Tibetans from the high plateaux have managed to trek across the Himalayas in secret and in defiance of the Chinese soldiers lying in ambush, crossing mountain passes on foot at altitudes of up to 5,500 metres. All are driven by one goal and one goal only: to rejoin their spiritual leader, the 14th Dalai Lama, at Bodhgaya, the holy place where Buddha attained Enlightenment under the famous Bodhi tree. This year at Bodhgaya, the Dalai Lama will offer the precious initiation into the Kalachakra, the teaching of peace in the heart that he alone can dispense.

Three immense encampments of tents flank the village of Bodhgaya. The first is reserved for pilgrims arriving direct from occupied Tibet: here the Tibetan government in exile offers them food and lodging entirely free of charge. As soon as they arrive, these pilgrims hasten to make offerings to the Dalai Lama, in a large tent where a monk carefully notes each gift in a large register. A solemn-looking man comes into the tent. His hair, tied back with plaited red wool, is grey with dust. He is still carrying his jute bag, slung between two wooden sticks like a rucksack. He has just arrived from the high Tibetan plateaux. Deeply moved, he slowly greets the monk, his hands held palms together against his breast. Plunging one hand inside his long woollen robe that smells of wood smoke, he carefully draws out a small scroll wrapped up in a piece of cloth that is yellow with age. He bows before this threadbare, gold-painted holy image that he has rescued from the ravages of the Red Army, and with both hands offers it to the monk: 'I wish long life to the Dalai Lama. I have walked for three months to be here, with my four children. On the last pass one of them died...'.

In their thousands, the pilgrims pray and slowly circle the stupa that stands beside the Bodhi tree. This evening, Bodhgaya resonates with an unaccustomed air of taut expectation that can be read on every face. The stupa glows with the light of thousands of candles, arranged in three concentric tiers. Tomorrow is the great day, tomorrow will see the event for which these people have surrendered their wealth and sacrificed their strength on windswept paths: the opportunity to join with the Dalai Lama in prayer and to follow his teaching. Tomorrow, at eight o'clock precisely, the Dalai Lama will appear and the Kalachakra will begin. Tomorrow, thousands of Tibetans from the high plateaux will at last see their spiritual leader, after decades of suffering under the yoke of Maoist China.

At three o'clock in the morning, fires of cow dung and twigs are already burning in front of each tent. At four o'clock, the penetrating note of a conch pierces the night air. Under an immense awning, two hundred metres in length, eight thousand monks in saffron robes sit cross-legged, chanting a solemn prayer as though with one breath and one voice. All around them in the darkness of the night, three hundred thousand people sit beside each other in silence. In four hours the Dalai Lama will be here, before his throne, facing the monks. The prayer hovers over their heads in the star-studded darkness, undulating as the voices rise and fall. Everyone is lost in concentration. Now and then a baby cries, and is put to its mother's breast, enfolded in her robe. In the distance, dawn breaks. The sun rises, blood red. The monks' prayer grows louder. It is nearly eight o'clock. In the expectant atmosphere, everyone tells their beads, their eyes riveted on the door that is about to open. Beneath heavy woollen robes, hearts pound and pulses quicken. The prayer becomes a whisper. In this silence in which no one prays, no one draws breath, he appears in the doorway and stops before the throne. He puts his hands together and bows to his followers, facing in all directions. Not a sound breaks the silence, not a cry. Three hundred thousand pairs of eyes are fixed on one man, calm and composed. Spontaneously and still in complete silence, the crowd rises to its feet. No one applauds. But many weep silently, their hearts choked with emotion.

The Dalai Lama sits down in the prayer position. Almost everyone follows his example, sitting cross-legged on the ground; a few remain standing, as though transfixed. The prayer begins, grave and soft. But it tears through the silence. The voice of the Dalai Lama is amplified by loudspeakers. Everyone stares fixedly at the metal trumpets, trying to reach closer to their spiritual leader. So tightly stretched are their nerves that at the sound of his voice several sink their heads into their hands, unleashing twenty-five years of suffering. On this day at Bodhgaya, time and the world stand still, frozen for eternity in the hearts of those present.

Seventeen years later, in the year of Iron and the Snake, in the month of January 2002, crime and thuggery are rife on the plain of Bihar. The world is gripped by violence, and peace between its peoples is in peril. A few hundred kilometres away, in Afghanistan, war threatens to engulf the planet. To support world peace, the Dalai Lama decides once more to offer his precious teaching of the Kalachakra at Bodhgaya, an offering which cleanses the mind of hate, greed, jealousy and pride. On this occasion, four hundred thousand pilgrims flock to join him. Trekking from the remotest valleys of the Himalayas, these pilgrims bring with them the heightened awareness of people who have retained their intuitive approach to life, their strength and their gentle motivation. Their tolerance and compassion creates an everlasting bond between them and the community of humankind. They bring with them an instinctive understanding of the interdependence of all living beings. Modest players in the theatre of world peace, they arrive at Bodhgaya clutching their beads and with a prayer on their lips.

Once again, the village of Bodhgaya is transformed. Every pavement is filled with people sleeping, eating, bartering and praying. For a radius of two kilometres around the village, the paddy fields are filled with tents. Twenty thousand monks and nuns from every school of the Tibetan tradition, together with a hundred and fifty monks recognized as reincarnations of the great spiritual teachers, gather around the tree of Buddha. Day and night, Bodhgaya pulsates with a palpable energy, by turns electrifying and soothing according to the time of day, the light that bathes the village, the dust in its streets, the smoke of incense, and the power and rise and fall of every pilgrim's prayers.

But when the Dalai Lama arrives at Bodhgaya this year, he is in a weakened state, and is not able to dispense the teaching of the Kalachakra. When this news is announced over the loudspeakers, the whole village is suddenly shattered. The Dalai Lama, the Victorious One, the Wish-Fulfilling Jewel, is ill. Pain darkens every countenance. Faces are filled not only with pain but also with suffering, as though each individual is taking on a share of the Master's suffering in order to spare him. What can be the cause? A virus picked up on the journey? Or the accumulated fatigue of his travels around the globe in the name of peace? Is it a sign of destiny, an omen for the future of world peace? Every individual interprets this fact according to his or her own beliefs, whether secular, religious or superstitious. On the dais and beneath the great awning from which he was to dispense his teaching, one hundred thousand pilgrims pray throughout the night for long life for the Dalai Lama. Everyone focuses on their inner being, releasing an outpouring of strength, transmitting their energy to the weakened Master. Every face is filled with concentration, all eyes are closed, all hands joined. Towards one man. For one man. From an entire people.

The Dalai Lama must be flown to a major city for treatment, but the Tibetan people will not remain bereft for long. It is as though the energy they have expended in coming here to foster world peace has already taken wing. Prayers of compassion are taken up again at Bodhgaya, and with even more fervour than before, prayers for our weakened world.

A few days later, enriched by the prayers they have offered, the pilgrims return to their valleys with joy in their hearts. Just as they labour to grow grain in their fields, they know that their prayers are fertile, and will allow the seeds of peace to grow.

THE MEANING OF PILGRIMAGE

What does pilgrimage mean to a Buddhist? Some sites are sacred because they are associated with a particularly deity. Mount Kailash, for instance, is regarded as the palace of Chakrasamvara, situated in the centre of his mandala. Others are sacred because great sages have blessed them with their presence. Sites where Guru Rinpoche stayed and caves in which Milarepa meditated can be found all over the Himalayan region.

Often a site combines both of these aspects, because its sacred nature attracts eminent hermits there to meditate. The many sages and yogis who spent years in retreat around Mount Kailash include Milarepa, Gotsangpa and Shabkar. Pilgrims walk around the sacred mountain, reciting the mantra of Chakrasamvara, and stop in the caves where these great holy men lived to recuperate for a few minutes or spend a few days – which might turn into months or even years – in retreat.

These places are a powerful source of inspiration for spiritual practice. It is said that as much progress can be made in one month of meditation there as in a year anywhere else, for several reasons. Firstly, contemplating the lives of the remarkable men who meditated on that very spot is much more inspiring than simply reading their life stories. The site is a constant reminder of their unstinting determination to follow the path of Enlightenment and their spiritual qualities. This encourages diligence and enthusiasm and makes it easier for the faithful to dedicate themselves to asceticism.

In these places, every moment has something special about it. Even outside the meditation sessions, while the hermit is resting, eating or engaged in any other routine activity, inspiration is always there like an invisible presence.

At a deeper level, the sites carry a special blessing, because the bonds of interdependence mean that all of our actions form part of a continuous process. That is why the spiritual presence of past hermits has a powerful ability to transform. Pilgrims can often be heard exclaiming, 'It is as if he were here only a moment ago!' That feeling is reinforced by the visible traces of the sage's passing: the stone hearth where he made a fire, the corner of the simply furnished cave where he sat, a stone wall built to close off the entrance to the cave. Some signs, for instance a hand- or footprint in the rock, are evidence of miraculous deeds.

For us, his followers, a visit to the caves and hermitages in eastern Tibet where Dilgo Khyentse Rinpoche lived in retreat for more than twenty years was not just a voyage of discovery, it was most of all a teaching and a source of strength that can be recalled at any time to give a fresh impetus to spiritual practice.

The pilgrimage is also seen as a kind of purification. Pilgrims will put enormous effort into it, where possible avoiding riding on horseback and walking the whole way. Some even prostrate themselves along the route, measuring the length of the journey with their bodies. These pilgrims will take two to three years to travel from Kham or Amdo to Lhasa. We met one man who had gone round Mount Kailash thirteen times, prostrating himself all the way. Each circuit took twenty days, including the crossing of the 5,900-metre-high Drolma Pass.

It is not surprising, then, that sacred sites have inspired Tibetan bards like Shabkar, who sang for joy when he reached the foot of Amnye Machen:

'This white and majestic snow mountain
Is beautified by a raiment of white silk
Those seeing this white glacier peak
Have white thoughts and delight in the Dharma.

On the valley meadows in the mountain's foothills
Wild animals move about at leisure
Chasing one other, gamboling playfully
Watching this, one feels like laughing

When one has a stone hut
And a natural abundance of slate, water and firewood
All the necessities are gathered
It's not true to say one needs attendants

At this mountain, good fortune and prosperity come together
Nothing inauspicious is ever even heard of
The sun of meditation experiences
And realization will dawn

When you live here, banish all concern for this life
Simply live here, and happiness, joy and contentment will come about

Pilgrimage is even more inspiring if it is made with someone who knows the oral tradition associated with a place. The details and anecdotes he recounts can be supplemented by reading a written description of the site, outlining its history and explaining its qualities.

Roaming from one site to another, like the wind that passes by without attaching itself to any of the places it flies over, reawakens the feeling of impermanence, reduces our attachments and puts everyday concerns that often make us forget what is really important into perspective. The offerings made at these sacred sites encourage generosity and non-attachment. Paying homage to the deities reinforces respect for the Buddha. Remembering the teachings develops faith in the Dharma, while the joys and hardships shared with the other pilgrims illustrate the qualities of the Sangha.

Lastly, pilgrimage is a training in the 'pure vision', in which the Buddha-nature can be recognized in all beings and in the original purity of phenomena. The world becomes a mandala, sounds become mantras and thoughts become expressions of Enlightenment. In another of his songs, Shabkar says:

'In the immeasurable palace
Of primordial purity born of itself
The universe and beings appear as an array
Of deities, visible and yet unreal.

All sounds being the echo of emptiness
Prayer is never interrupted
The thoughts liberated from themselves
Are the immensity of the absolute plan.'

But any physical pilgrimage, however inspiring, is eclipsed by the spiritual pilgrimage, the journey to Enlightenment that can be made within the small space of a hermit's retreat.

Padmasambhava
The Lotus-Born Teacher

In Tibet, the Lotus-Born Padmasambhava, usually known as Guru Rinpoche, 'the Precious Master', is revered as a second Buddha. It was he who was mainly responsible for the arrival of Buddhism in Tibet. At the invitation of King Trisong Detsen, he completed the building of the first monastery, Samye, had all the texts in Buddhist canon translated and carried out the first Vajrayana initiations in Tibet, establishing the first spiritual lineage of Tibetan Buddhism, the tradition of the 'Ancient School' or Nyingma, which was the only one in Tibet from the 9th to the 11th centuries.

Tibetans believe Padmasambhava to be a manifestation of the Buddha Sakyamuni. In a prediction in the Parinirvana Sutra, the Buddha Sakyamuni announced that he would return in an immaculate birth to spread the teachings of the tantras. The lotus, which grows undefiled by mud, symbolizes the Buddha-nature which is present in every being, the original purity of the nature of mind. Although there are very few documents on the life of Padmasambhava that would be regarded in the West as historical records, his miraculous life is described in many texts, some visionary, and a rich oral tradition. The following are a few extracts and summaries.

The blind King Indrabodhi, ruler of the land of Oddiyana (believed by some scholars to be the Swat valley in northern Pakistan) had no son. His chaplain advised him to perform acts of great generosity. The King distributed so many alms that the royal treasure house was soon empty. He then sailed off in search of the Island of Jewels, hoping to find the Wish-Fulfilling Jewel. Having found it, he made a wish to regain his sight and his right eye opened. On his return journey across Lake Danakhosha, he witnessed the following astonishing scene, described in *The Life-Story of Padma*:

'Whilst the cries of the flocks of scarlet
 ducks rang out
On the lotus sat a child who looked
 eight years old
A beautiful child, delighting the eye
His body was purple, the colour of shells
And the King, filled with amazement, said:
Miraculous and wonderful child!
Who is your father? Who is your mother?
What country do you come from? What
 is your caste?
What do you live on? What are you
 doing here?
And the child replied:
My father is the knowledge of wisdom
My mother is Samantabhadra, sacred joy
 and transcendence of the void.
I have no country, I am unborn in Essence
I belong to the family of the indivisibility
 of space and enlightenment
I feed on dual perceptions and discursive
 thoughts
Here, I am devoting myself to the
 destruction of misery.

At these words, the King wept
And his closed left eye opened in
 its turn.
The prince was named Diamond born
 of the Lake.
The King thought him the incarnation
 of a celestial Being.
And the stem of the lotus with the child
 was carried away.

And some water birds, geese, cranes and
 others
Followed, some pursued with piercing
 cries
Others swooped down above the child
Others flew around the eight points of
 the four shores of the lake
Others rolled on the ground, stabbing
 their beaks into the sand.'

The child was received at the palace with great
pomp and the King made him his heir. The
prince soon realized that he could not be a
great deal of use to his fellow beings if he was
ruling the kingdom. To damage his reputation
in the eyes of the King and ministers, he
committed some seemingly reprehensible acts
and was exiled. He then went to the
Graveyard of the Cool Grove, where he
devoted himself to yogic practices, taught the
Dakini and remained in contemplation of the
absolute truth.

 He then went to Benares and studied
astrology, medicine, languages, arts and crafts.
Then, knowing that in order to enlighten his
fellow beings he had to pretend to go through
the gradual stages of the spiritual path, he
went to the master Prabahasti, 'Elephant of
Light', who ordained him as a monk. By
doing so he stressed the importance of the
teaching of the Lesser Vehicle, the Hinayana.

 He was then given the main tantric
teachings of the Eight Holders of Awareness
in India and the instructions by Shri Sing-ha
for Great Perfection. When asked by
Padmasambhava to teach him the ultimate
meaning, Shri Sing-ha pointed at the clear
sky and said:

'Empty! Originally empty!
Always empty! Perfectly empty!
This crucial point of the absolute truth
 is a treasure

That illuminates every direction in space
From the zenith to the abysses
Shri Sing-ha made it arise
From the perfect vessel of action
 inseparable from the view'.

Padmasambhava saw that the time had come
to convert the kingdom of Zahor in the north
of India. When he took Princess Mandarava
as his disciple, he was accused by the King
of leading his daughter astray and was
condemned to burn at the stake. But the stake
turned into Lake Tso Pema, with a lotus in
the centre carrying the radiant Padma. The
King, stricken with remorse, offered him his
kingdom.

 After that Padmasambhava went with
Mandarava to the cave in Maratika in Nepal,
where he had a vision of Amitayus, the
Buddha of Infinite Life. He then decided he
should convert the kingdom of Oddiyana,
from which he had been exiled. He arrived
with Mandarava, in the guise of a beggar. He
was recognized and people said, 'In the past
this man broke the royal law and killed our
minister's son. He is going to bring harm here
again. He must be punished'. Padmasambhava
and his companion were tied to a stake. But
after burning for twenty-one days the fire was
still smoking. In the centre of the lake formed
by the oil from the stake, the teacher and his
companion were sitting on a lotus flower, fresh
as the dew.

In Bodhgaya, the Diamond Throne of India, Padma challenged the powerful *tirthika* masters (the name given to followers of non-Buddhist doctrines) to philosophical debates and contests of magical powers.

After achieving realization of the true nature of mind in the cave at Asura in Nepal, he was invited to Tibet. When emissaries from King Trisong Detsen met the master in Nepal, they prostrated themselves in front of him and offered him a large quantity of powdered gold. But Padma threw the powder to the wind. Seeing that the emissaries were contrite, he filled their robes with pebbles which immediately turned into jewels and gold nuggets. They became devout believers and presented the King's request to the master.

On the way to Tibet Padmasambhava subjugated the demons and evil spirits and made them promise to protect the Dharma. So when a fury tried to crush him between two mountains Padma ascended into the sky. The humiliated fury swore never to harm anyone again.

King Trisong Detsen came to meet the master on the banks of the Tsangpo. Padmasambhava thought to himself, 'The King was born of a human womb. I was born by a miracle. The mind of the ruler is obscured. I achieved Enlightenment in a single life. If I pay homage to the ruler, it will belittle the Buddha's great teaching.' The king thought to himself, 'I am the ruler of Tibet. The Guru must pay homage to me first.' Then Padmasambhava sang of the greatness of his incarnation. At the end, he turned his hands and flames shot out of his finger and burned the King's clothes. The sovereign and his court could no longer resist and all prostrated themselves upon the ground.

Padmasambhava was invited to the site where the monastery was being built at Samye. Before he arrived, hostile spirits had been undoing by night the work the men had done during the day. But after his arrival, the spirits continued the day's work during the night and the monastery was soon finished. Several young Tibetans, including Vairochana, later the most eminent of translators, were sent to India to learn Sanskrit. Then the great pandit Vimalamitra and one hundred and eight scholars from India were invited to Samye, where they translated the Buddhist canon, both sutras and tantras, with an equal number of Tibetan translators.

At the time it was the custom for the Bön priests to sacrifice animals during the royal rites. Saddened and disgusted by this tradition, the Buddhist translators refused to carry on their work or to teach. The Buddhists were victorious in a contest of philosophical debates and miraculous powers. The King banned bloody sacrifices and exiled priests who refused to obey his decree.

King Trisong then asked Padmasambhava to initiate him into the practice of the Adamantine Vehicle, the Vajrayana. In the cave at Chimphu, Padma initiated the King, Queen Yeshe Tsogyal and six other disciples. Then, in the form of Dorje Drollö, one of the eight aspects or 'names' under which he appeared. Padmasambhava hid teachings in various places in the form of spiritual treasures or *terma* and foretold how they

would be rediscovered for the benefit of
future generations.

Soon afterwards King Trisong Detsen
died at a horse race. He was succeeded by
his sons Mune Tsenpo and later Mutik
Tsenpo. It was then that Padmasambhava
announced that he was departing for the
land of Chamara where the Glorious
Copper-Coloured Mountain was to be
found. Accompanied by Mutik Tsenpo,
Queen Yeshe Tsogyal and a number of other
disciples, Padma went to Gungthang Pass,
where he taught for the last time and then
flew off into the air astride the winged
horse Bahala:

'And, bathed in the iridescent light,
 he flew off into the sky.
Prince and subjects, like fish thrown on
 to a burning shore,

With no thought of hunger or thirst,
 lingered at the Gungthang Pass.
Meditating, they watched him awaken
 in the morning sun.
And they saw him amongst the golden
 rays, like a crow flying in the
 distance.
Going forward fluttering in the light,
 he flew away
Soon he was like a wood pigeon,
 then like a sparrow.
Like a bee, like a tiny vanishing speck.
And he was no longer visible.
And although they were preparing to
 meditate, they looked and saw him,
Sitting in the cool shadow of a magnolia
 on the island of Sri Lanka,
Near the city of fire, teaching the
 ogres and ogresses of Chamara who
 venerated him.'

THE SYMBOLISM OF PADMASAMBHAVA

Padmasambhava's body has the indestructible nature of the *vajra*, or diamond, and he has the appearance of an eight-year-old child, radiant with youth, symbolizing the immortality of the Enlightenment. He wears nine garments, representing the nine *yana*, or vehicles of Buddhist teaching. Amongst them are the three monastic robes symbolizing mastery of the Lesser Vehicle (Hinayana), a blue garment symbolizing mastery of the Greater Vehicle (Mahayana), the way of the Bodhisattvas, and a brocade cape, symbolizing mastery of the esoteric teachings of the Diamond Vehicle (Vajrayana).

His face represents the ultimate truth, his arms the union of wisdom and method, or emptiness and compassion, his legs the equality of samsara and nirvana in the ultimate reality. His eyes are wide open and staring at the sky straight ahead of him, showing that he is always aware of the absolute nature of mind. He is seated in the posture known as 'royal ease', the right leg slightly extended and the left bent back, a sign that all the realms of samsara must follow his words, the instructions of a king of spiritual knowledge. In his right hand he is holding a five-pronged *vajra*, symbol of the transformation of the five mental poisons – desire, hatred, ignorance, envy and pride – into five wisdoms. In the palm of his left hand, on his lap in the gesture of equanimity, is a skull full of nectar surmounted by the vessel of immortality, a sign that Padmasambhava's spiritual knowledge goes beyond birth and death.

Padmasambhava is wearing a lotus headdress, the five petals symbolizing the five families of the Buddha: Buddha, Vajra, Ratna, Padma and Karma. The headdress also signifies that, like the lotus rising spotless above the mud, Padmasambhava appeared spontaneously in this world, undefiled by the process of birth. At the top of the headdress are the sun and the moon, symbolizing method and wisdom, surmounted by a white vulture's feather representing the ultimate view of the Great Perfection. In the crook of his left arm he is holding a trident, or *khatvanga*, the three points symbolizing the emptiness of all things, its expression, which is luminosity, and omnipresent compassion. Infinite rays of light radiate from his body in the ten directions of space. Padmasambhava does not have a physical and tangible body made of bones, flesh and blood. His body is made of light, clear and translucent like a rainbow, devoid of any substance, like the moon reflected on the water. But he is not an inert form, because he is full of wisdom, love and the ability to help others.

The Great Spiritual Lineages of Tibetan Buddhism

Tibetan Buddhism has four main schools, Nyingma, Kagyu, Sakya and Geluk, which continue to pass on the rich heritage of Tibet's philosophical and contemplative traditions to this day. They are part of what is generally known as the 'Eight Chariots of Spiritual Accomplishment'. The ancient local religion, Bön, has also survived. It is strongly influenced by Buddhism and Buddhism in its turn has incorporated and adapted several Bön customs.

The great Indian sages Shantarakshita and Padmasambhava established Buddhism in Tibet in the 7th century. Most of the canonical texts were therefore translated into Tibetan. For two centuries, the only Buddhist tradition in Tibet was known as the First Translation Period. Later the followers of this first school of philosophy were referred to as the 'Ancient School', or Nyingma.

Although the monastic tradition barely survived the persecution under King Langdarma (841–46), lineages of highly accomplished yogis kept Buddhism alive.

Thus the Nyingma tradition, organized in nine vehicles or *yana* incorporating the different aspects of Buddhist theory and practice, handed down the teaching of all the sutras and mantras. A vehicle is defined as a 'medium' through which the goal of the spiritual path, the state of Buddha, is attained. The vehicles are varied and graded according to the different natures and abilities of beings. Each is a stage that incorporates the previous stages. The vehicles culminate in the 'luminous adamantine essence' of the Great Perfection (*Dzogchen*). 'Perfection' means here that the qualities of Enlightenment are inherent in the essential nature of the mind. 'Great' means that this perfection is the mode of existence of all phenomena. The three main ways of passing on the Nyingma tradition are the long canonic lineage, or *kahma*, the short lineage of spiritual treasures, or *terma*, and profound and pure visions, or *danang*.

Having taught his disciples meditation based on a particular mandala and given them all the necessary instructions, Padmasambhava recorded his teachings on parchments covered with symbolic writings which he hid in the earth, rocks, lakes, sacred images or even in the sky. He then appointed one of his male or female disciples as heir to these spiritual treasures and foretold the time and place at which this disciple would reveal the texts in a future life to offer the contents to the beings of the time. Over the centuries, several hundred 'treasure finders' (*terton*) have appeared. This tradition of 'revealed treasures' (*terma*) has played an important part in the development of Tibetan Buddhism to this day.

Amongst the leading teachers of the Nyingma tradition are Ronzom Mahapandita (1012–88), Longchen Rabjam (1308–63), Minling Terchen (1646–1714) and his brother Minling Lochen Dharmashri (1654–1718). Longchen Rabjam was both a yogi who had achieved ultimate Enlightenment and a

remarkable scholar who explained the teachings and practice of the Nine Vehicles in a series of lucid and masterly writings.

At the beginning of the 11th century, a second wave of translators went to India to seek out more texts. This 'New Translation' period (*Sarma*) began with the great translator Rinchen Zangpo (957–1055). The emergence of distinguished scholars and sages produced new spiritual lineages.

The Kadampa school ('the school of the supreme precepts'), forerunner to the Gelukpa, was founded by Atisha (982–1054). It emphasizes the training of the mind (*lojong*), based on renunciation and compassion. Atisha was born in Bengal. He studied with various masters before sailing to Indonesia to join Serlingpa, his principal master, and studying with him for twelve years. When he returned to India he became abbot of the Buddhist university at Vikramashila. King Yeshe Ö and King Changchup Ö invited him to Tibet, where he lived until his death. His many disciples, the most eminent being Dromtönpa Gyalwai Jungne (1004–64), continued to teach the Gradual Path (*lamrim*).

In the 14th and 15th centuries, the Kadampa school gave rise to the Geluk ('Virtuous Tradition') lineage. This developed in Ganden, a monastery founded by a remarkable teacher, Tsongkhapa Lobzang Drakpa (1357–1419). Tsongkhapa introduced reforms, reinforcing respect for monastic discipline and advocating the study of texts. Amongst his many writings, *The Gradual Path* (*Lamrim Chenmo*) explains the stages on the way to becoming a Bodhisattva. His student Gedun Drup (1391–1474) was retrospectively recognized as the first Dalai Lama and his lineage has remained a profound influence on Tibet's history to this day.

The Sakya tradition based on 'the path and its fruit' (*lamdre*), taught by the great Indian master Virupa, was introduced to Tibet by the charismatic translator Drokmi Lotsawa (993–1077[?]). This spiritual lineage was known as Sakya, 'pale earth', after the colour of the landscape around the monastery built in central Tibet by the main founding fathers, including Kunga Nyingpo (1092–1158) and Sakya Pandita (1182–1251). The latter became one of the leading luminaries of his age and his nephew Chogyal Phakpa (1235–80) was tutor to the Mongol emperor Kublai Khan.

The *Lamdre* teachings are based on the metaphysical view of the union of samsara and nirvana and maturation through the four initiations, leading to the evolution of the four primordial wisdoms. The teachings follow those of the 'parting from the four attachments' (attachments to worldly concerns, samsara, selfish desires and fixation on set points of view) given to Trakpa Gyaltsen in a vision of Manjusri, the Buddha of Knowledge.

The Kagyu tradition of 'oral instructions' goes back to the great teachers or Indian Mahasiddha such as Tilopa (988–1069), Naropa (1016 or 1060–1100) and Marpa the Translator (1012–97), who made the hazardous journey to India three times to receive the instruction of his teacher Naropa. His student was the heroic Jetsun Milarepa (1040–1123), whom he put severely to the test before initiating and teaching him. During his extraordinary life Milarepa spent twelve years of asceticism in solitary meditation. He taught his disciples in improvised songs of spiritual realization. Milarepa is still the most famous of the Tibetan yogis and even nowadays his life is a powerful source of inspiration.

Amongst Milarepa's numerous disciples were Rechungpa and Gampopa. The latter was master to Phagmo Drupa and the first Karmapa, Dusum Khyenpa (1110–93). Four major and eight minor lineages developed in the Kagyupa school. Notable among the Kagyupa teachings are the 'Six Yogas of Naropa': the yogas of the inner fire, the illusory body, the dream-state, the clear light, the *bardo* (the intermediate state between death and rebirth) and the transference of consciousness at the moment of death. The culmination of these teachings is the sight of the Mahamudra or 'Great Seal'. The term means that the true realization of the ultimate nature of mind encompasses all phenomena, imprinting its 'seal' on the world of appearances.

The other four lineages, included in the 'Eight Chariots', incorporate the Shangpa Kagyu, Chöd and Shije, Kalachakra and lastly the Urgyen Nyendrub traditions. These have also survived, but mainly in conjunction with one of the four main traditions.

The Shangpa school which is very close to the Kagyu tradition, was founded by Khyungpo Naljor in the 11th century. The deep and complex tradition of the Wheel of Time, based on the Kalachakra tantras (whose history is associated with the legendary 'secret land' of Shambhala) has remained very much alive. The practice of Chöd was introduced to Tibet by the yogini Machik Labdrön (1055–1153), one of the leading female figures in Tibetan Buddhism. Her master Padampa Sangye (who died in 1117) spread the doctrine of *shije* meditation, or the 'pacification of suffering'. The word *chöd*

means to cut. In this case it refers to ending attachment to the self and all forms of dependence. Finally, the tradition of the great siddha Urgyenpa (1230–1309) has survived only because of the efforts made by Jamyang Khyentse Wangpo and Jamgon Kongtrul to bring together all the surviving traditions in Tibet.

As His Holiness the 14th Dalai Lama has often stressed, the Tibetan tradition may be the only culture in which all levels of Buddhism, exoteric and esoteric – the Hinayana, the Mahayana and the Vajrayana – are not merely preserved but integrated and put into practice harmoniously and effectively. These three vehicles represent three basic aspects of Buddhism: renunciation, compassion and pure vision.

Renunciation is the basis of the Hinayana and therefore of the other two vehicles, and implies a strong desire to escape the suffering of samsara, the vicious cycle of rebirths.

Compassion is the life force of the Mahayana, and comes from an understanding that the individual self and the appearances of the world of phenomena have no intrinsic reality. Ignorance, seeing the illusory effect of appearances as a permanent entity, leads to suffering. Moved by an infinite compassion, the practitioner expresses a wish to achieve Buddhahood in order to liberate all beings that have been led astray by this delusion and cast adrift in the ocean of suffering that is samsara.

The pure vision, the extraordinary view of the Vajrayana or 'Adamantine Vehicle' means recognizing the Buddha-nature present in all beings and the purity or original perfection of all phenomena.

THE VISION OF TANTRA

The term 'Tantra' means a concept of continuity and denotes that everything
is related in a whole so that nothing can happen by itself. This is the continuity of the
original purity of phenomena, which remains essentially unchanged in samsara and
nirvana. The concept also describes the ultimate nature of mind, beyond the concepts of
subject and object. When the world of phenomena emerges from this nature, however, the mind
loses sight of that unity and creates a false duality between consciousness and the world. It
consolidates the separation of self and non-self which is the basis of the world of ignorance,
samsara. Samsara was not created at a specific moment, but is a constant reminder to us of the
ignorance that solidifies the world. But like a dream or illusion, this error has no real existence
and so it can be dispelled. The path of Tantra means realizing the perfection, the 'Buddha-
nature', that lies within us, not creating it.

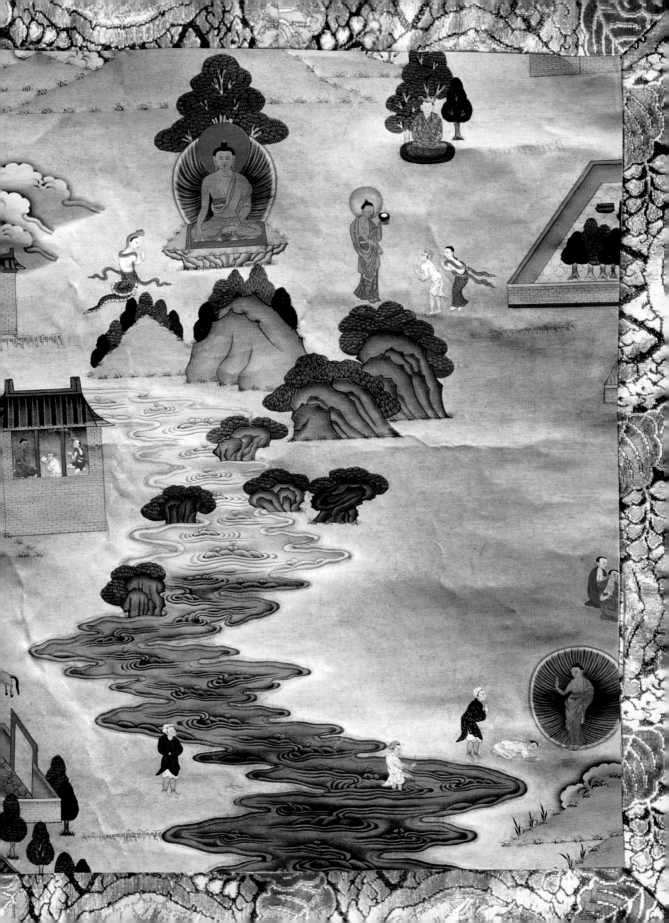

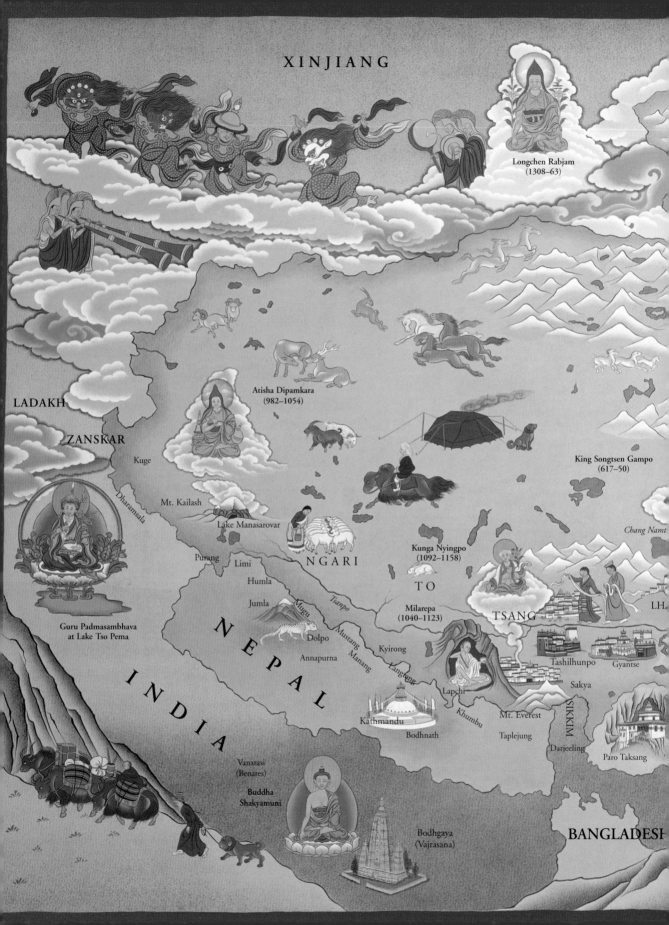

XINJIANG

Longchen Rabjam
(1308–63)

LADAKH

ZANSKAR

Kuge

Dharamsala

Atisha Dipamkara
(982–1054)

King Songtsen Gampo
(617–50)

Chang Namt

Mt. Kailash

Lake Manasarovar

Purang

Limi

NGARI

Kunga Nyingpo
(1092–1158)

TO

LHA

Humla

Jumla

Tsanpo

Milarepa
(1040–1123)

TSANG

Guru Padmasambhava
at Lake Tso Pema

Mugu

Dolpo

Mustang
Manang

Kyirong

Langtang

Tashilhunpo

Gyantse

Annapurna

Lapchi

Sakya

INDIA

NEPAL

Khumbu

Mt. Everest

SIKKIM

Kathmandu

Bodhnath

Taplejung

Darjeeling

Paro Taksang

Vanarasi
(Benares)

Buddha
Shakyamuni

Bodhgaya
(Vajrasana)

BANGLADESH

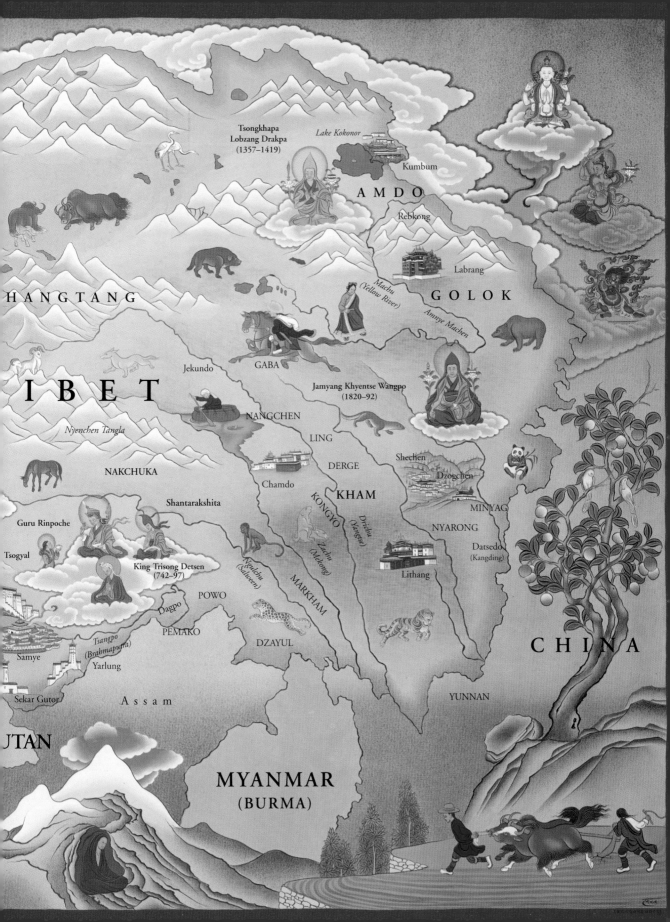

HANGTANG

TSONGKHAPA
Lobzang Drakpa
(1357–1419)

Lake Kokonor

Kumbum

AMDO

Rebkong

Labrang

GOLOK

Machu
(Yellow River)

Annye Machen

Jekundo

GABA

Jamyang Khyentse Wangpo
(1820–92)

IBET

Nyenchen Tangla

NANGCHEN

LING

Shechen

NAKCHUKA

DERGE

Dzogchen

Chamdo

KHAM

MINYAG

Shantarakshita

KONGYO

NYARONG

Guru Rinpoche

Zachu
(Mekong)

Drichu
(Yangtse)

Datsedo
(Kangding)

Tsogyal

King Trisong Detsen
(742–97)

Ngulchu
(Salween)

Lithang

CHINA

Dagpo

POWO

Tsangpo
(Brahmaputra)

PEMAKO

MARKHAM

Samye

Yarlung

DZAYUL

Sekar Gutor

Assam

YUNNAN

JTAN

MYANMAR
(BURMA)

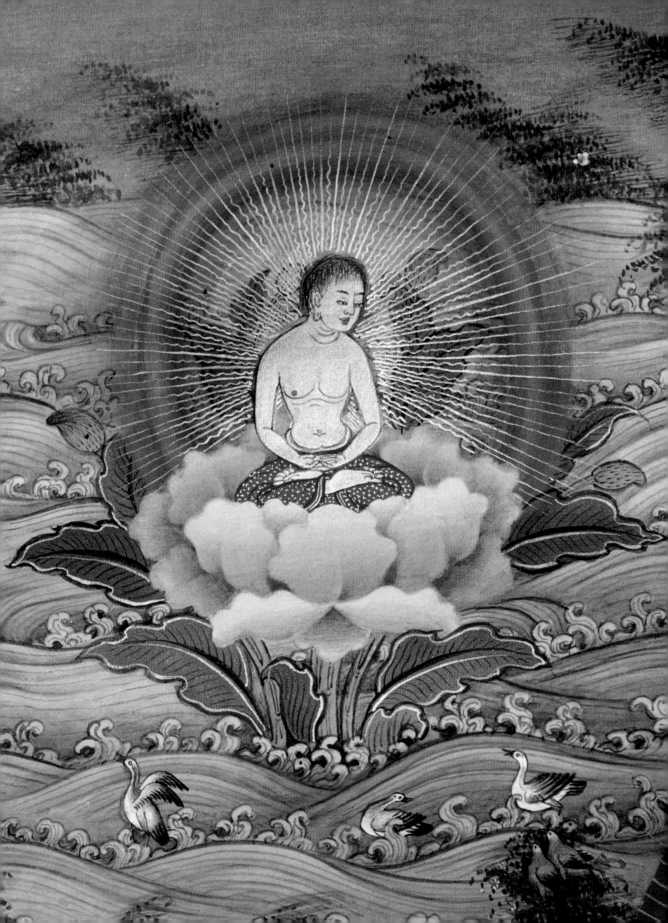

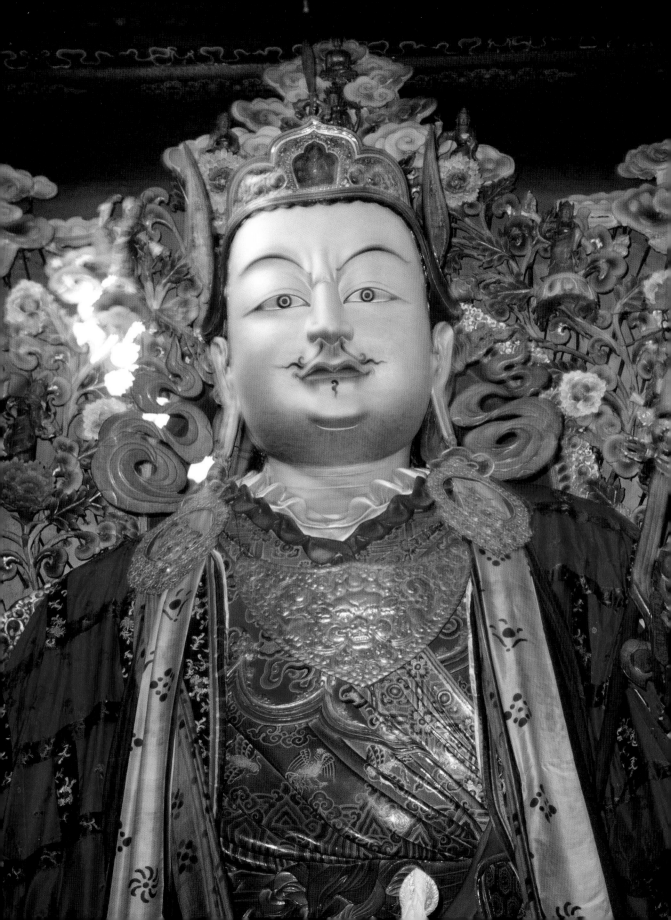

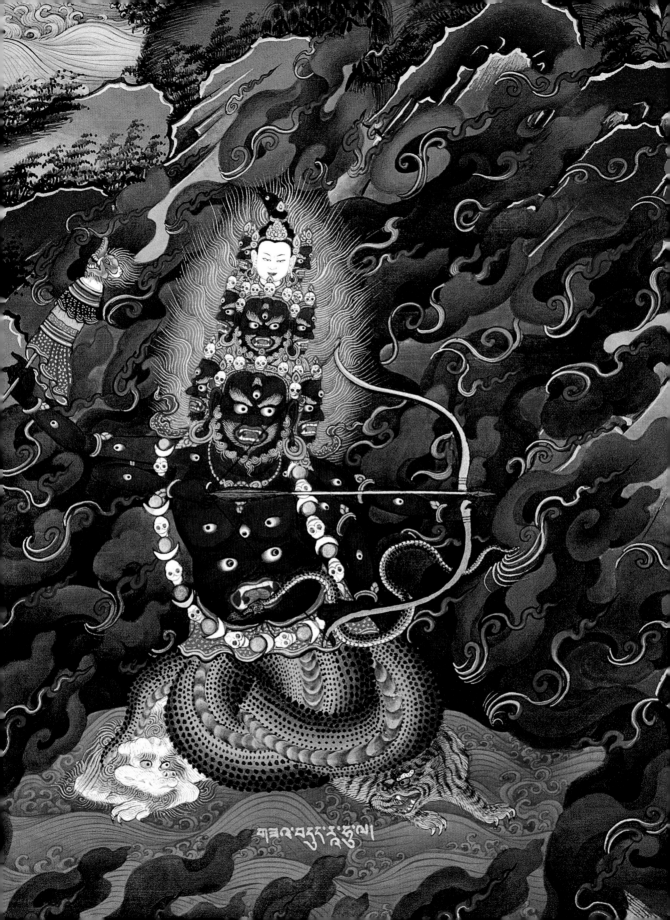

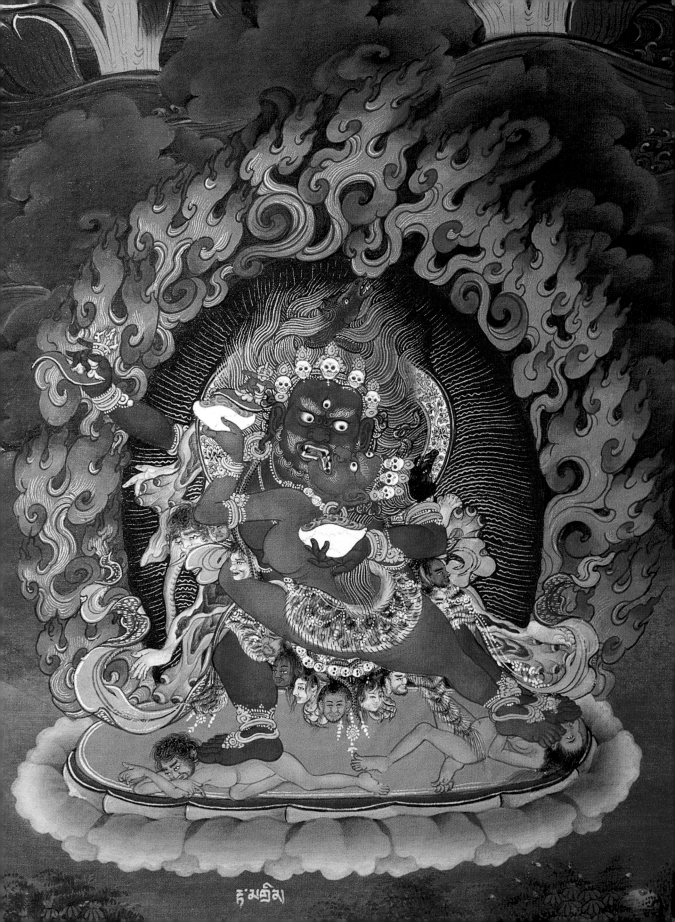

Tibet, in the Beginning

The vast and massively elevated mountain plateau at the heart of southern central Asia, ringed on all sides by the great ranges which form natural borders with its neighbouring territories, is the most outstanding feature on the physical map of the world. For the most part rugged, inhospitable and sparsely populated, it towers over the agricultural heartlands of ancient civilization, the Indo-Gangetic plains to the south, the Yangtse and Yellow River valleys of China to the east, the oases of the Persian borderlands to the west. All of the great rivers of south and east Asia, from the Indus in the south-west to the Yellow River in the far north-east, have their origins on this great plateau, which neighbouring lowland peoples have traditionally regarded as awesome and inaccessible, a source and repository of natural wealth beyond the pale of their world.

The name 'Tibet' was imported into European languages from Arabic. The Sanskrit name 'Bhot', still widely understood in northern India, is closer to the indigenous name, which modern Tibetans pronounce as 'Pö'. For the ancient Indians, as much as for the Chinese, who knew the great plateau as 'Hsi-tsang' ('western treasury'), it was the source not just of glacial waters, but of gold, salt and medicinal substances, as well as a sanctuary for ascetics and spiritual masters who had forsaken the comfort and familiarity of the habitable world. In any case, no other landlocked country on earth has such clearly defined borders: whether in the monumental southern arc of the Himalayas or the northern desert fringe of the Kunlun mountains, the arid gorges of the Kansu corridor or the cloud forests of Szechwan, there has never been any doubt about where the Tibetan world began and ended. And despite their differing dialects, clan and regional affinities, and even rival kingdoms, all the peoples of this enormous territory regard themselves as above all Tibetan, and have done so throughout their recorded history. If a 'nation' is the collective identity of an entire people based on a common language, culture, history, and homeland, Tibet is one of the world's oldest nations.

This identity of a people with a naturally defined territory is implied in the more poetic Tibetan name for the country, 'Land of Snows'. In the conventions of literature and song, Tibetans have idealized their homeland as 'encircled by snowy ranges', 'a land of high mountains and pure earth', 'fountainhead of waters and centre of the earth'. They saw it as the 'temperate land' of high pasture and river valley, where the sun's brilliant intensity was moderated by fresh, icy winds blowing off the snowy peaks, a tranquil place happily removed from the hot, crowded lowlands of neighbouring countries. It was traditionally divided into three regions, corresponding with broad gradations of climate and elevation: these were 'upper' Tibet, the high, windswept desert of the north and far west, occupied by nomad pastoralists, 'middle' Tibet, the great valley of the Tsangpo or Brahmaputra river, and its agricultural tributaries, and 'lower' Tibet, the forested river valleys and grasslands of the east. The political divisions of clan territories and regional states, however, were far more complex.

As far as anyone knows, the Tibetans are descendants of nomadic peoples who migrated into the plateau from the north and east. The earliest known Tibetan civilization, of undetermined antiquity, was centred on the kingdom of Zhang Zhung, with its capital in the far west. Recorded history begins only with the Yarlung dynasty, which originated in the south-east of the country, unified the regional fiefdoms of central Tibet and, after conquering neighbouring kingdoms to the north and west through the 6th and 7th centuries, went on to build one of the greatest military empires of medieval Asia. By the time of its eventual disintegration in the mid-9th century, the Yarlung empire stretched from the Pamirs in the west across the Tarim basin and eastern central Asia to the Chinese borderlands. The administration of this vast and rapidly expanded domain called not only for military organization but civilian bureaucracy, hence the development of literacy, centralized government and legal institutions.

Even before its emergence as a great power, foreign influences on Tibetan religion and culture were significant. The Bön religion of the Zhang

Zhung and early Yarlung rulers, often depicted as indigenous, actually seems to have been assimilated from the Iranian world to the west. In the course of its prodigious military and diplomatic relations with Sogdiana and Khotan, Tang China and Nan-chao, Kashmir, Nepal and Bengal, the Yarlung court must have presided over a cosmopolitan cultural milieu, and it was in this context that Buddhism, already long established in those countries, was first disseminated in the Land of Snows. From the second quarter of the 7th century, Tibet's Yarlung emperors founded Buddhist temples across their realm, invited foreign saints, scholars and artists to their capitals and sponsored translations of the Buddhist canon into Tibetan. According to retrospective Buddhist orthodoxy, the Vajrayana master Guru Padmasambhava of Oddiyana established the first Tibetan Buddhist monastery at Samye (during the 770s), in the heart of Yarlung Tibet, with the patronage of the emperor Trisong Detsen, after first subduing the wild and hostile spirits of the high plateau.

The imperial state was undermined by and eventually collapsed due to internal power struggles, driven to some extent by resentment among sections of the Tibetan nobility towards their rulers' indulgence of a foreign, pacifist religion. At that point, Buddhism had not taken root in Tibetan society beyond courtly circles, and monastic institutions had not had the chance to develop on a significant scale. The period between the assassination of the last Buddhist emperor Tritsuk Detsen (836) and the re-establishment of Buddhist monasticism in central Tibet (c. 1000) is the most obscure in Tibetan history. It came to be represented as a dark age when all visible signs of Buddhist faith were banned, although the teachings themselves survived and even prospered among lay practitioners (known as *ngakpas*) who were visibly indistinguishable from the adherents of pre-Buddhist religion. Meanwhile, numerous regional kingdoms were formed in the wake of the empire by lineal descendants of the Yarlung royalty, who became patrons of the second, deeper dissemination of Buddhism beginning in the early

11th century. One of them, Lha Lama Yeshe Ö, monk-ruler of the Guge kingdom in the far west, is credited with the defining act of this renaissance, the invitation of the Bengali pandit Atisha Dipamkara to Tibet (1042).

In contrast with the earlier phase, the second dissemination of Buddhism drew exclusively on Indian Mahayana and Vajrayana, and consolidated its influence on Tibetan society with the swift proliferation of great monasteries. Within two centuries of Atisha's pioneering visit, the greatest powers in the land were the flourishing monastic principalities (Sakya, Drikung, Tsel and Taklung were among the most important) founded by the Tibetan disciples and successors of 11th-century Indian Buddhist masters, and continued by their father–son or uncle–nephew lineages. Apart from serving as the country's universities of scholastic and technical learning, the great monasteries fulfilled such lesser functions as elementary schooling, healthcare and community banking, and became social as much as religious institutions. As in the Indian world, patronage of and devotion to a Guru (or 'Lama') was seen as an essential complement to a Tibetan ruler's secular authority, but increasingly, the monastic states themselves came to encompass both forms of authority, especially after the Sakya lineage holders were appointed as the Lamas of the Mongol Yuan emperors, and overall rulers of Tibet under imperial tutelage (1253).

In order to grasp the phenomenal growth and centrality of the 13th-century monastic principalities, and indeed the subsequent role of the monasteries in Tibetan society, it should be appreciated that Tibet was a land without cities. The typical Tibetan settlement consisted of a *dzong*, the local ruler's fortified palace, built on a natural prominence, with the houses, stables and storerooms of the subjects clustered below, and even Lhasa, cultural capital of Tibet throughout its Buddhist history, was never much larger than a European village. Buddhist monasteries quickly assumed important institutional and economic functions under Tibetan demographic conditions, and became centres for the concentration

of wealth, human resources and political power, quite apart from the program of monastic education. The great monasteries were corporations, with their own sectarian identities, whose religious academies were at the apex of a greater organization serving economic, administrative and even military functions, and which drew in not only thousands of monks, but also artisans and officials, stewards and traders from all over the country.

With the development of Buddhist scholasticism came the dogma of Indian superiority and devaluation of indigenous wisdom, but as in every other country in the region, the cultural expression and popular understanding of the Buddhist teachings in Tibet were deeply coloured by pre-Buddhist traditions and beliefs. The accommodation of the cults of local territorial or protective deities is very evident, and it is not unusual to find the oracles of such deities enthroned at the local monastery. Tibetan Buddhism also lays peculiar emphasis on the teachings and rituals concerning death, which seem to have been central to the pre-Buddhist religion of the Tibetan kings. Perhaps most remarkable of all is the ancient Tibetan tradition of transmitting spiritual lineages from father to son (for laymen, and from uncle to nephew for monks), and the later development of succession by reincarnation.

Ever since those far-off times, Tibetan thought and attitudes have been saturated by Buddhist influence, to the extent that religious faith and adherence to Buddhist morality came to be regarded as definitive qualities of the Tibetan cultural identity. But how else might this identity be described? Given the ingrained divisions running through the Tibetan world between farmers and nomads, centre and periphery, and the profusion of regional and sectarian allegiances, Tibetans tend to say that what they have in common is eating *tsampa* (the roasted ready-to-eat barley flour which forms their staple diet). The common written language seems equally significant. Beyond that, Tibetan civilization is no more reducible to generalizations than any other.

From my own very limited experience, I would venture that the Tibetan spirit is characterized by a deep-seated tolerance and an exceptionally resilient self-reliance. The strong sense of shame and obedience required by a rigidly hierarchical social order coexists with the cavalier dignity and freedom of the high plateau livelihood. Tibetans regard the natural world as alive and dynamic, suffused with the supernatural and populated by all manner of non-human beings, but if their outlook is non-materialist, this in no way prevents them from approaching the business of human life with sturdy practicality and inimitable straightforwardness. Much importance is attached to laughter, and no conversation is complete without attention having been drawn to the humorous side of things.

It is not hard to imagine the influence of nomadism on the Tibetan way of life. There is a readiness to get up and go, and an unusual fondness for extended travel, whether for pilgrimage, trade or (in the past) banditry. The most typically Tibetan social occasion is the picnic, the enjoyment of the great outdoors, and even the instant convenience of Tibetan staple foods – *tsampa* mixed with tea, wind-dried meat – hints at the capacity for itinerant, carefree mobility. While shaped by the power of the Buddhist teachings, as well as the rich oral and folk tradition, the Tibetan spirit is ultimately inseparable from its unique surroundings, the vivid clarity and boundless space of the high mountain wilderness.

In the Temple of the Crowned Buddha

In the very heart of Lhasa, the Tibetan capital, the ancient Jokhang Temple still holds the statue of Jowo Rinpoche, the Crowned Buddha. Monks, herdsmen, nomads and peasants trek for months or ride in trucks for days in order to come and venerate the statue with an offering of a white silk scarf. The most revered of all Tibetan sanctuaries, the Jokhang Temple is encircled by a street known as the Bar Khor, on which pilgrims pray as they circle the temple in the same direction as the stars. Lined with two-storey, flat-roofed cob houses, the Bar Khor is crowded with dimly lit stalls laden with religious objects, great balls of rough wool, yellowing slabs of rancid butter and clothes from China. Holding beads or prayer wheels, thousands of pilgrims wander past, contemplating, passing comments, making purchases and slowly circling the temple in a continuous loop. On all four sides of the temple, pilgrims are wreathed in clouds of juniper smoke as they pass, the fragrance impregnating their heavy robes with blessings. Alongside the slow and never-ending tide of pilgrims revolving like a galaxy around the temple, a knot of herdsmen from Kham holds a heated discussion against the whitewashed wall of a brick house. Notes are passed feverishly from hand to hand, and at length one of them strolls off with a satisfied air, a snow-leopard skin slung over his shoulder. Opposite them, an old man, his face etched with lines, burns a bundle of incense while murmuring a prayer, his closed eyes turned towards the temple. Further on, four destitute pilgrims chant a prayer and gather up the small coins tossed willingly by other pilgrims as they pass, for this is a way of gaining merit. An astrologer tells the fortune of a young and beautiful woman with troubled eyes.

On the stone-flagged square in front of the temple, beneath its great wooden doors, a hundred or so pilgrims prostrate themselves. The gentle serenity of their expressions suggests that they have fulfilled their noblest dreams: they have come to pray in the Jokhang Temple. Slowly or fervently, each in their own rhythm, they place their palms together and raise their hands to the skies, their eyes misty with faith, murmuring all the while a constant prayer, as strong as their will and as gentle as their thoughts. Then they fall to their knees and lie face down on the ground, prostrating themselves body and soul on the flagstones, worn smooth by centuries of religious fervour. Here, beneath the sacred porch of the most sacred of temples, the only sounds are the mesmerizing litany of prayers and the tap of wooden runners as they slide along the ground at each prostration. Once through the heavy red doors and within the temple walls, all voices are instinctively hushed. Some twenty monks are at prayer in the internal courtyard, before hundreds of butter lamps. A low mutter of prayers chanted in unison hovers beneath the painted wooden roof. Slowly, men swathed in heavy cloaks made from animal skins and women with turquoise beads woven into their plaited hair move from one lamp to another, from one flame to another, their palms together, to unite the flame of their hopes with those that burn before them. In the light of these lamps, there beats the slow pulse of the Tibetan world. At the far end of this light-filled courtyard, a low doorway opens on to a dark corridor from which there emanates a strong smell of butter. There, in the privacy of the temple at the end of the corridor, before a multitude of altars, butter brought from high mountain pastures far away melts day and night in the gilded dishes of small votive lamps, so that a flame may burn eternally and everywhere, the link between man and the gods.

A second low door leads to the sanctuary, the very heart of the temple, thronged with pilgrims. A timeless silence hovers over the thousand or so faithful who move from chapel to chapel, holding incense in their hands, their eyes gleaming in the golden flames of the little lamps and brimming with emotion. Here men and women are united with their divine nature. The heart of the Jokhang Temple beats with love and compassion.

In this city now invaded by its Chinese occupiers, soldiers and prostitutes, the Jokhang is the last vestige of the Tibetan world. Outside the temple, on the roof of an unmarked police post, a video camera films the pilgrims as they leave the temple, overwhelmed by their experience. A long-range microphone records everything they say. Should there be an uprising, this will make it much easier to arrest the culprits. And to go and shoot them.

Bhutan
Defiant Miracle of the Himalayas

Forming a striking contrast to the rocky, arid landscapes of the high Tibetan plateau – to which it lies so close – Bhutan nestles in a green setting of forest and jungle on the southern slopes of the Himalayas. Rice, barley and buckwheat are grown in the deeply incised valleys dominated by the high peaks of the Himalayas, but the greater part (72 per cent) of this country the size of Switzerland and with a population of only some 700,000 is covered with coniferous and broad-leaved forests. At the same time as being heavily influenced by Tibetan culture, which – as the presence of Buddhism testifies – has for centuries been its guiding light, Bhutan has also developed its own culture, especially since it became a state in the 17th century. Today it is quite distinct in many ways from other regions influenced by Tibetan culture, and with its unique ecology, political system, architecture, textiles and cuisine, among other features, it remains (for now) a relatively untouched enclave of indigenous culture in the context of an increasingly troubled region.

Geographically, Bhutan resembles a gigantic and vertiginously steep staircase: within a distance of some 100 kilometres as the crow flies, it rises in altitude from 300 metres in the south to a dizzying 7,400 metres in the north. Add to this a latitude on a level with Morocco and a summer monsoon climate, and it becomes clear how, within its relatively small surface area (46,500 km^2), Bhutan manages to encompass a range of ecosystems of unparalleled variety, from semi-tropical to alpine, via the temperate monsoon climate of the central region. With its rich profusion of flora and fauna, its remarkable forests and jungles, its abundance of rivers, its high rainfall and its modest population, Bhutan possesses a great wealth of natural

resources. In the past these have played a significant part in its cultural development, in contrast to more arid regions of the Himalayas, and today they represent important economic resources. Lying as it does between the high Tibetan plateau and the monsoon region of Asia, Bhutan is something of an ecological watershed.

Bhutan is also the only Asian country in which Vajrayana Buddhism is the state religion, and the only Tibetan-influenced region in the Himalayas to have preserved its independence from the great twin hegemonies of India and China. Since its formation in the seventeenth century, Bhutan has stoutly defended its autonomy, with invasions by the Tibetans and the British invariably ending in failure. Auspicious historical conditions; mountainous terrain prohibiting cavalry manoeuvres but favouring ambushes; the courage and skill of Bhutanese archers; or simply good fortune and divine protection: any or all of these factors are customarily cited as reasons for the virtually miraculous preservation of the independence of this tiny country, around which the conflicting political stakes have been raised so high. Ruled by a theocratic regime from the 17th century to the early 20th, Bhutan became a monarchy in 1907 and established a national assembly in 1953. A member of the United Nations since 1971, it supplements its national income, generated largely from hydroelectricity, with international and bilateral development aid. Development is set within clearly defined political guidelines, however. On the one hand, economic progress should go hand in hand with individual and social progress, a concept for which King Jigme Singye Wangchuk coined the term 'Gross National Happiness' in the late 1980s. On the other, modernization and access to communications

should not be fostered at the expense of traditional values, including respect for the elders of the community, for religion, and for the national cultural heritage.

The administration of this extremely rich cultural heritage has been put in the hands of a National Commission for Cultural Affairs, which has at least succeeded in preserving the nation's monuments, although they are in urgent need of restoration. An inventory and catalogue of these works is being gradually compiled, but the task is Herculean in scale: architectural monuments alone include 13,000 chortens and 2,000 temples, all containing precious objects and books and so requiring protection against robbery and fire.

The architecture of Bhutan shares the beauty and grace of the building traditions found elsewhere in the Himalayas, but with a charm that is less austere, similar to that of the Kham region of eastern Tibet. The most striking difference between the buildings of Bhutan and those of central Tibet, meanwhile, lies in their generous use of timber from the local forests, with pitched roofs of wooden shingles, an essential feature in a country subject to violent monsoons. These are literally perched on beams placed over a flat roof, so lending the building as a whole – whether it be a house, a temple or a fortress – an impression of lightness. This open attic space is also used for drying and preserving a wide variety of foodstuffs. The tripartite structure of the windows is another characteristic feature of Bhutanese architecture, topped by lintels made from many pieces of wood and often purely decorative in nature. Each valley is guarded by its own fortress, or Dzong, a combination – also unique to Bhutan – of state monastery and seat of power. In a country where temples and monasteries are frequently of modest proportions, these

fortresses are the most impressive monuments. In contemporary Bhutan, the dwelling houses are whitewashed and painted with auspicious signs: a relatively recent addition to the country's vernacular architecture which nevertheless enhances its distinctive character.

While religious art in Bhutan on the whole adopts the same vocabulary of styles and techniques as other Tibetan-influenced regions, and is carried out exclusively by men, the art of textile manufacture is a female preserve, practised by women from all social strata. Elevated to the heights of artistic excellence and endowed with a role of considerable socio-economic importance in traditional society, this is a craft that has no equivalent elsewhere in the Himalayas or in Tibet. Made from wool, cotton, silk or nettle fibres, the fabrics are woven on backstrap, treadle-operated or low-warp looms, using techniques including additional warp as well as weft threads. The meticulous detail of the decoration is reminiscent more of embroidery than of woven textiles, while the motifs used are strongly evocative of those of the Tibeto-Burman peoples of Arunachal Pradesh, or those found in Burma and Laos.

Bhutanese textiles, which are found as far west as the Ladakh range in Kashmir, used to be bartered for rugs and carpets in Tibet, and until 1959 were one of the country's principal trading commodities, after rice, medicinal plants and paper. In Lhasa society, ownership of a shirt made from Bhutanese raw silk was a mark of prestige.

The cultivation of raw materials, heavily dependent as it is on ecological and environmental factors, is one of the spheres in which Bhutan differs most markedly from other Himalayan regions and central Tibet. The bamboo, rattan and wood that grow in such abundance here were traditionally used to

make a wide variety of everyday objects, including bows and arrows. Medicinal plants flourished in luxuriant profusion, as did plants that yielded vegetable dyes. The forest was the primal source of succour, providing essential nourishment whenever rice or cereal crops failed. Here wild tuberous roots such as yam and taro could be harvested, along with ingredients such as mushrooms, ferns, bamboo shoots, bananas, tree tomatoes and even orchids – to name but a few – to add variety to the local diet.

It is not easy to discuss Bhutanese cuisine in general terms, as each region once had its own diet and cuisine according to the crops that could be grown in its particular conditions of climate altitude. The staple food in the west was rice, in the east maize, and in the centre buckwheat and corn. Nowadays, rice (partly imported from India) is the staple food virtually throughout the country, while over the last twenty years the potato has made remarkable inroads into the Bhutanese diet. The Bhutanese people are not vegetarians,

their preferred meats being yak, pork and beef. Typically, small dishes of vegetables, often in a cheese sauce, and different meats – generally boiled or stewed – are arranged around a great mound of rice. If there is one feature of Bhutanese cuisine that distinguishes it above all others from the cuisines found elsewhere in the Himalayas, it is the use of hot peppers, without which no meal is complete. Flourishing in valleys at altitudes between 1,200 and 2,300 metres, the pepper is considered not as a condiment but rather as a vegetable in its own right. The national dish of Bhutan, indeed, is simply hot peppers in a cheese sauce, and visitors – including those from other regions of Tibetan influence – generally experience some difficulty in doing justice to a traditional Bhutanese family meal.

Cultural crossroads, ecological watershed and geopolitical buffer zone, Bhutan has contrived – against the odds – to retain its own unique and individual identity among the nations that make up the Himalayan region.

In the Land of the Thunder Dragon

In Bhutan, each part of the sky and earth has a name straight from Buddhist scriptures. The plains are 'eight-petalled lotuses' (symbols of purity) and the mountains 'elephants lying down' (symbols of strength), 'proudly posed lions' (symbols of courage) and 'garuda birds taking flight' (symbols of the loftiness of metaphysical views). Lakes are 'vessels of plenty' or 'cups of ambrosia'. The parts of the sky seen between the rocks are like 'spirals of joy' (*gakyil*) or daggers representing the destruction of mental poisons (desire, hatred and ignorance). The whole country is sacred. Every valley is a place of pilgrimage, every rock, river and cave has its spiritual history. In one spot a hermit meditated, in another a holy man left his footprints in the rock. Another pot is the dwelling place of a spirit who protects the teachings. One spring is the home of a *naga*, half man, half snake; one forest will never be cut down because it was once blessed by a great teacher.

Although many of these sites are unknown outside their own valley, others have an almost mythical reputation in the Himalayan Buddhist world. One such place is Taksang, 'Tiger's Lair', in the Paro valley, one of the most impressive sacred sites in the Himalayas. It is said that Padmasambhava hid a number of 'spiritual treasures' in this cave, which is surrounded by temples that cling to the face of a steep cliff. Another example is Mönka Senge Dzong, 'Lion's Fortress', a sacred site blessed by Padmasambhava and his disciple Yeshe Tsogyal. This lofty site, whose spiritual power is said to have remained intact, lies at a height of 4,000 metres and is surrounded by rocky mountains and glaciers. It takes several days to reach it, on marshy tracks overgrown with semi-tropical jungle.

Bhutan, covered with dense forests and clear rivers, has not been conquered since Vajrayana Buddhism was introduced there by Padmasambhava in the 8th century, then by Pema Lingpa, who revealed the 'spiritual treasures' in the 15th century, and finally by Shabdrung Ngawang Namgyal (1594–1651), who played an important role in both the religious and political unification of the country. Thus Buddhist culture has been able to flourish in Bhutan to this day and its values are deeply rooted in the minds of the Bhutanese people. Some of the main monasteries, such as that in the capital, Thimphu, have over a thousand monks. Each hill has its own small temple surrounded by prayer flags fluttering in the wind. The streams turn the prayer wheels day and night. All over the mountains and forests are retreats where practitioners – monks, nuns and lay people – go to meditate. Impressive ceremonies and sacred dance festivals are held all the year round.

Two schools of Tibetan Buddhism predominate in Bhutan: the Drukpa Kagyu school, to which almost all the State-supported monasteries belong, and the Nyingma school, which has long been represented by a succession of important and remarkable spiritual teachers and followed by a large section of the population. Bhutan's patriarch, Je Khenpo, who belongs to the first of these two traditions, theoretically has a religious rank equal to the king's temporal rank.

Because Bhutan has escaped the devastation suffered by its neighbour, Tibet, its Buddhist artistic heritage has remained intact and is unequalled in the world. Religious art traditions are still very much alive and Bhutanese sculptors in particular are renowned throughout the Himalayas for the delicacy and beauty of their statues.

Bhutan has so far been remarkably successful in integrating its traditional Buddhist culture with the most useful aspects of Western civilization, particularly when it comes to conserving the environment and improving public health and education. A senior Canadian official who helped Bhutan become a member of the United Nations remarked that Bhutan could become like any other country, but no other country could ever become like Bhutan.

Nepal
Crossroads of Cultures

According to Buddhist tradition, Nepal was created by Manjusri, the bodhisattva who is the embodiment of the perfection of Knowledge. In his omniscience, he knew that the original Buddha had manifested himself spontaneously in a mountain to the south of his dwelling place. Manjusri lived in the region of Great China, on the Mountain of Five Terraces (Wu Tai Shan). Accompanied by his two wives, Varada and Mokshada, and a throng of disciples, he left the celestial sacred mountain. After scaling the highest peaks, he reached a circle of mountains which surrounded a lake. Raising his sword, he cleft the mountainous wall in two, allowing the waters of the lake to pour out through the breach. At the bottom of the lake was revealed the lotus stem that held Swayambhu in its sacred flower, the Buddha spontaneously made manifest. On his journey, Manjusri crossed the region of the Tibetan plateau and scaled its natural ramparts, the arc of the Himalayas, with their lower flanks reaching down to the Ganges. Freed by the sword of Wisdom, the waters of the lake left in their wake the valley of Kathmandu, the hub of a vast sacred region.

Buddhas, holy men and scholars, both Buddhist and Hindu, have all spent time in this valley, each leaving his mark behind him. It is frequently likened to a huge reliquary, its jewels being the hill of Swayambhu, the great shrines of Bodhnath and Chabahi and the huge sacred complex of Pashupati. Temples, sanctuaries and monasteries – expressions of a vibrant faith – number in their hundreds. During the annual propitiation ceremonies, every house becomes a place of worship. Spared by any major conflicts, this artistic and architectural heritage has been preserved and constantly restored through the faith of kings and followers.

Today's geographers liken the slopes of the Himalayas, from their loftiest peaks to the plain of the Ganges, to a giant patchwork. The rivers that rise below the high peaks have created a huge chequerboard, slicing through the mountain ranges that lie perpendicular to them to create discrete areas, now inhabited by populations with disparate origins. These remarkable landscapes have fired the imaginations of those who live in them, who in turn have populated them with deities, mythical creatures and hidden treasures. Peaks and lakes have become the dwelling places of patron goddesses, mountains a shelter for the guardian spirits of treasure troves, their slopes the home of fabulous creatures and their caves a refuge for wise men.

Bordered by Tibet to the north and by India to the south, east and west, Nepal today occupies the most accessible region of the central Himalayas, with a population of over twenty-three million. Though it spans a mere 100 kilometres from north to south, over the centuries it has become home to a wide range of ethnic groups with very different cultures and lifestyles.

Some Tibetan peoples, originally from the high Tibetan plateau and the Tsangpo (Brahmaputra) valley, found similarities between this area to the south of the Himalayas and their own region to the north, and settled here while still retaining close links with Tibet. From west to east along the foothills of the towering mountain range, a number of different enclaves can be distinguished today, including the Limirong, the Dolpo, the Lo and the Solu-khumbu. History offers an explanation for the presence of these communities that cling to their Tibetan language and customs in northern Nepal. At the time of the early kings, Songtsen Gampo (who died in 649) extended the influence of Tibet far beyond its present-day frontiers, stretching south of the Himalayas to include the region stretching from Zanskar in the west to Bhutan in the east. These small ethnic groups are thus living testimony to an illustrious past. Heirs to the great traditions of Tibet, they have preserved aspects of traditional culture and beliefs that have now vanished in their native lands. Though each group has its own individual character, they nevertheless share the same cultural identity. These endogamous societies observe a hierarchy that gives seniority to those established earliest, and those that have yielded religious and secular leaders. Due to their thrifty irrigation methods and efficient use of water, a rare commodity in these regions, they have been able to continue their traditional farming activities, especially the cultivation of barley. This does not yield enough to feed a family

throughout the year, however, and so is supplemented by the produce of the sheep, goats, yaks and horses they raise, as well as by trade.

In the central valleys of the Himalayan foothills, the Magar, Gurung, Tamang and Kirant peoples, Tibeto-Burman in language and culture and formerly herdsmen by occupation, have succeeded in taming this desolate mountain region by creating tier upon tier of cultivation terraces watered by a cleverly designed irrigation system. Their local religions, based on worship of their ancestors and spirits through the intercession of shamans, have nowadays been subsumed into popular Hinduism.

Meanwhile, ethnic groups from the plain of the Ganges settled in the far south of the region, where they cultivated rice and raised herds of buffalo. With their social hierarchy based on the caste system, their Hindu beliefs and their Indo-Aryan languages, these peoples could scarcely have been more different from their counterparts in the high valleys. Indeed, recent developments have posed a threat to the hegemony of the increasingly sparsely populated mountain regions, favouring instead the Tserai plain, now home to over half the country's population. The Indo-Nepalis, who form some 45 per cent of the population of Nepal, are also the most important Hindu group in terms of numbers. Making their first appearance in the 14th and 15th centuries, they too are organized according to a caste system, with the two highest castes, the Bahun-Chhetri, traditionally fulfilling the (now diversified) roles of the priesthood and positions of power. In the area where they settled originally – the long ribbon of land straddling the middle of the country from west to east – they remain the dominant group.

The Newar, who consider themselves the earliest inhabitants of the Kathmandu valley (did they not arrive with Manjusri?), have transformed this region into a centre for cultural, economic and religious exchanges between India and Tibet. These are the people who have created and laid down the civilization that we know as Nepali, but whose cultural heritage is in fact largely Newari, a fact which may be explained in part by their position at the crossroads of northern and southern, or Tibetan, Chinese and Indian cultures.

With their extraordinary prowess and creativity in every artistic field, they were well placed to take full advantage of this unique geographical position. Another caste-based society, the Newar people have for centuries preserved a way of life and religious practices that are specific to themselves, often combining Hinduism and Buddhism in their rituals, ceremonies and expressions of faith on feast days and pilgrimages.

Great occasions such as the Buddhist pilgrimage to Bodhnath and the equally popular Hindu pilgrimage to Pashupati, both hugely popular festivals as well as religious celebrations attracting devotees from throughout the country, offer a dazzling panorama of the diverse ethnic strands and multicultural traditions that make up present-day Nepal. At the Tibetan New Year, or *losar*, Bodhnath teems with life as a steady stream of people pours in from the high Himalayan valleys and the Tibetan hinterland. At the onset of winter, their numbers are swelled further by Tibetan families from the borderlands, who journey down into the Kathmandu valley, bringing with them woollen fabrics, salt and medicinal herbs to exchange for goods from India. Some of these families pitch their tents at Bodhnath or Swayambhu, which are permanent centres for their trade and religious activities. Here they take full advantage of the climate – so much less harsh than in the high mountain regions – to visit the countless holy places in the valley and its surrounds, sanctified by past Buddhas and great teachers such as Nagarjuna, Padmasambhava and Milarepa.

Due to its geographical position, the Kathmandu valley has been and remains an important trading centre, facilitating the circulation of goods and ideas not only in the fertile basin but also to a lesser degree in the other valleys and the 'thirteen passes' leading to Tibetan Central Asia. The Chinese invasion of Tibet from 1950 has also caused an influx of Tibetans into Nepal, where they now form a large and dynamic community. Temples and monasteries have sprung up in sacred places such as Swayambhu and Bodhnath, transforming them into true centres of Buddhist excellence and energy, and so contributing to a unique and continuing cultural dialogue in this mountainous region of Asia.

Ladakh
Buddhism and Beyond

At the north-west extremity of the tremendous complex of mountains, plateaux and valleys that is Tibet, lies Ladakh; the political border between the two an artificial line running through a geographical continuum. At the same time, Ladakh itself is an area of geographical transition. In the south-east, the plateaux and rolling hills characteristic of Tibetan Changtang gradually merge into the proliferation of ranges that marks the western end of the Great Himalaya. Indeed, the region spans no fewer than four major ranges: the Great Himalaya, the Zanskar range, the Kailash–Ladakh range and the Karakoram.

Each of the four, particularly the Zanskar range, branches out into a bewildering complex of sub-ranges. Separating the ridge lines of these are the river valleys where alone human settlement is possible. In the rain-shadow of the Great Himalaya, Ladakh is a high-altitude desert, its fragile mountain soils becoming fit for cultivation only where glacier-fed streams can be tapped for irrigation. The backbone of the whole system is the Indus, one of the world's great rivers, its valley forming Ladakh's historical heartland.

Communication between villages in neighbouring valleys is by passes varying in height between 3,350 metres and 5,500 metres. (*La*, a pass; *La-dakh*, land of passes: it figures.) The ruggedness of these mountain trails forbids the use of the wheel, and yet, up to a mere half-century ago, a busy inter-regional trade found routes along the valleys and over the passes to spread the surpluses produced in particular areas, and make up deficiencies in others. Economic independence, both regional and individual, depended on trade. Whatever necessities could be got only outside Ladakh – salt, rice, tea, spices, or the turquoises, coral and pearls that were the women's wealth – were paid for in local products: barley, butter, dried apricots, or the famous Zanskar ponies.

Ladakh was also the channel by which *pashm*, the soft superfine goat's wool that was the raw material for the Kashmir shawl industry, reached Kashmir from western Tibet. Leh, the capital, was the hub for traffic in luxury goods – silk, spices, narcotics, carpets and bullion – between India's Punjab, Yarkand in Chinese Central Asia, and Lhasa. By the end, it had become so cosmopolitan that during the trading season its bazaars were a babel of half a dozen languages.

The existence of 8th-century rock engravings of Maitreya and Avalokiteswara in a distinctly Indian style is proof that Buddhism first entered Ladakh from Kashmir, long before the foundation of the kingdom by a member of the Tibetan Yarlung dynasty about 950 B.C. When Yeshe Ö, king of Guge, representing a cadet branch of Ladakh's ruling family, initiated the revival of Buddhism known as the Second Spreading, his first action was to send Rinchen Zangpo and other scholars to Kashmir to study iconographic traditions and translate texts. Rinchen Zangpo brought the fruits of this endeavour to Ladakh, where Alchi, founded by one of his followers, the jewel among Ladakh's religious sites, exists as one of the few surviving examples of 11th-century Buddhist iconography. Its murals, executed with delicacy and verve by master painters probably from Kashmir, show an astonishing similarity (in spirit if not in detail) with those of Ajanta, painted six centuries earlier and 1,600 kilometres distant: a moving testimony to the unity of India's Buddhist culture in space and time.

Tibet imposed its own distinctive imprint on the traditions brought from India by Rinchen Zangpo, Atisha and other teachers, and it was not long before a centralized orthodoxy was established. Within two hundred years of Yeshe Ö's initiative, the various monastic schools established in central Tibet had asserted absolute authority over their daughter houses in Ladakh and elsewhere on the peripheries. No Ladakhi novice could become a *geshe* except by a course of study lasting up to 25 years in one of the great monastic universities at the centre. A Tibetanized iconography replaced the Indian one so vividly preserved at Alchi, and the influence of Tibet over the region's religious life was all but complete.

Yet the transition that marks the region's geography also mirrors a religious and cultural transition. Ladakh, at the extremity of the Tibetan cultural domain, sits on the cusp between Buddhism and Islam. Although in the 15th and 16th centuries it repeatedly faced Muslim invasion, the penetration of Islam into the western part of the country seems to have been accomplished without coercion. Many of the missionaries – preachers from Kashmir and Iran – were Syeds, directly descended from the Prophet Muhammad.

They settled in villages in the Kargil region, where their descendants, known as Aghas, have exercised spiritual authority in an unbroken line to the present. They profess the Shia school, as do the descendants of immigrants from Baltistan settled at Chushot near Leh. The capital itself is home to a community of Sunni Muslims known as Arghon, originating from marriages contracted by Muslim merchants from Kashmir or central Asia with local women.

Later political developments – the establishment of the second dynasty, the Namgyal; war with Tibet in the 1680s; Ladakh's acceptance of the suzerainty of the Mughal empire; the end of its independence in the 1830s and 1840s; and the series of historical accidents which led to its becoming part of the state of Jammu and Kashmir in 1846 – did little to modify the basic parameters of social and religious life. A mission of the Moravian Church opened in Leh in 1885, and a handful of local Buddhists converted to Christianity. But radical change started only with the events that took place after India's independence and Ladakh's incorporation into the new state. The borders with Tibet and central Asia were closed, bringing to an end commercial and religious relationships of a millennium's standing. The abrupt termination of traditional trade systems, together with the extension to Ladakh of India's ambitious programme of 'development', has initiated a revolution in the region's economy the full implications of which – ideological and social as well as economic – are yet to work themselves out.

Even so, Ladakh still retains its own intriguingly individual character, distinct from that of Tibet. In central and eastern Ladakh and Zanskar, it's true, the external signs of Buddhism are everywhere: *mani* walls, chortens, prayer wheels and flags. For the people of these areas, Tibetan-style Buddhism, embodied in the *gompas* or monasteries, not only forms the bedrock of their belief but also permeates their social life. Yet this has traditionally been without prejudice to their serene acceptance of, and coexistence with, their Muslim compatriots. And these in their turn, uncompromising in the practice of their own religion, seem to have been touched by Buddhism's characteristic tolerance and openness. On the map of western Ladakh, it is possible to plot with precision the line at which the proselytizing vigour of Islam finally came up short against the calm certainties of Buddhism. Here are villages where Buddhist and Muslim live together without friction; in some places both religions are represented within a single family, a stick laid across the top of the cooking pot representing the divide between the food permitted to the Muslim members, and that for their Buddhist kin. It has even been known for individuals to have composite names like Ali Tsering. Ladakh's extensive oral literature is enriched by elements from both cultures, and it's said that the liveliest recitations of the Gesar Saga, the Tibetan national epic, are those by the Muslim bards of Chigtan, near Kargil.

This meeting of cultures is symbolized by polo and archery, Ladakh's two main sports. Historically, archery was a significant part of the Tibetan lifestyle but, practised everywhere, it is taken particularly seriously by the Shias of Kargil district. Polo, on the other hand, was a favourite sport with the Muslims of the Karakoram and the Hindu Kush; here it is played – using traditional rather than international rules – with equal verve by Buddhists and Muslims alike. Neither archery nor polo, nor any other public celebration, is complete without the accompaniment of *surna* and *daman* (oboe and drums). Introduced from Baltistan in the 17th century, the complex rhythms of this music betray its origin in pan-Islamic musical forms; but today it is played only by Buddhist musicians, known as *Mon*. And echoing over Lhasa from the roof of the Potala on important occasions like the death anniversaries of Tsongkhapa and all the Dalai Lamas, it is almost the only example of the cross-fertilization of Tibetan culture from Ladakh.

For most of the 18th and 19th centuries Tibet turned in on itself, denying access to outsiders except those pilgrims and traders whose arrival was sanctioned by ancient usage. Ladakh, on the other hand, situated at the meeting point of different geographic and cultural domains, and at the crossing of trade routes, remained throughout its history open to a wider world. Hence the creation, on the secure foundation of Buddhism, but influenced by Islam, Christianity and latterly the presence of India, of a unique culture, joyous and gentle, rooted in its native soil and yet rich in universal values.

Zanskar
Blessed by the Gods

In their home at the heart of Indian Kashmir, the people of Zanskar are believed to be one of the most isolated populations on the planet. To the peasants who lead their virtually self-sufficient lives in the valleys of Zanskar, the Indian plain seems so remote and so different from their own experience that they call it a foreign country. Should they wish to reach this distant land, they must scale mountain passes at an average altitude of 5,000 metres before scrambling down the densely forested southern slopes of the Himalayas, ravaged by heavy rainfall. All this in order to end up in noisy cities full of frantic people: no wonder the villagers of Zanskar show no great enthusiasm for exchanging their valleys for this deranged world in which material desires have usurped religious faith.

Lying at an altitude of 3,500 metres, the ancient Buddhist kingdom of Zanskar irrigates the lands beneath it with the pure waters of two rivers, the Doda and the Tsarap, both of which rise amid the glaciers of the Great Himalaya range before flowing together into a great triangular-shaped valley to become the Zanskar Tsangpo river. Looping in great meanders – brown in summer, turquoise in autumn and white in winter – the river is imbued with the influence of the gods of the Karsha and Stongde monasteries, which bless the waters from their rocky outcrops facing each other across the valley. The river flows on, curving in a broad meander around the ancient shrine of the village of Tzazar: within its sun-cracked earth walls, a time-worn butter lamp burns constantly. After passing the two cob houses of Hanamur, white and solitary, the river crashes and churns between the sheer walls of an austere canyon some hundred kilometres long. Regaining its composure 150 kilometres downstream, the Zanskar Tsangpo sweeps calmly through the Ladakh valley before flowing into the Indus. This sacred river rises near Mount Kailash, pillar of the universe and the holiest mountain in Tibet, before flowing westwards to water the hanging oases of the valleys of the Karakorum, then plunging southwards to reach the sun-baked plains of Sind in Pakistan, 2,000 kilometres downstream.

Some 12,000 peasants inhabit the fifty or so villages scattered along Zanskar's three valleys. Each family possesses a cob house, terraced fields, ten or so goats, two or three horses, and sometimes a yak and its female, the *dri*, but more usually a few *dzomos*, a cross between a yak and a cow which produces good milk. The Buddhist Zanskarpa eat little meat and abhor the killing of any living creature, even an insect. Their staple diet consists of barley flour, peas and maize, which they cultivate in summer.

The Zanskar spring is a time of tranquil beauty, when villagers pray on their rooftops as they wait for nature to reawaken after winter. They spread the accumulated ashes from their hearths on the snow in order to hasten its melting and warm up the land for ploughing. Summer is a more anxious time of feverish activity, when the Zanskarpa have barely three months in which to grow, harvest and take chortein the year's yield of grain and animal fodder. Now whole families work from dawn till dusk, cultivating and irrigating the fields, scouring the mountainsides for brushwood, keeping watch over the animals grazing the high mountain pastures and churning butter. If the family is numerous enough to be able to spare him, one of the younger brothers might volunteer his services as a guide to the foreign travellers who make the bone-shaking journey here in order to trek on foot between the villages and monasteries of the valleys. In summer, a road of sorts runs from Padum to Karil, plied by trucks shaken to the point of collapse by potholes, on which visitors perch before being unceremoniously deposited in Zanskar, grey with dust and fatigue. This new tourist trade provides local families with the means to buy valuable items and precious goods imported from the Indian plain: a pressure-cooker, perhaps, a thermos flask, or some rice or sugar.

In autumn, nature prepares for its winter sleep, painting the rivers turquoise, draping the land with deep shadows and turning the brushwood the colour of fire. Before the snows come, squally winds from the south sweep the plain. The fields echo with the cries of men as they encourage their beasts to trample the grain, and with the chants of women calling the wind to come and thresh the harvest. The young people swap jokes and remarks as they carry the grain, as though choreographed, from the fields to the village. Autumn is also the season for weddings. A great feast, washed down with quantities of *chang*, or millet beer, is held to honour the young bride, who weeps as she leaves her village for ever in order to set up home with her husband's family. In her husband's village, which she has never seen before, another feast awaits her. The marriage has been arranged by the couple's parents, for how can young people, with their paltry experience of life, understand what the future holds for them as husband and wife? Love here is not measured in passion, but is forged and deepened by the joys and sorrows shared with the passing of the years. The newlyweds now take over the running of the household, assuming responsibility for younger brothers and sisters, while the parents withdraw to a smaller, more spartan dwelling next door to the main house. If they are fortunate enough to retain their health, their lives now become easier, more pious and therefore more serene, enabling them to prepare for the journey of death and its final destination in reincarnation.

Winter is long and harsh. With the first snowfalls the high passes become inaccessible, and the villages are transformed into islands of life in a sea of spotless white. Not until January will it be possible to make the twelve-day trek to Ladakh, walking the course of the Zanskar river, which freezes along its banks for a few weeks in the depths of winter. Villagers with goods to trade and friends returning from pilgrimages take this majestic but difficult and dangerous route, while the more sedentary Zanskarpa stay at home. For them, winter is a time to be enjoyed, a time for prayer and for savouring with increased intensity the beauty and profundity of life. Everyone has time to share with others, sensitivities are sharpened and feelings magnified. At this time of year, the Zanskarpa have an air of even greater gentleness and nobility; they speak in low voices, their soft expressions and graceful gestures, like monks bestowing blessings, reflecting their spirituality. Winter forges bonds between people and strengthens the social fabric, emphasizing the individual's responsibility to the community and sharpening everyone's awareness of their interdependence, their only guarantee of survival.

Gradually, Zanskar is changing. Schools are springing up, fostering new ways of thinking among the young. Villagers make more frequent pilgrimages to the sacred places of Buddhism, bringing fresh energy back with them. Many young monks travel to southern India to study under the great Tibetan masters who have taken refuge there, returning to teach this more profound knowledge in their own country. Residual Muslim interference, linked to the fanaticism that blights Kashmir, introduces a note of conflict into Padum, the tiny capital, on an annual basis. The intrusion of television now poses a major threat: at present the region boasts just four television sets, the proud possessions of four families lured by the ersatz glitter of the modern world. But the Zanskarpa remain open to change and find something of interest in everything, a magnanimity in any gesture, and a potential for Enlightenment in all beings. They face the future as simply as they live the present, with a generosity of spirit that makes them happy to be and to exist together, in the tidal wave of life. Shortly before his death, the old Zanskar king Tashi Namgyal Gyalpo observed: 'Our death teaches us about impermanence. All things are destined to be born, to grow and to die, then to be reborn. We should always adapt to change.'

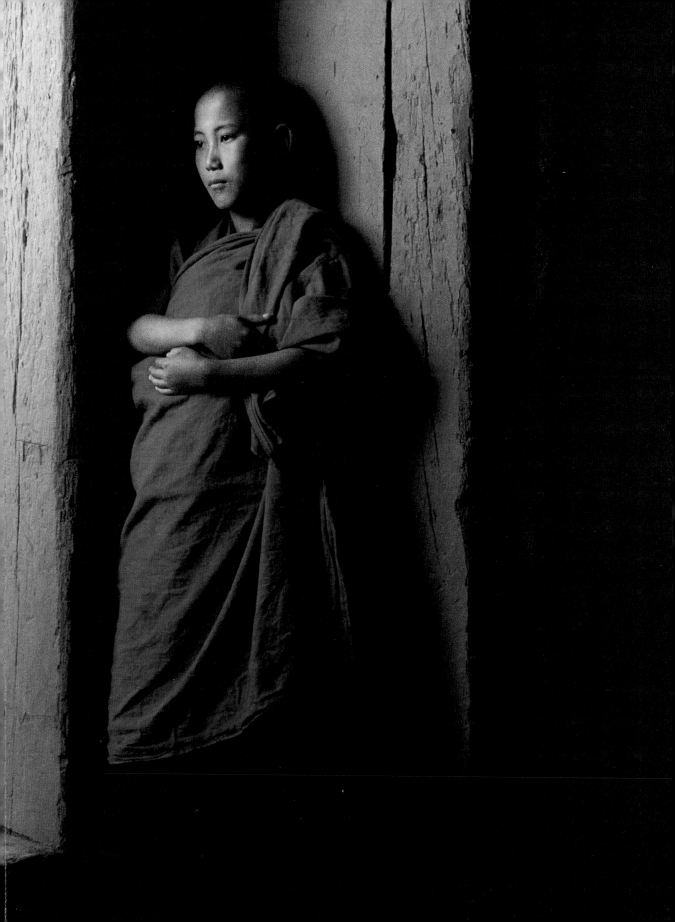

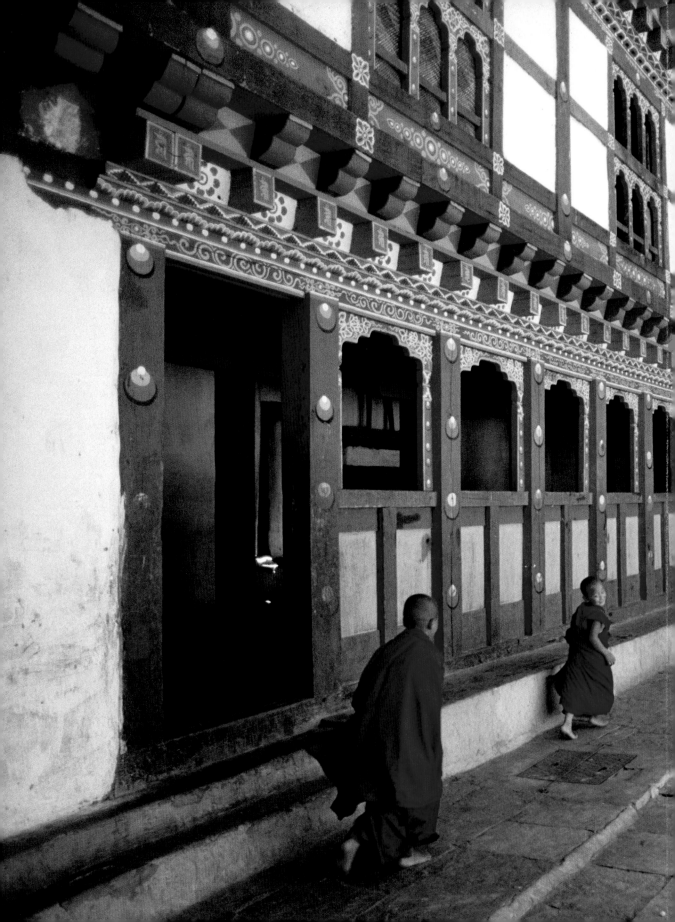

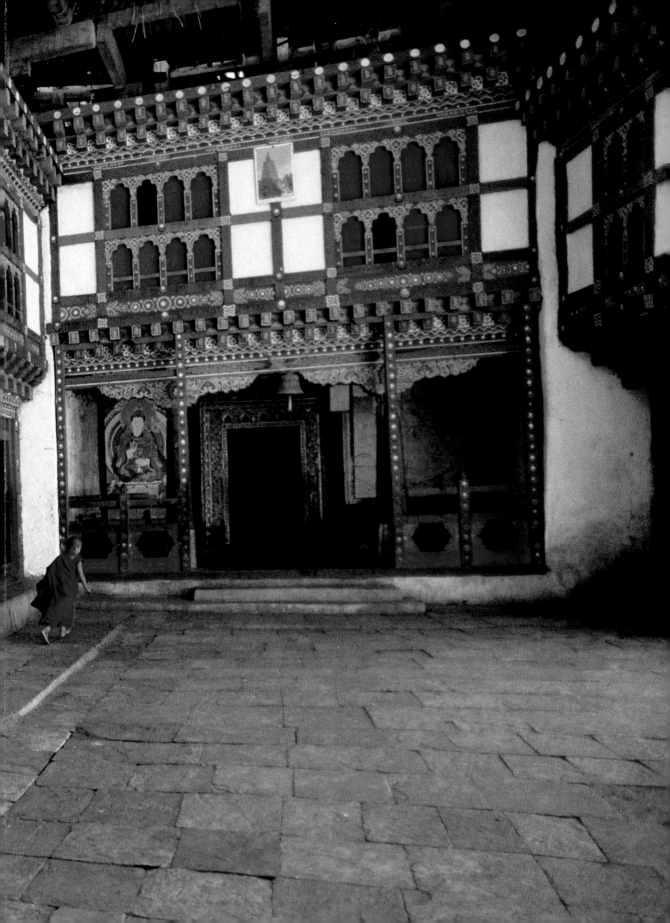

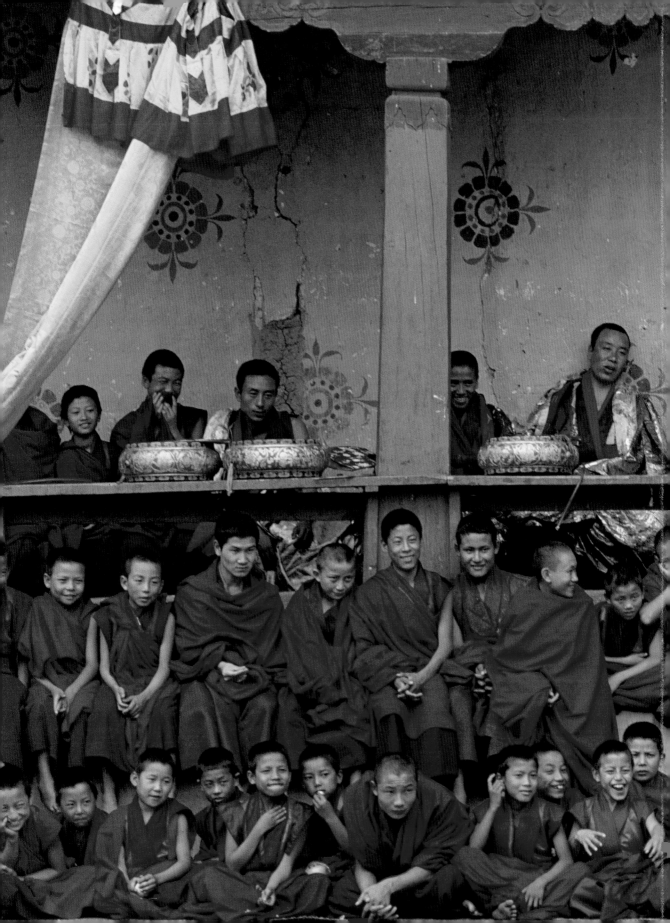

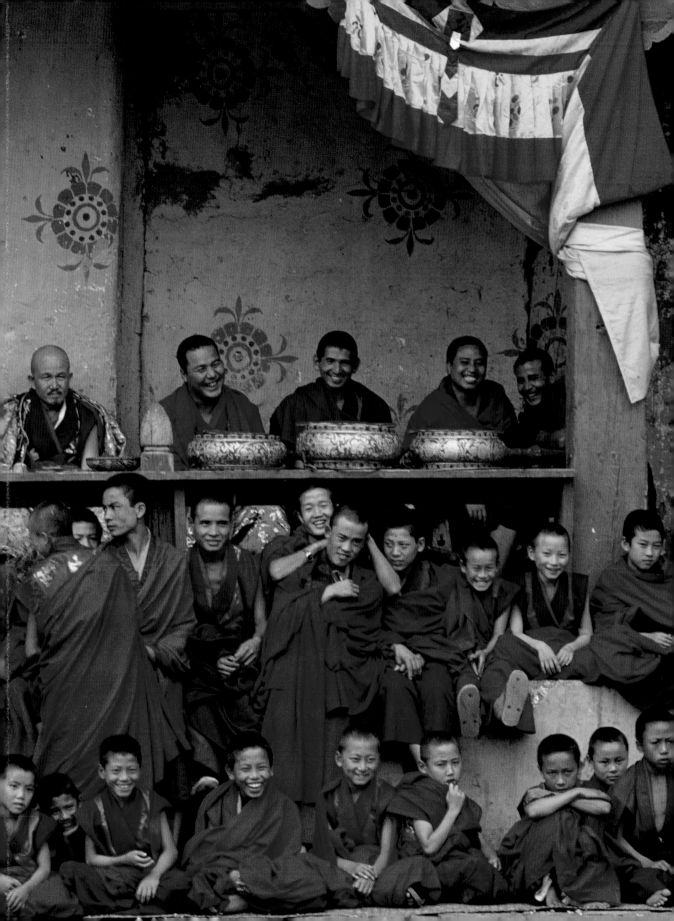

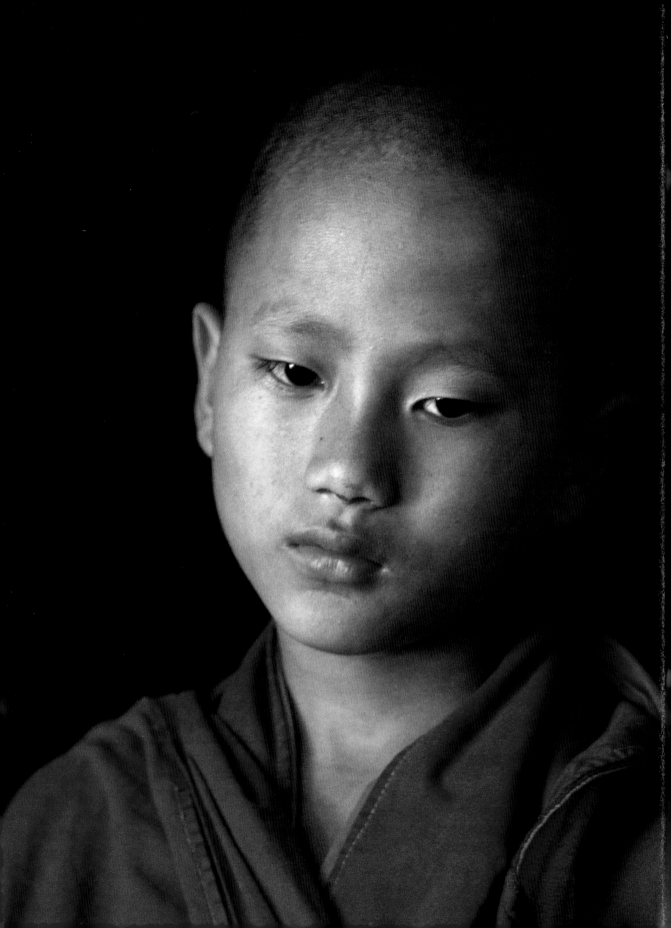

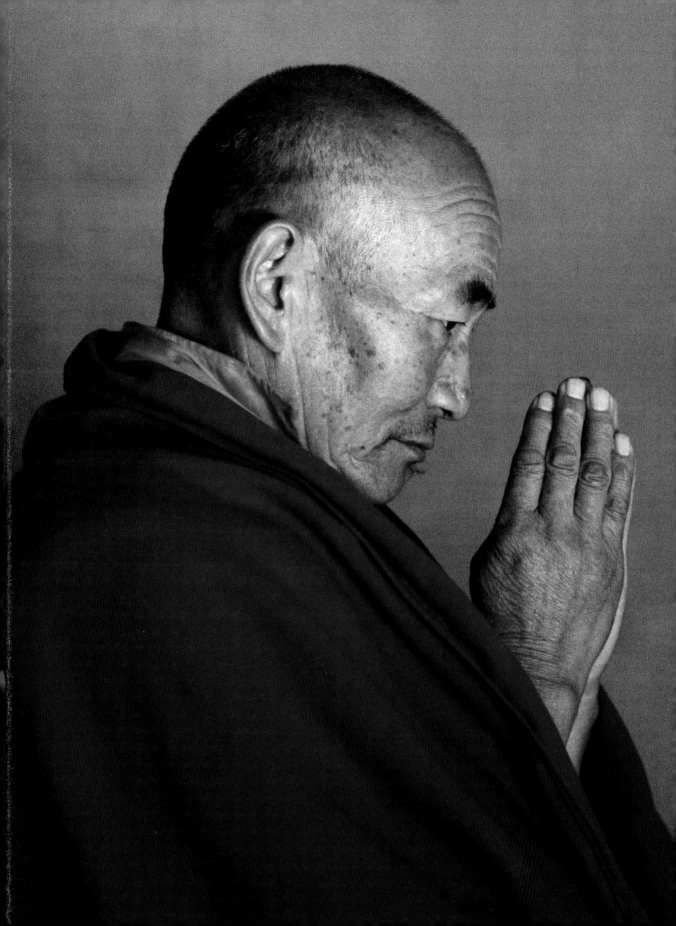

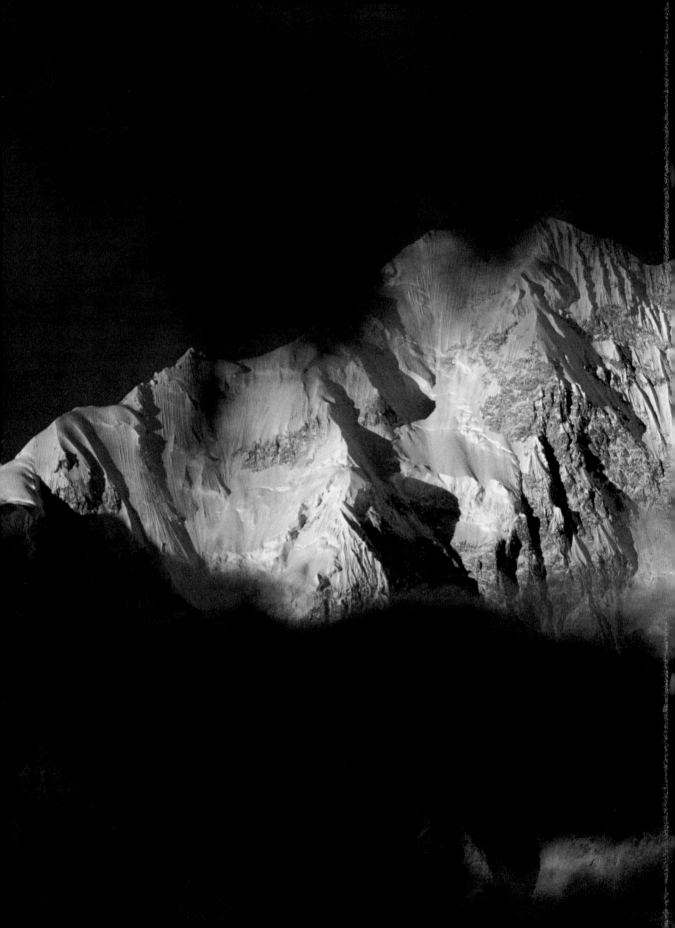

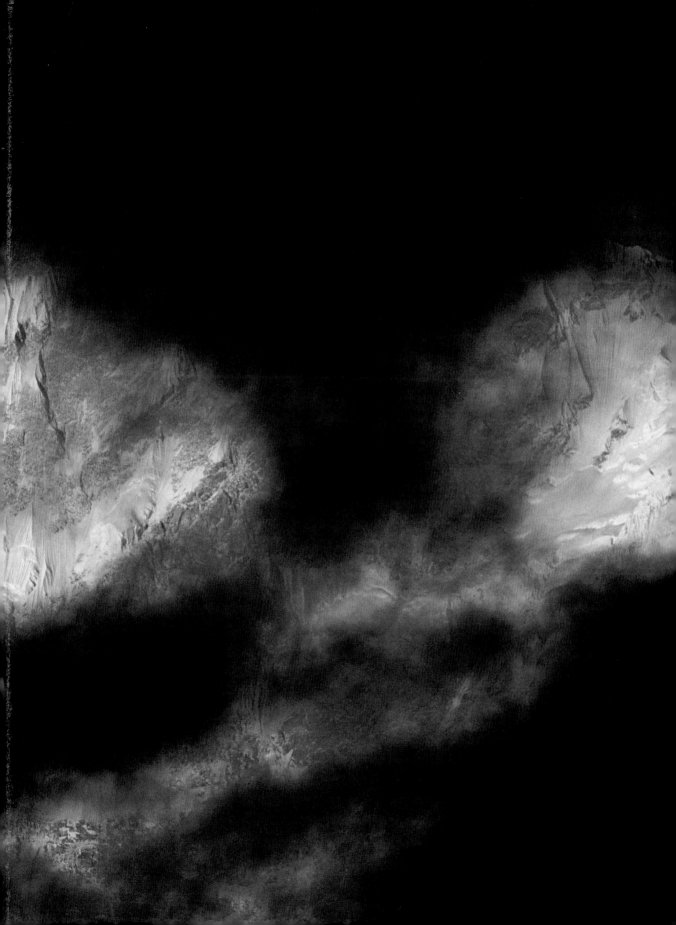

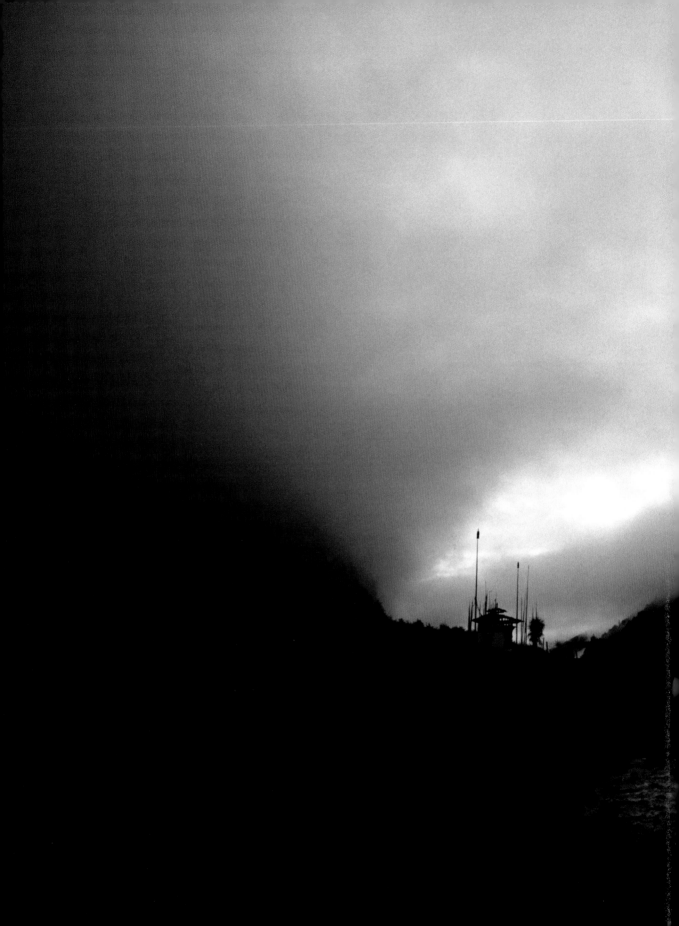

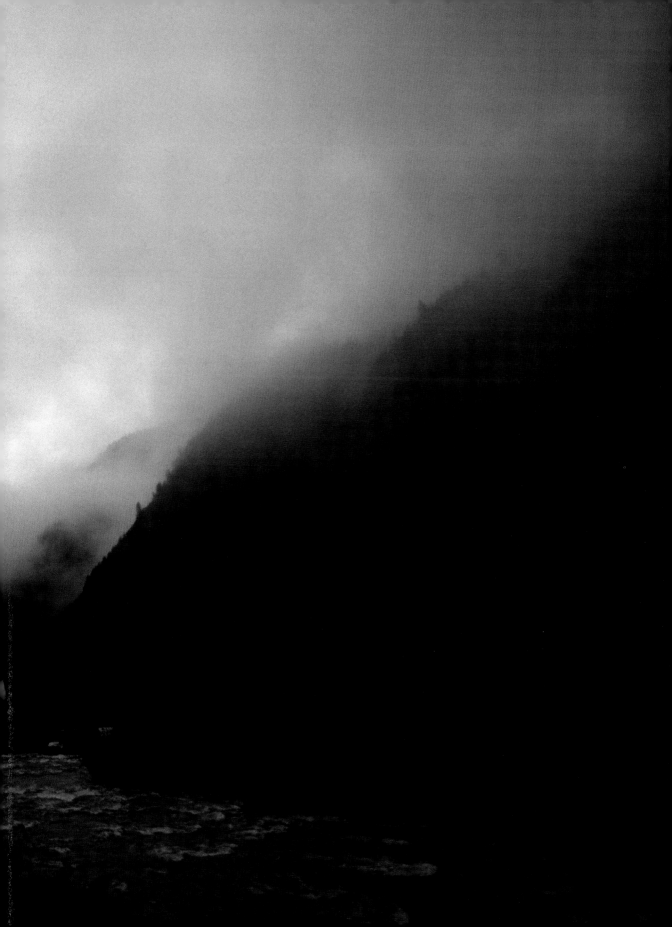

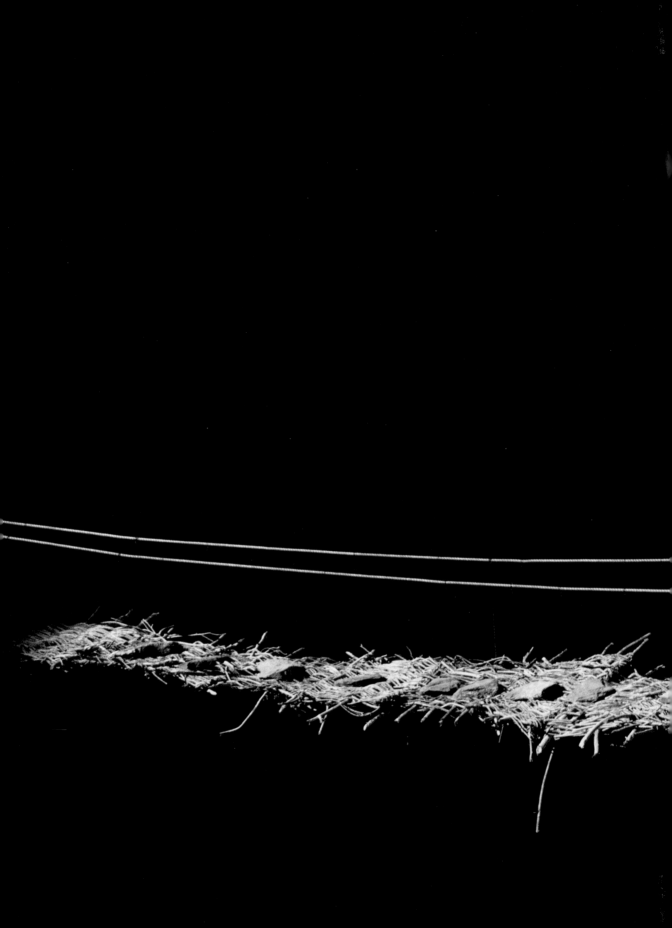

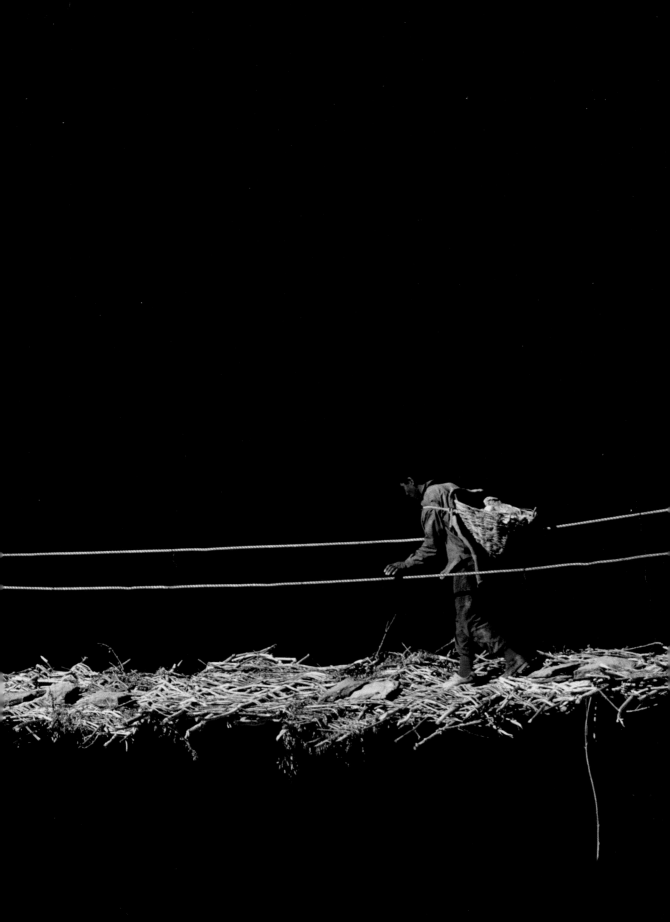

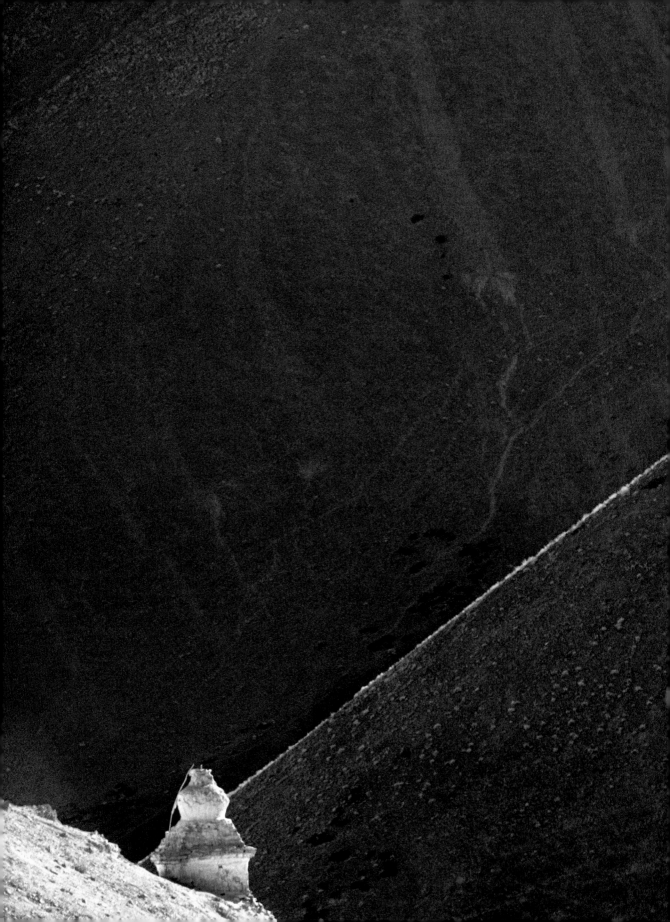

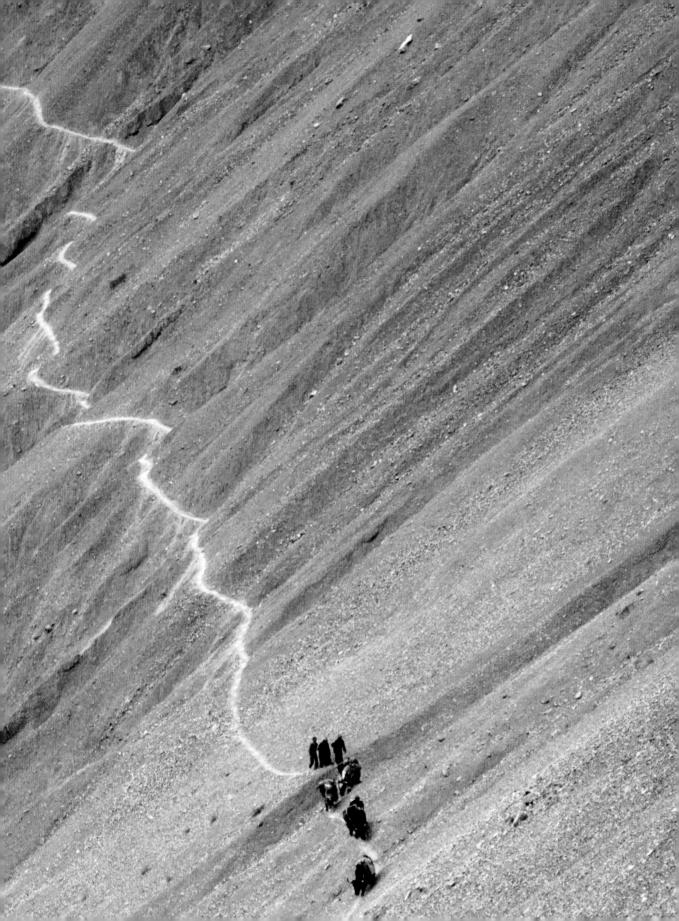

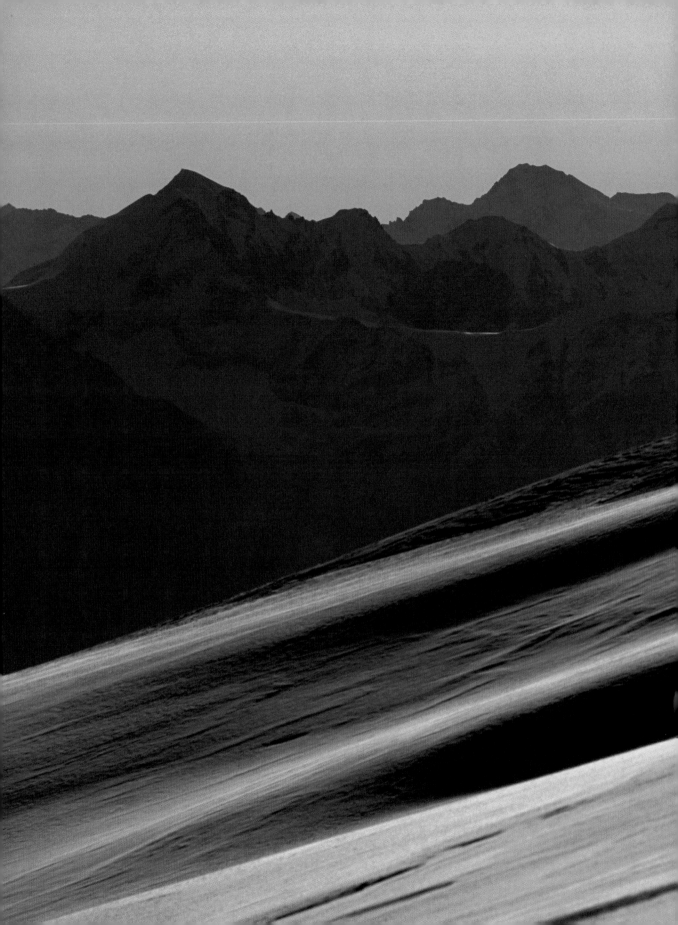

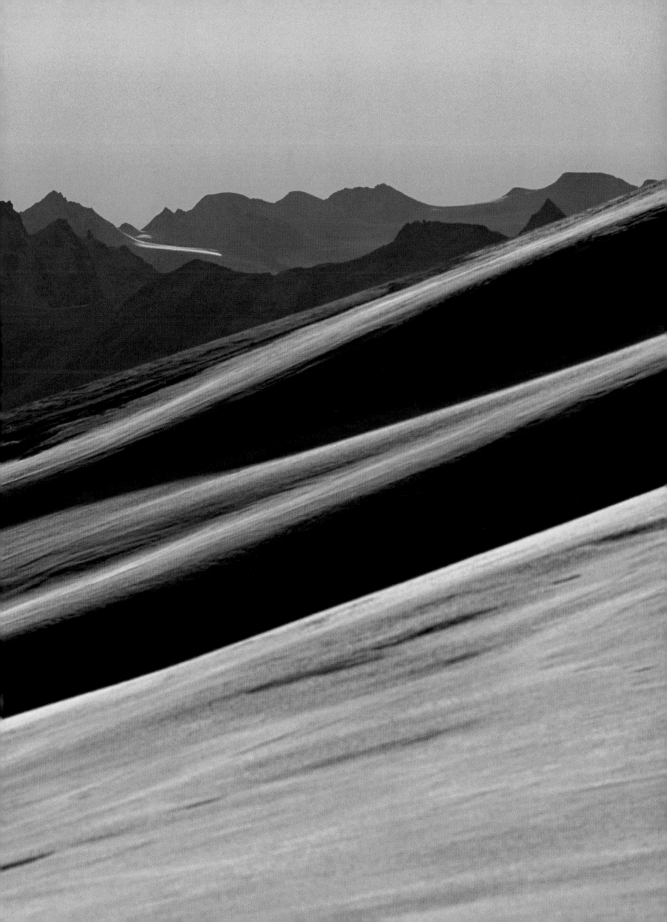

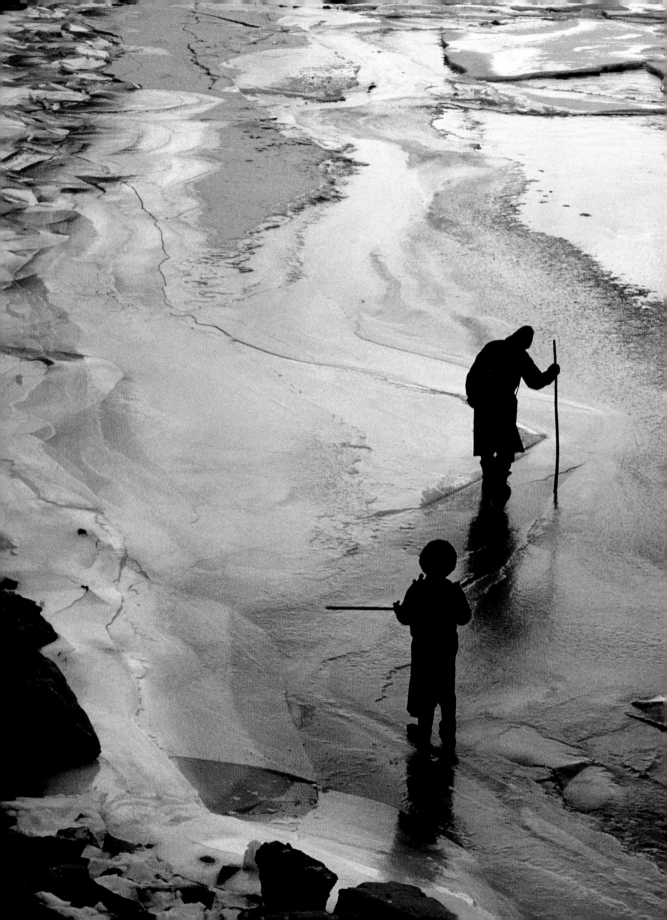

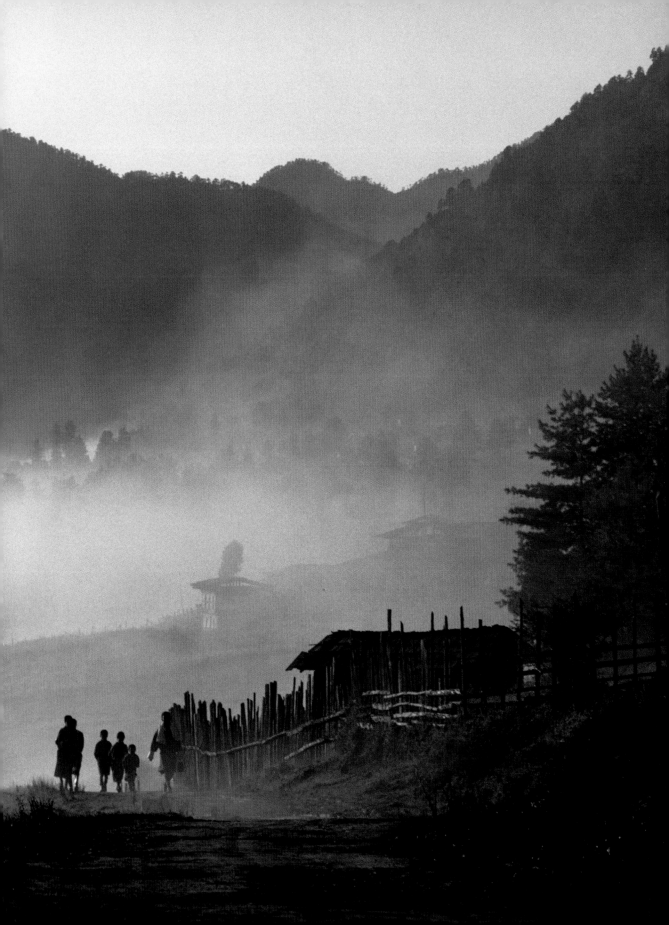

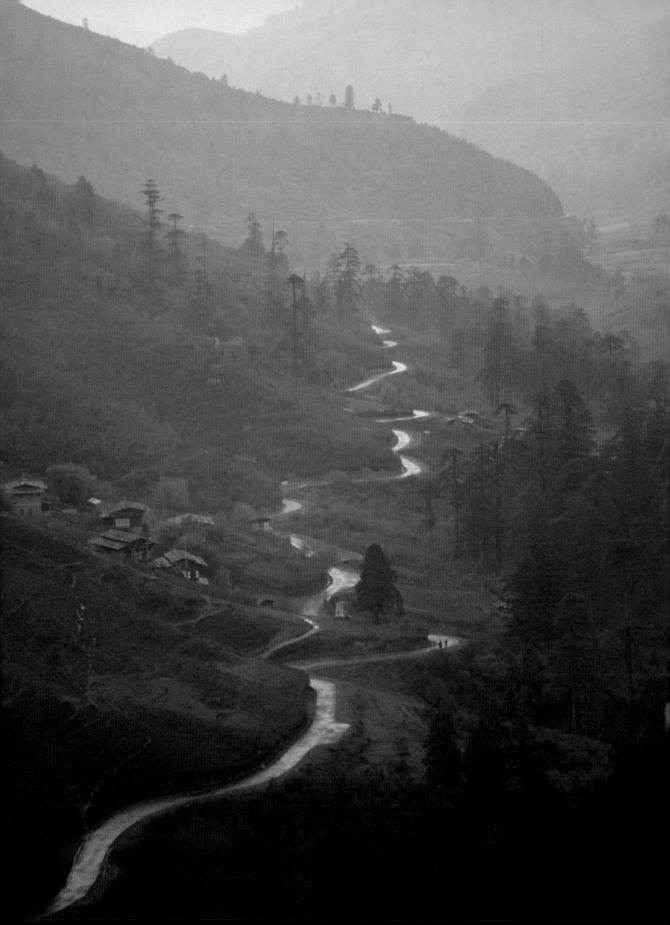

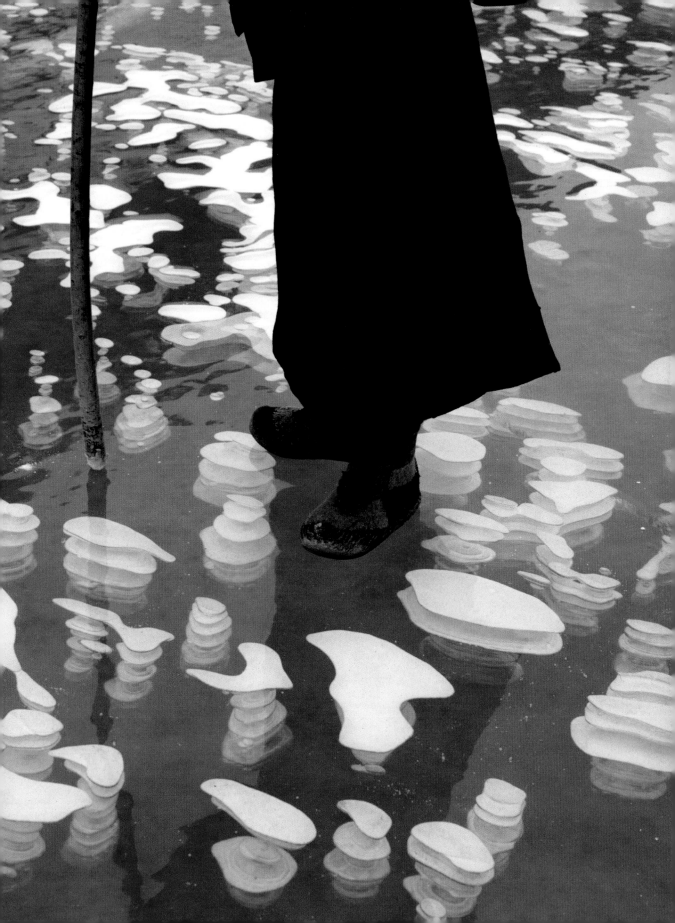

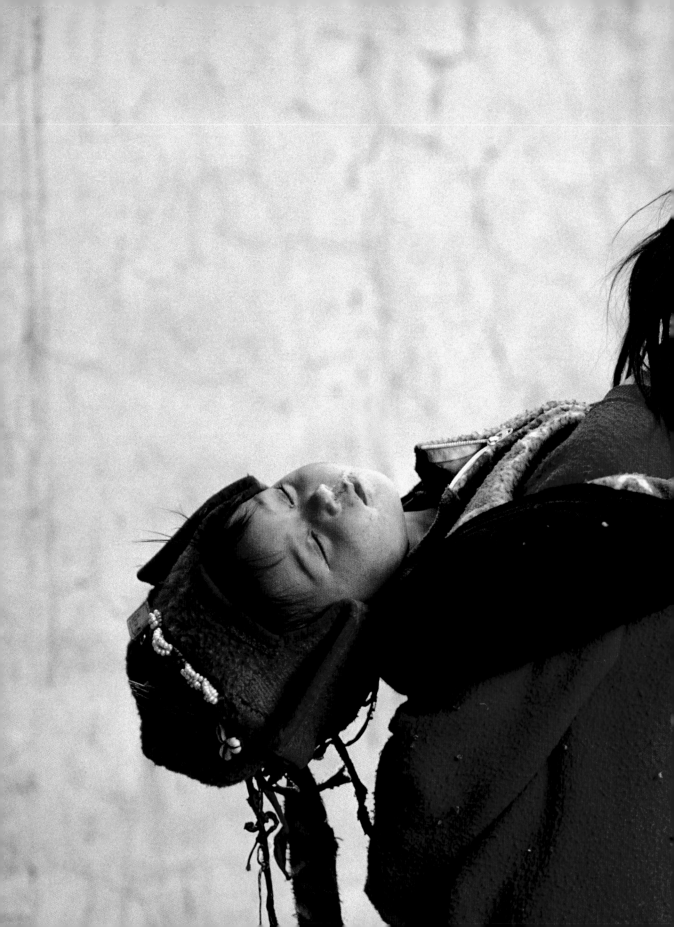

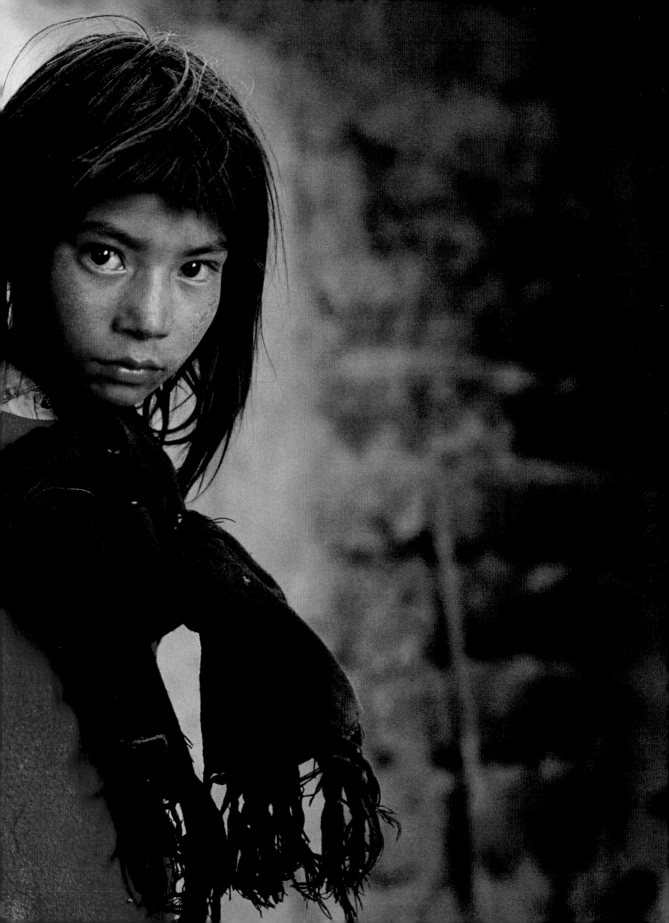

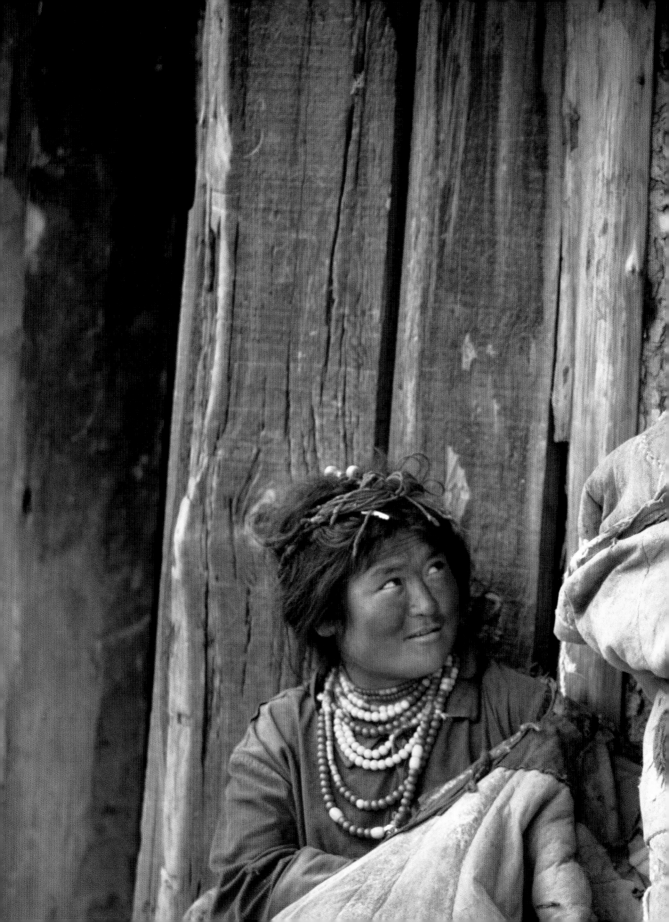

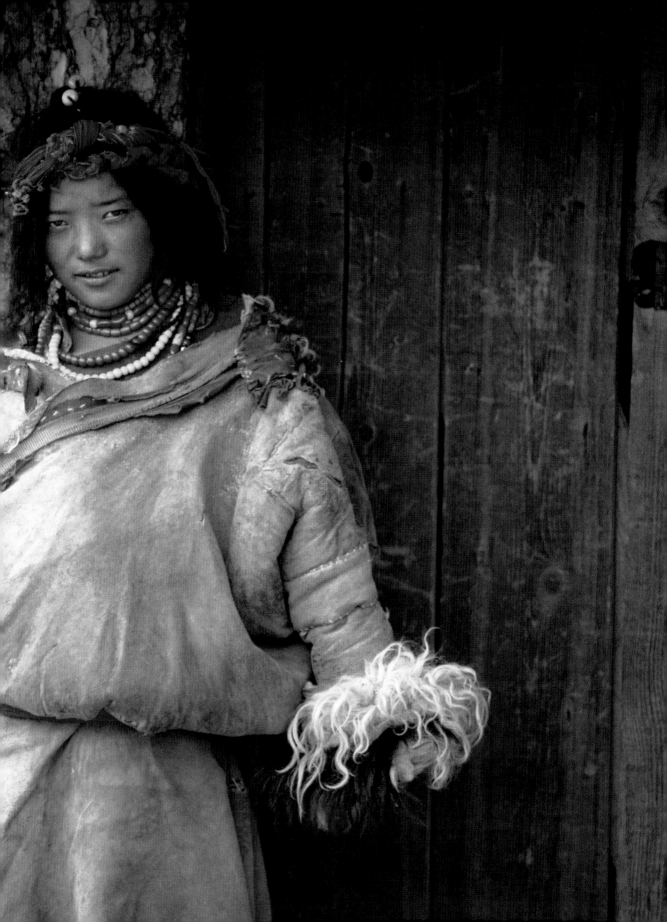

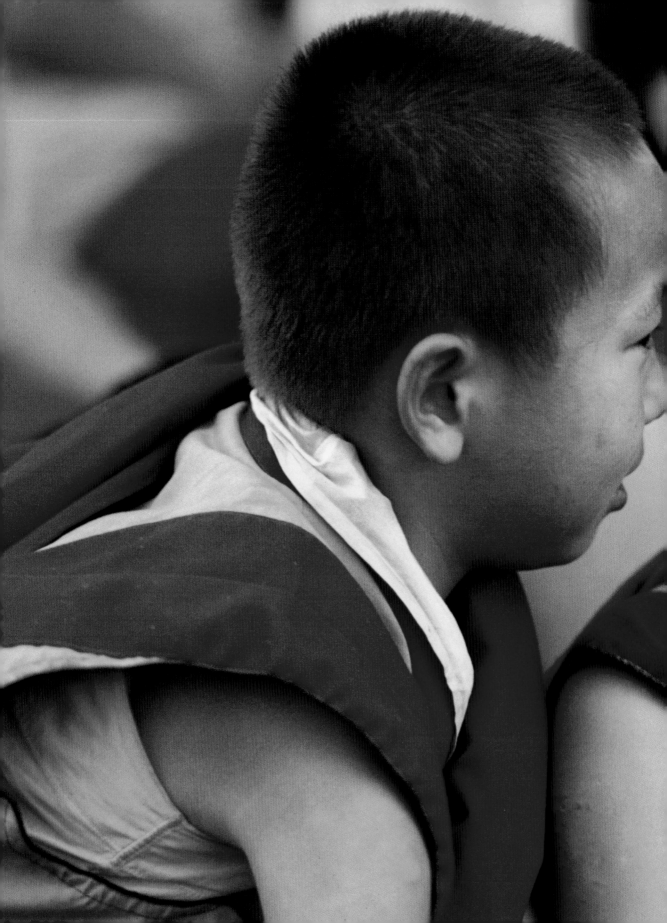

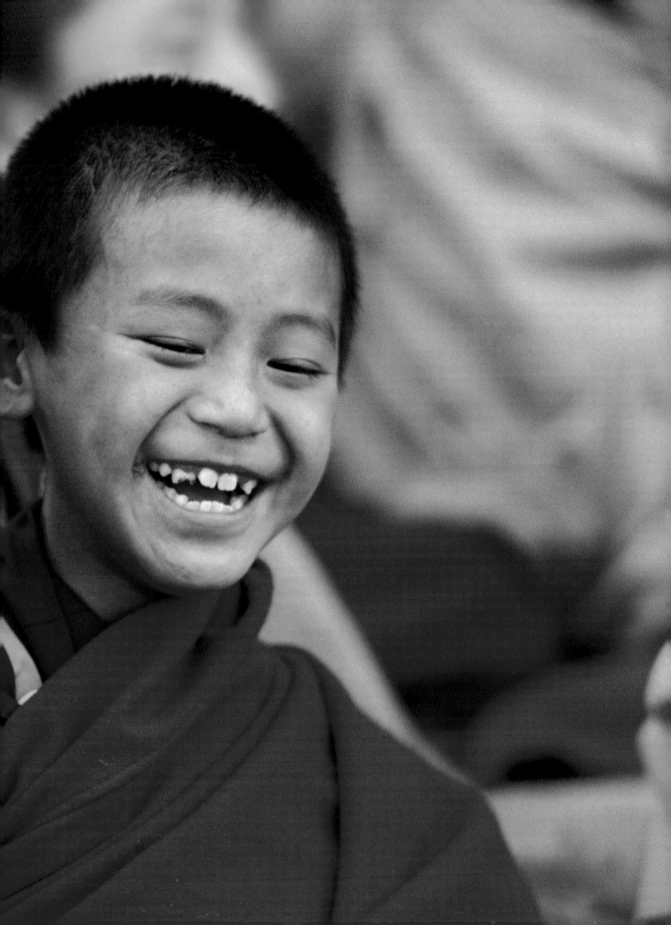

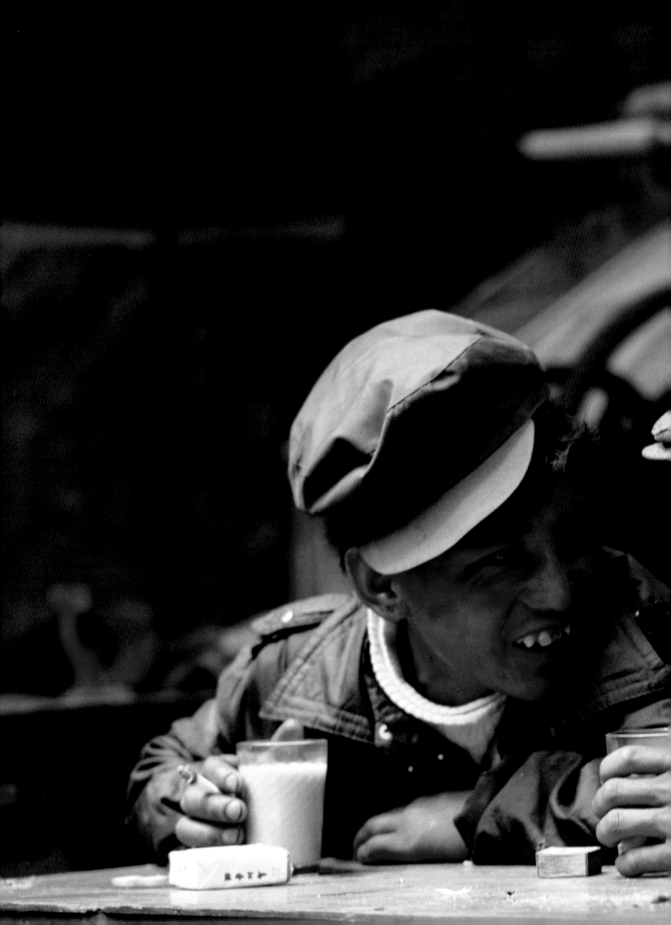

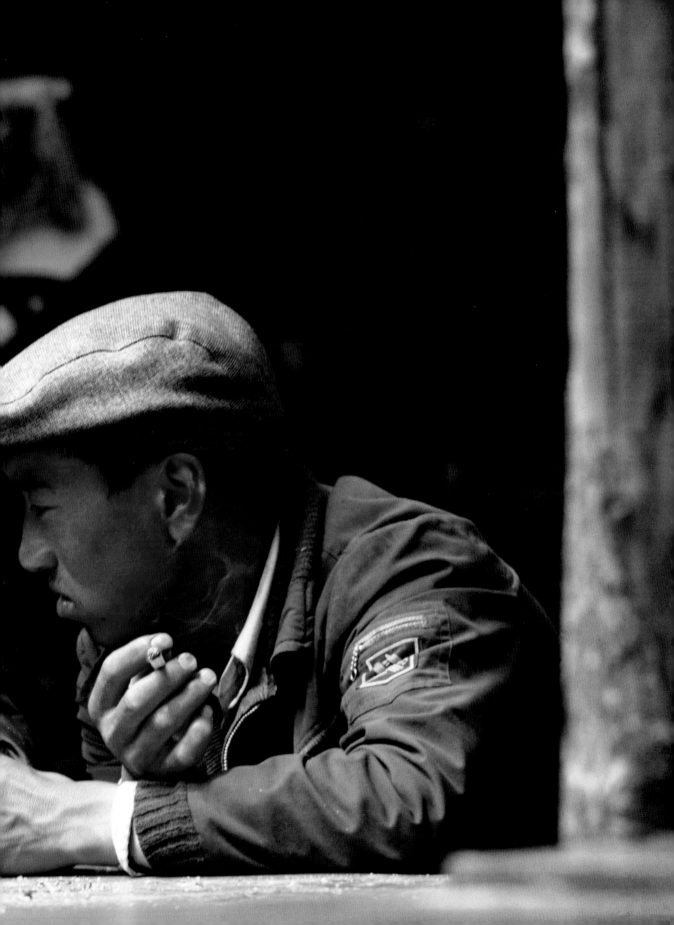

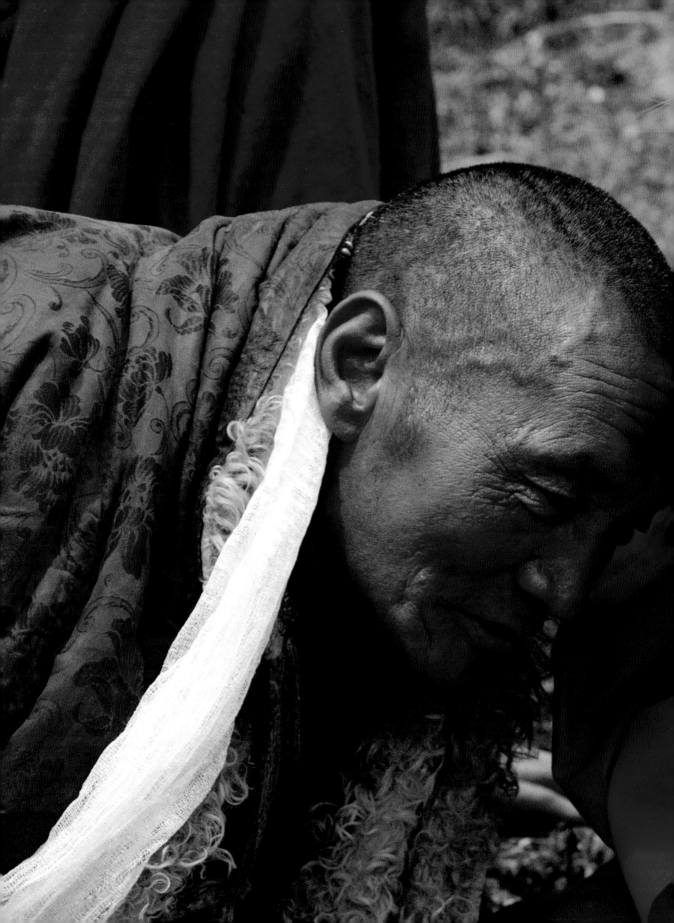

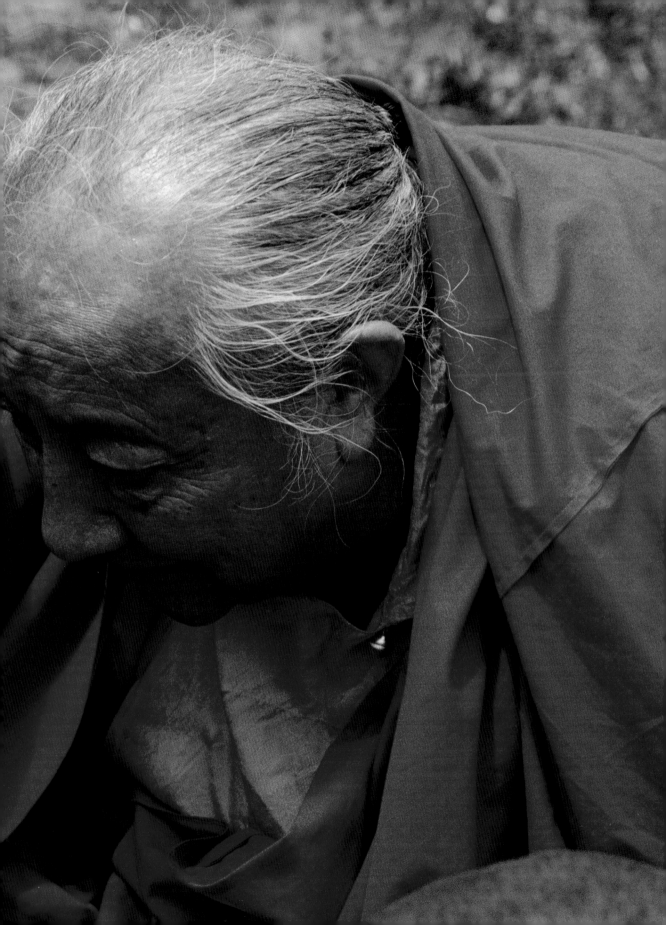

The Treasure of Salt
Caravans Across the Roof of the World

The Himalayan range divides two regions that are as different as they are grandiose. To the north, at an altitude of over 4,000 metres, stretches the vast Changtang plateau of Tibet, an immense and thinly populated steppe scattered with depressions in which saline deposits have accumulated. To the south lie the foothills of Nepal, India and Bhutan, seamed with fertile valleys whose inhabitants are consumers of salt. Hence the contacts and exchanges that have existed for centuries, prompted above all by the trade in salt, that vital treasure without which men and beasts alike would perish.

Salt lakes and salt deposits are plentiful on the vast expanses of the Changtang, home of the Drogpa people, but it is the salt-pans to the south of the high plateau that are exploited, owing to their relative proximity to inhabited regions. Since time immemorial, the nomadic Drogpa herdsmen (the name means 'men of the pastures') have supplied salt to the people of central Tibet and the high valleys of northern Nepal.

The natural resources of the regions to the north and south of the Himalayas are thus complementary in nature: salt and wool to the north, and cereal crops to the south. Trade in these commodities developed along the long caravan routes that traversed the high passes. No pass was too high and no terrain too treacherous – including the deep river gorges that could only be negotiated in winter, when the rivers were frozen – for these dogged traders with their vital merchandise.

Trabye Tsaka (longitude 31°30'N, latitude 83°50'E) lies to the north of the Tsangpo (Brahmaputra) river and the inhabited regions of central Tibet and the high Himalayan valleys. Its geographical position, relatively close to the Himalayas and hence to the principal north–south crossing points, reduced the difficulties involved in transporting heavy cargoes of salt. Each year in early spring, the Drogpa would leave their encampments, accompanied by their pack animals, yaks, goats and sheep, to make their way to Trabye Tsaka, the 'Salt Cellar of Prosperity'. Ten days' trek to the north of the Tsangpo river, Trabye Tsaka is a great salt-pan exploited by the nomads for their own needs, and it was from here that they set off towards the south.

Viewed from a distance, the salt-pan looks like an immense snowy expanse, gradually revealing itself as a crust of salt covering an area of several hundred hectares, which in summer becomes a vast briny lake. According to tradition, the salt was treasure (*ter*) belonging to Pholha Tashi Apa Gyepo, the 'Ancient Bearded Ancestor' who was the Drogpa divinity of the male line, and who revealed his miraculous treasure to men and entrusted its protection to the 'Purple Sheep' (*lugru mugpo*). A pure heart, ritual fumigation, offerings for the divinities of the land and the ancestors, and respect for the age-old regulations governing access to the site were the minimum requirements for those wishing to approach the salt deposits.

Exploiting the salt, transporting and trading it together make up a lengthy process. First of all the salt crust is broken up and a goat or yak horn is used to crush it into small pieces. Then it is put into a bag, and all openings are skilfully sewn up. The bags are then piled on top of each other to form loads of some sixty kilos per yak and twelve per sheep. Loading these heavy bales on to goats and sheep, in particular, is no easy matter, and the animals are not unburdened until they reach their destination in the herdsmen's spring encampments. The salt is then taken on to a series of Drogpa camps along the course of the Tsangpo river, where it is bartered with the inhabitants of the high Tibetan and Nepali valleys, with no money ever changing hands. These trading expeditions take place one after another, following a precise timetable drawn

up according to weather conditions and the activities of the Drogpa herdsmen and of the Sonampa, a sedentary farming people. A strict code of regulations governs these transactions, laying down in detail the itineraries to be followed, rates of exchange to be applied and traditional codes of conduct to be respected. One of the first rounds of trade to take place in the Drogpa camps strung out along the banks of the Tsangpo is with the villagers of the middle valley and from enclaves to the south of the Great Himalaya range, in the valleys of the Lo Manthang, the Dolpo, the Mugu and the Limi. The people who live in these valleys form caravans and journey into Drogpa country in order to barter a portion of the grain they produce in exchange for salt. The high altitude barley they bring is consumed in the form of a flour known as *tsampa*, made by roasting the grain before it is milled.

Caravans bring life to the Dolpo valley twice a year, and indeed it is salt from the Changtang plateau that keeps the people of these high Nepali valleys alive, not only because it is essential to the human metabolism but also because it sets up a beneficial exchange system with the inhabitants of the middle valleys which enables those in the high valleys to obtain a variety of cereal crops, an essential addition to their diet without which they would be unable to survive the harsh Himalayan winters.

The organization of caravans is the job of young men under the age of thirty. When a Tibetan boy reaches manhood and is capable of driving the herd, his father gives him a lighter (*me shag*) in order to make fire and a sling (*urtu*) to help guide the animals to pasture: these are the attributes of the future caravan-leader. The oldest man in the group prepares everything necessary for a journey of several days with the yaks, goats and sheep; he also selects the strongest animals, best able to

face the rigours of the terrain while carrying heavy loads. The members of the caravan wear ceremonial costumes, topped with the traditional four-peaked hat (*tsering khingkab*), and carry with them sweetmeats believed to bring good fortune, such as *kate* (a sort of fried biscuit). On the journey, they make sure that the yaks, goats and sheep find good pasture, and they travel in short stages in order to allow the animals to rest and regain their strength.

The day of departure is an occasion for celebration among the whole community. The lama blesses the animals, and the members of the caravan daub the horns of their yaks with ochre-coloured clay as an auspicious sign. The villagers accompany the caravan as far as the chorten that marks the end of their cultivated lands, and the caravan itself sets off, journeying in five or six stages until they reach the bartering place (*tsongdu*) in Drogpa country. As they cross the pass of Kore-la, beneath the highest peak in the Himalayas, they offer up prayer flags (*lung-ta*, meaning literally 'windhorses') and make a fumigation of juniper branches to appease the gods. At the *tsongdu*, two measures of salt are exchanged for each measure of barley, with care being taken to keep back a few grains to symbolize the quintessence, or *yang*, of the barley. These will be placed in a small casket that sits beside the hearth, in which a tiny fragment of everything with which the house owner has had to part is kept, so that it will live on.

This exchange system is not limited to cereal crops, but also includes a variety of other produce from the southern valleys, including rice, pimentos and goods obtained from Indian peddlers such as dyestuffs and aluminium kitchen utensils. When business has been concluded, tea is produced and everyone sits round the fire, endlessly chatting away. The return of the caravan, announced by a village herdsman who has spotted it

moving towards the valley in the distance, provides another cause for celebration. The women of the village go out to meet the travellers bearing ceremonial scarves (*kata*) and jars of beer (*no*) as symbols of welcome.

A second round of trade takes place between the inhabitants of the Dolpo valley and the people of the middle valleys of Nepal, who grow a variety of cereal crops. This trade, which takes place in the autumn, after the harvest, enables the Dolpo people to complement their own barley crop, which provides them with enough food for only half the year. These occasions offer the people of the upper valleys the opportunity to acquire a wide variety of produce, including rice, millet, eleusine (*ragi*, a type of millet), maize, corn, pimentos and spices. For these commodities, the rate of exchange is set at three or four measures against one of salt.

So this system of successive rounds of bartering offers something for everyone. But while exchanges that take place in Drogpa country remain limited to salt and wool, the basic essentials for survival, the further this trade extends into the mixed farming areas of the southern valleys, the more likely it now is to involve a commercial element, as barter inexorably gives way to cash payments.

In the final decades of the 20th century, a fundamental change took place in the system of bartering grain for salt. In Tibet, trucks have replaced yaks, sheep and goats; only in regions on the southern slopes of the Himalayas, more difficult to access, do these traditional pack animals survive. Yet for all that, this change does not spell the disappearance of the caravans' significance. For the truck drivers' cabins are now decorated with the eight auspicious signs, and ceremonial scarves flutter from the rear-view mirror.

All these transactions – whether the original bartering between the Tibetan tribesmen and the villagers of the high valleys of Tibet or the subsequent trade between the inhabitants of the upper and middle valleys of the Nepali slopes – are distinguished by a high degree of loyalty and trust, with dealings between different 'firms' carried out according to the laws of hospitality, and with each people respecting its own traditions.

And so caravans still remain the unifying force and vital axis linking two vast regions and two societies with very different strategies for survival. And the spirit of the caravan also survives, for the barter system establishes contacts and relationships between people that transcend differences in religious beliefs and customs, forming an emotional bond that is powerful enough to overcome social taboos, founded as it is on the basic essentials for survival.

'The salt of Trabye Tsaka is the jewel of the Changtang.'
Drogpa saying

THE MEANING OF PRAYER FLAGS

Anyone who has travelled in the Himalayas will have seen prayer flags fluttering gently in the breeze or flapping in the strong winds that sweep constantly across the Roof of the World. They are found wherever the Tibetan Buddhist tradition is practised.

Historically, prayer flags in their present form are believed to have been introduced to Tibet from India by the famous pandit Atisha in the 11th century. Atisha taught his disciples how to print sacred texts and the mantras of the various Buddhas on pieces of fabric. Fluttering freely in the wind, these flags became a source of merit for the disciple and a blessing for the environment, because the wind communicates with everything and the blessings of the sacred texts can be spread anywhere.

One reason why the prayer flags became so common in Tibet is that they echoed the ancient local Bön tradition, whose followers had for centuries hung wool from trees as an offering to the gods or to bring good luck.

The question remains: how are the prayer flags thought to work? They are not regarded as talismans, working by some form of white magic. Since happiness can be seen as an expression of good karma, the object is to accumulate the merit that will generate that good karma by printing and publishing sacred texts.

Hence these customs reflect the diversity of the methods used by Buddhism to stimulate our minds constantly. Everything in nature – the wind that blows the flags, the heat of a butter lamp that turns the prayer wheel, the rock with prayers carved on it, the water of a stream that drives the paddles of another prayer wheel – serves as a reminder, so that every activity, every part of nature, everything we see is an encouragement to prayer and altruism.

When a Tibetan prints flags and hangs them up to flutter in the wind, he is thinking, 'Wherever the wind goes after it passes over these prayers, may all living beings be delivered from suffering and the causes of suffering. May they know happiness and the causes of happiness'. He repeats the Bodhisattva's wish, 'May I attain wisdom so that I can help everyone to free themselves from the causes of suffering'.

These external aids are used so that everything we see and hear reminds us of this altruistic attitude and becomes an aid to meditation. Nature then becomes an instruction book. Everything around us encourages spiritual practice. This is a very human way of not forgetting the Buddha's instructions.

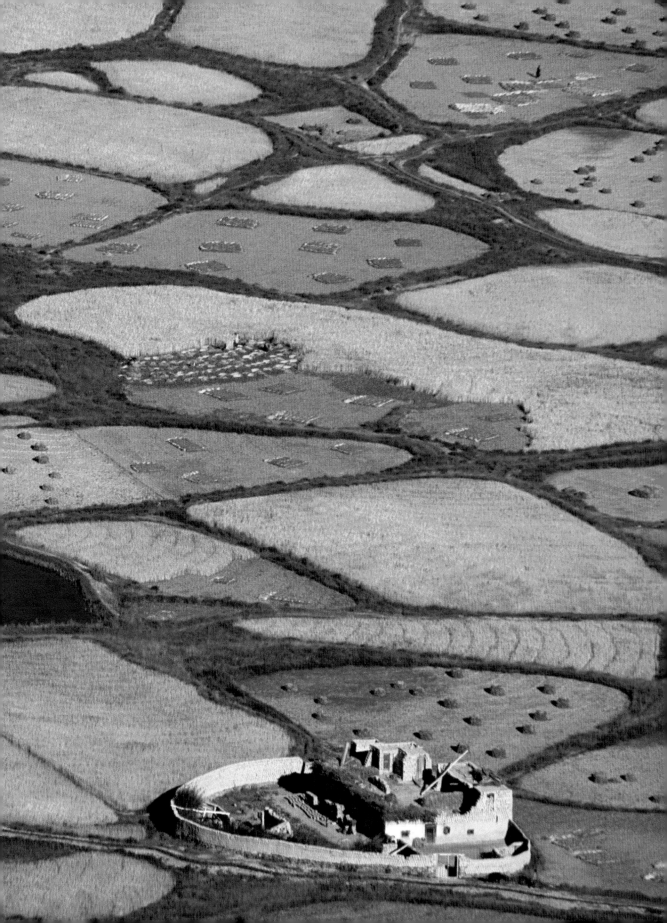

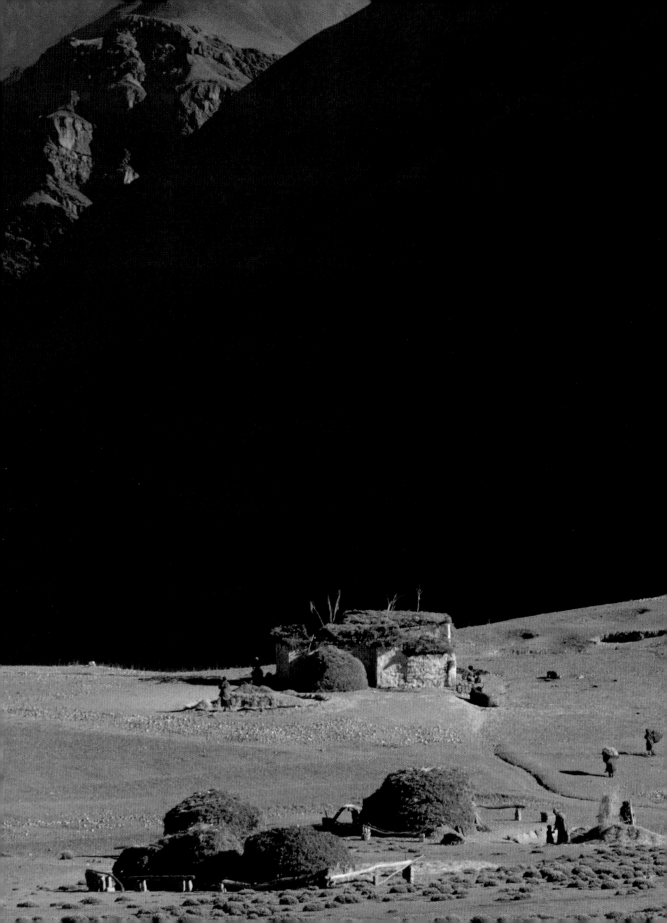

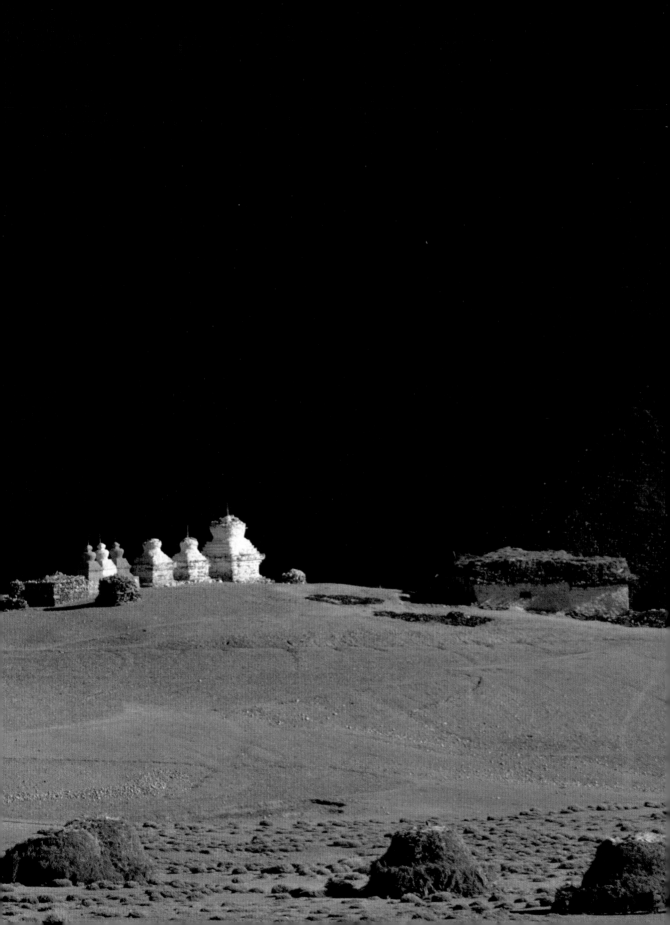

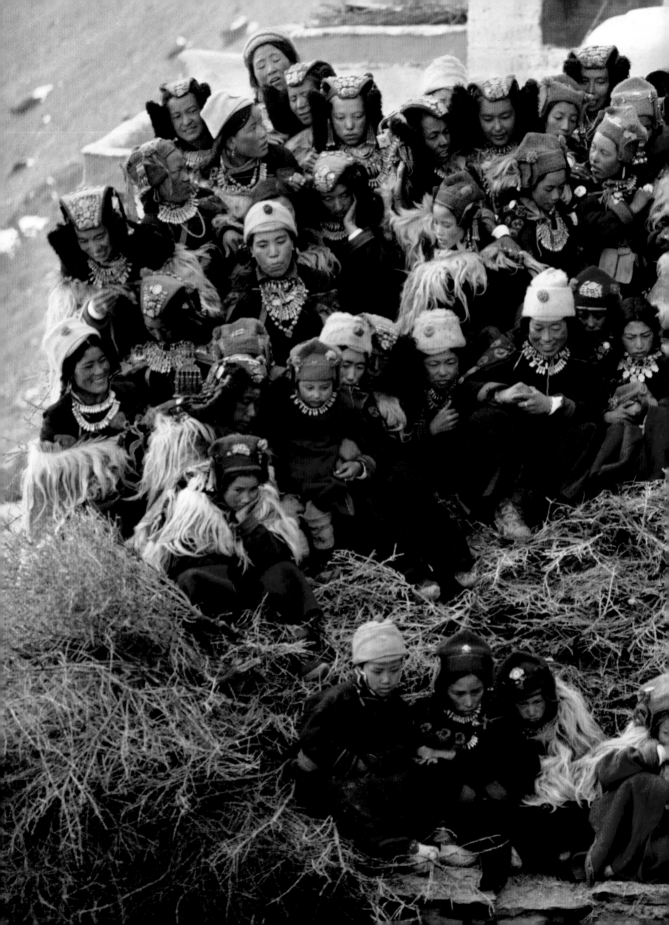

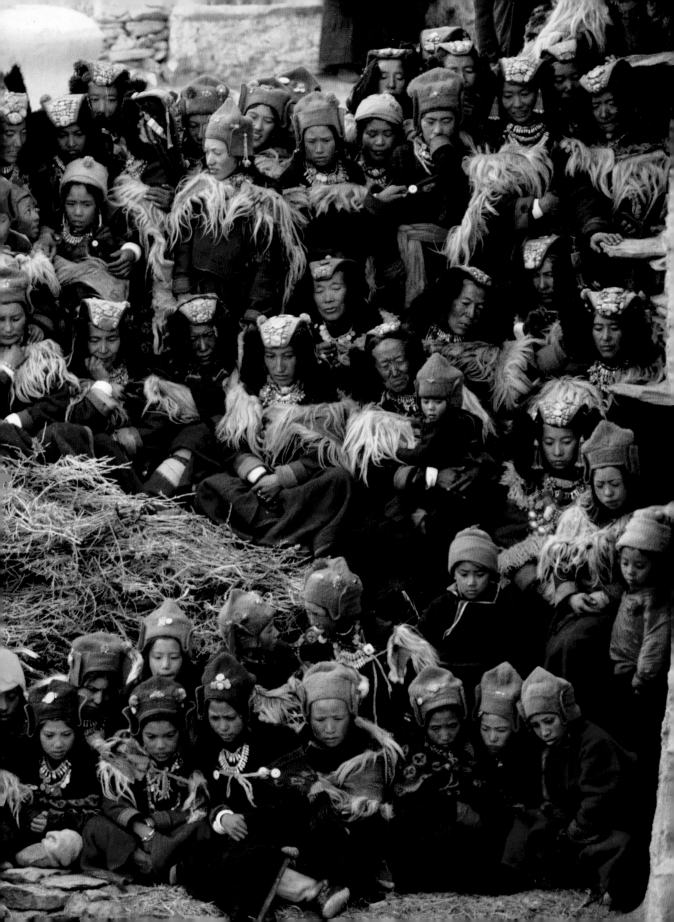

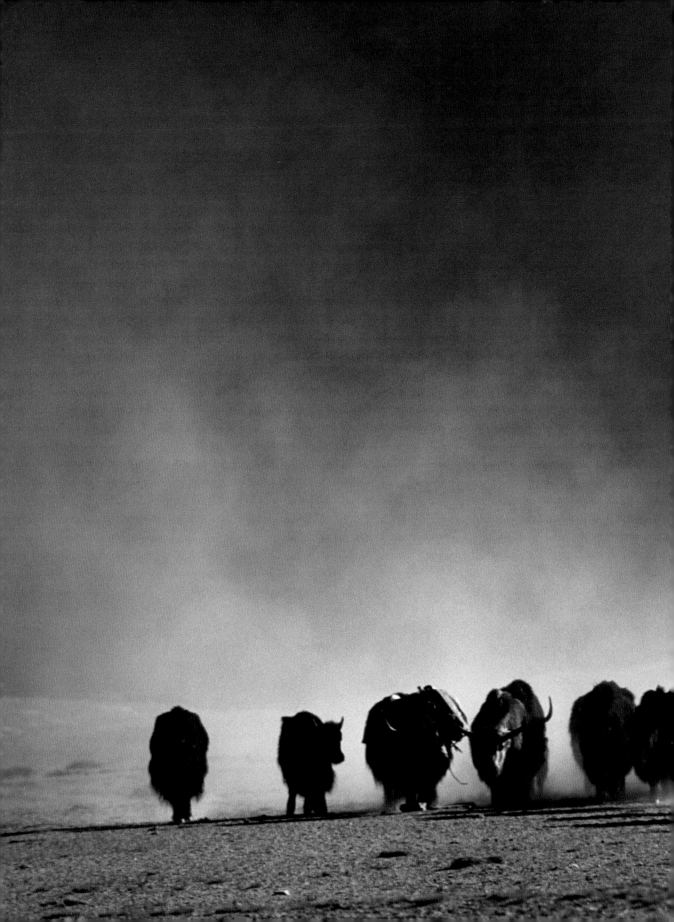

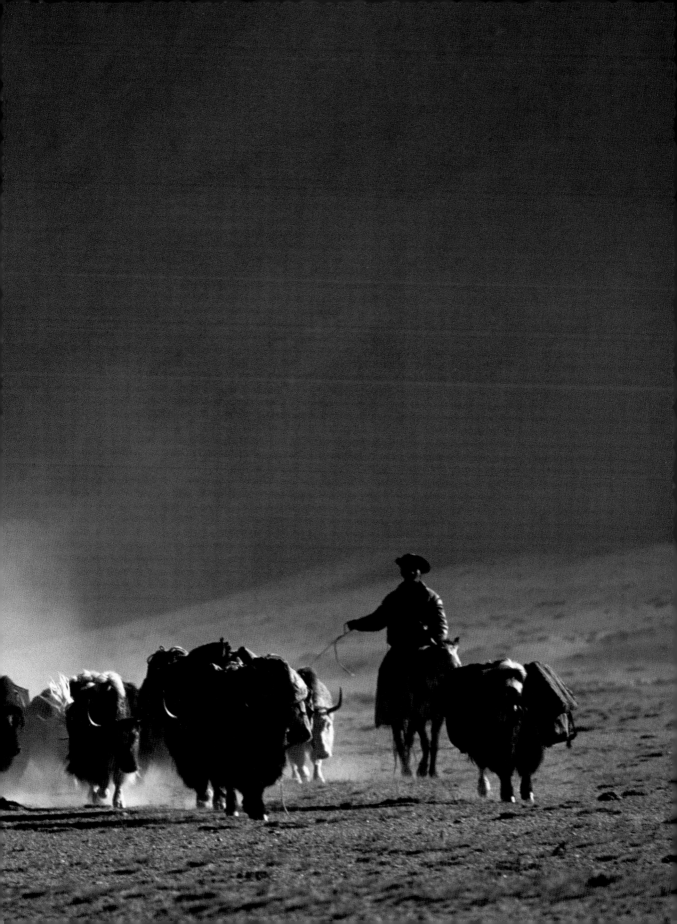

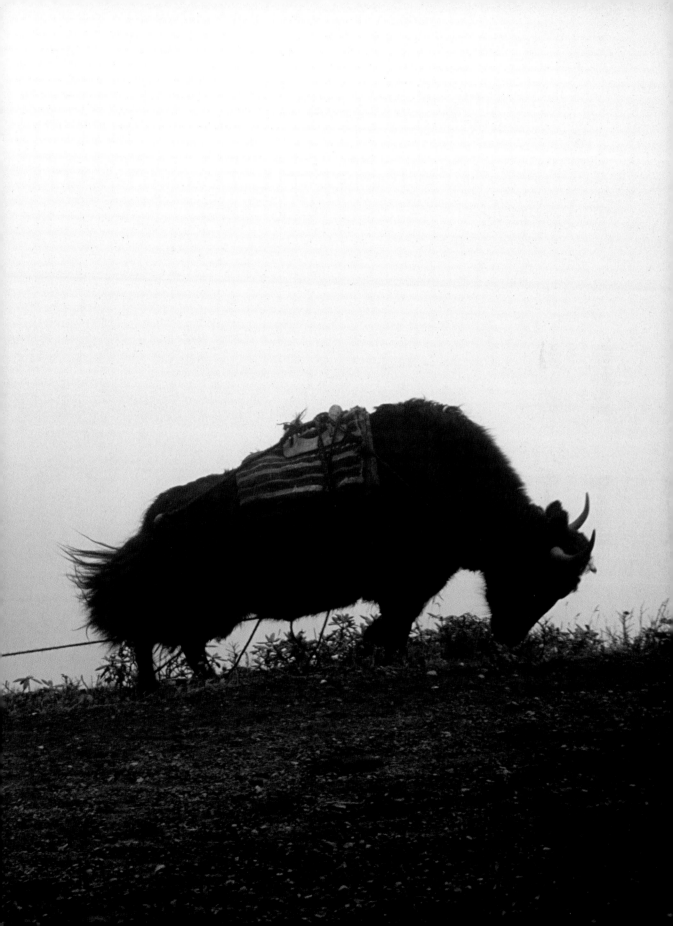

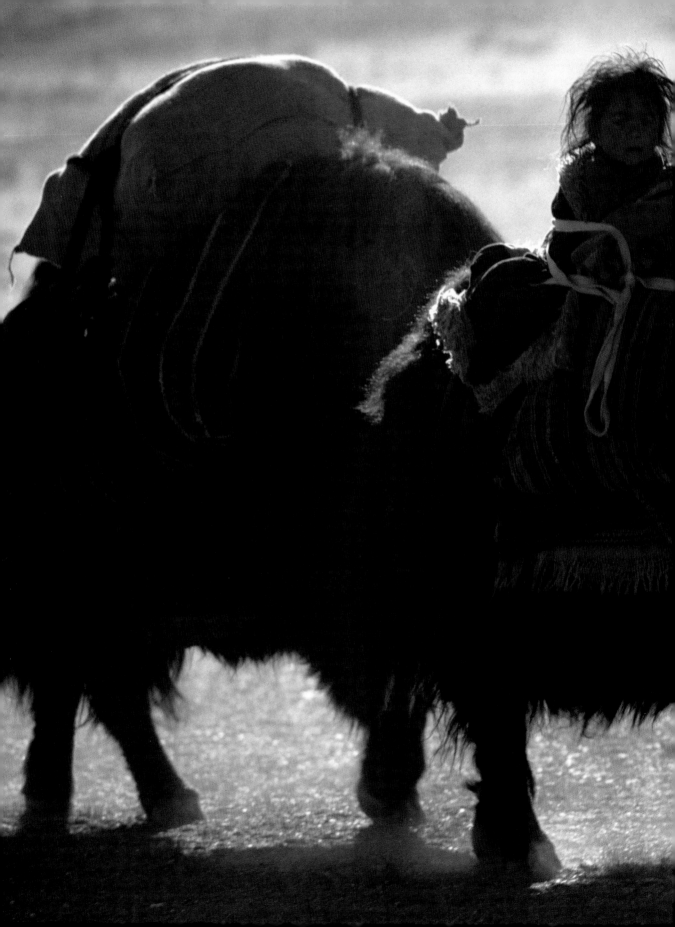

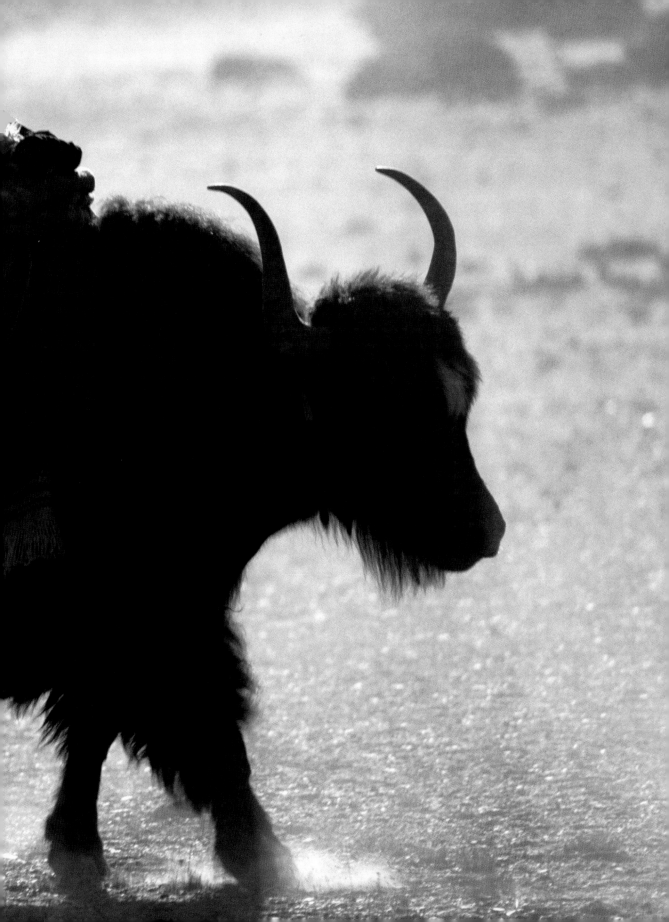

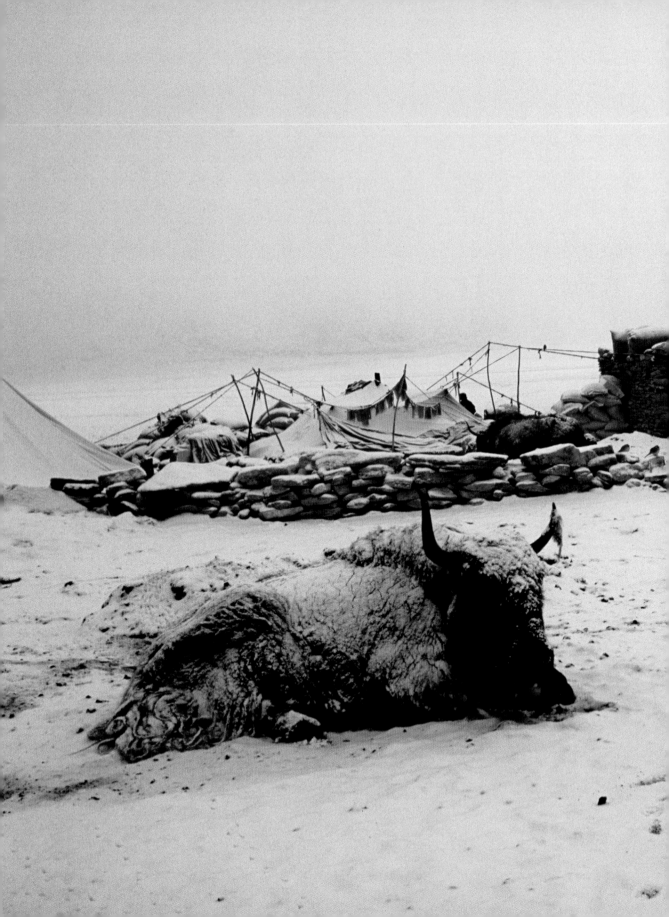

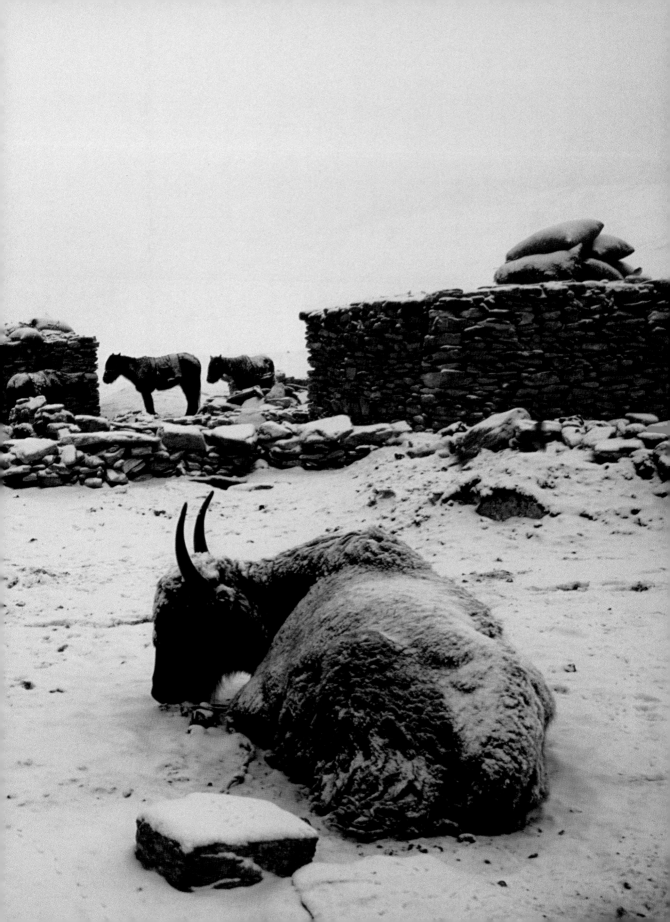

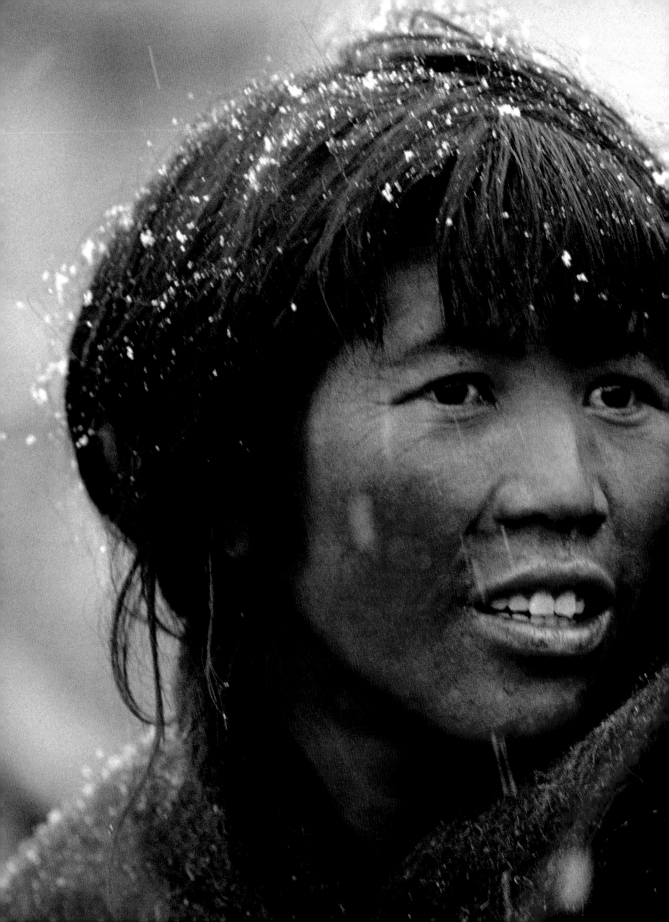

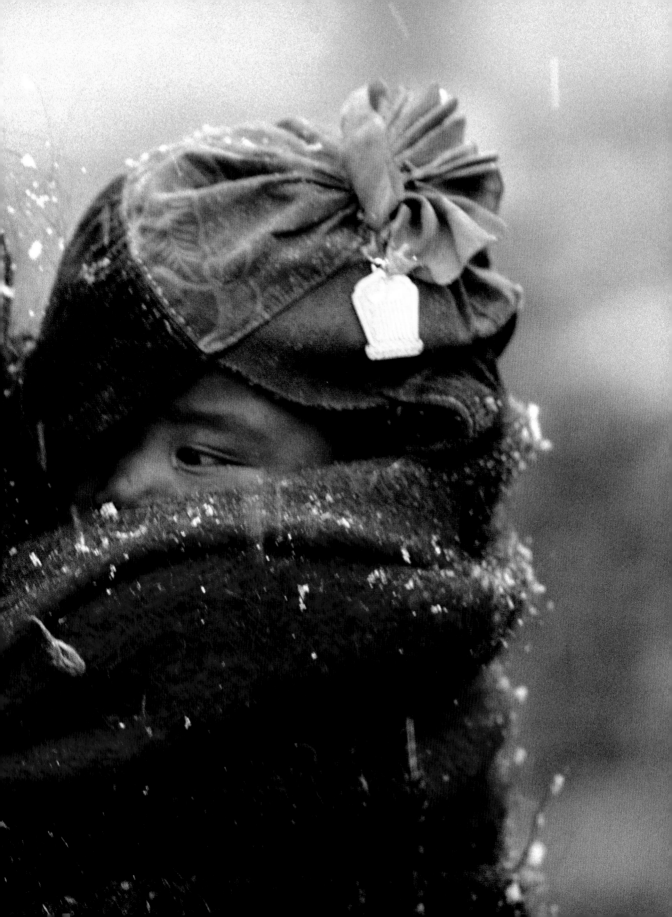

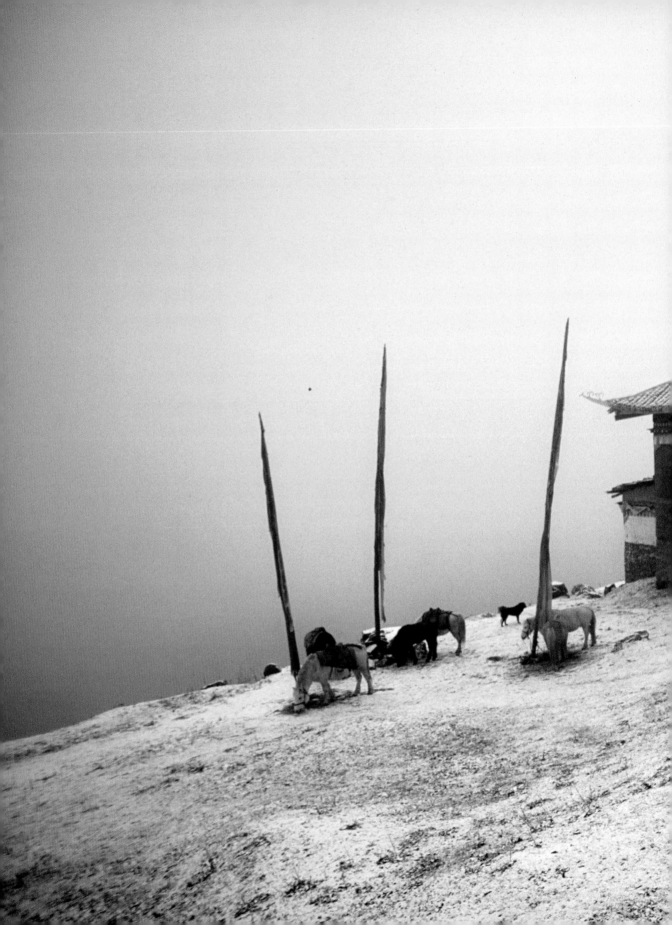

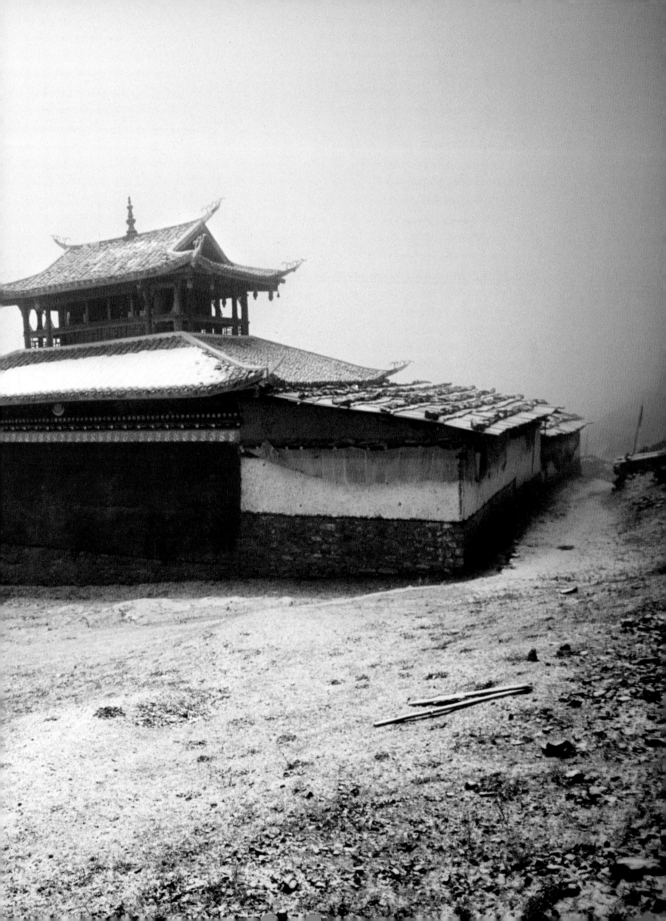

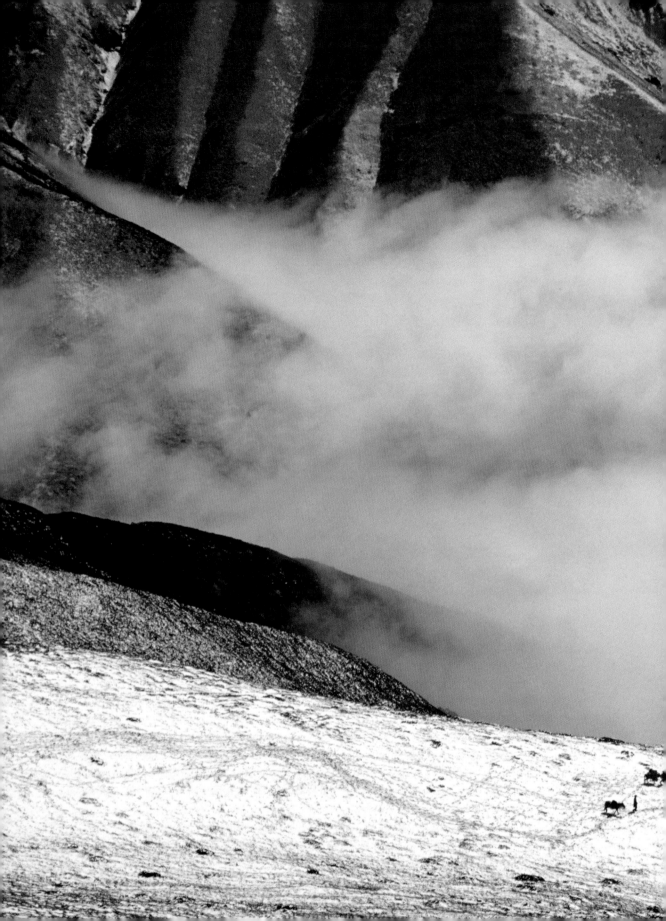

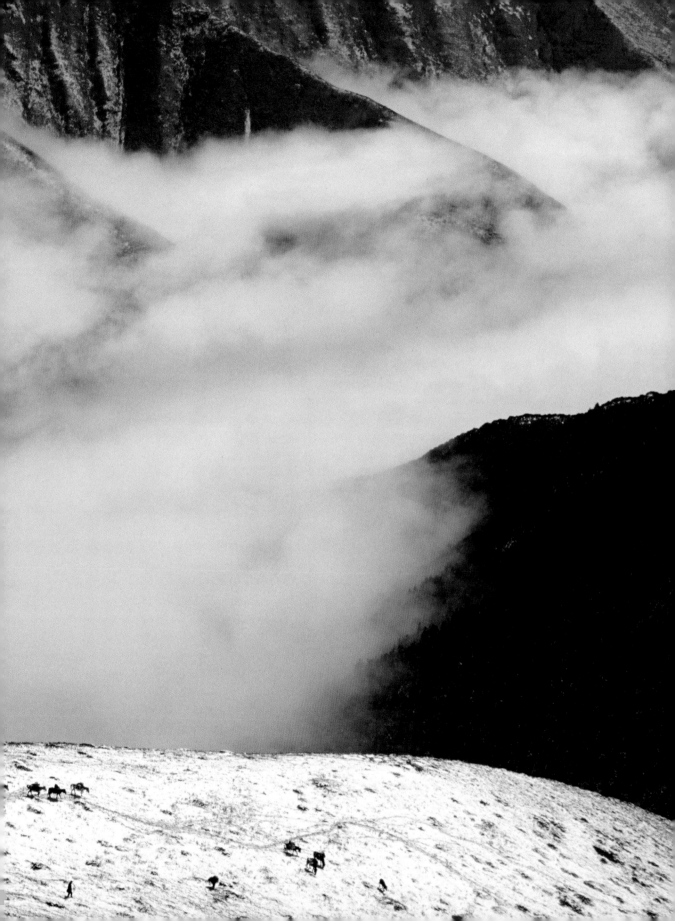

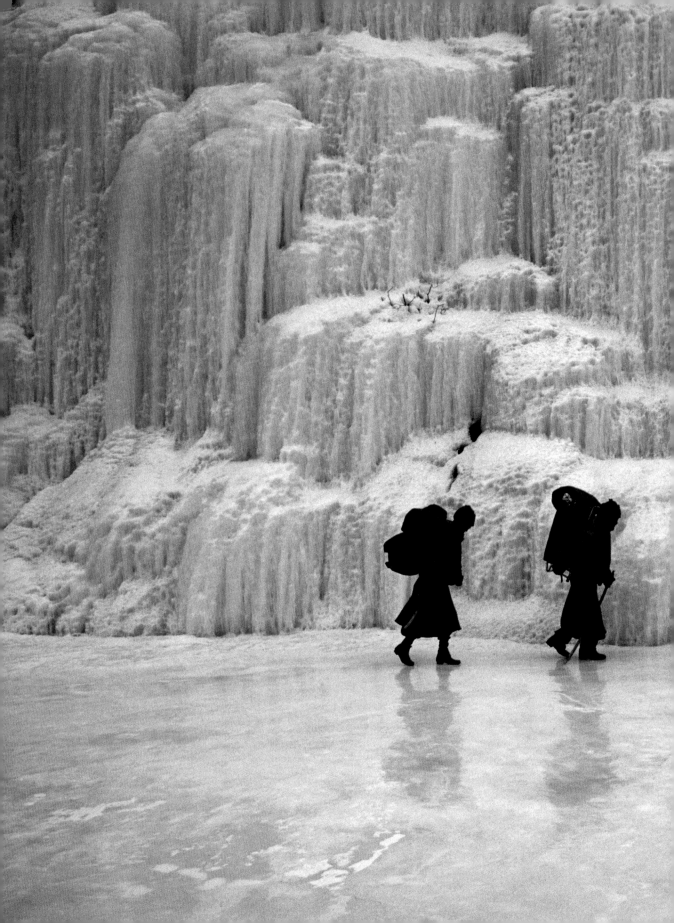

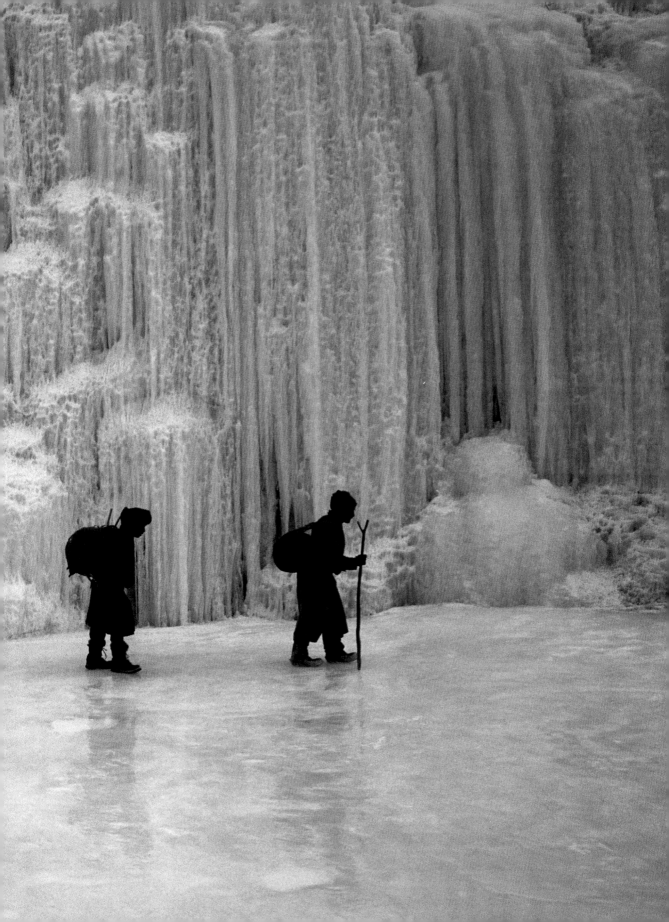

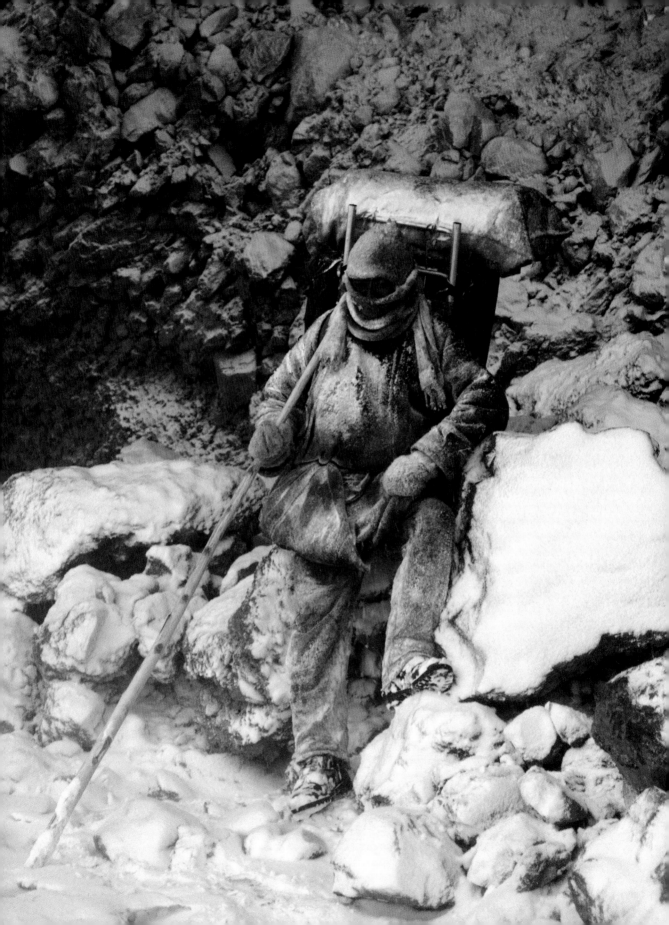

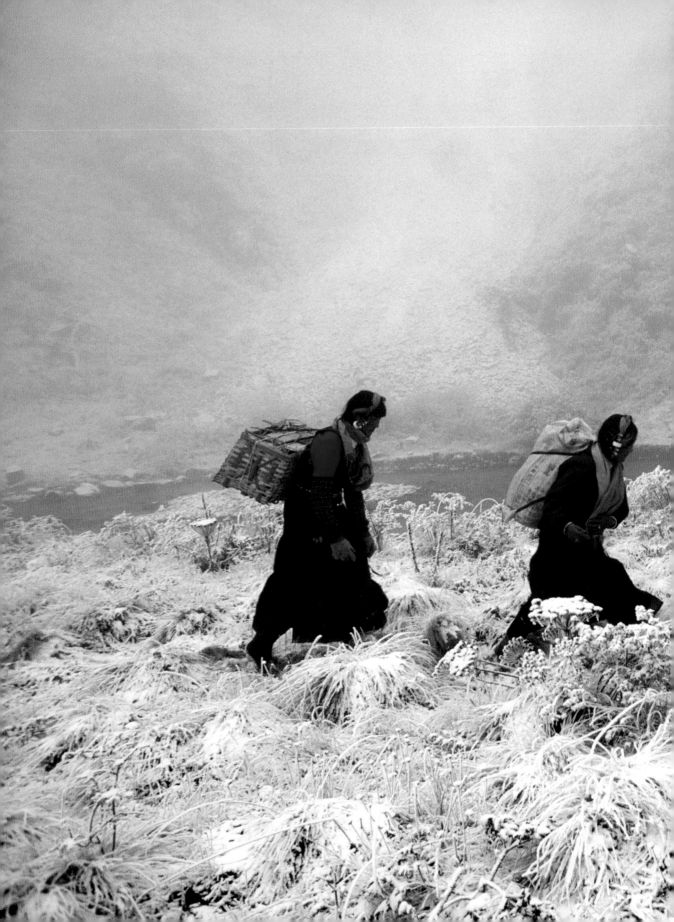

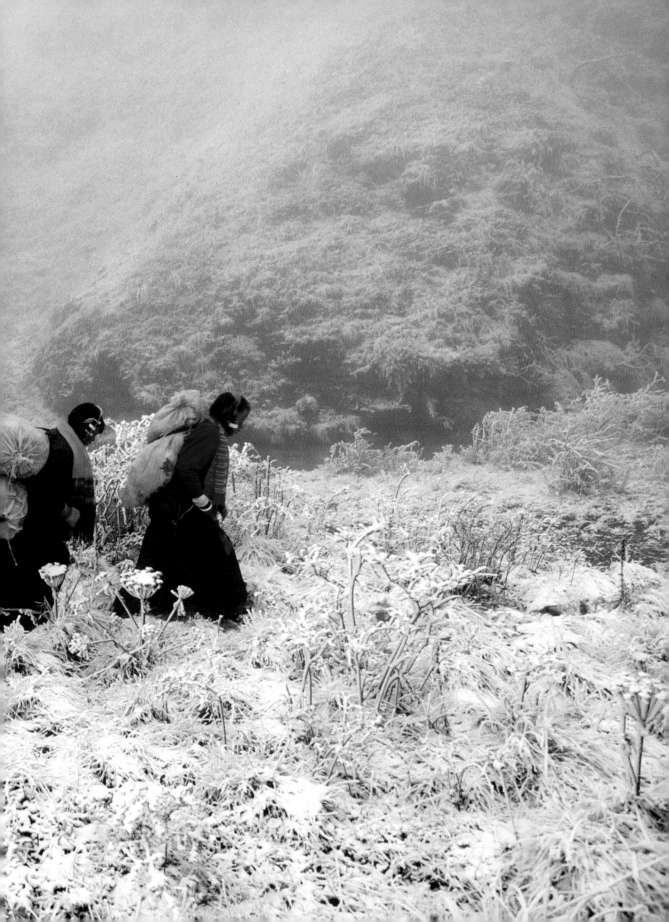

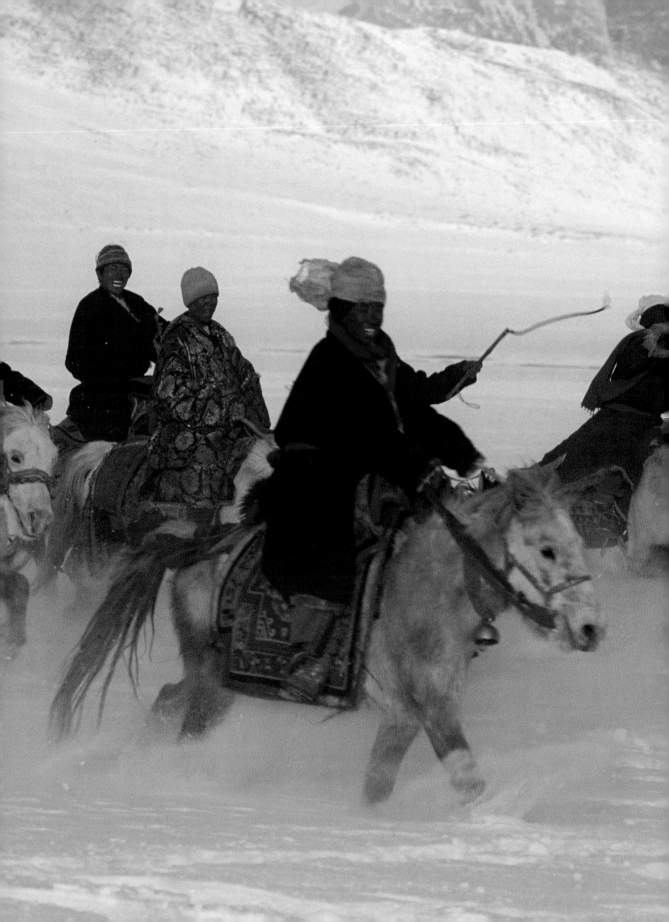

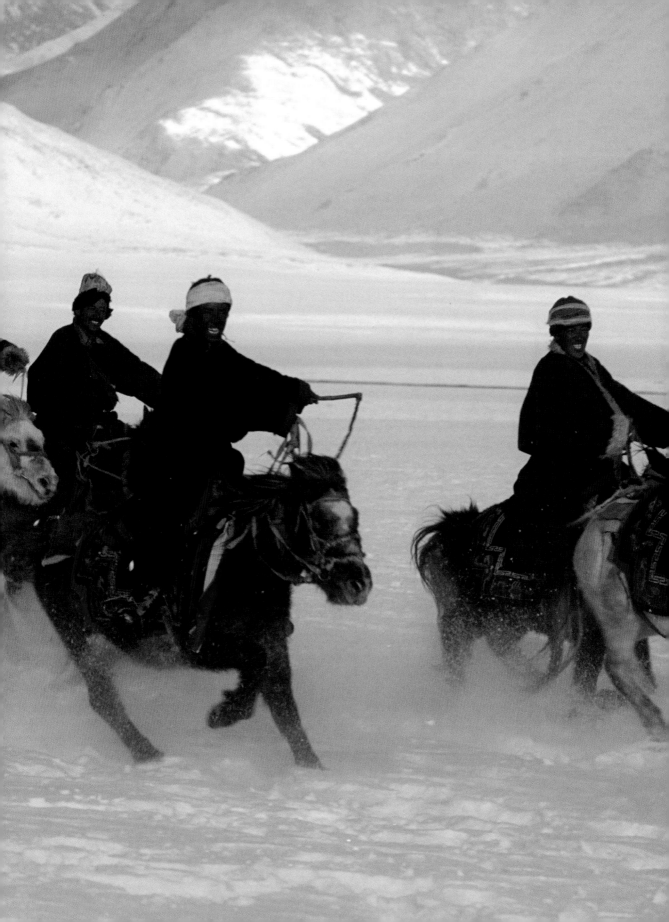

Nomadic Life
The People Who Move Behind the Sheep and the Goats

It was four in the morning and preparations were under way to move to Norchen. It was dark and a cold wind blew all around us. Tashi Zangmo quickly lit a fire and made tea. Tharchen and Angchuk took the tent down, folded it lengthways, inserted the poles in the middle and rolled it up. They then rounded up the yaks and began to load them. Carpets and blankets were first laid across the animals' backs, followed by saddlebags, stove, butter tea maker, hand-mill, and the loom. One yak carried a steel trunk, which contained Tharchen's prayer books, silver prayer boxes and offering bowls. Another carried the tent. One of the more docile yaks was chosen for five-year-old Chogyal to ride on, and a seat fashioned for him among the luggage. He cried as he was lifted and strapped on to the animal's back, but a few sweets quickly placated him. By five o'clock, Norgey had left with the sheep and goats. An hour later the horses were saddled, and soon the nomads were ready to move. Tashi Zangmo took out her *pad-rag* (turquoise-studded headdress) and balanced it on her head, then she mounted her horse and led the way for her family. As the snow-capped mountains shimmered in the first light of the sun, they gradually made their way out of Rina.

The caravan spread over at least one to two kilometres and within this, the pack animals of each tent were kept close together. The yaks were driven in the front, followed by the women and children. Dogs glided in and out, barking at the yaks to ensure they kept moving. The men, some with radios slung over their shoulders, came in the rear leading the horses. Behind them lay just a flat stretch of land, a few stone walls, and smoke rising from the burning embers of hastily doused fires.

'Look at the kind of life we lead,' Tharchen once remarked between moves of the camp, 'always moving, always packing, never staying in one place.'

'We have to keep moving,' Skarma pointed out, 'After all, we are the people who move behind the sheep and the goats.'

Tharchen resides in a brown yak-hair tent along with his younger brother Angchuk, their wife Tashi Zangmo, and their five children. His tent is one among several thousand that dot the arid landscape of the vast undulating, plains of Changtang or the 'Northern Plateau'. Changtang spans a thousand miles from Ladakh in the west, across Central and North Tibet, to the Chinese province of Qinghai in the east. The nomadic pastoralists who inhabit Changtang, often camping at altitudes ranging from 3,500 to 4,500 metres, live in an extreme environment where temperatures drop as low as −50°C in winter. They follow a migratory route which sees them shifting camp about ten times in a year. While the period of time spent at any one place is not fixed, each move, they will say, is dependent on the availability of pasture and water. The children who take the livestock out grazing will tell their parents that the grass on the mountains is virtually exhausted, and the women will grumble that the flow of water in the stream has ebbed. These sentiments are eventually conveyed to the chief, who calls all the men to a meeting, and a date is fixed for the camp to move.

Once the day for moving has been fixed, each family prepares itself for the journey. Saddlebags are taken out and examined for tears and holes. Clothes are washed if the stream in the next campsite

is going to be far away. Horseshoes are examined and repaired.

Along with the nomads move their large herds of livestock. These consist largely of sheep and goats, as well as yaks and *dri* (female yaks), and a few horses. Livestock is rarely purchased by the nomads who instead prefer to breed their own as they believe it is in their best interest to retain the purity of their stock. Dogs are also highly prized domestic animals, and are kept to protect the tent and livestock.

Each move to a new campsite is typically carried out early in the morning, just before sunrise, as later in the day it is too hot to walk. It was midday by the time the nomads reached Norchen, and each family moved to their hereditary tent site. Soon they were preoccupied with putting up their tents.

Tharchen and Angchuk busied themselves levelling the ground where they would pitch their tent, clearing it of stones and shrubs, and rebuilding the stone wall circumscribing the tent. They unrolled the tent and spread it over the wall, pulling at the ropes stitched to the four corners of the tent, stretching them over the tent poles and then tying them firmly to large rocks. While putting up the tent, they ensured they kept the door facing east. Tashi Zangmo explained the reason for this: 'We consider it inauspicious for tent doors to open towards the west, as this is where the wind comes from. Doors must always open towards the rising sun; it would be unlucky for us if we turned the tent's back to the rising sun.'

Once the tent is in place the women move in and begin arranging their kitchen. The stove is the first to be set up, a fire is lit, and soon tea is boiling away.

Four months had passed since the entire camp had last been together, and people who had not met since then renewed contacts and exchanged news. Padon had given birth to a daughter, Lanze was soon to get married, and Dawa Urgyal was arranging a feast to mark the ceremony at which he would bequeath his tent to his eldest son, Skarma Tagdol. The Manipa from Spiti had also arrived, and would soon be invited to each tent to read horoscopes and predict fortunes or unforeseen catastrophes. He would also perform the stone-breaking ceremony, which is symbolic of the destruction of all evil.

Every year at around the same time, usually the end of July but always after the sheep have been sheared, the nomads hold a large prayer ceremony at Norchen. 'It is for the good of our people and our animals,' Nawang Chogyal said, 'To protect us all, cleanse us of our sins, and eliminate all the misfortune amongst our people.'

This year the lama from Dubbock Monastery had been invited to preside over the prayers. A delegation of men, led by the chief, had already left for Dubbock to request his presence at the prayer ceremony. Dubbock was a small monastery, but the nomads of Rupshu had always sent their young monks and nuns to train there. No matter that it belonged to the Nyingma school of Buddhism, and they to the Kagyu.

Beliefs and practices associated with Buddhism are enmeshed in the nomads' lives. In a society that depends solely on pastoralism, it is not surprising to discover that animals are a crucial link between man and the gods.

'My elders once told me,' Abi Yangzom said as we sat in her tent in the evening and waited for the livestock to return, 'that in the

beginning our sheep were all different colours. They were mainly white, red, and blue. Some people say there were other colours also, like green, yellow, maroon, black, and brown. One day Gyamo Konjor, a princess from a neighbouring kingdom, came and she decided to take all the sheep for a walk. Along the way she came to a big river, and she made all the sheep walk through it. The water washed away all their colour and since that day we have only had white sheep.'

The Buddhist pantheon is represented by a hierarchically structured three-tier division of the world. The uppermost level is inhabited by the gods; the lowest by spirits of the aquatic and subterranean worlds. People live between the gods and the spirits, in a world which is also inhabited by demons. The three worlds are depicted by a system of colours: white for heaven, red for earth, and blue for the aquatic and subterranean realm. That the nomad's sheep were once mainly these colours is not, therefore, coincidental.

The nomads believe that their livestock are intrinsically sacred animals bestowed upon them by the gods. As a result, each nomad family's herd will contain sheep representing the three worlds. These sheep are specially consecrated, and it is through them that the nomads invoke the gods for blessings and make offerings to the spirits to appease them. The gods and spirits are constantly invoked and appeased by the nomads, and one way by which they do this is through the regular propitiation of their livestock. Each morning, once their owners offer incense at the altar in their tent, it is then taken outside and offered to the livestock. At the time of the annual prayer festival the animals are brought before the rinpoche who blesses them, offers each of

them a ceremonial white scarf (*kha-btags*), and ties a religious thread (*sru-nga*) around their necks.

Apart from a source of divine blessings, the livestock are also the nomads' sole source of livelihood. It is from the sale of their fibres that the nomads survive. The main fibres the nomads trade in are sheep wool and pashmina, though they also sell a little goat and horse hair. However, they do not sell any yak hair and yak wool as it is not abundantly available and they require it for the making of their own fabric. Yak wool is warmer than sheep wool and they use it to weave their blankets and carpets, while yak hair is kept to weave their tents.

The removal of fibres from the livestock takes place only once a year and for the nomads this usually begins around the end of May. The season commences with the combing of pashmina from the goats, followed by the removal of hair and wool from the yaks, and ends with the shearing of the sheep. Once the removal of fibres is completed and after the annual prayer ceremony, the nomads can then begin trading their wool and pashmina. They have to work expeditiously, as they must complete all transactions before the passes get blocked with snow.

The chief holds a meeting to officially declare the season open, and to discuss prices for the current year. Though outer limits of the price of pashmina and wool are set by the chief, decisions regarding whom to sell to are taken individually by each family. While sheep wool is generally bartered for barley with villagers, pashmina is sold for cash to Muslim traders whose families have been following this profession for centuries.

Sheep wool is also widely used by women for weaving blankets, carpets, bags, belts, and

fabric for their clothes and boots. Each morning after the sheep and goats have left for the day's grazing, it is a customary sight to see the women stretch out their looms in the pens the animals have vacated. While the women bask in the sun's warmth, exchange news or gossip with each other, drink innumerable cups of butter-tea and consume spoonfuls of roasted barley flour, they are absorbed with their weaving. Deftly raising one heddle rod at a time, they pass the warp threads through the weft and then push them down with the wooden beater. Other women join them, busying themselves with further wool-related activities such as spinning and carding. Even the children are involved; they scrounge around the pens for any stray bits of wool and hair the animals may have shed during the night. Later they will exchange their small bundles for sweets with passing traders.

The men also weave, though their repertoire is not as extensive as the women's. They primarily weave saddlebags and tents. The tents are square in shape, and have a flat roof. An entire tent is seldom woven at one time, as Tharchen explained: 'The black tent is something we inherit from our fathers; it is passed down and not something that will be made in one generation. I got my tent from my father, who got it from his father. Some sections of it are very old, probably more than 100 years, but other parts have been recently woven by me. Tent building goes on like this.'

While tents are essential for shelter on the Changtang, saddlebags are used when the nomads go salt collecting. This is usually done in the fall, after the water in the lakes has dried up.

By evening the sheep and goats return from the day's grazing, and are led into the stone pens where they will spend the night. But first the females have to be separated from the rest of the flock and milked. This is women's work, and they tie the animals, each facing the opposite direction, by looping a section of the rope over the neck in a slip knot. The women work their way twice up and down the line of animals, milking them, and once finished, they pull the loose end of the rope and the slip knot unravels to free the animals at once.

As night approaches the flicker of oil lamps, from inside many tents, can be seen burning the length of the valley. As stars fill the pitch-black sky, the cold wind rises up again. The outlines of the prayer flags fluttering on the roof of Tharchen's tent can be discerned, as smoke rises up through the smoke hole. Tashi Zangmo picks up the goatskin bag in which she churns her butter, and softly chants her prayers to the motion of the moving bag.

By Firelight
A Family Evening in Zanskar

Shrouded in snow, the high valley of the Luknak in Zanskar is cut off from the world throughout the long winter months. Dwarfed by the virgin snowy expanses, four houses perch above the frozen river. It is barely two o'clock in the afternoon. Blue shadows creep up this ribbon of ice to engulf the hamlet. The sky is vast and limpid. The silence is deafening, the cold lacerating. The animals return to their byres, chilled to the bone.

To join Dorje's family in the room beneath their stone house that is their refuge in winter, you have to negotiate a cramped labyrinth of dark passages and cross the byres on tiptoe, passing through six tiny doors that squeak and groan loudly on their hinges. The best plan is to let little Tashi be your guide, holding his hand as you go. Otherwise, you run the risk of bumping your head against an unseen beam or stumbling over a sleepy yak. When you reach the room, which is barely high enough to stand up in, you find the family sitting cross-legged in the half-light, forming a circle around a small tin stove. The temperature is barely one degree Celsius. In his great robe of deep red wool, Dorje blows on the dry brushwood embers, his forehead almost touching the floor. Suddenly a glowing flame leaps from the hearth, and the greasy smoke that fills the room slowly disperses. Two skylights let in a feeble light. In a dark corner, a pair of kids, born at the full moon, bleat and shiver. Set on a copper bowl turned upside down, the yellow flame of an oil lamp casts a weak, flickering light on each silent face.

With her straw whisk, Diskit Lhamo mixes barley flour and butter from the mountain pastures into some simmering water. Then she adds a handful of hard cheese and leaves the soup to simmer in the stone pot. *Tukpa*, which warms the whole body, is a treat on winter evenings. Waiting patiently are her two silent children and grandfather Meme Anchuk at his prayers. Diskit Lhamo's gestures are the gentle, reassuring ones of a fulfilled mother. Her expression is candid, her smile serene. On her head is a heavy turquoise and coral *peyrac* that she inherited from her mother on her marriage to Dorje. She wears a fine goatskin, with long white hairs down its back. A turquoise necklace embellishes her only dress, a long robe of claret-coloured wool impregnated with the smell of woodsmoke. Her shoes are sewn from goatskins. Diskit Lhamo means 'happy goddess'. Cheerful and determined, she is the hub around which the family revolves. Working from dawn to dusk, she milks the nanny goats, fetches water from the stream, cooks, cleans out the byres, and purifies the house each morning with a musical prayer and a stick of juniper incense. While the soup is cooking, she spins goats' wool with a smooth movement. Each time she draws her arm back towards her before slowly letting it fall, her eyes follow the movement of her hand as it nimbly twists the wool; as she turns softly towards the heat of the fire, the flames light up her tranquil face. Rested and replete, her youngest son dozes on her knee, still suckling at her breast. Whenever he loses that contact, his eyes open wide with a lost expression; then as soon as he starts to suckle again he nods off, a picture of trusting innocence and security.

Seated cross-legged beside the flickering flames, Dorje sews a shoe out of animal skin. Like all the men of Zanskar, with their uncomplicated attitude to life, Dorje is reserved by nature. With his distinguished bearing, his gentle voice and his quiet, rippling laugh, he is loved and respected. The laconic Zanskarpa live in harmony with the silent mountains. The few words they exchange are uttered in a low murmur. In the Tibetan region, it is impolite to speak loudly. Seven-year-old Tashi watches his father as he works, silently undergoing his initiation into the tasks of daily life. Aware that his son is observing him, Dorje sews with particular care, sticking out the tip of his tongue in his concentration. This is how he teaches his children about life, about the importance of every task, and the meticulous care and honesty with which it should be carried out: without morals or words, simply by example.

Sitting in a corner of the room, wearing a heavy goatskin robe worn skin side out, is another Tashi, a young cousin deep in sorrow. His young wife bled to death giving birth to their first child. During her long death agony, her dead baby lay on her stomach. Such terrible events are common: half of all children die before reaching the age of three. The local doctors, known as *amchis*, use herbs to heal, a tradition learned from their fathers. But their powers are limited. In these mountain villages life is a struggle, but death comes easily.

'*Acho Tashi, done eh!* Drink, big brother Tashi!' Gently, Diskit Lhamo encourages Tashi to drink his glass of sweetened tea, a privilege reserved for guests, while it is hot. When the Zanskarpa address each other, they always invoke a tie of kinship, such as *nono* (little brother), *achang* (uncle) or *ache* (big sister). These simple and direct connections ensure that everyone always feels welcome and supported, wherever they may be.

Within the family, tasks are shared out quite naturally. Everyone does the jobs that fall within their capabilities. Children look after newborn babies, carrying them on their backs parcelled up in goatskins. All through the year, they run after the yaks to collect the fresh dung, which they form into pats and lay out to dry on stones, later to be used as fuel. Old people with still-nimble fingers spin wool or weave garments. As they grow stiffer and wearier, so they are allotted tasks that call for more patience. When they are infirm, they serve as summer bird-scarers to deter sparrows from stealing the grain on the roof. In winter they pray for their children and for the good of all living creatures. Right up to their last breath, they continue to make themselves useful. Gentle and wise, they demonstrate to the young that life is still worth living, even when you are old. Keeping himself warm beside the little stove, Meme Anchuk, the grandfather, reads in a sing-song voice from the texts in his thick prayerbook balanced on his knees, following each line with his calloused index finger. His beads – one hundred and eight wooden globes worn smooth over the years – are wound around his right fist. In the spring, if he is still alive, Meme Anchuk will pray on his roof, sitting cross-legged in the sun, his face turned up towards the eagles that swoop in the sky. How old is Meme Anchuk? Even he has no idea. His face is furrowed by wrinkles; his life has been harsh, but his eyes remain gentle. He has eight surviving grandchildren, the youngest of whom is already adept at milking the nanny goats. His life must therefore span a good fifty winters. Nobody – neither the monks nor the head man – keeps a register of births in the village. What does age matter when life is lived according to the seasons? Wrinkles offer a rough idea of age, but as each person's experience of life is different, so everyone displays the age corresponding to their level of vitality. The Tibetan calendar follows a cycle of sixty years, after which it starts again from the beginning, inexorably, just as people take each other's places and one generation succeeds another. One life leads to another, just as one step leads to the next on the stony path that leads to Enlightenment.

Diskit Lhamo serves the last bowl of soup to her sleepy children. Dorje takes the copper ewer engraved with a symbol of good fortune and pours bowls of *chang* for Tashi and grandfather. The family gazes into the fire, listening to the embers crackle and fizz. They exchange few words, but the silence is filled with contentment, with attentive looks and tender gestures. Outside, the dancing stars, the night cold and the disc of the moon above the icy peaks seem to weigh down on the huddle of four houses. The hoarse yelping of a dog cuts through the frozen silence: is a snow leopard on the prowl? After a last bowl of *chang*, Tashi goes home. Diskit Lhamo unfolds two old yak skin rugs on the floor, and the family lies down together, sharing the same heavy cover. Dorje takes the little oil lamp and quickly blows it out, and soon the darkness of the night is filled with dreams.

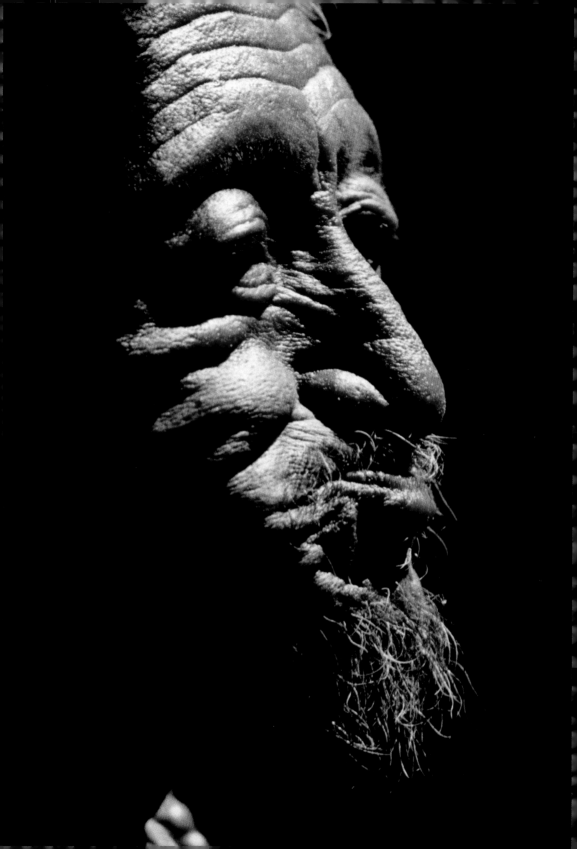

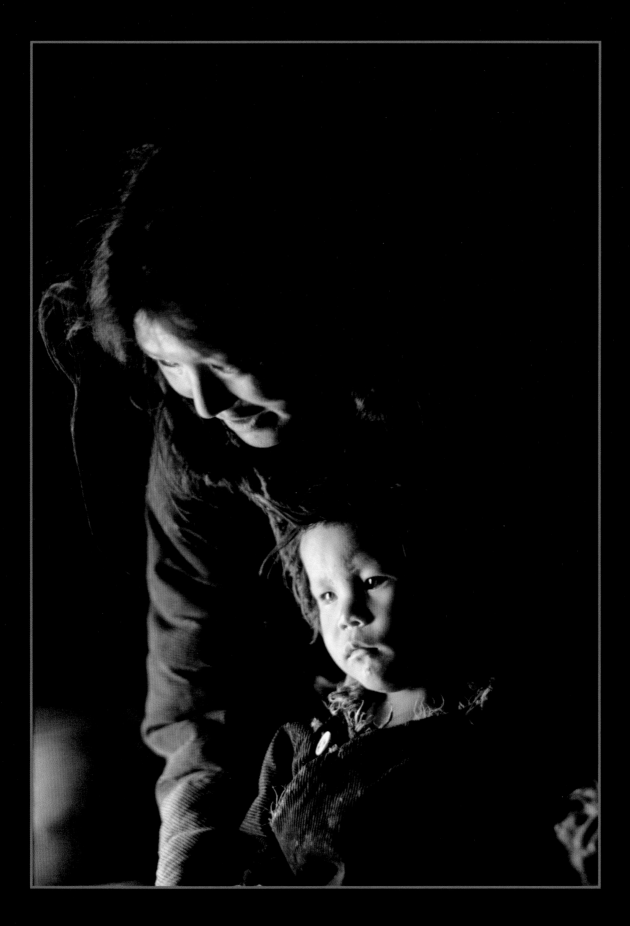

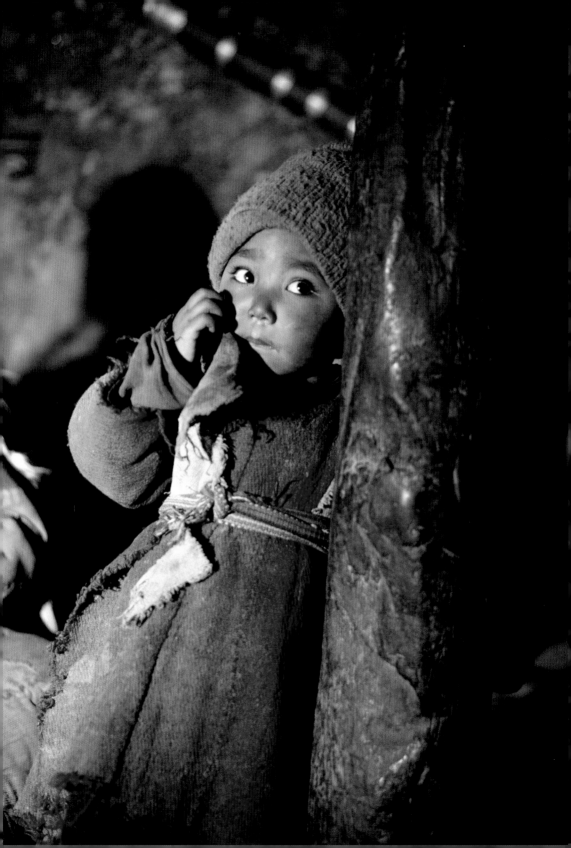

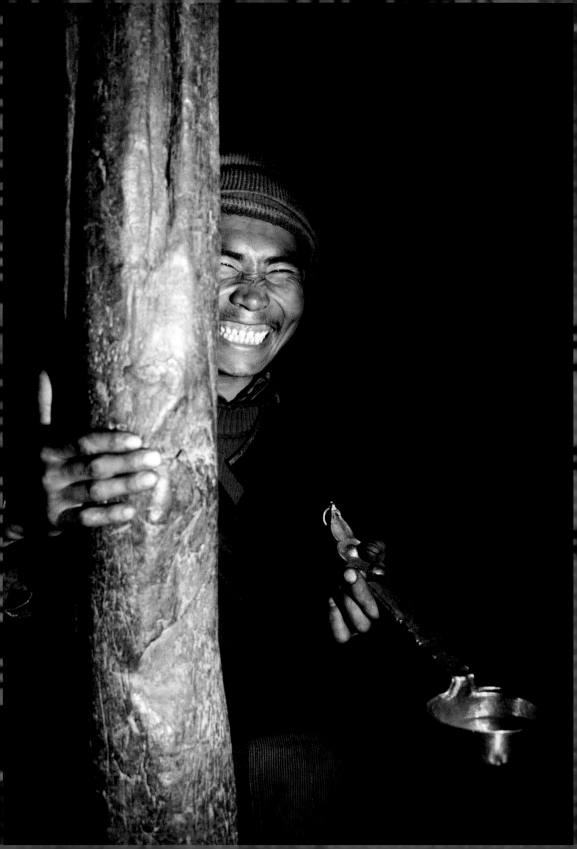

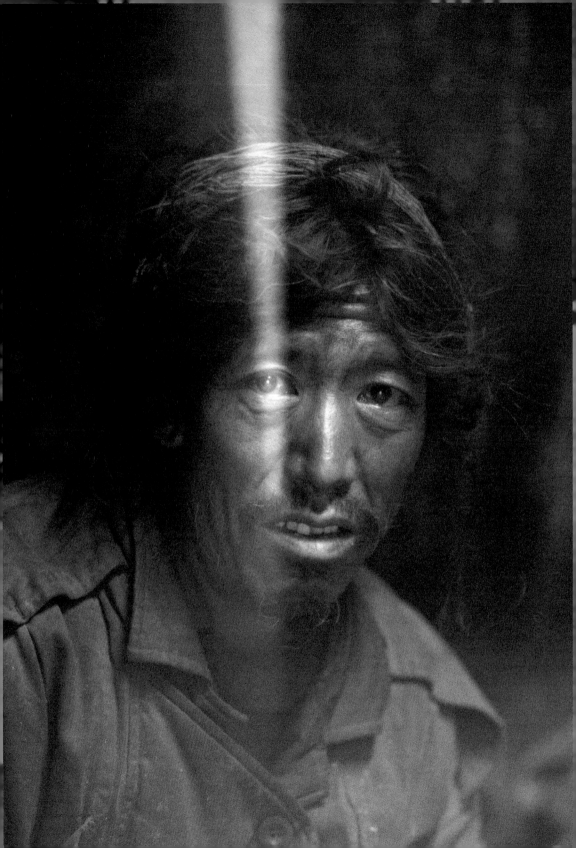

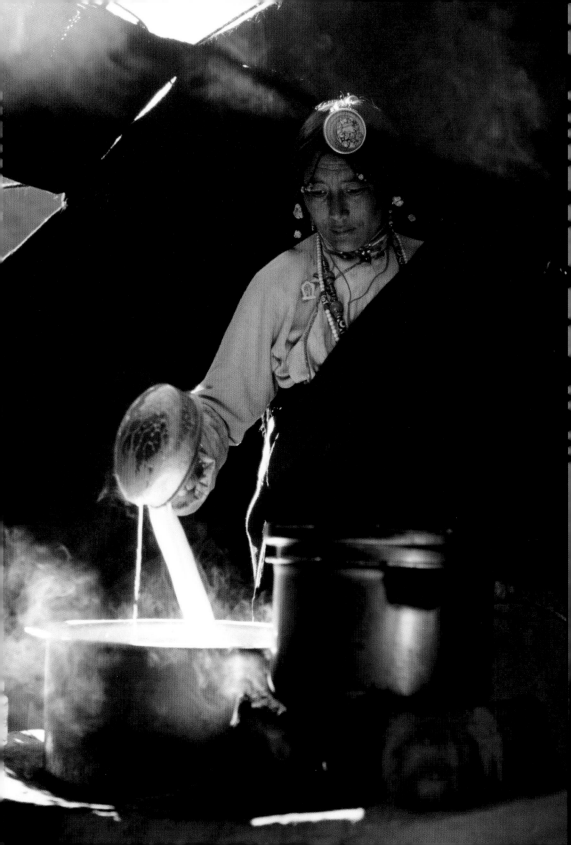

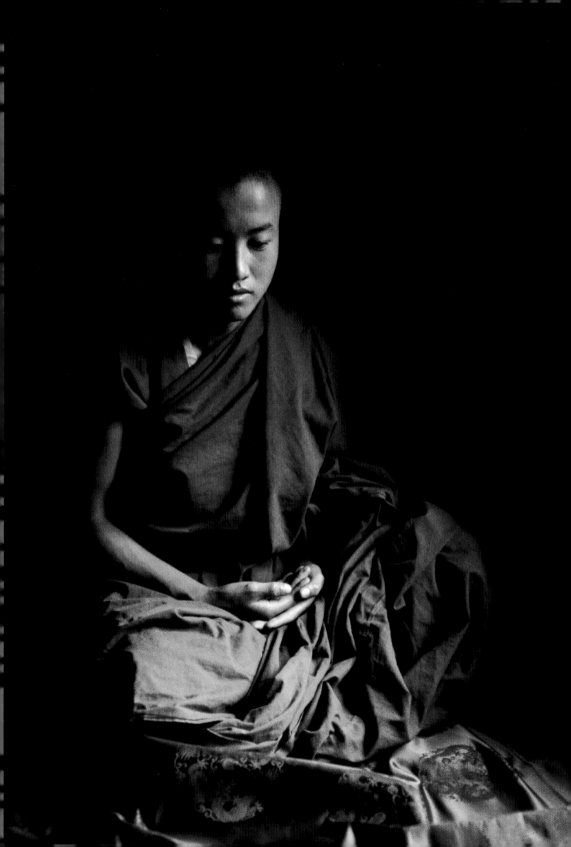

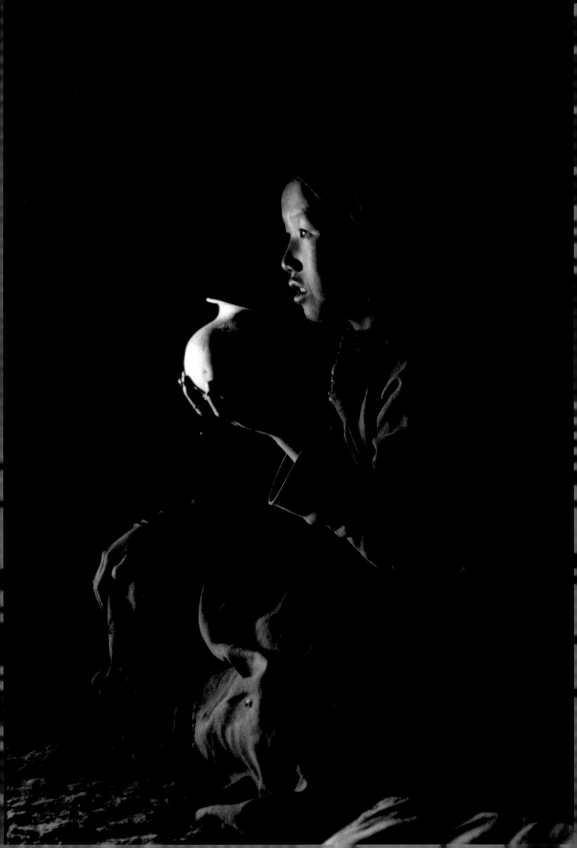

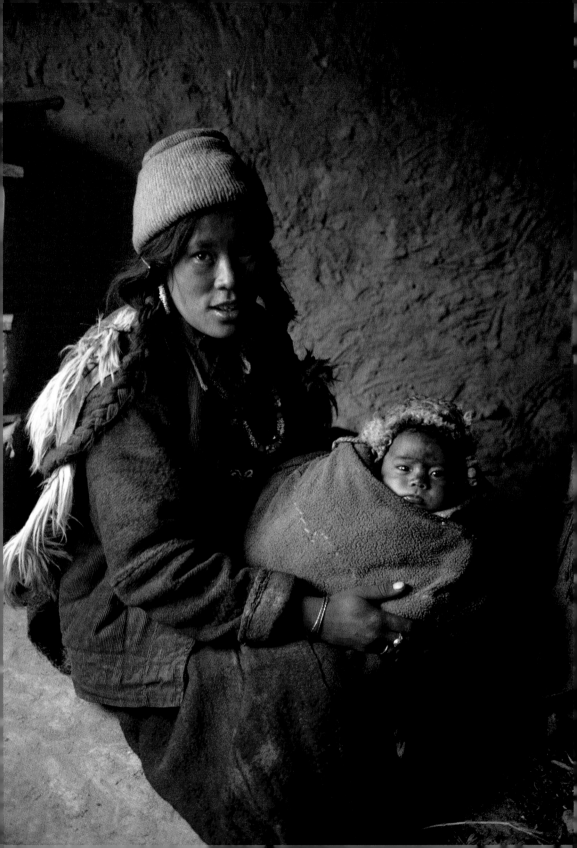

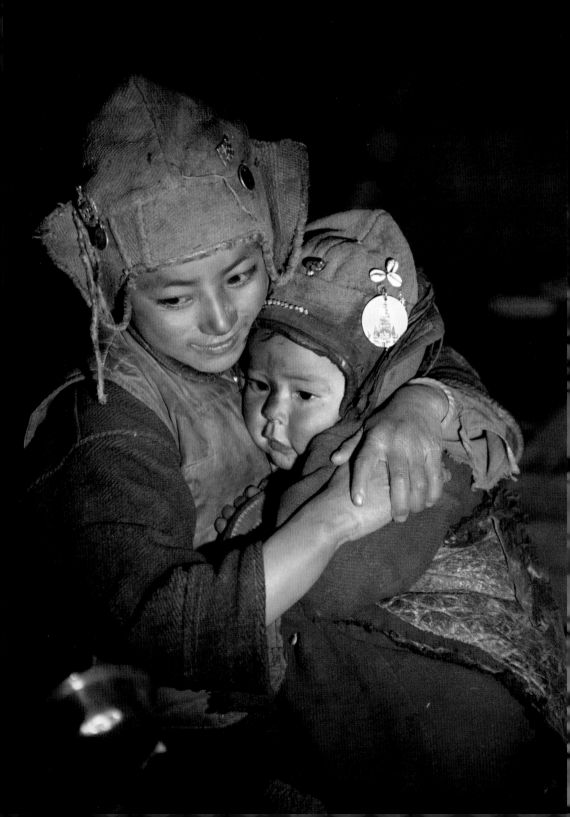

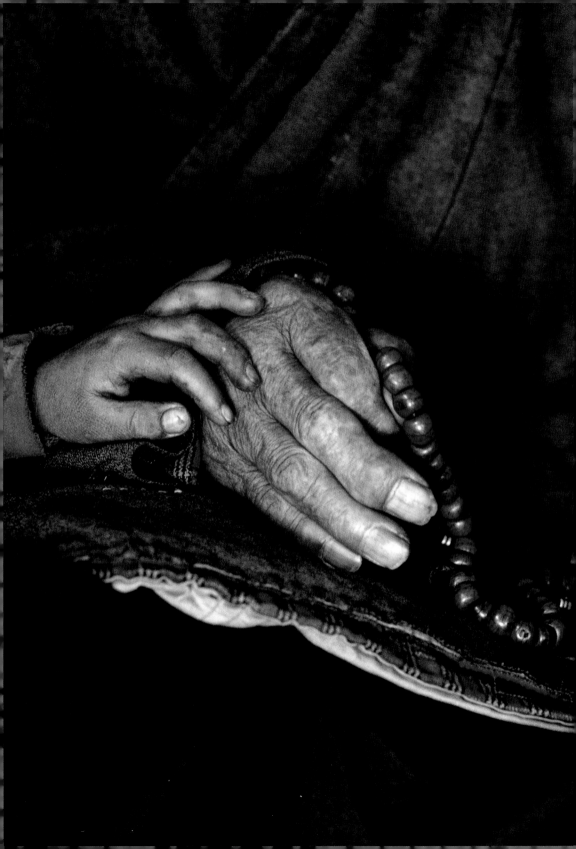

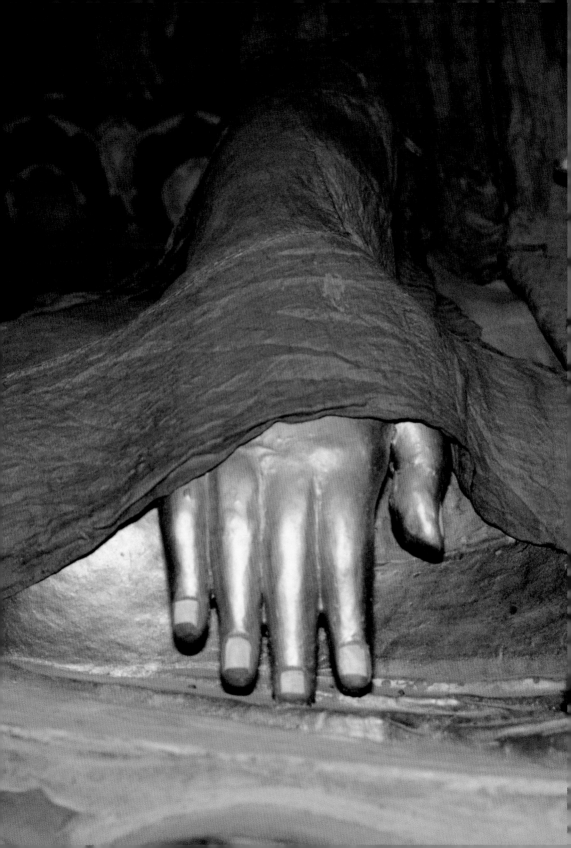

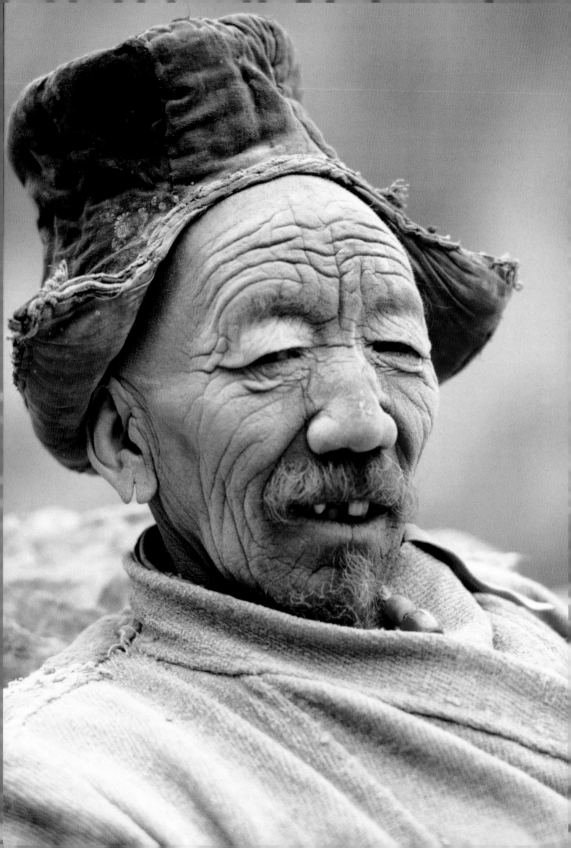

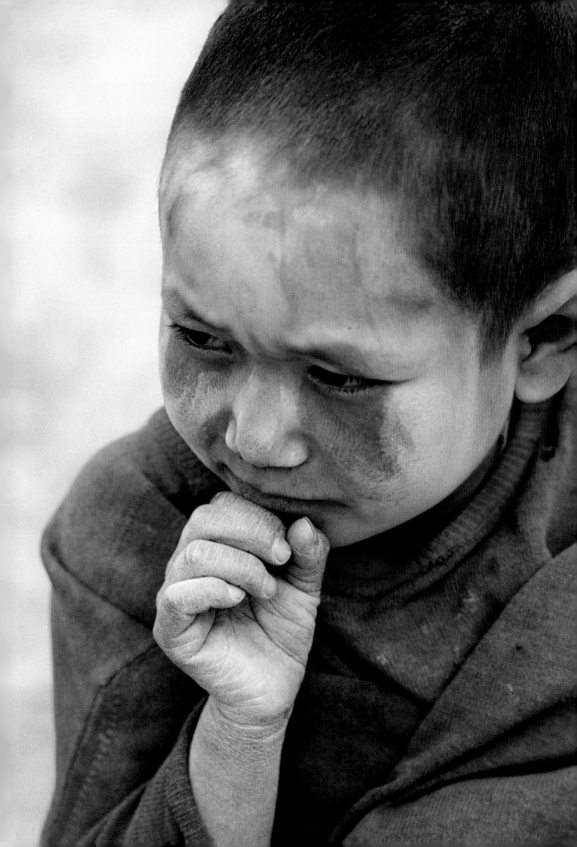

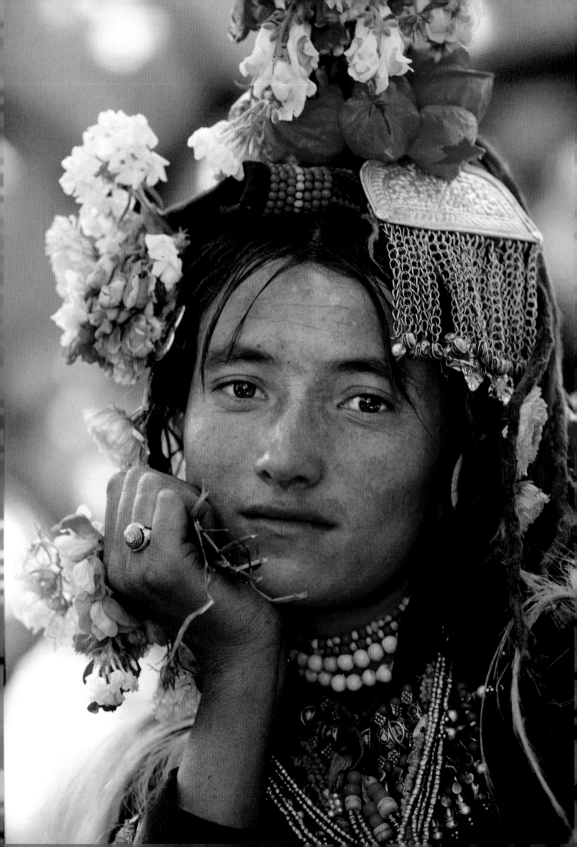

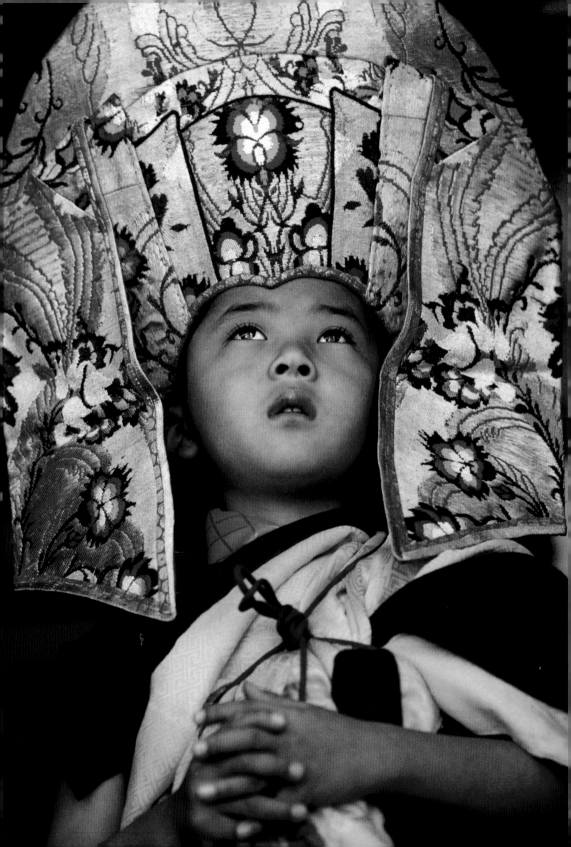

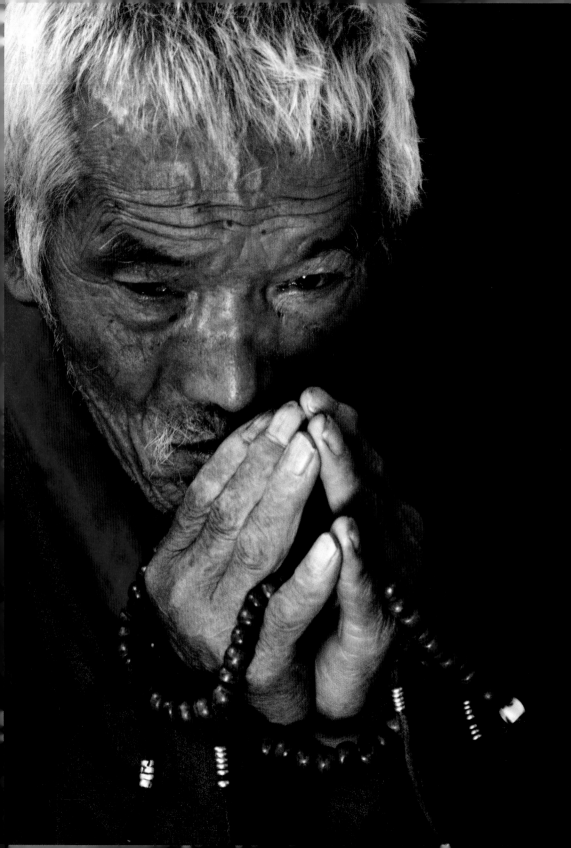

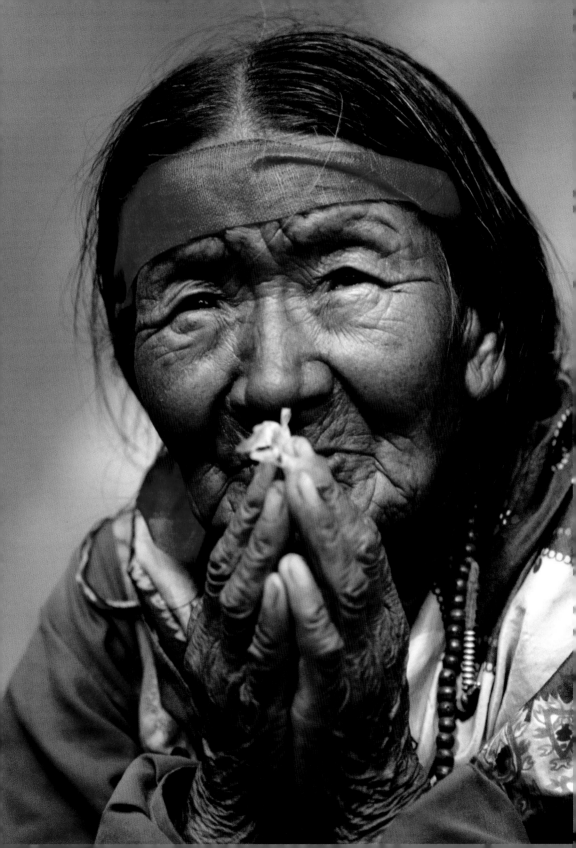

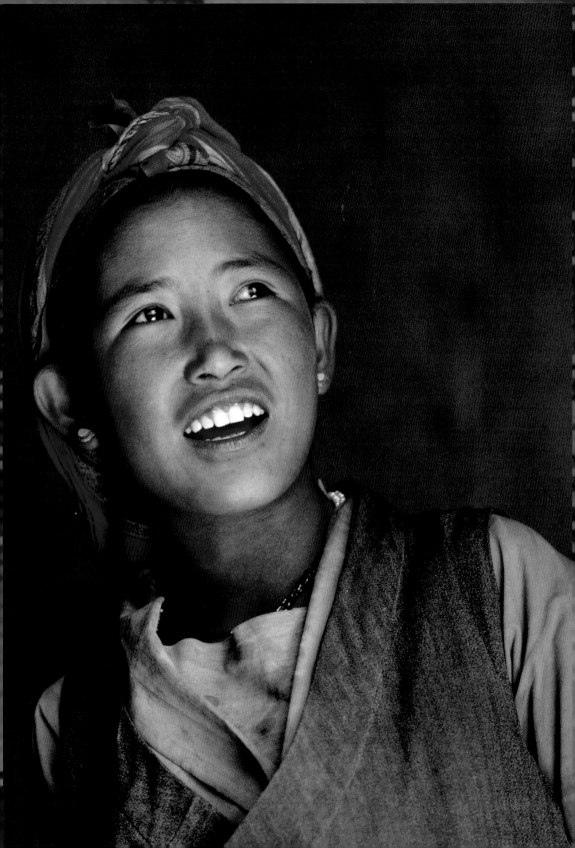

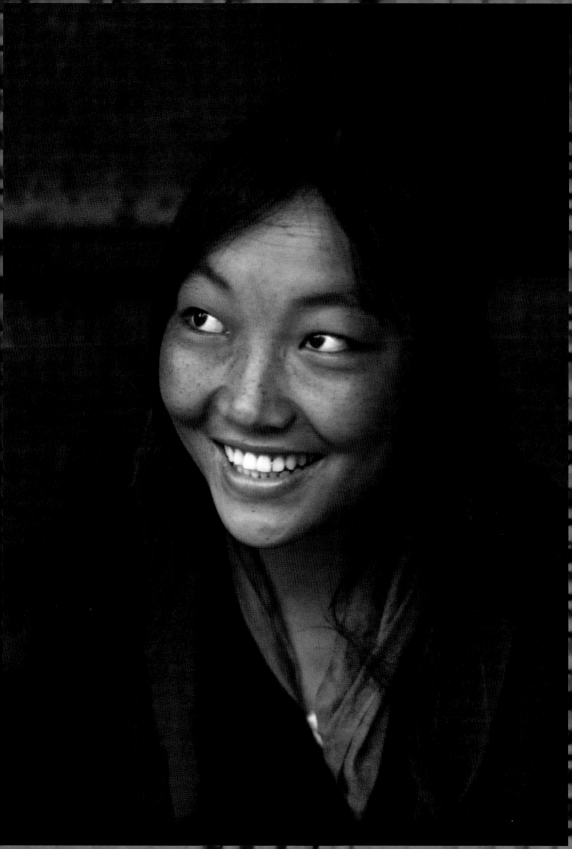

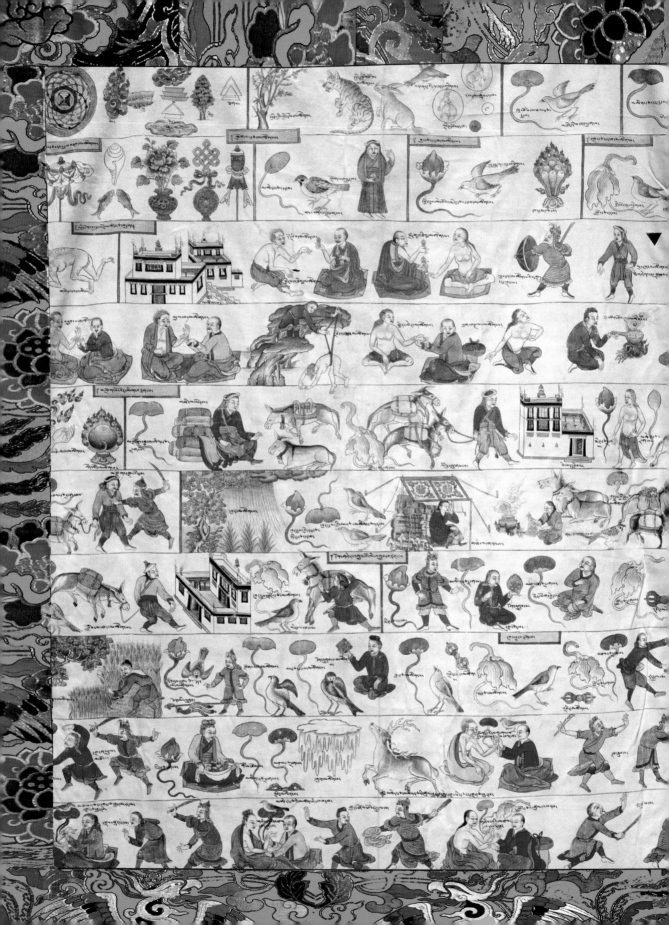

Monastery Life
A Buddhist Community

Around 5.30 in the morning the deep sound of a gong in the cold sharp air calls the monks to prayer. It is echoed almost immediately by other sounds: the faster rhythm of the novice school gong, the more high-pitched note of the philosophy school gong and, twice a month, the muffled beat of the *gandi*, a long piece of sandalwood used to summon the community to confession. The monastery soon comes to life and starts to teem with activity, although some of the monks, having woken up around 3 or 4 a.m., well before dawn, are meditating and praying in their cells.

A large Tibetan monastery is divided into three main parts: the monastery itself, the philosophy school and the retreat centre in a more secluded site. The monastery is the heart of spiritual life, resonant with rituals, music and sacred dances. It is also where novices are given a basic education and ageing monks and nuns live out their old age in prayer. It is an open place, full of life. Of the three hundred residents of Shechen Monastery in Nepal, over half are children or teenagers. Even the abbot, Rabjam Rinpoche, is only thirty-six years old. One of the monastery's main activities is education. From the age of six, children learn to read and write the various Tibetan scripts.

The novices lead busy lives. They start their day at 5.30 a.m. with communal prayers. Then they have breakfast: tea with salt and roasted barley (the famous *tsampa*), sometimes rice with chilli peppers. Then they go to their classes. They study until nightfall, with a break for lunch and another for tea at 3 p.m. Discipline seems strict, but these children are unusually full of energy and *joie de vivre*. During their breaks they play happily, like children anywhere. But in their enthusiastic games there is always a camaraderie and gentleness that contrasts with the violence sometimes seen in playgrounds in the West. Fights are rare and are seen as aberrations. The children attend primary school for six years.

After that they spend two years learning rituals and the sacred music and dances. Then, around the age of fifteen, they make an important choice which is agreed with their teachers and the abbot of the monastery. They may stay in the main monastic community and take part in its liturgical and artistic activities, or go to the philosophy school. Some of them leave the monastery for secular life. They do not take their monastic vows until the age of twenty, so they have plenty of time to decide what they want to do with their lives.

Apart from the basic education and philosophical studies, on the purely spiritual side there are three types of teaching and spiritual guidance. First, initiation, which allows and enables the student to practice the various meditation techniques. A large or small group of students may be initiated, depending on the spiritual level of the teaching. Then there are explanations of contemplative practices and commentaries on relevant texts. Lastly, the teacher gives personal instructions geared to the needs and aspirations of each student. For these highly spiritual forms of teaching, the monastery obviously needs a true spiritual teacher.

The monastery usually has a library, which might contain thousands of books. Most of the books in Tibet were destroyed during the Cultural Revolution. Some texts have been lost altogether. Only a few copies of others

have survived. The monasteries built in the country of exile have therefore often dedicated themselves to the task of preserving the ancient manuscripts that could be saved and reprinting important texts to make them accessible to all.

Shechen Monastery also has a school of traditional arts at which pupils are taught to paint and make clothes, masks and incense. A growing number of monasteries, inspired by the Dalai Lama, are now dedicating themselves to various forms of humanitarian action and building dispensaries and schools for the local communities. Shechen, for example, has set up a clinic that treats over a thousand patients a month.

The second major centre of activity at a monastery is the monastic school, at which the monks follow philosophy courses lasting between nine and fifteen years. They are taught metaphysics, logic, history, grammar and poetry. At the end of the course the monks or nuns become teachers in their turn, sometimes taking up highly responsible posts. Some opt for lives of contemplation.

The retreat centre is the third focus of the monastic life. In a calm spot, conducive to contemplation – a mountain hermitage or an isolated place in the forest – monks and nuns who have become hermits devote themselves to the meditative life that is the culmination of their spiritual education. Putting the theoretical knowledge into practice and integrating it into one's own experience all through life are the very essence of the Buddha's teaching. The goal at the end of the path is to achieve Enlightenment. But that is a far from selfish process. The instructions for the Buddhist contemplative life make it quite clear that anyone retreating to a mountain hermitage simply to escape the worries of everyday life is no different from the wild animals that have lived in those remote spots for centuries. After acquiring sufficient internal strength, the hermit returns to the world to share not only intellectual knowledge but also a profound experience of the nature of mind. Transforming oneself is the only way to transform the world in an enlightened manner. So the monastery, together with the retreat, offers a path to transformation that leads to the end of suffering and the discovery of unfailing happiness for oneself and others.

A NECKLACE OF PEARLS
INTERDEPENDENCE AT THE HEART
OF BUDDHIST THOUGHT

In one of his sermons, the Buddha describes reality as a pearl necklace. Each pearl reflects all the others, together with the palace whose façade they adorn and the entire universe. That means that all of reality is present in each of its parts. This image clearly illustrates the concept of interdependence, according to which no single entity anywhere in the world can exist separately from the others.

Buddhism considers that reality can best be described in terms of the interdependence and global nature of phenomena: 'This happens because that is.' Nothing can happen by itself, without causes or conditions. The idea that everything is produced on an interdependent basis prevents us from falling into the extremes of eternity and nothingness. The world of phenomena, including consciousness, is conceived as a dynamic network of transformations governed by the laws of cause and effect. Phenomena are merely events, which are relative and have no existence of their own. They do not contain any autonomous or permanent entities. This web of relationships, which has no beginning and no end, is not governed by any absolute determinism, because these connections are influenced by a limitless number of causes and conditions. They cannot, therefore, be traced back to a primary or unique cause.

It would be quite wrong to believe that we are fundamentally separate from the rest of the world and, more specifically, from other living beings. The concept of interdependence is a constant incentive to the practitioner to become more altruistic, to feel less grasping, fear and hatred. It enables him to break down the illusionary wall that the mind has erected between 'self' and 'others'. It renders hatred, pride, jealousy, greed and obsession absurd. If all beings are linked in this way, we must feel intimately concerned with the happiness or suffering of others. To quote the Dalai Lama, 'The need to receive and give love and tenderness is the proof of interdependence. If happiness did not depend on others, if it existed by itself, love would have no reason to exist.'

Our happiness necessarily comes through that of others. It would not only be amoral but unrealistic to try to build happiness on the suffering of others. So it is vital for our compassion to encompass all living beings without exception, friends, strangers and enemies. Becoming mindful of this interdependence therefore begins a process of internal transformation that will continue until Enlightenment.

Tibetan Astrology

Considered to be one of the five traditional Tibetan sciences, astrology remains a powerful and relevant force in the daily life of both monks and the general population. Its aims are to predict, to prevent and to repair, restore and make redress. Among its many uses, it offers rituals for dispelling hostile planetary influences, for invoking individual prosperity, and for plotting protective charts. Anchored deep in the culture of the Himalayan region, astrology is a traditional art that remains a living force of considerable power in Tibet, Bhutan, Ladakh, Nepal and Sikkim, as well as among refugee communities in India. It is a significant element in every aspect of life, from birth, marriage and death to – to take just one example – major events in the agricultural year.

In Tibet, the astrologer or *tsipa* is a specialist, generally a monk or yogi, or sometimes a doctor. Astrologer-monks are in charge of drawing up the calendar of worship and also the yearly almanac. In small villages and hamlets, married yogis or *ngakpa* assume responsibility for divinations, astrology, medical care and religious ceremonies. Even meteorology falls within the sphere of the stars, and almanacs invariably include weather predictions for the coming year. From the 17th century, colleges of medicine became the preferred places for undertaking apprenticeships in astrology, and during the reign of the 13th Dalai Lama (1876–1933), a Medical and Astrological Institute, the Mentsikhang, was established in Lhasa; it now continues its work in Dharamsala in India. Highly valued as a complementary tool in difficult diagnoses, astrology is also believed in

many respects to be a method of predicting suffering and future calamities. Placed under the aegis of Manjusri, bodhisattva of wisdom, the prime duty of astrology is to offer useful help at moments of crisis and times of trouble. Outside these parameters it is held to be a more worldly tradition, of secondary importance to the more essential practice of Buddhism.

As such, Tibetan astrology offers a faithful reflection of the evolution of Tibetan society. The ancient Tibetan heritage has gradually seen foreign cultural influences grafted on to it, starting as early as the beginning of the Christian era with the western kingdom – possibly of Persian influence – of Zhang Zhung, followed from the 6th century by Chinese culture. But both these outside forces were little by little to give way to the increasing influence of India, which by the 11th century was virtually omnipresent. Tibetan astrology may therefore be likened to a tree with roots that are Tibetan, but with branches springing from grafted wood of foreign origin. The grafts have taken well, however, and the resulting tree not only has an intricate, many-branched structure but also presents a harmonious overall shape. Astrology's roots are thus firmly planted in Tibetan soil, and also embrace many animist and shamanistic elements from earlier native traditions. Although these have often been identified with the ritual practices of the ancient Bön religion, strictly speaking the term Bön covers a range of religious forms that originated in Zhang Zhung. It was when these spread within the Tibetan region that they subsumed the pre-existing native beliefs. The ancient Bön religion accords a

place of great importance to the sciences of prediction, of which astrology forms one of the twelve traditional branches. In present-day Bön beliefs, the first of the Nine Vehicles, the 'Vehicle of Shen and Prediction', emphasizes the pre-eminence of astrology (*Tsi*), of divination (*mo*), and of the ceremonies and diagnostic practices linked to these methods. The Bön religion contains the earliest lists of local and astrological deities, together with the rituals associated with them and creation myths recounting the origins of the universe.

Of particular interest among these ancient elements in astrology is the pre-Buddhist notion of *tendrel*, that is a concatenation of favourable or unfavourable circumstances, a notion that was subsequently assimilated into the related concept of the interdependence of phenomena, for which Tibetan Buddhists also use the term *tendrel*. The *La*, or 'vital spirit', is an individual life force that dwells simultaneously in the human body and in an external support, whether a tree, rock, precious stone or hill. When this 'spirit' is attacked by demons or strays into the outside world, life is put in peril. The astrologer's task is to determine the points at which the vital spirit is under threat, and if necessary at those moments to invoke the ceremony of 'recalling the soul'. The famous 'Windhorse' or *lung-ta*, meanwhile, whose image appears in the centre of the prayer flags that flutter in the wind, is the symbol of the harmony between the various forms of inspiration or breath of life and their connections with internal elements. In another reference to ideas that pre-date Buddhism in Tibet, the horse has the power to unite, balance and strengthen vitality, health and *wangthang*, or 'personal power'. At the

popular level, the *lung-ta* personifies good fortune and the ability to ward off undesirable events. Printed alongside the mantras on prayer flags, it is carried by the wind to places and beings, to both of which it restores harmony. And finally there comes a litany of deities and natural forces which dwell underground and in rivers, rocks and trees, which are easily provoked or plain vindictive, and with which men's activities tend to interfere. These deities are placated with appeasement rituals, offerings and fumigation ceremonies, all carried out on dates determined astrologically.

In the 7th and 8th centuries, when royal Tibet maintained close links with Tang dynasty China, Tibetan astrology also borrowed numerous elements of its calendar from Chinese geomancy and medicine. When King Songtsen Gampo (569–650) married a Chinese princess, his bride was accompanied to Tibet by a great number of Chinese men of letters, doctors and astrologers. On the birth of King Trisong Detsen (755–97), a Chinese astrologer was instructed to calculate the royal horoscope. The sixty-year cycle, twelve animals and five elements – all borrowed from China – play a role of central importance in Tibetan astrology, forming the backbone of its entire chronology and calendar.

Indian astrology started to infiltrate Tibet – most probably in rather hesitant fashion – in the 8th century, when a body of Sanskrit texts was translated into Tibetan. But it was only with the arrival of the Kalachakra Tantra in 1024, followed by the later introduction via Kashmir of the Sarodhaya Tantra of the Shiva cult (which gave rise to the Yangchar system of astrology) that its influence became

established. The system of the Kalachakra, the central tantra of the second wave of Indian Buddhism in Tibet, revealed Indian astrology in a form akin to the ancient *rishi* of Brahmanism, investing it with Buddhist teachings and explaining it according to the doctrines of the Buddha.

Although Indian astrology was founded on very different principles from that of its Chinese counterpart, both were assimilated with ease into the Tibetan systems. Perhaps the most striking example of this three-way accommodation is to be found in the application of the sixty-year cycle: although the system was of Chinese origin, and the Chinese started a cycle in 1024, the Tibetans chose to begin their corresponding cycle three years later, in 1027. The difference was accounted for by Indian astrology, in which the Kalachakra laid down a different sixty-year cycle (*prabhava*), with each year bearing a specific name. As one of the Indian cycles was due to start in 1027, the Tibetans chose to combine the two systems by starting their own cycle in the same year. Thus it is that the Tibetans name their years according to the Chinese system, while starting their cycles according to the Indian calendar.

A number of astrological systems co-exist in Tibet, but they may be categorized broadly under two headings: black astrology or *Nagtsi*, of Chinese origin, and white astrology or *Kartsi*, of Indian origin.

Black astrology takes its name from the Tibetan name for China: *Gya Nag*, or 'Black Expanse'. This system embraces numerous different methods, all derived from a knowledge of the Chinese cycle of five elements, from which it gains its other name, *Djungsti*, or 'astrology of the elements'. The

five elements – wood, fire, earth, metal and water – are active influences in a state of constant interaction, which determine the natural cycles of change within the universe. Each element symbolizes a fundamental characteristic: wood is vitality and motion, fire a transforming or destructive ardour, earth fertility and solidity, metal rigour and sharpness, and water penetration and receptiveness. All astrological factors are believed to obey these elemental laws, and all interpretation is derived from them.

The years are designated by a sequence of twelve animals: mouse, cow, tiger, hare, dragon, snake, horse, sheep, monkey, bird, dog and pig. The sixty-year cycle that shapes the Tibetan calendar is derived from a combination of the five elements and twelve animals. The cycle is applicable to years, months, days and hours, but it may be affected by other factors, such as the nine *mewas*, or magic squares divided into nine compartments which turn each year, and the eight trigrams or *parkhas*, derived from the Chinese I Ching and used mainly in geomancy.

Black astrology is used chiefly in working out the cycles of the calendar, in deciding whether a particular year is propitious or not for a particular individual, in medicine, in establishing the dynamic compatibility of future spouses, and in laying down the details of funeral ceremonies. Resting as it does on simple and cyclical mathematical calculations, this is the easier of the two systems to master.

White astrology (*Kartsi*), so named from the Tibetan name for India, Gya Kar, or 'White Expanse', is also known as the 'astrology of the stars'. It shares its Mesopotamian origins with Western astrology, and rests on a system based on the twelve

constellations of the zodiac: Aries, Taurus, Gemini, Cancer, Leo and so forth. Taking into its calculations the seven traditional planets (Sun, Moon, Mars, Mercury, Jupiter, Venus and Saturn), it also adds Rahu and Ketu, the northern and southern nodes of the moon. At the same time, the Indo-Tibetan zodiac is a sidereal system based on fixed constellations. Since the time of Ptolemy, by contrast, the West has opted for a seasonal zodiac linked to the 'vernal point', or the point at which the sun rises at the spring equinox. The two zodiacs are out of kilter because of the effect of the precession of the equinoxes, which causes the vernal point to shift slightly in relation to the fixed stars, the difference at the time of writing being equal to almost twenty-five degrees.

Added to these factors are the twenty-seven *Gyukar* or lunar constellations, which play an important part in daily predictions and in nuptial horoscopes, the degree of harmony and compatibility depending on the position of the moon within each of the future spouses' astrological charts. This system of astrology is used to work out individual horoscopes, according to quadrangular charts reminiscent of those used in the West in medieval times, on which signs are plotted to indicate the positions of the planets and the twelve houses. Through a skilful system of planetary periods, it enables astrologers to predict the principal periods of an individual's life and to estimate his or her lifespan. It is also used a great deal in almanacs to determine dates that are auspicious for particular activities.

Along with many other aspects of Tibetan culture, the very existence of this traditional and highly complex skill and body of knowledge is now in peril. In a world of increasing uniformity, it is in danger of becoming yet another forgotten folk tradition of yet another ethnic group that has been treated shamefully by history.

Tibetan Buddhist Art

The sacred arts of Tibet were a means of representing, evoking and bringing to life the highest Buddhist ideals and realizations. In traditional Buddhist iconology, a sacred object such as a Buddha statue or painting was technically a 'support' (*rten*) of enlightened body. Sacred books and stupas were also 'supports' of enlightened speech and mind.

Tibetan Buddhists viewed the making of sacred art as a source of great spiritual merit and thus as a cause for future benefit and happiness. Many donors sponsored the making of holy objects to generate merit. Powerful merit could also help ameliorate troubles or remove sickness, and thus ordinary Tibetans were sometimes advised to commission religious art to dispel physical or mental obstacles or to create the conditions for a long life. Often the deity portrayed was connected with the desired effect. Green Tara, for instance, was effective in removing obstacles and granting protection, while Amitayus bestowed long life. After the creation of a sacred image, the patron was expected to practise the recitations and prayers that were appropriate for that deity.

Sacred scroll paintings were commonly commissioned after the death of a relative or loved one. Called 'signs of birth' (*skyes rtags*), they were ordered to be painted in the name of the deceased and were meant to create the conditions necessary for propelling the deceased to a happy rebirth. Such thangkas had to be executed in the seven weeks after the person's death, in other words, before their next conception and rebirth. Lamas often consulted prognostication texts to determine which would be the best deity to portray.

Much religious art was thus prompted by the desire to avoid suffering, gain happiness, and ensure good fortune in the next life. Such results depended on the functioning of moral cause and effect accepted by all Buddhists. But for Mahayana Buddhists, another motivation remained: the desire to gain perfect awakening by benefiting all living beings. This altruistic thought imbued the good act with the strongest power, so that its force would persist until the attainment of Buddhahood. Similarly, the merit

was dedicated to Enlightenment through prayers at the end of a major religious art project.

Upon its completion, a sacred object was brought to life by ritually imbuing it with enlightened mind through a consecration ritual. Thereafter, any consecrated object was treated by Buddhists with utmost respect, almost as a living thing.

Sacred art aided and made possible further religious activities. An icon of the Buddha acted as focus and support for the Buddhist's faith and was a reminder of the Buddhist's commitment to travel the Path. Occasionally a simple Buddha image was used as an object of focus during concentration meditation (*zhi gnas*), but more commonly it functioned as a worthy object for worship and offerings, providing the Buddhist with the right circumstances for accumulating the merit necessary for spiritual advancement. Paintings also bolstered the visualizations generated during meditation. Many practitioners about to accomplish the preliminary practices of the Vajrayana had paintings made that depicted their teacher and his lineage in the form of a 'tree of refuge'. Such a painting inspired and strengthened the meditator's own internal image of the vast assembly toward which such practices as taking refuge, bowing in homage and offerings of symbolic mandalas were directed. In the same way, a monk who recited the Confession Sutra every day might commission a painting of the thirty-five Buddhas of confession in whose presence he envisioned himself when reciting the scripture. Meditators who applied themselves to the main practices of the Vajrayana often kept thangkas not only as objects of devotion and sources of inspiration, but also as points of reference for clarifying their visualizations. Those who were about to enter a special retreat would sometimes order a painting to be made of the deity who was to be intensively worshipped.

Thangkas also had ceremonial uses outside the monasteries, shrine rooms and meditation huts. Buddhist funeral processions in Sikkim and Nepal, for instance, were sometimes led by a man bearing a

staff from which a thangka hung. *Srid-pa-ho* thangkas were similarly used to ward off evil in the processions of a lama or a bridal party. Wandering lama *manipa* teachers travelled with thangkas that they unrolled and used to illustrate their tales when reciting before an audience. Some monasteries or palaces possessed huge appliqué thangkas that were unrolled outside on certain holy days for viewing and worship.

Although the primary function of sacred art was as an aid to practice or as a means for generating merit, Buddhist art could also be appreciated for its beauty, and the greatest Tibetan scholars were connoisseurs of traditional styles. The most extraordinary artworks were produced by artistic geniuses who sometimes founded schools of art named after themselves. Such geniuses were great exceptions, however, and most artists were humble, ordinary artisans born into hereditary lineages of painters or sculptors. Though usually not full-time meditators or yogis, most artists were religiously minded and were tantric initiates, at least in a formal sense. According to the Vajrayana, artists who depicted deities of the four classes of Tantra needed to be ritually initiated, and most painters had received initiations.

Though always an object of reverence, Buddhist sacred art was not idolatry. For Buddhists, the image of an Enlightened One embodied the realization of potential latent in every living being. The ultimate responsibility for reaching that realization rested on the shoulders of each individual. A Buddha – to say nothing of his physical representation – could be neither pleased nor displeased by worship or a lack of it, for he was beyond all attachments and sufferings. Instead, it was the practitioner who benefited from acts of worship, moving closer to the ultimate goal through strengthened faith, deepened insight and purer vision.

THE MEANING OF THE DEITIES
TOWARDS A PURE VISION

In the Buddhist pantheon, God has not made man in his image; instead the deities appear in the image of man. They manifest the various qualities of Enlightenment – transcendental wisdom, compassion and altruistic action – and appear as the 'radiance of Enlightenment'. These deities are one with the ultimate nature of mind, the nature of Buddha that is present in every being. In this way, meditation, which consists of visualizing oneself in the form of a deity, allows the mind obscured by confusion to rediscover the nature that was always its own, the Buddha-nature. However varied the forms of a deity may be, the practitioner does not see them as different from the Buddha and the spiritual master.

Although they may seem disconcerting at first sight, the wrathful aspects of the deities express the full force and splendour of compassion, a compassion that tolerates neither the suffering of beings nor its causes, which are ignorance and negative emotions. As for the deities shown in union, they must not be regarded as beings of flesh and blood who feel ordinary passions but as symbols of the union of emptiness (or wisdom) when shown as female, and of compassion (or method) when shown as male. For those who practise these visualizations, nothing retains its ordinary appearance. The world of forms then becomes an infinite deployment of the form of the master, sounds become mantras and thoughts become manifestations of enlightened mind.

The Inner World of Statues

An uninformed visitor looking at the statues in a Tibetan temple would never guess that they are entirely filled with mantras, prayers, relics and sacred objects. As much care and often more time is spent preparing these items than is spent making the sculpture itself.

It takes months of work to fill a large-scale statue. A group of monks print thousands of mantras and prayers, paint them with saffron-coloured water mixed with consecrated substances, cut them into narrow bands that are rolled up as tightly as possible, and wrap them in a strip of cloth. The monks are careful to mark the top of the scroll to ensure that the script is positioned correctly inside the statue.

The monks then prepare the tree of life, which forms the central axis of the statue, its backbone. They seek out a noble and fragrant species of tree, preferably on the slopes of a sacred mountain. The favoured essences are white or red sandalwood, juniper and aloe. They fell the tree at sunrise, after making offerings to any local deities that might live in it and carefully noting its orientation, for it must be placed inside the statue in its natural position, the right way up and taking note of the points of the compass. The side that faced east in nature will face the front of the statue.

The trunk is then cut in such a way as to ensure that its cross-section narrows slightly towards the top. The apex is sculpted in the form of a stupa and the base in the form of a half-*vajra*. The tree is carefully polished, painted red and covered with mantras written in fine gold. Specific syllables indicate the different levels (head, throat and so on).

Relics of deceased sages, such as hair, pages of their writings, fragments of bone, clothing or ritual objects that belonged to them, are attached to the tree at the levels corresponding to the statue's body. The tree is then enveloped in fine yellow silk and the interior of the statue is purified with saffron-coloured water and incense smoke. If the statue is small, a spiritual master is asked to place the tree inside it. He then prays for the Buddha's teachings to spread and for those who transmit them to enjoy a long life. In the case of large statues, the monks carry the tree of life in a procession before setting it up inside the statue.

Specific mantras are then glued to the inner side of the eyes, ears and other organs. Next, scrolls of mantras and prayers are inserted to entirely fill the free space, which can be quite large since the outer wall of the statue is only a few centimetres thick. There are different mantras for each level.

Very large statues contain a veritable library. In a temple in Shechen Monastery in Nepal, for instance, a giant statue of Padmasambhava contains not only mantras and prayers but also the 103 volumes of the Buddhist Canon and many other scripts, together with 100,000 miniature statues of Padmasambhava.

The last remaining cavities are filled with fragrant plants, stones and flowers brought from sacred places, medicinal herbs and spices, pieces of gold and silver, turquoises, coral, amber and pearls. Diagrams, either printed or engraved on copper and covered in fine gold, dedicated to the deities of prosperity, are placed at the centre of the base. Finally, the

monks seal the back, on which a double *vajra* is engraved as a symbol of immutability. Weapons are enclosed beneath the statue in order to prevent wars by 'crushing' them under wisdom and compassion.

In the case of large statues, it would be impossible to reach all the cavities to fill them after the statue is completed. So the tree of life is set up first and then, as they build up the statue with clay, the sculptors ask the monks to come every four or five days to fill the various levels one at a time.

The clay or fine earth used to model the statue is prepared with water mixed with consecrated substances, then kneaded for a long time with fibres of 'rice paper' (actually made from daphne bark) until it reaches the required consistency. The clay statues are painted either in colour or in gilt, made from a mixture of gold, reduced to powder by a long and complex process, and glue. The gilt surface is then polished with an agate to make it shine. In the case of repoussé copper statues, a gold amalgam is first applied to the surface and then the entire statue (if it is small) or its parts (which will be assembled later) are fired at high temperature on charcoal or with a blowtorch. The mercury evaporates and the gold precipitates on the copper. Mercury vapours are highly toxic, but Himalayan goldsmiths believe that drinking large quantities of beer after this operation gets rid of the poison!

Finally, the statue is consecrated in a ritual that consists of purifying it and asking the deity's wisdom-mind to enter it, as though asking for consciousness to inhabit a body. At a given moment in the ceremony, the face, veiled until that point, is uncovered and an artist puts the last touches to the pupils, to 'open the eyes'. In the case of the large statue of Guru Padmasambhava mentioned above, Dilgo Khyentse Rinpoche performed the ritual of consecration one hundred times.

Buddhists believe that a statue consecrated in this way is endowed with the same benedictory power as the deity itself. However, when China invaded Tibet, most of the statues that were not destroyed were emptied of their contents.

A Master of Painting

As an aid to meditation or reflection, the sacred art of Tibet links us, through its symbolism, to spiritual practice and inner knowledge. Although traditional artists use all their skills in the service of their art, their personalities are totally effaced in their work. Tibetan painting is therefore usually anonymous. However, even though an artist cannot give free rein to his imagination and constantly invent new forms, that does not mean that his art is fixed in the past, because spiritual teachers are constantly enriching it with new elements drawn from their meditative experiences.

Konchog Lhadrepa was trained by Dilgo Khyentse Rinpoche. Gen Tragyal, one of the last great artists to be trained in Tibet, taught him his art in the 1970s. Today Konchog is headmaster of Tsering Art School at Shechen Monastery in Nepal. Here he tells us how an artist views painting as part of the path towards Enlightenment.

'We can distinguish several approaches to the art of painting. The first consists of reproducing the outside world as faithfully as possible. The second offers a personal interpretation of this world and translates, figuratively or not, the artist's thoughts, feelings and imaginary world. The third, that of traditional religious art, follows the guidelines laid down on proportions and the way to represent the deities and symbolic objects. The fourth and most rare is that of the spiritual teachers or great meditators who sometimes express their experiences of meditation through drawings and paintings that do not necessarily follow conventional formats.

Tibetan sacred art comes under the last two categories. It goes hand in hand with the practice of Buddhism, which it accompanies and reinforces. The student therefore begins by taking refuge in the Three Jewels, the Buddha, the Dharma and the Sangha. Early in the morning, he devotes a certain time to prayer. When he begins to paint, he must practise what is known as 'pure vision', visualizing himself in the form of the deity he is painting, visualizing the place he is working in as the Pure Land of that deity, and his tools – brushes, pots, compass, and so forth – as the attributes the deity holds in its hands. That means the artist respects his tools as though they were sacred objects and, for example, avoids stepping over his brushes and his pots of paint.

Throughout his work, he recites the mantra of the deity he is drawing or painting. At the end of each session, he dedicates the work's merits to the temporary and ultimate good of all beings. All this enables him to turn his art into an integral part of his spiritual practice. This form of art demands great care and meticulous attention to detail. It is said that over the course of a day, a careful painter can, on average, complete an area the size of a fingernail.

Over the course of the centuries, many different styles of sacred art have developed. They differ not in terms of their symbolism or deeper meaning but in the techniques used and sometimes in the canonical proportions of the deities or figures who are represented. The style of central Tibet, for example, is highly ornamental and uses paints that give thick coverage, with saturated colours, lending the picture a certain solidity. The style of eastern Tibet, the style I have learned, is luminous and transparent, depicting vast empty landscapes from which diaphanous deities emerge. I belong to what is called the Karma Gadri School, or more precisely Karshoma.

This very precious tradition is now at risk because of the confusion of styles and lack of spiritual motivation often seen in commercial studios that supply the tourist market. My greatest hope is to perpetuate it. Our school now has forty students who follow a course of between three and six years of study. I hope these students will in turn manage to pass on this deeply meaningful art, while also carrying on the tradition themselves.'

A Remedy for Suffering
The Tibetan Healing Arts

According to a famous aphorism in Tibetan medicine, illnesses are an inseparable part of the biological condition of the living: 'Suffering adheres to all beings, even those in good health, as surely as a bird is followed by its shadow even when it flies through the air.' The constant vulnerability of human beings to the hazards of illness, accident, disability and premature death was, and still largely remains, a fact of everyday life in most traditional societies, especially those exposed to particularly precarious living conditions and an extremely harsh natural environment, as is the case in the high Himalayan valleys and the Tibetan plateau.

So it is not surprising that the vicissitudes of human biology have been presented by Buddhist tradition as paradigms of the tragic impermanence of phenomena. It is said to have been successive encounters with a sick man, an old man and a funeral procession, followed by a meeting with someone who had renounced the world, that persuaded the future Buddha Shakyamuni to abandon the carefree existence of a young prince and go in search of a response to suffering, the sudden discovery of which had overwhelmed him.

In fact, Buddhism has close affinities with medicine at several levels. As a doctrine and path of salvation, the healing of disease became a metaphor of the eventual release from bondage to the endless cycle of rebirth. More fundamentally, the problem of suffering has always been at the heart of the Buddhist doctrine of salvation. Finally, Buddhism's affinity with medicine was further reinforced, at the beginning of the Christian era, by the development of the doctrine of Mahayana and its new ideal of the bodhisattva, 'a being dedicated to Enlightenment', one who regards the healing of diseased bodies both as an opportunity to cultivate the perfections of compassion and generosity, and as an effective means of converting living beings. Medical science itself from then onwards, therefore, tended to form part of the Buddhist curriculum of studies, particularly in monasteries.

As with other misfortunes, the damaging, unexpected and apparently selective nature of illness means that its victim, with the help of his friends and family and, if necessary, that of specialists, often wants both to find an explanation for it and to adopt a course of effective action. The relevance of any interpretation does not necessarily correlate with its degree of accuracy – whether scientific or simply empirically verifiable – but relates instead to how closely it matches the patient's subjective experience, and his ideas of his relationship with others and with the visible or invisible world. Throughout history, in their search for meaning, humans have tended to turn first of all to explanations that attribute their illnesses to beings with aggressive intentions towards their victims, such as ancestors, spirits, gods, demons or sorcerers.

Consequently, for a long period of human history, illness was generally treated, whether

by laymen or specialists such as magicians, shamans or priests, in exactly the same way as more general forms of misfortune. Other more abstract causes or moral explanations, such as the law of retribution for one's past actions (karma), were also blamed in different philosophical and religious traditions. It was only later that specialists began to emerge who focused their knowledge and activities on disease, that particular type of misfortune that attacks the human body. Explanations of disease then started to focus on impersonal, 'natural' causes, which lacked intentionality and could be universally applied, such as climate, diet, lifestyle and emotional states, as well as on the disease processes themselves: imbalance of the humours, engorgement or diversion of biological energies, infection of bodily fluids and so on. This new focus gave rise to early medical science, as enshrined in the written reference sources that began to be complied, in the centuries prior to the Christian era, by several great civilizations, particularly in the Mediterranean region, as well as India and China. This new science of medicine did not, however, eliminate other therapeutic practices which continued to offer alternatives.

For these reasons, the Himalayas and Tibet experienced therapeutic pluralism. The quantity of alternative or complementary remedies available varied, depending on location. Even limiting our attention to Tibetan medical science, it should be emphasized that most of the preventative and therapeutic practices were – and still are, in many remote places – the products of what are, strictly speaking, non-medical domains: traditional pagan practices, ritual acts intended to accumulate merit (for example: giving to the poor, freeing an animal destined for slaughter, sponsoring the reading of religious texts), pilgrimages and visits to holy places, blessings from great religious teachers, wearing protective charms and amulets, divination or astrology, rites of exorcism, longevity or healing, and shamanic cures, among others.

The development of Tibetan medicine was closely linked to that of Tibetan culture, and therefore to Buddhism, which had a profound impact on every aspect of that culture. Classical histories of Tibet place the origins of the medical tradition in the 7th century when the land was unified as a kingdom for the first time, and came into contact with neighbouring civilizations of that era: India, China, central Asia and Iran. Having adopted a writing system from India, Tibet was eventually able to assimilate a large number of texts (particularly Buddhist ones), which included medical works. According to Tibetan historians, the origins of their country's medicine were marked by a variety of influences, in particular Indian and Chinese and quite possibly Greco-Arabian, and this claim is corroborated by ancient Tibetan

manuscripts and by clues found in medical treatises that are still in use today. Some of those influences were abandoned over the course of the centuries, while others were integrated, along with traditional local therapies, into a coherent body of specialized practices and knowledge. A treatise entitled *The Four Tantra (Gyushi)* is the primary reference source for all Tibetan practitioners, and lies at the heart of a vast medical literature which remains little known.

For centuries, medical knowledge, consisting of texts as well as oral instruction and practical techniques, was handed down, often together with religious education, from teacher to student, within a monastic environment or outside, or from father to son in familial succession, but not in specialized institutions. The training was not sealed by any formal diplomas and medical practice did not require licensing by any civil or religious authority that demanded a standard level of theoretical knowledge or technical expertise. Moreover, Tibetan practitioners never constituted a defined socio-professional group, and many also had other more important jobs or roles, often religious ones. It was not until the end of the 17th century that the first monastery specifically devoted to medical training was founded on the Mountain of Iron, near Lhasa. This later served as the model for several similar establishments in eastern Tibet, in Beijing and among the

Mongols. Tibetan medical science experienced a new flowering in 1916, when the 13th Dalai Lama founded the Medical and Astrological Institute (Mentsikhang) in the very heart of Lhasa. Nevertheless, alongside these centres of medical education, institutionalized and sanctioned by examinations, medical traditions continued to be passed on in the traditional way, outside all official controls, by individual practitioners, sometimes as a family inheritance, often with widely varying levels of knowledge and skill. This was the way in which women began to gain access to medical education, generally as students of their fathers.

In Tibetan medicine, just as in Indian ayurvedic medicine from which it takes its basic theories on physiology, pathology and treatment, the living body is made up of an organic foundation, within which three humours – pneuma, bile and phlegm – perform different vital functions. These humours, the blood and other organic fluids travel round the body in a network of channels. The humours confer life and health as long as they remain in equilibrium, and illness is merely the harmful result of an imbalance in these same humours, whether they are excessive or lacking. This internal balance can be influenced by nutrition, lifestyle and the seasons, among other factors.

A medical diagnosis is reached by means of a logical process, and the physician should,

ideally taken into account clinical evidence obtained by questioning the patient and taking the pulse, as well as a physical examination of the tongue and the urine in particular. In practice, a diagnostic examination is often confined to taking the pulse.

Treatment encompasses four types of therapy, in the following order, each regarded as more drastic than the one before: daily routine, diet, medicines and external treatments. It often involves an attempt to balance the humours that are in excess with their opposites and, if that fails, evacuating them. Among the sensory qualities associated with foodstuffs and drugs, special emphasis is placed on their flavours and whether they are hot or cold. Medicines comes in various forms (primarily powders, potions and pills), and combines ingredients from a very rich *materia* *medica* in which products of vegetable origin predominate. External treatments include the burning of moxa (which is quite common), the application of poultices and medicinal baths as and when appropriate, as well as ointments, bleeding and minor surgery.

Tibetan medicine is practised today in many Tibetan-language communities in the Himalayas or Tibet itself, to varying degrees of quality and sophistication. Some present-day health initiatives are attempting to integrate the traditional science of healing with modern biomedicine. The teaching of traditional medicine is becoming more institutionalized and open to the layman, while traditional drugs are becoming more standardized, and are often produced semi-industrially and distributed on a large scale. For a number of years now, Tibetan medicine has been arousing growing interest outside the region of its origin.

Dr Tenzin Chodak
The Memory of Tibetan Medicine

Two hazy silhouettes in the shadows of a small room: the broad back of a man sitting on a chair and, facing him in the fading light, a man whose features are hard to distinguish. But something in his bearing seems out of the ordinary: a concentration so intense that it is almost palpable, as if he were giving out some strange kind of energy. His stance reinforces this impression: the fingers of both his hands placed at the point where the other man's wrists join his hands: the attitude of someone listening intently. This was Dr Chodak as I saw him for the first time, in 1985.

He was the Dalai Lama's personal physician, and it was the period of his life when he travelled the world. As I met his gaze for the first time, he immediately seemed to personify all that is best and most valuable in the medical tradition of the mountain country: a wide range of knowledge, remarkable attention to his patients, a gentle but insightful capacity for listening: an indissoluble union of the scientific and the spiritual.

Born in 1924 in Ringpung Dzong, near Shigatse in central Tibet, Tenzin Chodak entered the nearby monastery of Nyepo Chode at the age of six. Seven years later he left for Lhasa to be initiated into the art of healing under the tutelage of a well-known physician, Shekar Tsultrim Tenzin. In 1941 the apprentice *amchi* was admitted to the famous monastic school, the Mentsikhang on Chakpori (the Mountain of Iron) overlooking the Potala, where he was taught by the venerable Khyenrab Norbu. He left the school

in 1952 with the highest of accolades, an expert in the eleven major branches of basic Tibetan medicine.

At the age of thirty, Tenzin Chodak returned to practise in the monastery in his birthplace, then became the official physician of the Dalai Lama's mother in 1953. The following year he went to Phari where he devoted several months to practical experiments into detoxifying mercury with a view to its therapeutic use. In 1955 he was summoned by the Tibetan government to become one of the four specialists caring for the health of the Dalai Lama. The failure of the popular uprising of 1959 against the Chinese, and the bloody repression that ensued, caused a massive upheaval in his life and that of thousands of his compatriots.

Arrested and sentenced to seventeen years of 'severe punishment', Tenzin Chodak spent almost twenty years in Chinese jails, from the forced-labour camp at Chow-Chin on the edge of the Gobi Desert, to the prisons of Sangyip, Sethun and Drapchi, on the outskirts of Lhasa. These were dreadful years, marked by interrogation, torture and starvation. He watched his companions in distress die one by one, without being able to do anything for them: out of every hundred detainees sent to the labour camp scarcely five returned. From 1973 onwards, after treating several of his jailers successfully, he was authorized to practise in the prison infirmary.

The first visit to Tibet of a delegation from the exiled Dalai Lama, led by one of his brothers, in 1979, brought some measure of

liberty for Dr Chodak, as a gesture of good will. The following year he was permitted to leave the country via Nepal, whose borders were still closed at that date. He reached India and Dharamsala, where he immediately resumed his duties as the Dalai Lama's physician. By his own account, he owed his survival to his diligent practice of tantric meditation, even through the worst moments among the daily horrors of his imprisonment.

An appearance almost of timidity on first meeting, a voice so quiet it might be a whisper, the indescribable smile common to all those who have come out of the house of the dead armed with a knowledge that is beyond words, Dr Chodak could easily pass unnoticed, until you met his gaze – a gaze filled with the perception of one who has seen so much that he has seen everything, seeing beyond the suffering he has experienced, beyond all the evil and the abuses he has witnessed, yet expressing boundless compassion for his fellow human beings. Appointed director of research at the Medical and Astrological Institute at Dharamsala, he would not rest until he had passed on his knowledge to younger generations in order to preserve the ancestral tradition. He is rumoured to have been the last surviving person to know the secret of the manufacture of a legendary remedy: the 'precious pill of the Dalai Lama'. Coincidence or not, this 'secret' was rediscovered shortly after his return.

Deeply anxious to preserve the knowledge threatened with extinction by the absence of proper teaching in his native country, Dr Chodak is said to have spent countless hours dictating or writing down the entire texts of now lost medical treatises that he learnt by heart during his own training. n 1984 he took part for the first time in an international conference on Tibetan medicine, held in Venice, and then travelled widely throughout the world, treating the sick and giving lectures. He also made notable contributions to Western research programmes, notably on asthma, cancer, hepatitis and AIDS. Many Western patients benefited from his remedies and all who met him were struck by his extraordinary understanding of his fellow human beings. When he passed on, at Dharamsala on 6 April 2001, a vital part of the living memory of Tibet went with him.

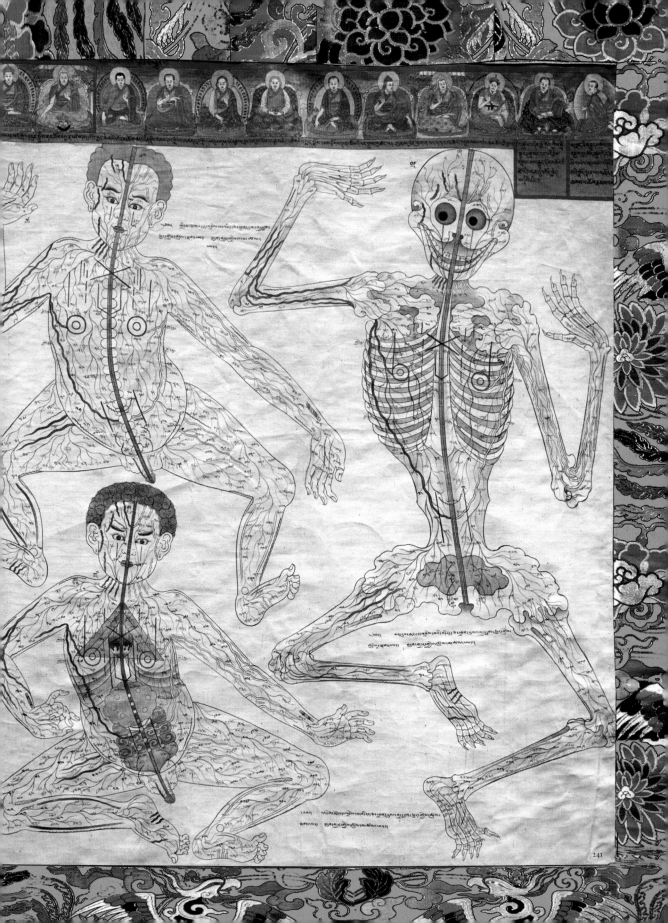

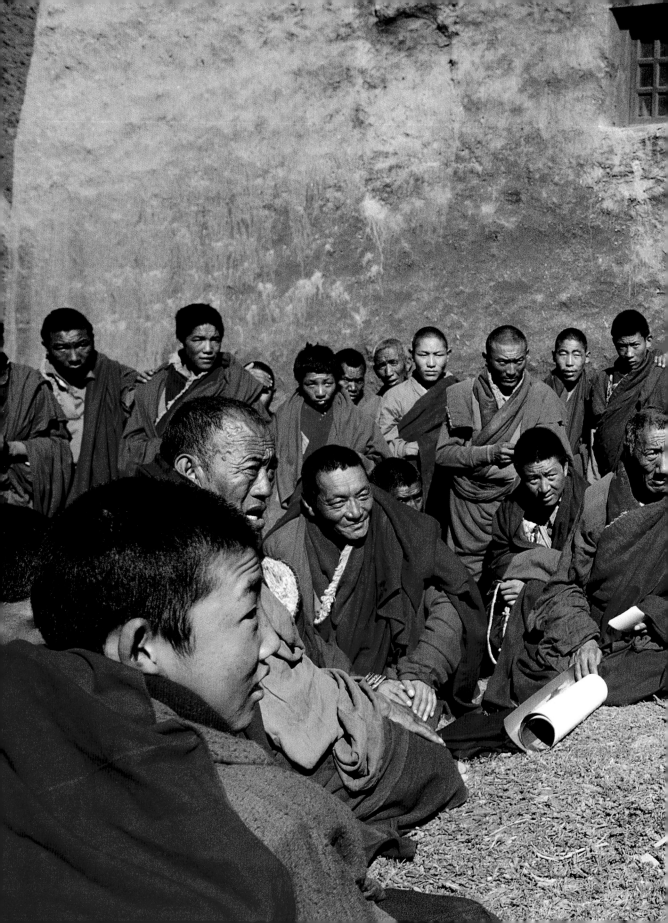

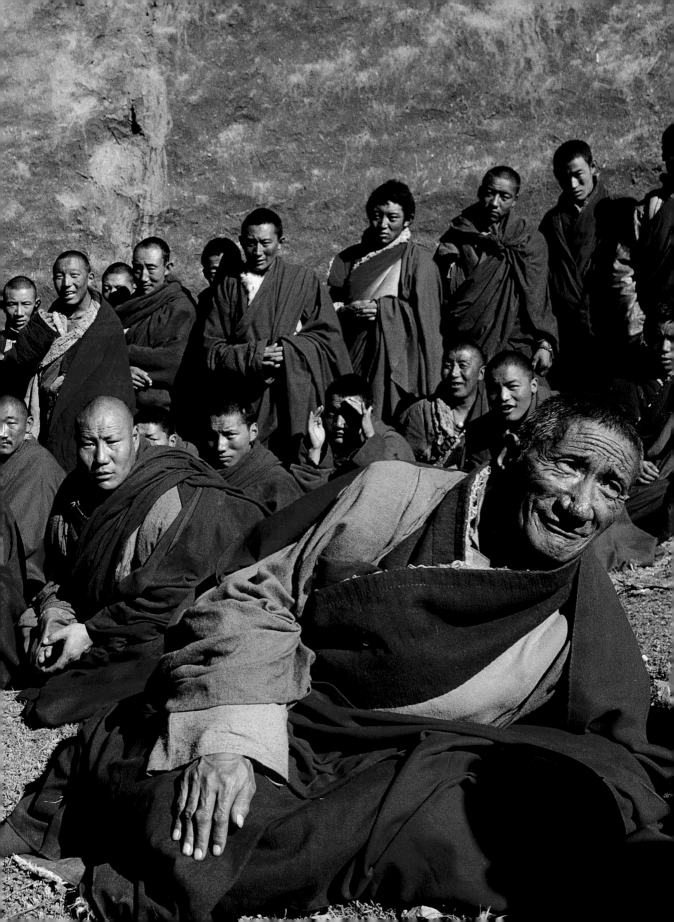

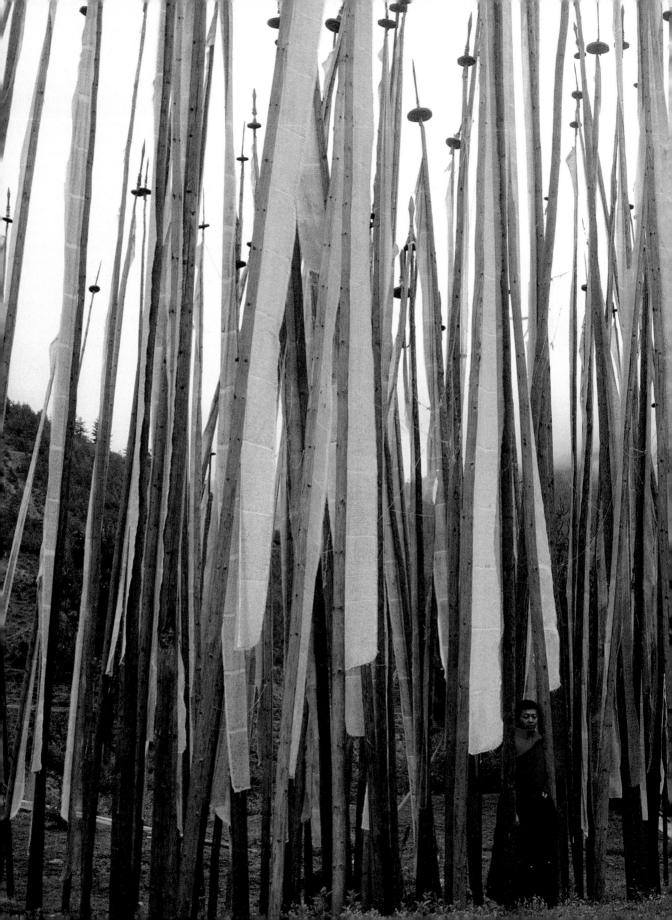

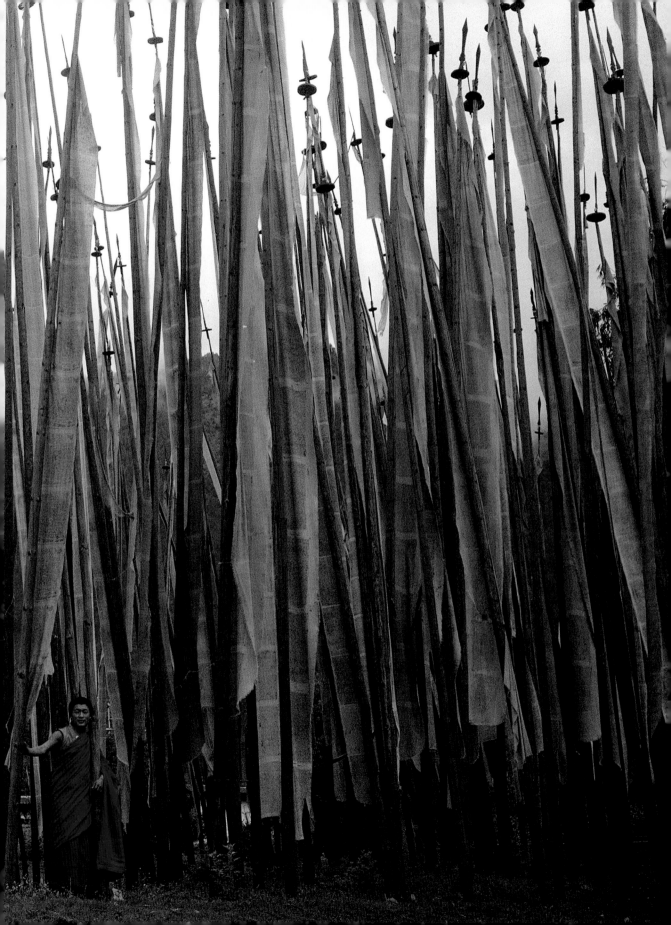

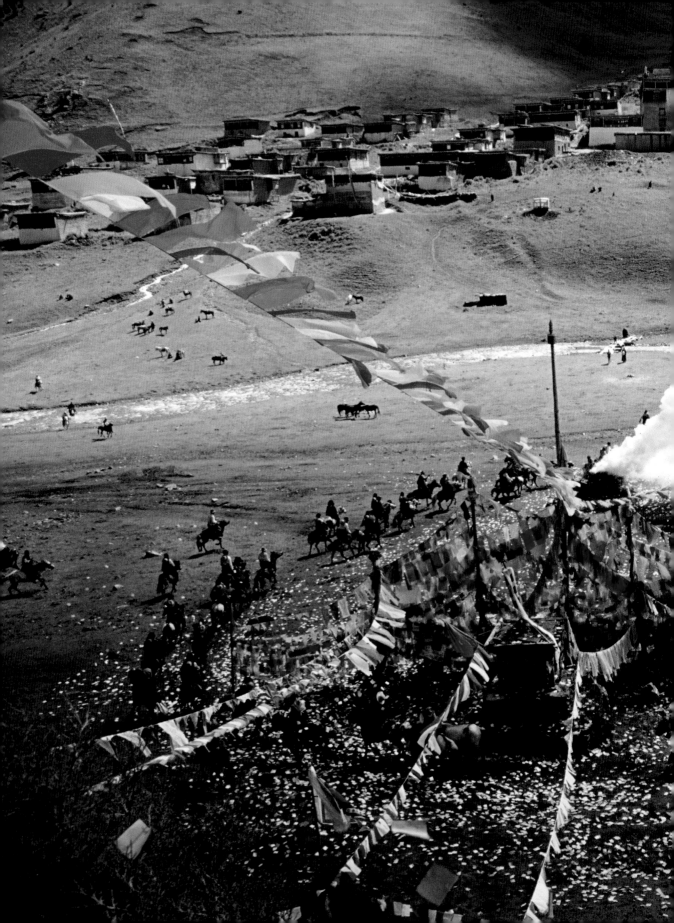

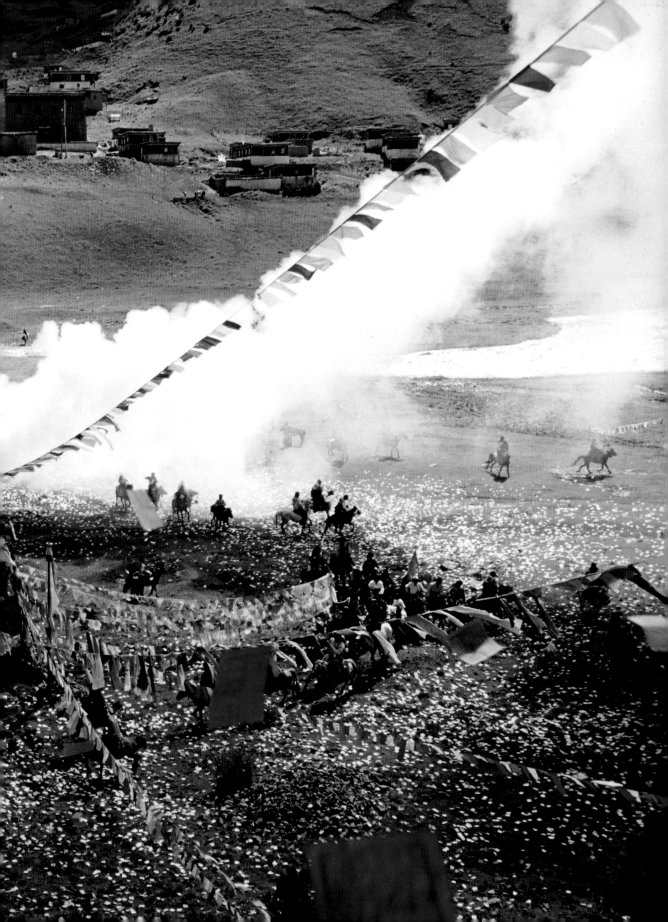

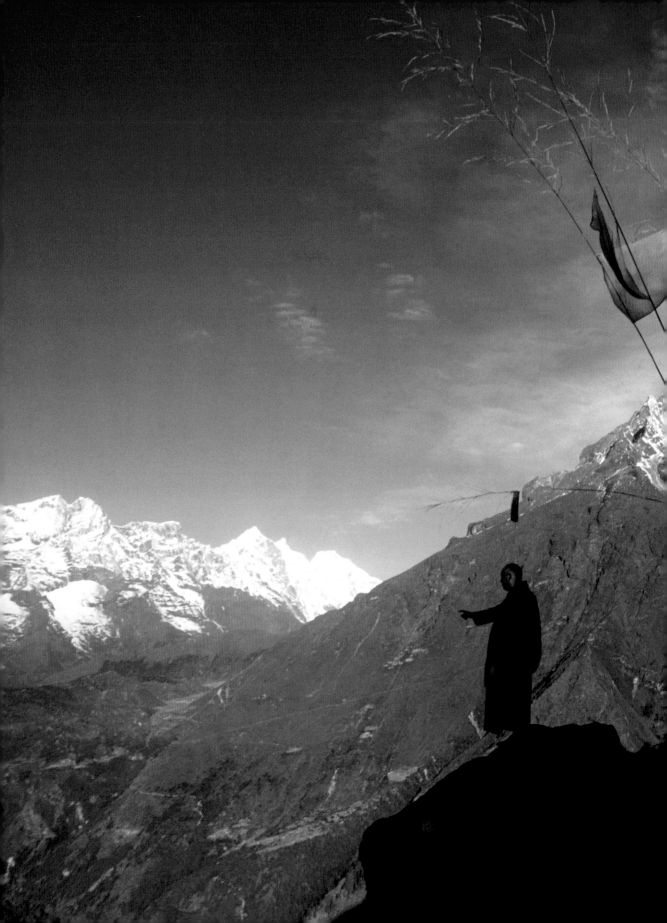

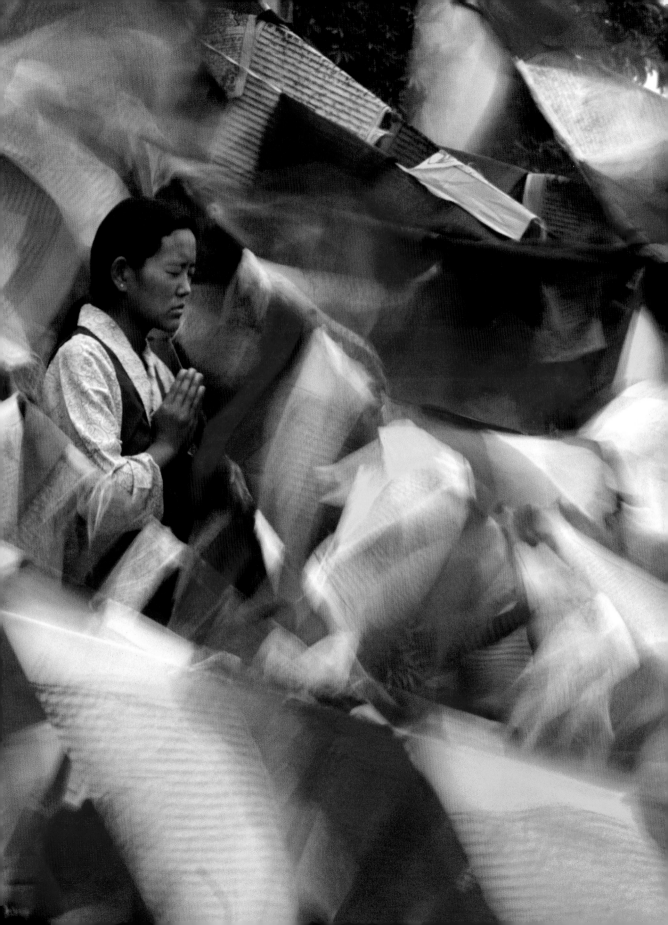

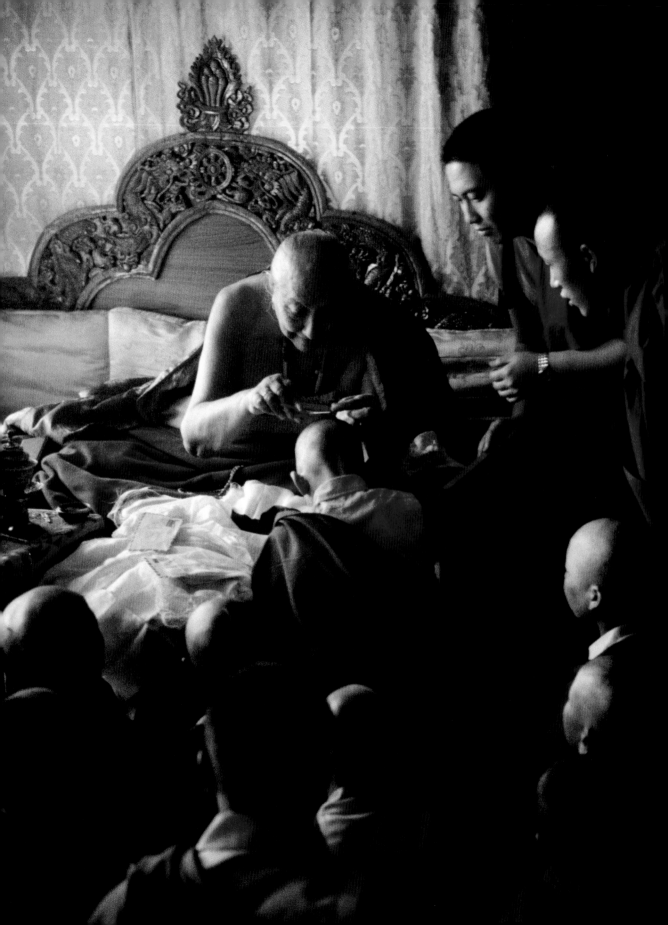

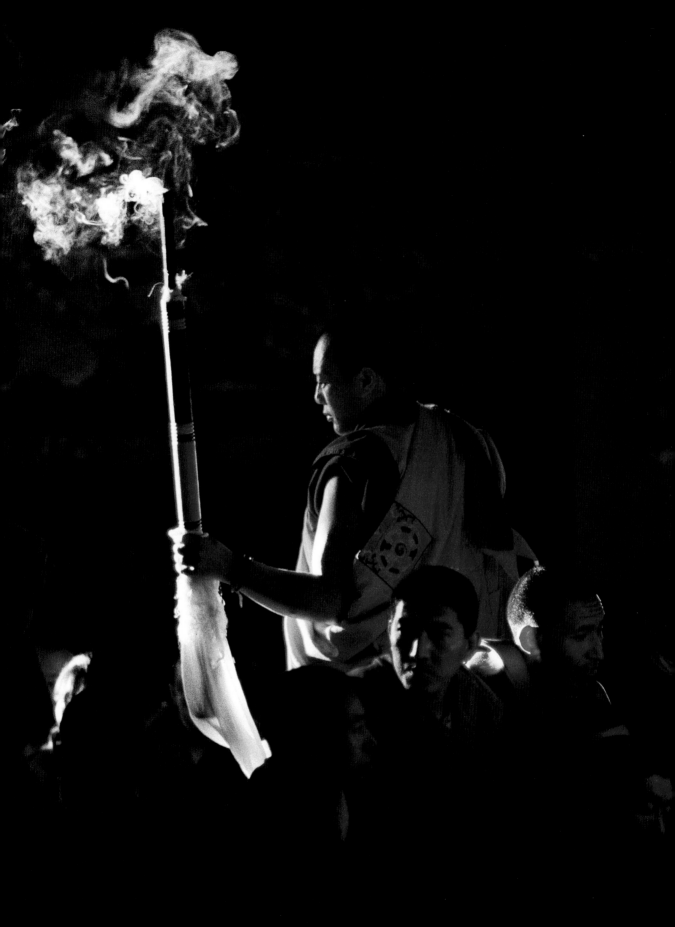

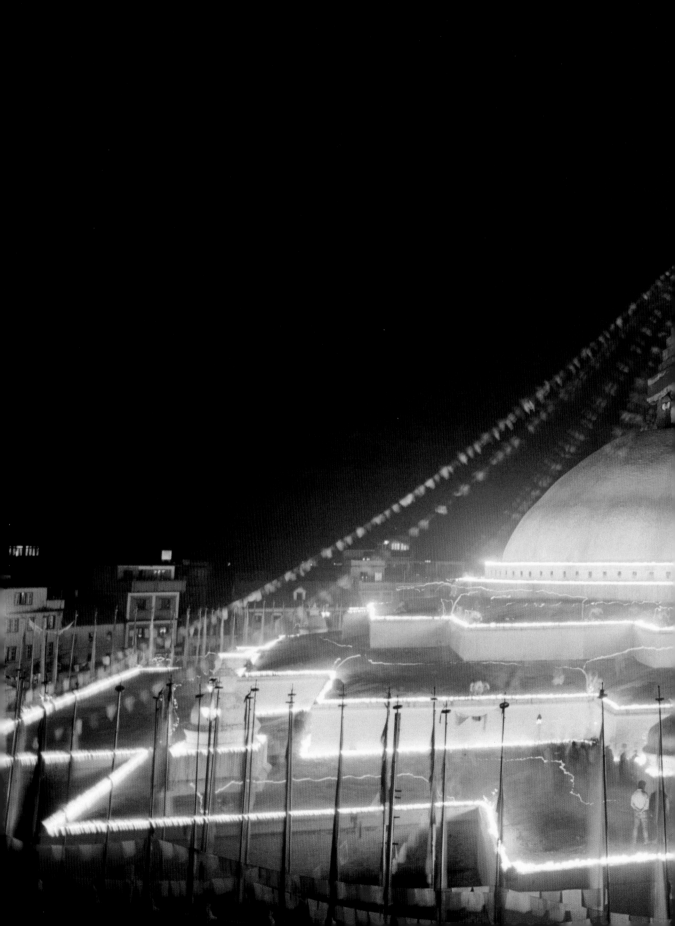

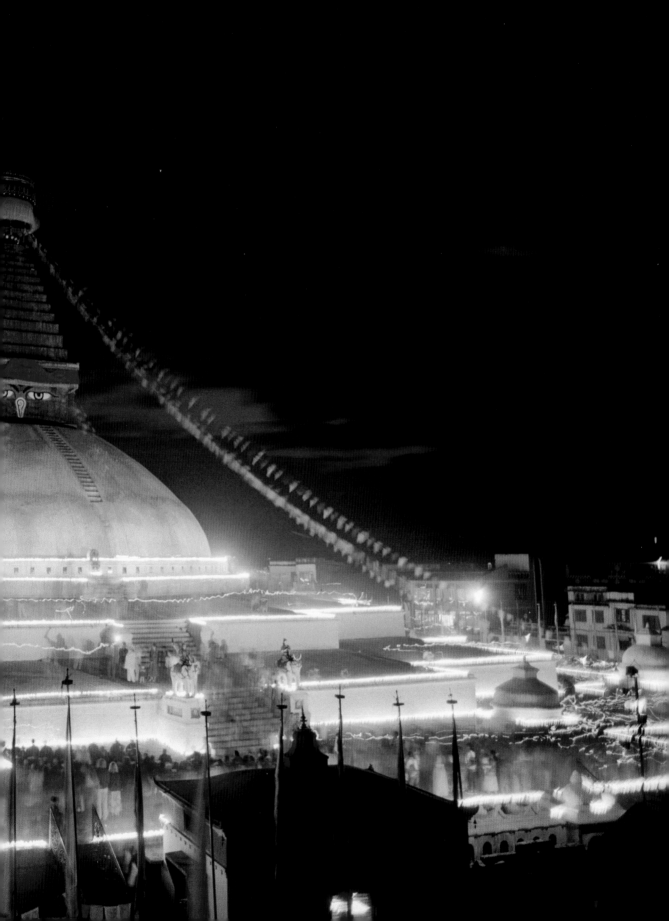

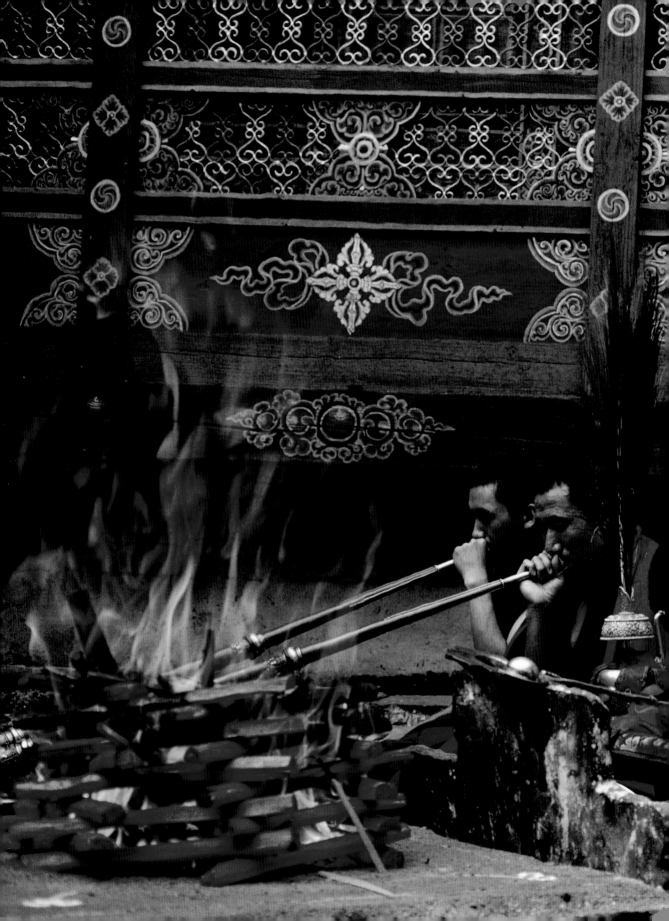

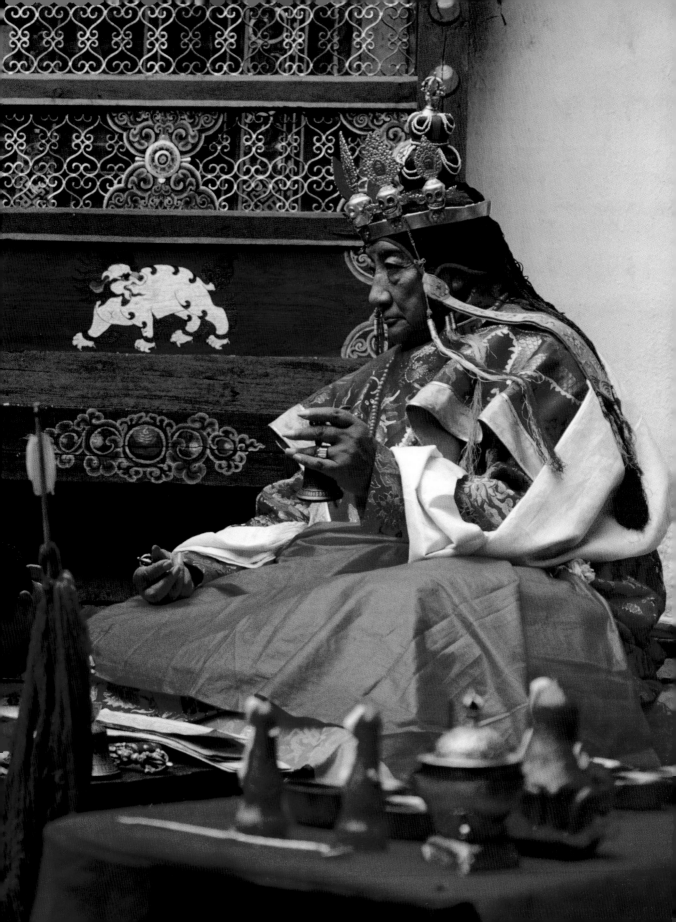

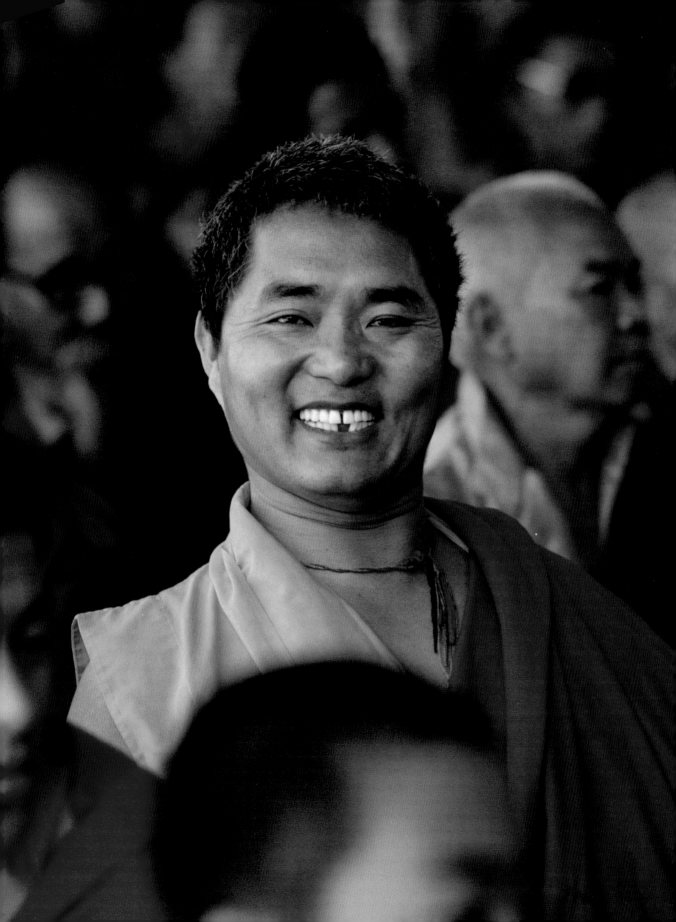

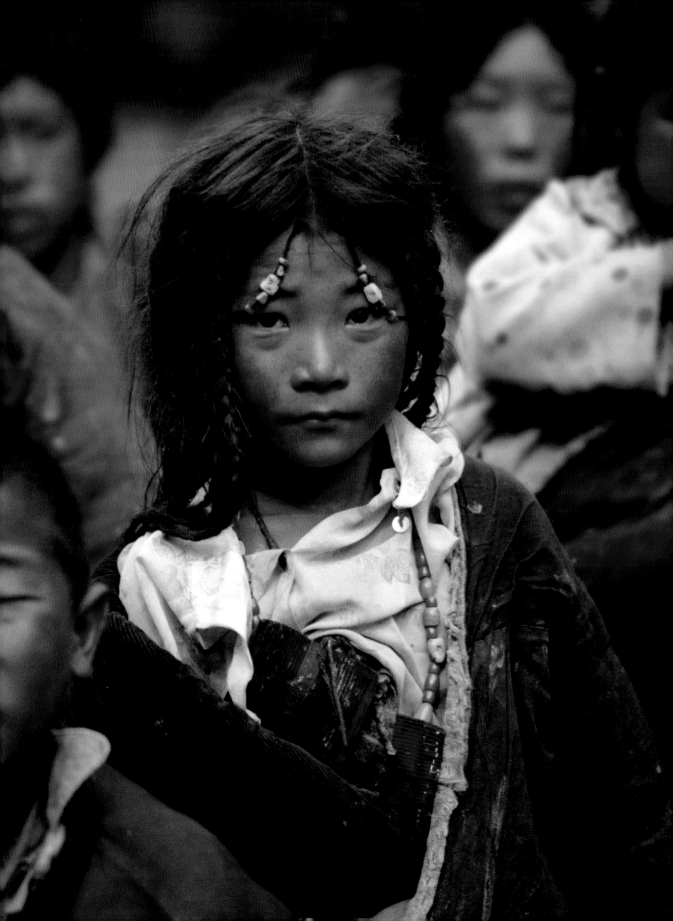

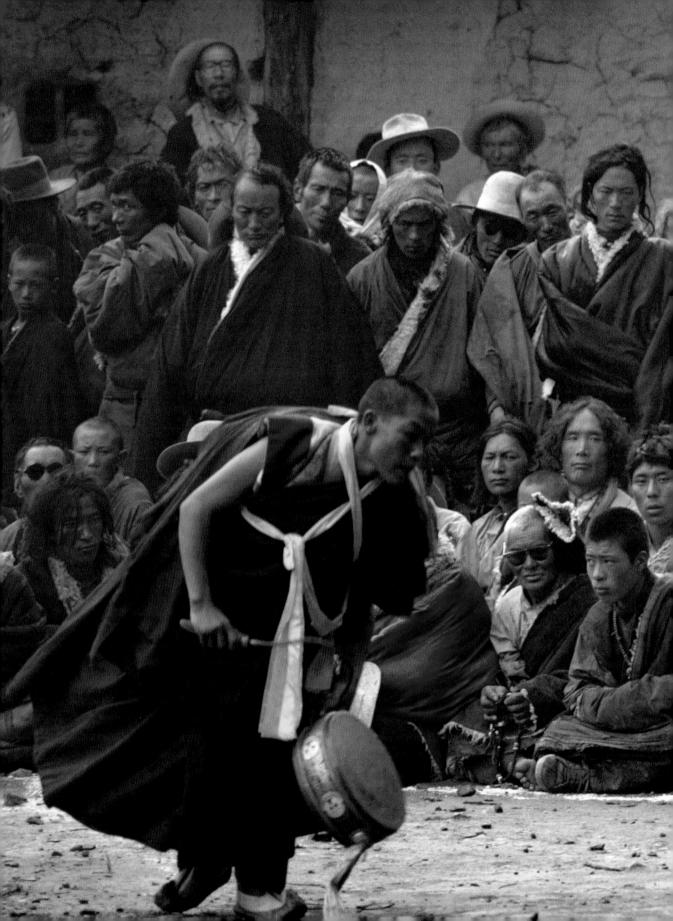

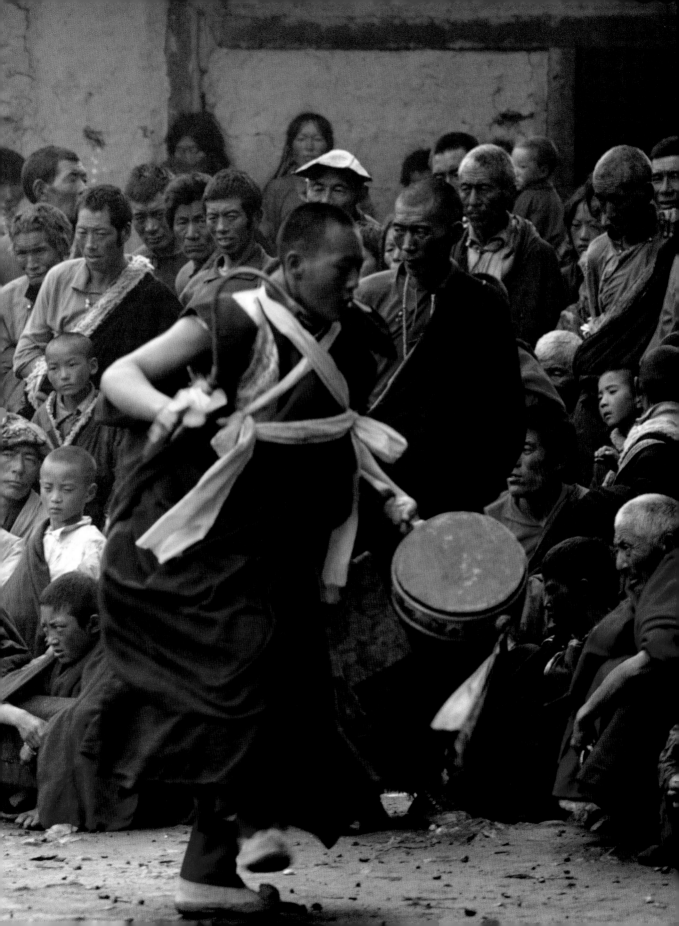

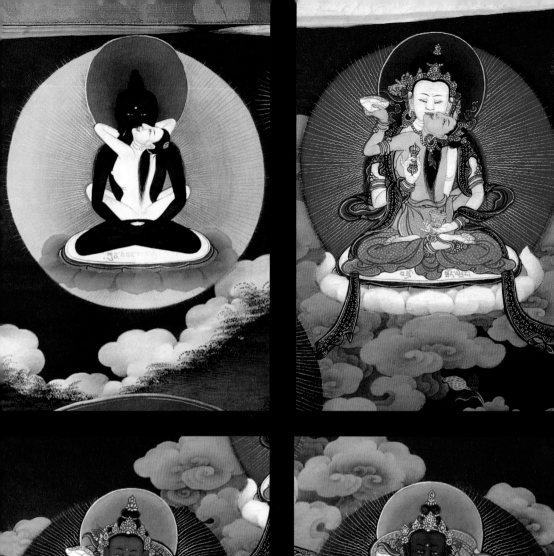
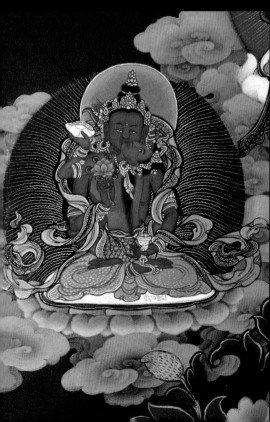
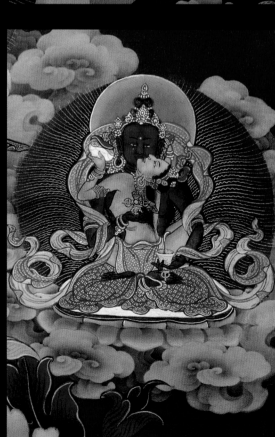

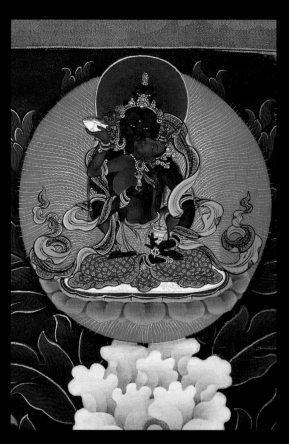
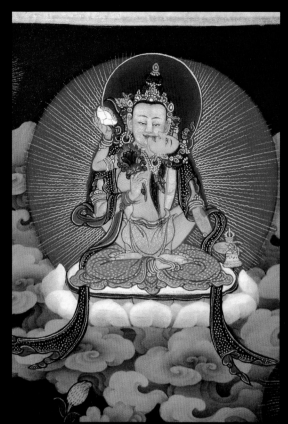
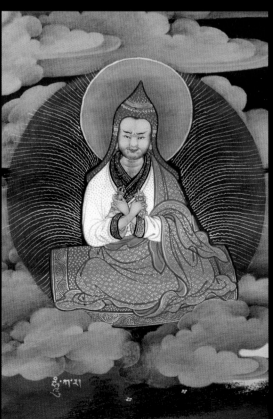
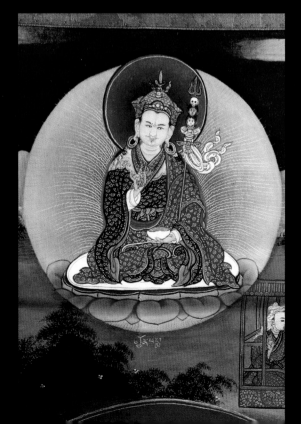

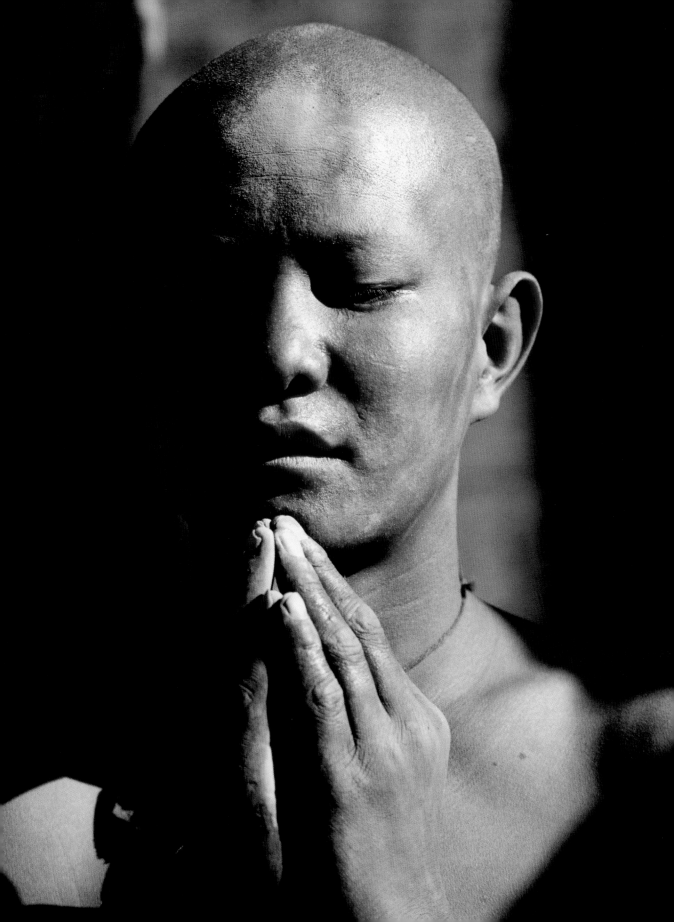

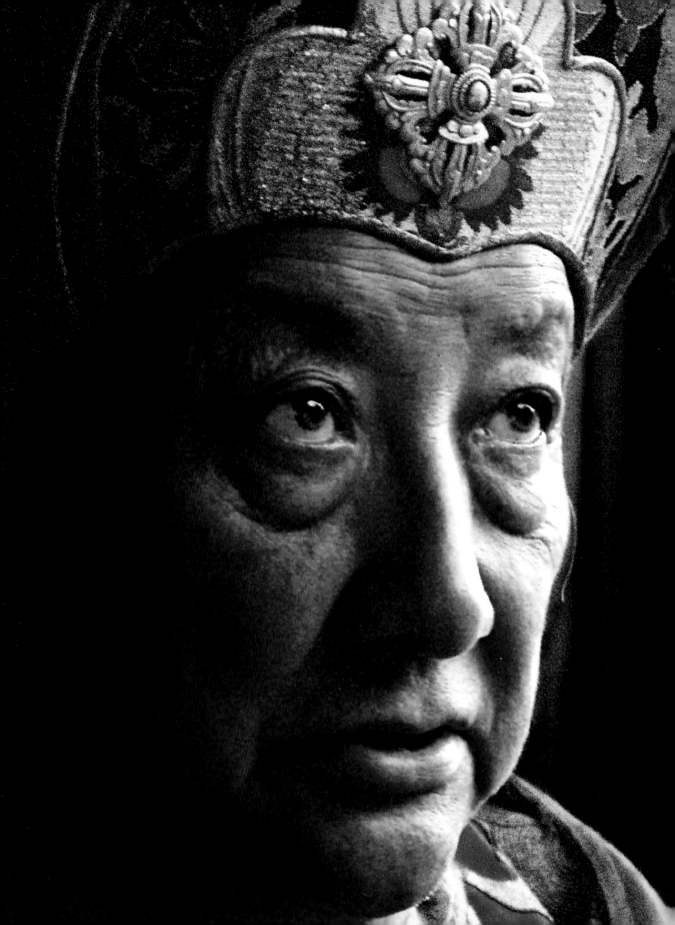

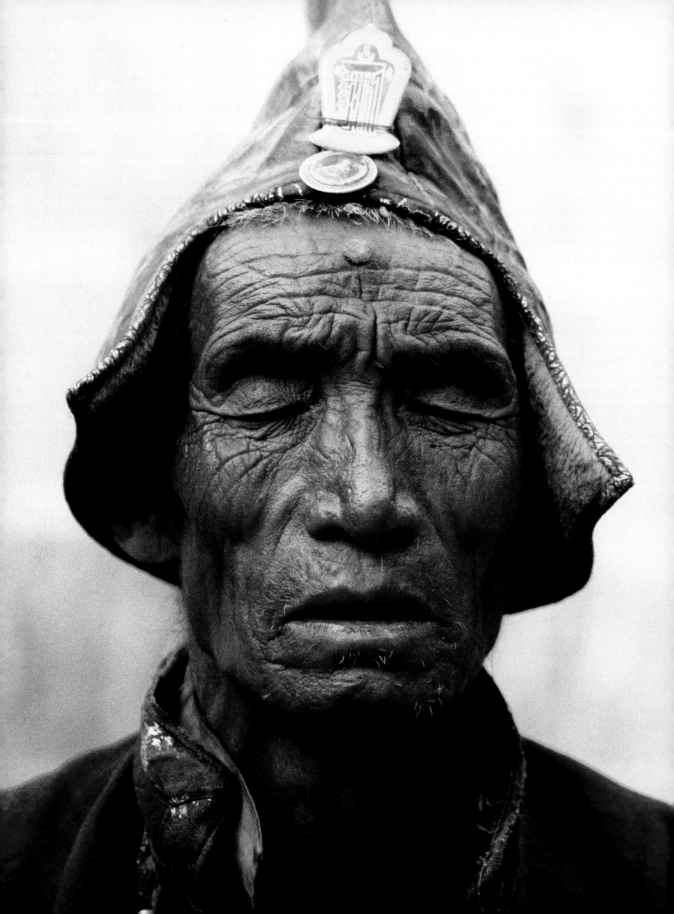

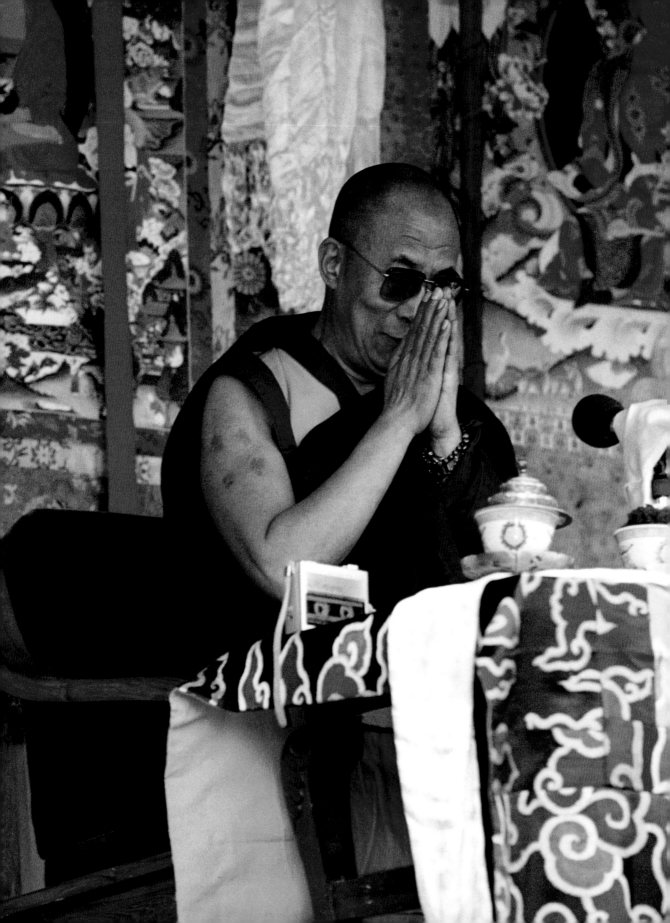

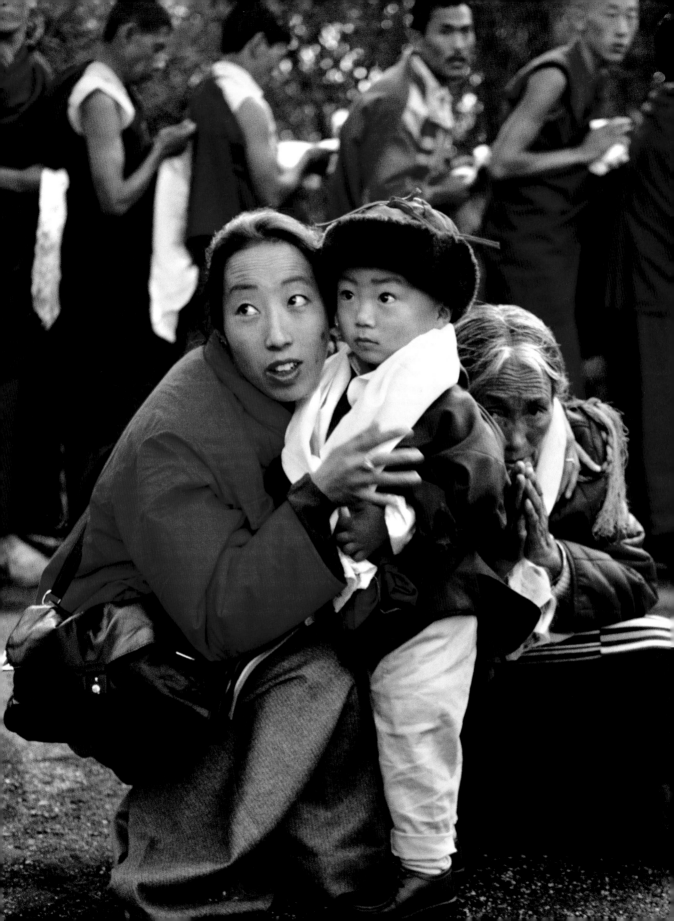

Tibetan Language and Literature

The Tibetan language belongs to the Tibeto-Burman group of the greater Sino-Tibetan family. Written Classical Tibetan reflects the 7th-century dialect spoken by the people of the connected Yarlung and Chongye valleys in present-day Tibet.

According to tradition the great religious king Songtsen Gampo dispatched a minister to India to learn how to write so that he could enlighten his countrymen. The minister Thonmi Sambhota returned to Tibet with an adaptation of an Indic script. He created a grammatical system with thirty consonant glyphs and four vowels and methods for their combination. The new writing system provided the means of promoting the translation of the extraordinary corpus of the Buddhist canon, the *Kanjur*, pronouncements of the enlightened Buddha and his manifestation, and the *Tanjur*, Tibetan translations of Indic masterpieces connected with Buddhism and India.

Thus began a millennium of translation activity and spiritual transmissions. Islamic conquerors had all but wiped out the great Buddhist institutions of India, and there was an influx of Indian masters into Tibet. Many of the books were brought to Tibet, where they were preserved in the temples and monasteries of the land, and were quickly translated into Tibetan. Tibetans in search of knowledge continued to travel to India where they encountered tantric adepts who collaborated with their Tibetan students.

The rulers of the Yarlung dynasty were busy spreading their authority through conquest and the superior Buddhist culture throughout what is now the Tibetan cultural area. The Tibetan script was adapted to a number of languages, most of which have subsequently disappeared. Some of these languages, including Nam, Sumpa and Shangshung, are known only by name. These languages and cultures were later replaced by the Tibetan language and Buddhist culture. The process of assimilation continued until the beginning of the 20th century when the principality of Kanam was conquered by the Lhasa government.

The oldest Tibetan literary monuments that survive are stone pillar inscriptions and an enormous corpus of materials written on paper, wood and birch bark, preserved in libraries in the U.K., France and China. From the evidence, it would appear that, by the 8th and 9th centuries, Tibet already had a well-developed literary tradition. The Tunhuang corpus contains highly sophisticated translations of Buddhist scriptures as well as a surprising wealth of folk literature.

Translation activities of Buddhist and Bön scriptures grew greatly during the 11th, 12th and 13th centuries. Many important Sanskrit classics such as *The Cloud Messenger* (*Meghaduta*) and *The Mirror of Poetry* (*Kavyadarsa*) were translated during this period, laying the basis for a literature based upon the well-developed principles of classical Indian literature and scholarship. The Indic poetic adornments and principles of metrics were adapted to the Tibetan language. Tibetan literati began to write creative works using highly stylized formulae of the Indian masters from whom they studied. In parallel, another literary style that followed different rules developed in Tibetan culture. The extraordinarily rich epic of Gesar the King of Ling and the wonderful poems which record the spontaneous spiritual outpourings of travellers on the path of realization (*gur*), for instance, follow a different literary canon, which owes little to the rhetorical adornments and artificial metric patterns of the classical Indian masters. Both types of literature persist side by side in Tibetan culture, and we find the same authors writing in both forms. The voices

heard in the *gur* resonate more to modern readers' tastes than do the equally significant literary forms based upon Sanskrit literature.

The earliest indigenous literary productions in the Tibetan language are translations from Sanskrit and other Indian languages, folk material, and chronicles. By the 14th century, there was a well-developed tradition of Tibetans composing their own works on religion, astrology and astronomy, and medicine. Most of the early literature written by Tibetans carefully followed the rules of Tibetan grammar that had been settled upon by Thonmi Sambhota. The vocabulary that was used slavishly followed the vocabulary laid down in the early terminological glossaries, which were used by the translators.

Perhaps the most Tibetan of the genres of indigenous literature were the *namthar*, or life stories, and the stories of the rise of the Dharma. These are very seldom encountered in Indic literature. So far, over 2,500 of these lives of great Buddhist teachers or righteous political kings have been documented. The Tunhuang caves contained scrolls containing fascinating stories of the early kings of the Yarlung dynasty and their deeds.

The biographical writings often reported quoted discourse and were replete with dialect words and constructions that bear little connection with the classic grammatical norms. Reading for instance the autobiography and the history of Buddhism of the great Drukpa Kagyupa master Pema Karpo (1527–92) is a difficult job because of the use of his native Kongpo dialect. There are Tibeto-Burman dialects spoken even today in southeastern Tibet which are incomprehensible to speakers of standard Tibetan. Similarly the *gur*, or songs of religious experience, are sometimes difficult to comprehend because of their usage of local lexical items and grammatical forms.

Tibetan literature is extremely rich in medical literature. These materials are only now becoming comprehensible. Many are the manuals for those who wished to study astrology, calendrical calculations, and prognostication. Besides the Gesar epic, which recounts the conquests of foreign lands surrounding Tibet, there are accounts of returns to the realm of the living from death (*delok*), stories of saintly rogues, and even love songs, the most famous collection of which is attributed to the 6th Dalai Lama Tsangyang Gyatso. One finds catalogues of blessing-bestowing objects such as stupas and temples, stories of acts of piety and merit by kings, monastic regulations, and didactic tales. Great writers like Chak Lotsava (1197–1264), Gedun Chophel (1903 or 1905–51), and Ripa Bayo (1876–1942) have recounted their travels to other lands.

Tibetan has now entered the modern world and authors living both in Tibet and in the diaspora have begun to adapt the short story, novel and play to the Tibetan experience. We now find accounts of foreign travel, Western history, and studies of European philosophy, and increasing numbers of translations of Western and Chinese literature are appearing. One of the better designed books published recently was a translation of a collection of plays by Norwegian playwright Henrik Ibsen. Tibetan literature has come of age.

'LIKE THE TWO WINGS OF A BIRD'
WISDOM AND METHOD

In Buddhism, wisdom means understanding the ultimate nature of the mind and phenomena. Method is unlimited compassion for the infinity of beings. This ultimate nature of mind is Enlightenment, the fundamental luminosity of the stream of consciousness, with no beginning or end, in which there is no duality between subject and object. 'Luminosity' in this sense means the faculty of knowing, as opposed to inanimate things. This nature is also called 'emptiness', in that nothing in the mind exists in itself or by itself.

The ultimate nature of external phenomena is also described as 'emptiness'. This term, which is often misunderstood, does not mean nothingness. It does not designate the absence of phenomena but rather their true nature, the fact that they have no independent or permanent reality. The famous saying from the Sutra of Transcendental Knowledge, 'Emptiness is form and form is emptiness', implies that the fact that phenomena have no existence of their own is the very condition that allows them to manifest themselves. Khyentse Chökyi Lodrö, a 20th-century Tibetan teacher, wrote this poem:

> 'Emptiness is not nothingness,
> It is Enlightenment and compassion,
> The spontaneous radiance of original wisdom.
> The enlightened presence is ineffable, indefinable.
> Its creativity gives rise to the multiplicity
> Of samsara and nirvana.
> But this deployment and its cause
> Are not two distinct things.
> Simply remain in this non-dual state.'

The method is compassion and altruistic love, accompanied, reinforced and nourished by the development of human qualities and the practice of altruistic actions grouped under the term 'accumulation of merits' or of 'good fortune' (*punya* in Sanskrit). The term 'merit' is defined not simply as a moral act consistent with goodness, but also and more importantly contains the notion of 'provisions', which are essential on the journey towards Enlightenment and to allow wisdom to unfold. This power of personal transformation can liberate from suffering.

This makes it easier to understand why wisdom and method must go hand in hand. It is sometimes said that they are like the two wings of a bird. A bird cannot fly with just one wing. Nor can we say that it should begin to fly with its right wing or its left wing in order to soar up into the sky.

The great Tibetan master Shabkar wrote: 'I will now give you advice from my heart: the sky needs a sun; the mother needs a child and the bird needs two wings. Similarly, the knowledge of emptiness is not enough in itself: it is essential to feel great compassion for all beings, friends, enemies or those to whom we are indifferent, who have not experienced this reality. Meditate on compassion day and night; in thinking of the suffering of beings, cultivate a compassion that is a hundred times stronger than that of the mother for its child burned alive, a compassion that is scarcely bearable.'

Wisdom (*prajna* in Sanskrit) and method (*upaya*) cannot, therefore, be dissociated. Without compassion, the knowledge of emptiness remains intellectual. But without an understanding of emptiness, compassion remains in the realm of ordinary feelings of sympathy or pity and its effects are confined to relieving suffering in the short term. The ultimate knowledge of the nature of things, together with great compassion, is the only way to truly eradicate suffering.

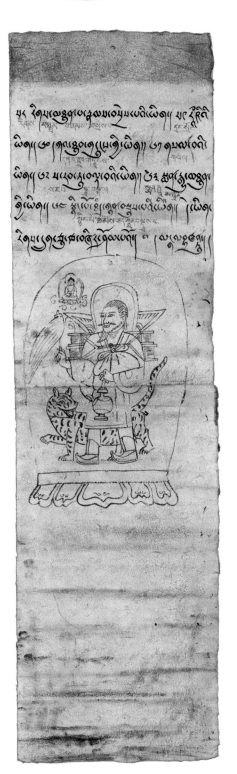

From Sign to Meaning
Tibetan Calligraphy

Bod-yig, or Tibetan calligraphy is little known in the West, although this form of writing extended across a large area of central Asia thirteen centuries ago. Calligraphy is the form, the presence of the sign. It is thus the medium of the word of Buddha. Along with reading, writing is the earliest thing we learn. Tibetan script uses an alphabet of thirty consonants and four vowels, adapted from the Sanskrit alphabet. It is written from left to right with a dot or a dash between each syllable. The use of composite syllables, with subscript and superscript letters, permits 256 different syllabic combinations.

Tradition has it that the 7th-century king Songtsen Gampo sent his minister Thonmi Sambhota to India to study languages, writing and grammar. On his return seven years later, the young man established an alphabet and a grammar adapted for the Tibetan language. The origin of *bod-yig* calligraphy goes back to the middle of the first millennium, to the time when monarchic rule was emerging. Writing played a part in stabilizing a kingdom subdued with a heavy hand, and later assisted the study and diffusion of Buddhism in the Land of Snows.

Two major scripts have coexisted since the 7th century: the jagged *shur* and the elegant *dzab*, better known nowadays as *u-mey* (headless) and *u-chen* (headed).

These had a common source in the Indian *brahmi* script, which flourished during the Gupta period (4th and 5th centuries). The first is linked to the western Zhang Zhung area where the Bön royal culture flourished, the second to the central and southern areas influenced by the Buddhist culture that came from India.

The art of calligraphy was enriched by diplomatic exchanges and by the diffusion of Buddhism by teachers and translators such as Padmasambhava, Rinchen Zangpo and Atisha.

Iconometry and wood-block printing regularized the 'elegant' *dzab* or *u-chen* script, and led to its formalization with a top that leaves the calligraphy 'suspended in the sky' and not 'set on the earth'.

The principal scripts in use nowadays are *u-chen* and are mainly used in the production of religious books and in printing; *u-mey* is the medium both of sacred texts and of general use, *dutsa* is the script of chanceries, *bam-yig* that of official texts and apprenticeship. The cursive *kyuk-yig* is used for correspondence and notes. There also exist two ornamental scripts, *lantsa* and *wartu*, which are used for titles and mantras in Sanskrit. *Hor-yig* is reserved for seals and friezes.

Like the temple at Samye, Tibetan calligraphy unites three influences: Indian, Chinese and Tibeto-Khotanese. It derives its

basic skeleton from Indian *brahmi* script, known from the edicts of Ashoka found carved on columns. This basic structure was then fleshed out by the use of the broad reed pen (calamus) of Sassanid Persia and Khotanese Turkestan. The relationship between form and emptiness is associated with the Buddhist culture of Tang China.

The calligrapher writes with a bamboo stick, cut into the shape of a broad, firm nib. This combines the advantages of the Indian stylus used on palm leaves, the wide-nibbed calamus of the Greeks, and a brush, and enables the writer to thin or thicken a line by turning the bamboo stick between the fingers. This convergence of formal references, and the different finishes that the tool can produce, contribute to the distinctive style of Tibetan calligraphy.

When it became the vehicle of Vajrayana Buddhism, Tibetan writing spread from Tibet into Bhutan, Nepal, Sikkim, Ladakh and Mongolia. Classical Tibetan literature thus became one of the richest of the East, alongside Sanskrit and Chinese.

Writings are held in the utmost respect in Tibet, because they constitute the Dharma, the medium of the Buddha's teachings. Books are never put on the ground if it can be avoided, and they are never stepped on. Damaged or dirty books are not carelessly thrown away but burnt or stored in a niche of a chorten.

While reading or reciting from a religious text is a pious act, copying one is even more so. Sometimes entire books are written out in gold ink.

The treatise on *yutri* calligraphy is itself an illustration of the passage from sign to meaning. The inscribing of each character in the *u-chen* script is described stroke by stroke. This is accompanied by notes on particular points and more general commentaries, the better to produce 'harmonious, beautiful, regular, dynamic and pure calligraphy'.

The treatise ends 'in being present in the base of the spacious Lotus, meditating, without concept but seeing by oneself; having thus accomplished the whole of the practice, this primordial knowledge bestows truth and goodness.'

Yig-zuk calligraphy is an education in itself. The letter A is highly symbolic, and to write it is the quintessence of calligraphic art. 'A' is the last letter of the Tibetan alphabet, but it is present in the sound of all the others (*ka, kha, ga*). In appearance and shape it combines the stroke (form) and the void (counter-form), and so allows access to emptiness, the source of all relationships between phenomena: 'A' embodies the message of the Sutra of the Heart of Transcendent Knowledge (*prajnaparamita-hridaya*): 'Form is emptiness and emptiness is form. There is no form without emptiness.'

Patrul
A Wanderer in Search of Enlightenment

He lived a wanderer's life, yet Patrul Rinpoche was an enlightened teacher and one of the most famous 19th-century spiritual guides. His memory remains very much alive and is a constant source of inspiration to all practitioners of Tibetan Buddhism.

A hermit is certainly not as visible as a spiritual master who lives in a monastery, but he represents the very heart of Buddhist tradition, the contemplative life. Those who live in the vicinity regard his presence in a particular place as a blessing and a reminder of what is essential. Villagers and nomads also regard it as a privilege to take care of the hermit's needs by leaving food, whether *tsampa*, butter or dried meat, at the entrance to his cave or retreat.

Patrul Rinpoche is the perfect example of the wandering hermit. He was born in 1808 in Dzachuka, a region of Kham populated by nomads. His main teacher was Jigme Gwalwai Nyugu, a great yogi who had meditated in solitude for years, near the land of everlasting snow. On the windswept mountainside where he lived, there was not even the shelter of a cave. His only home was a depression in the ground, and he survived by eating wild plants and roots. The fame of this remarkable ascetic soon spread far and wide, and hundreds of disciples flocked to him, living in tents nearby.

From Gwalwai Nyugu, Patrul Rinpoche heard the teachings on the 'preliminary practices' no less than twenty-five times, and later wrote them down in a famous book, translated into English as *The Words of My Perfect Teacher*.

Patrul Rinpoche spent most of his life wandering. He possessed nothing, walked in the mountains, living in caves, forests, and remote and solitary retreats. He would stop anywhere, with no specific plans; then he would leave again towards no particular destination. All he took with him were the clothes on his back, a stick, a bundle containing a little earthenware teapot and a copy of the *Bodhicharyavatara* (*The Way of the Bodhisattva*). He stopped wherever he chose, in the heart of a forest, or in a cave in the middle of nowhere, staying for an undetermined length of time.

He meditated constantly on love, compassion and Enlightenment. For him, these three points were the real root of spiritual practice. He would repeat to everybody, whatever their status: 'Be of good heart and act with goodness; nothing is more important than that.'

He had studied with the greatest masters of his time and, thanks to his amazing memory, knew most of the scriptures by heart. He could teach the most complex subjects of Buddhist philosophy for months on end without relying on a single page of text. He radically changed the minds of his listeners; they became serene and able to rest effortlessly in contemplation. Spoken by him, even a few simple words could open the door to a whole succession of new insights into spiritual life. He taught in a direct language which people could immediately relate to their own inner experience. Because of his immense knowledge, the warmth of his blessings and the depth of his inner realization, to receive teachings from him was quite different from receiving them from any other teacher.

From his outward appearance, nothing distinguished Patrul Rinpoche from a completely ordinary person. People who met him by chance would never have guessed that he was a great master. It even happened that other lamas, not recognizing him, gave him teaching on his own writings! He possessed nothing and never accepted offerings. If people insisted on presenting him with valuables, silver or gold or whatever they were, he would leave them lying there and go off carefree and alone.

He would teach or tell stories from the lives of the great masters of old, but no one ever heard him chat about any ordinary worldly goings-on. He spoke seldom, anyway, and when he did it was in a blunt and direct way, uncomfortable for anyone hoping for flattery. His presence inspired awe and respect, and was indeed a little intimidating at first. Only those who genuinely needed his spiritual guidance would come to visit him. But anyone who got to know him well would end up finding it very difficult to part from him.

One day, as Patrul was crossing the great Golok plateau, he met a poor woman accompanied by her three children. Her husband had just been killed by a red bear from the high plateaux. Patrul asked her where she was going. She replied that she was thinking of going to Dzachuka to beg a little food.

'But that is a long way,' answered Patrul, 'you cannot go alone! Let us travel together.' During the day,

Patrul carried one of the children on his back; the mother looked after the second one while the third walked beside them. At night they would sleep under the stars. Patrul wrapped two of the children in the folds of his sheepskin while the widow held the youngest in her arms.

When they reached Dzachuka, at the foot of the monastery, Patrul turned to the woman and said: 'I have to go to this monastery. I have a job to do.'

'What could you possibly have to do there?' the woman asked in surprise. 'You have been so kind to me and my children. Perhaps we could get married. Or I could simply live with you and enjoy your kindness.'

Patrul simply replied: 'Come to the monastery in a few days' time and you will find me there.'

The news of Patrul Rinpoche's arrival spread throughout the valley. People hastened towards the monastery. The widow felt great joy: 'A great lama has arrived! What an unexpected chance to make offerings and ask for prayers to be said for my late husband!'

Contrary to his usual habits, Patrul had told the monks around him to put all the offerings made to him aside, saying: 'I am expecting a guest who has great need of them.' On the specified day, the woman came to the monastery and sat down at the back of the main temple area. She listened to the teachings, without recognizing Patrul Rinpoche. It was not until she came up to the lama to receive his blessing that she recognized her travelling companion.

She bowed before Patrul and said to him, in great confusion: 'Forgive me for not having recognized you, for having made you carry my children and for having even dared ask you to marry me.'

After reassuring her, Patrul Rinpoche turned towards the monastery steward and said to him: 'This is my guest, give her all the butter, cheese and food I asked you to put aside.'

HERMIT AND POET

The art of the hermit and poet is to read the outer world as a guide for the contemplative life. Lofty white peaks or immaculate clouds make him see his beloved teachers seated on them, magnificent and radiant; a transparent, luminous sky enhances his realization of the view of the Great Perfection, the ultimate nature of mind; the change of seasons and the withering of flowers bring melancholy and remind him of impermanence and death; the murmur of cascading streams, the whistling of the wind and the songs of birds recall to his mind the words of teachings and conversations with his masters and friends. These are the words of Shabkar, the great 18th-century Tibetan yogi (quoted from *Shabkar, the Autobiography of a Tibetan Yogin*):

'Just as silvery mist rises
Into the vast, empty firmament,
Will not the form of the lord guru
Appear in the immensity of all-pervading space?

Just as gentle rain slowly descends
Within the beautiful arc of a rainbow,
Will not the guru shower down profound teachings
Within a dome of five-coloured light?

Just as rainwater remains
Upon the even ground of a broad meadow,
Will not these teachings remain in the mind
Of your faithful and devoted son?

Just as brilliantly coloured flowers
Spring up across the lush, soft moorland,
Will not spiritual experiences and realization
Arise in your son's mind-stream?'

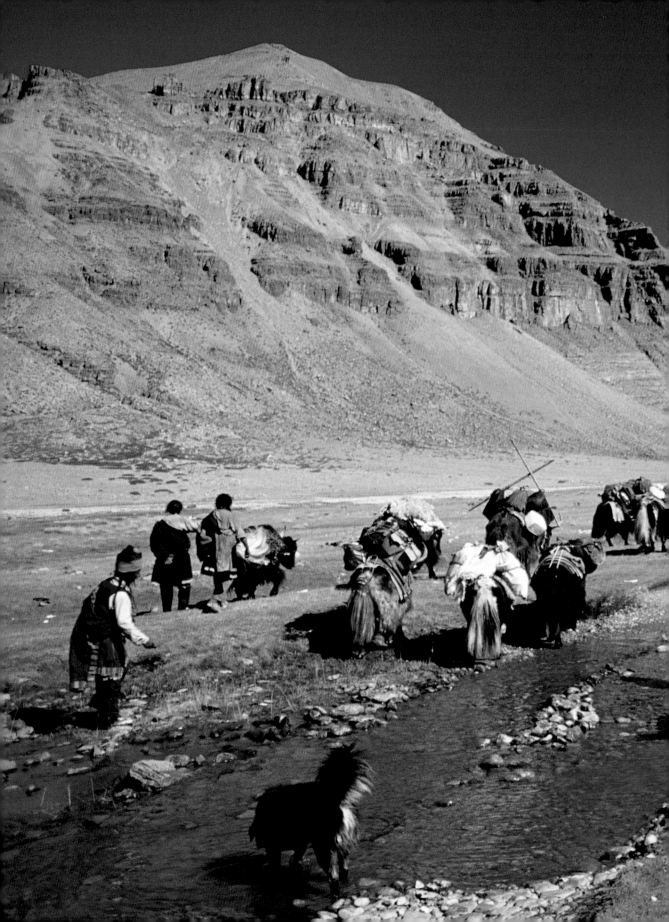

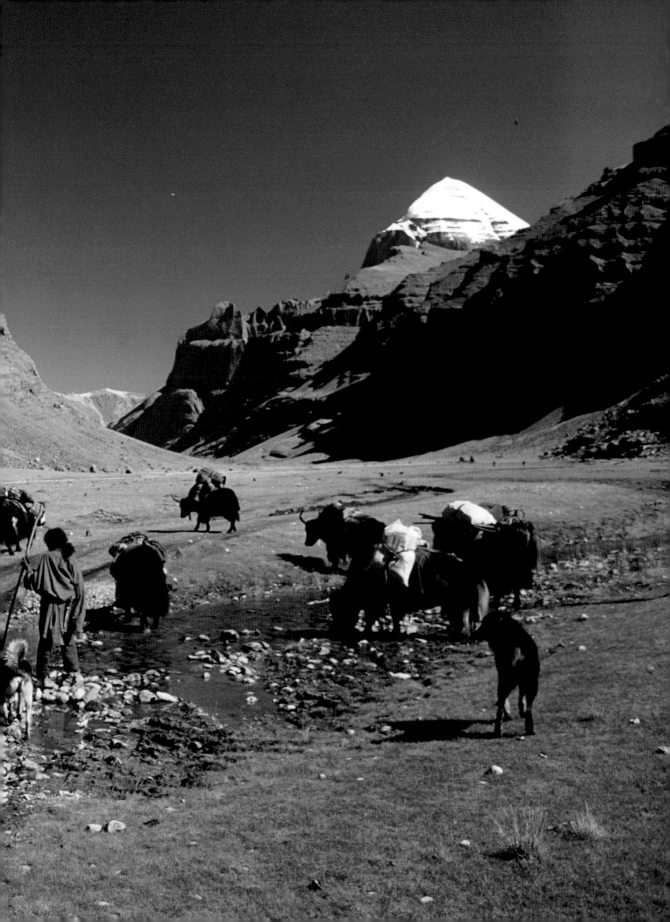

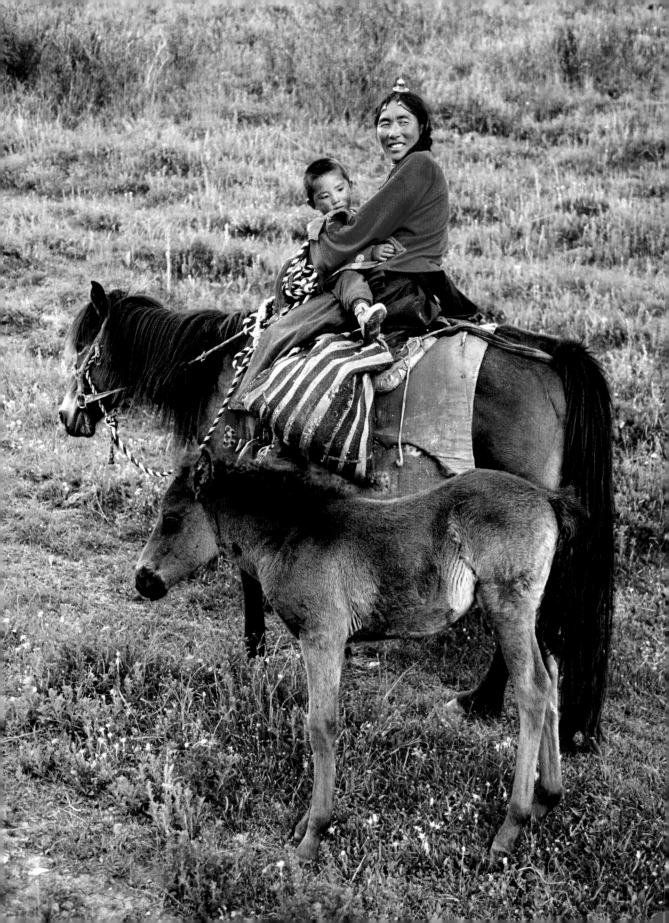

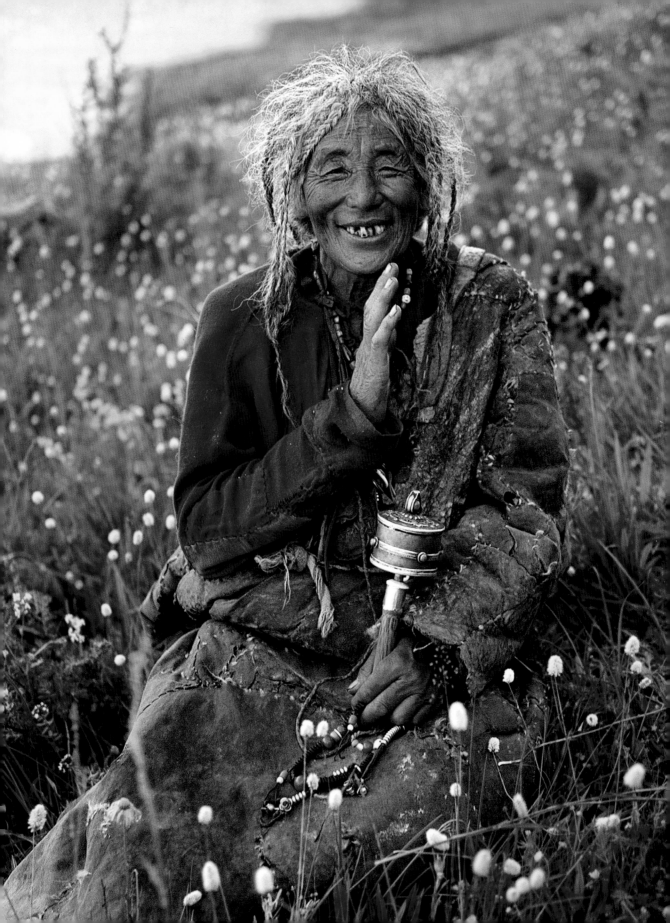

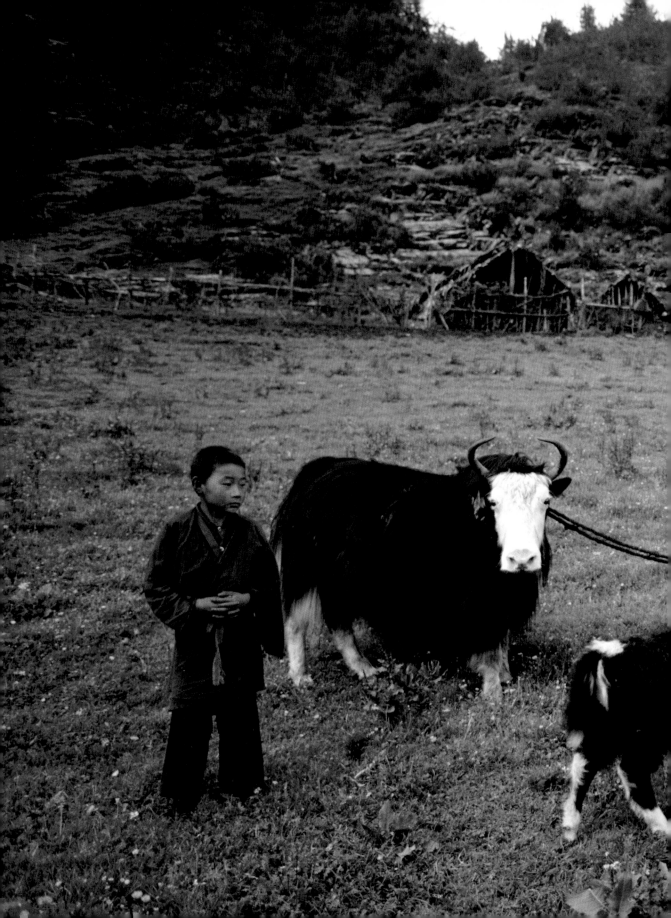

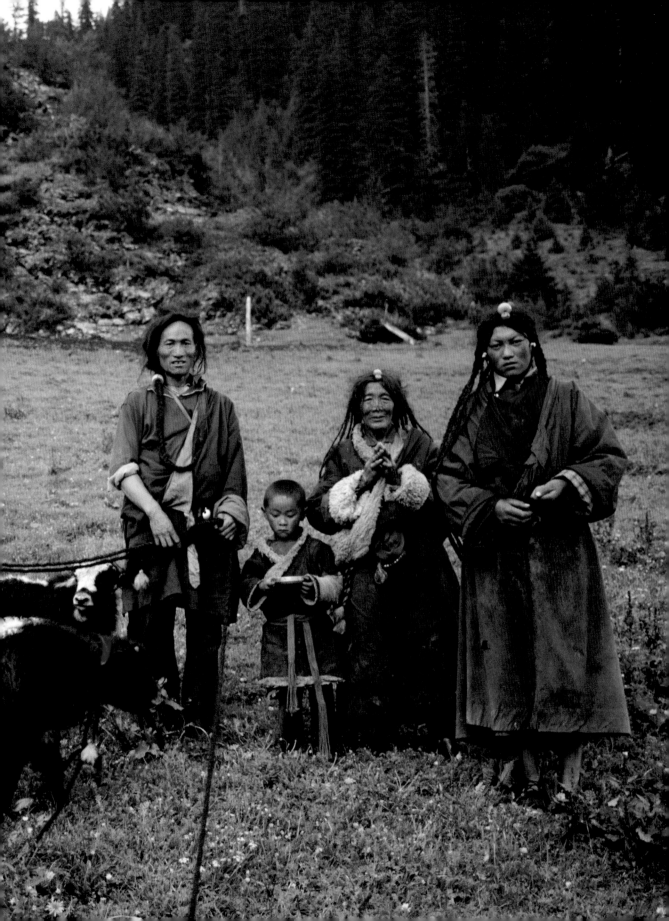

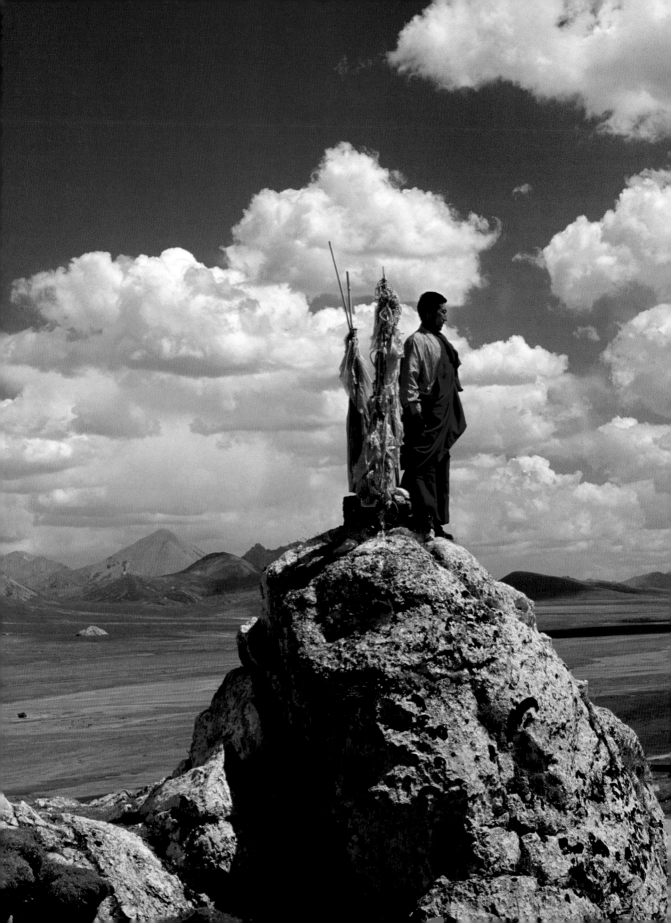

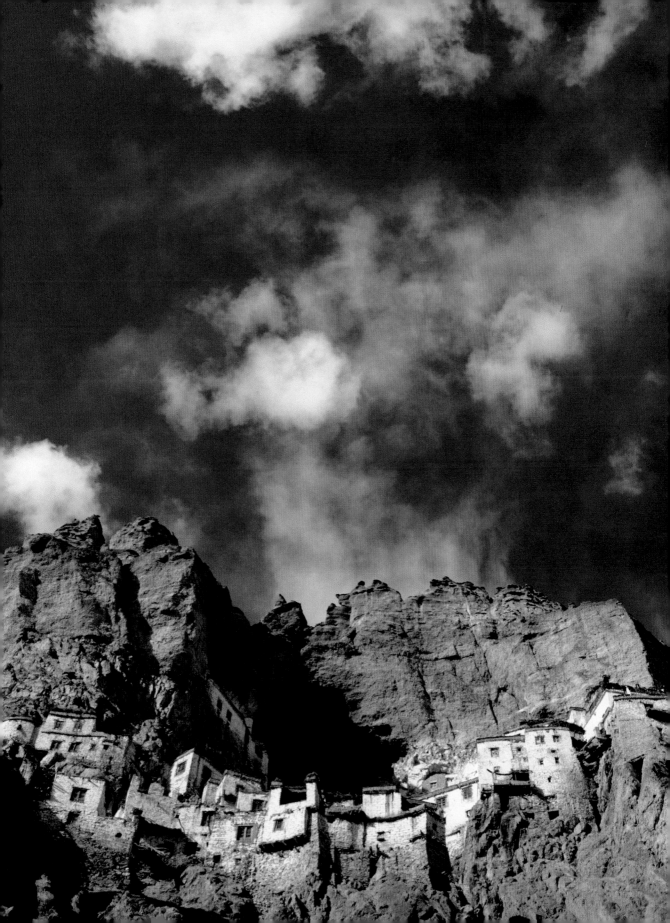

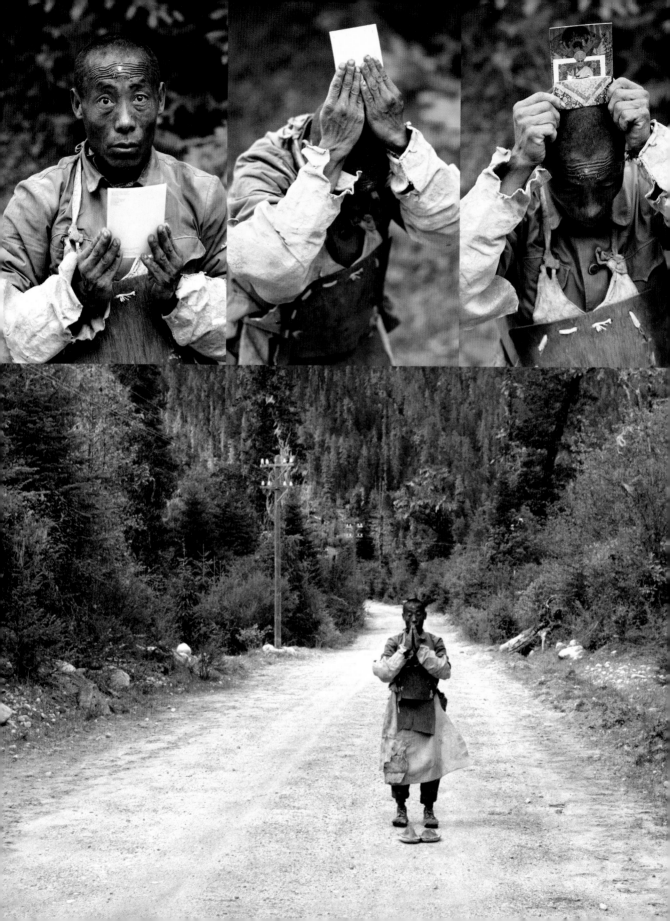

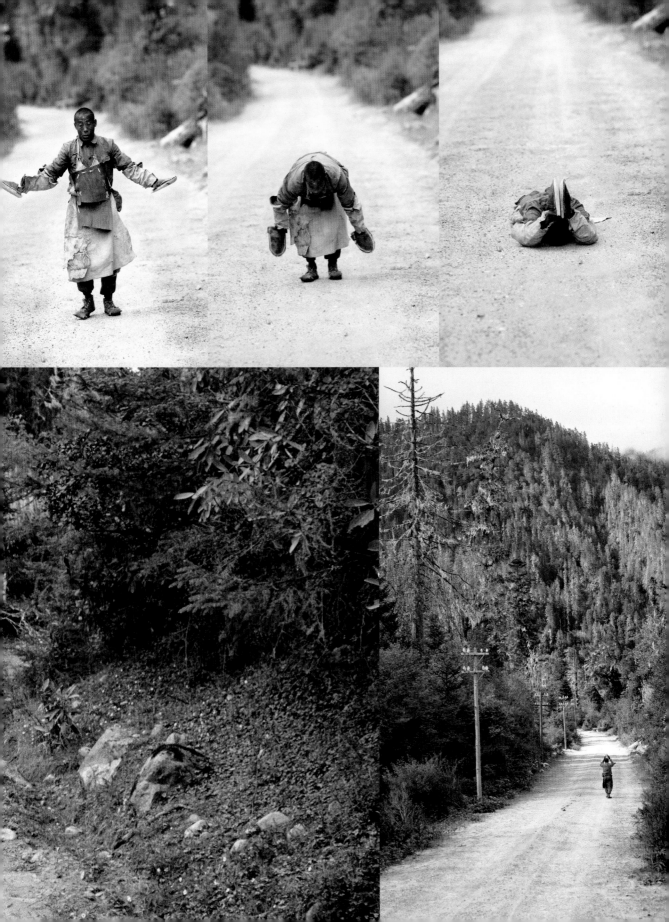

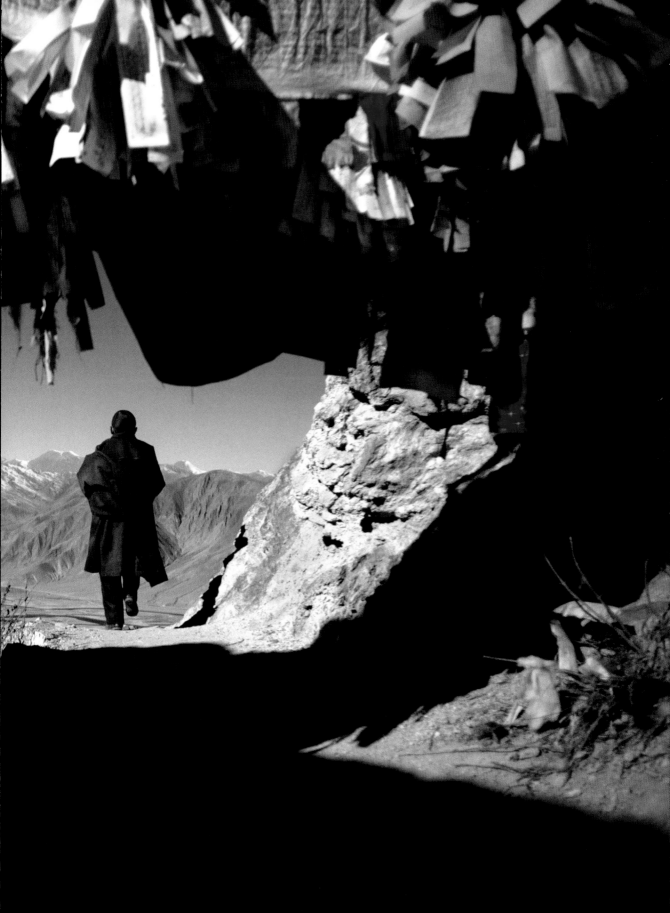

Death as a Passage
The Buddhist Concept of Death

For a Buddhist, death, like birth, is but one moment in the continuity of existence. This perspective very much shapes the way the Buddhist approaches death and prepares for it.

For those who think that the end of their life is the end of all existence, there is clearly no real point in contemplating this final annihilation. There is a Tibetan text that answers the question 'why think about death?' with the reply: 'We are all equal in having to face up to death, but we differ profoundly in our manner of dying and our belief in what will happen after our physical disappearance. Death is not like a pile of dry grass consumed by fire. We will be reborn.'

According to the Buddhist view, therefore, we must envisage our future within the much wider framework of a succession of countless states of existence. Since this future depends on transforming the flow of our consciousness, our spiritual life must become a major concern. That means our approach to death consists not in asking whether we will suffer more or less, but rather in preparing ourselves for a vital stage of our existence. The Buddhist practitioner's life is not haunted by the fear of death; instead it is a preparation for greeting death with serenity, taking it as a subject of constant meditation. Gampopa, the 11th-century Tibetan sage, wrote: 'At the start of the spiritual journey, you must be pursued by the fear of birth and death like a deer trying to escape from a trap. At the halfway point, you must have no regrets, even you die, like the peasant who has carefully tilled his field. When

the end comes, you must be as happy as someone who has completed a great task.'

This awareness of the approach of death acts like an incentive to diligence. Padmasambhava said:

'Like the torrent that rushes to the sea,
Like the sun and the moon that glide towards
 the western mountains,
Like the flight of days and nights, hours and
 seconds,
Human life passes inexorably.'

In Tibet, it is customary to upend the drinking cup of a deceased person. Hermits turn over their cup every night before going to sleep, in case they never wake up. They believe that every moment that passes brings them nearer to death. Every time they breathe out they consider themselves fortunate to breath in again. In a text entitled *Letter to a Friend*, the 1st-century Buddhist master Nagarjuna writes:

'If this life buffeted by the wind of a thousand
 sorrows
Is even more precarious than a bubble on water,
It is a miracle, after sleeping,
Breathing in, breathing out, to wake up refreshed.'

For a materialist, the death of a loved one can be an incurable trauma; a Buddhist family, however, will not take a morbid view of death and a 'good death' is not a dramatic event. Buddhists usually die surrounded by family and friends. This also helps

children to see death as a natural part of life. If a spiritual master is by the bedside of a dying man, that man will die serenely and his close relations will be gratified. If, in addition, the dying man is himself an experienced practitioner, no one will worry about him. Frequently, people returning from a cremation look very happy. 'How well it went!' they will say.

The experiences that occur in the intermediate state between death and rebirth, or *bardo*, are determined by the quality of our continuum of consciousness, which is itself the product of the life we have led. This can therefore produce serenity or fear, confusion or lucidity, suffering or freedom. Many factors can influence the bardo state. Confidence in one's spiritual master and his teachings is a very powerful liberating factor. It is said that engaging in spiritual practice during the bardo state is incomparably more effective than engaging in the same practice in ordinary life.

The duration of the bardo state varies. Traditionally, it is said that it lasts forty-nine days or stages, which do not necessarily correspond to our earthly days.

A great meditator can be liberated at the very moment of death and not have to pass through the bardo state. Then he will directly experience the 'bright light of absolute truth' or dharmakaya. It is said that this 'bright light' shines for all beings, if only for a very brief moment, because dharmakaya is the ultimate nature of mind. Most mortals are unable to seize the opportunity of apprehending this nature and attaining Enlightenment. Here, the term 'light' refers to the perfect clarity of spiritual realization. By remaining within this realization, the great meditator frees himself from samsara, the cycle of existence. This does not mean that he will not be reborn but that instead of being subjected to the constraints of karma his rebirth will be the fruit of his altruistic aspiration to work for the good of all beings. The yogi Shabkar wrote:

'On the limitless sea of conditioned existence,
He raised the sail of wisdom
Beyond nihilism and eternalism.
Carried on by the great winds of stainless
 aspiration,
He has reached the blissful realm
Of boundless happiness:
The vast golden continent
Beyond death
And beyond rebirth.'

Like the Eagle that Soars
The Death of a Great Teacher

'Even if, bright as a flash of lightning, death were to strike you today,
be prepared to die without sorrow or regret,
giving up attachment to what you are leaving behind.
Without ever ceasing to recognize the authentic view of the real,
leave this life like the eagle that soars into the blue sky.'
Dilgo Khyentse Rinpoche (1910–91)

For practitioners of Buddhism, the thought of death, far from being depressing, is one of the most effective encouragements to practice. Dilgo Khyentse Rinpoche wrote:

'In the midst of the clouds of illusion and
 impermanence
The lightning of life dances:
Can you say that you will not be dead
 tomorrow?
So, practice dharma!
The moment has come to conquer the citadel
 of great bliss.'

Tibetans consider that masters who have reached the level of Khyentse Rinpoche genuinely have transcended the limits of birth and death. The great yogi Milarepa wrote:

'Fearful of death, I walked in the mountains.
By meditating on its uncertain hour,
I conquered the immortal bastion of the
 immutable.
Now I am far beyond fearing death!'

Khyentse Rinpoche himself said: 'And when death finally comes, you will greet it like an old friend, fully aware that the entire world of phenomena is impermanent and like a dream.' He remained ever vigilant in regard to impermanence and death and when people asked him to visit them, he would always reply: 'If I am still alive, I will come.'

When he visited central Tibet in 1985, Khyentse Rinpoche had asked the Chinese government's permission to restore the historic monastery of Samye.

Rather curiously, the government agreed. Then the king of Bhutan, inspired by Khyentse Rinpoche, contributed a large donation towards the building work. In 1990, Khyentse Rinpoche returned to Tibet to reconsecrate Samye Monastery. In Lhasa, he offered a hundred thousand lamps in the famous Temple of the Crowned Buddha, then went on a pilgrimage and visited many central Tibetan monasteries. This was to be his last journey in his native country.

He was eighty years old at the time, but age did not seem to diminish his charisma. In 1991, while he was teaching in Bodhgaya, he showed signs of illness. Nonetheless, he completed his programme, went to Dharamsala and, with no apparent difficulty, spent a month offering the Dalai Lama the important initiations the latter had been requesting for some years.

When he returned to Nepal in early spring, it became clear that his health was failing inexorably. He spent most of his time in prayer or meditation, only devoting a few hours a day to those who needed to see him most. In the course of that year, he often said he would soon be leaving his body. He even joked on the subject, asking with a smile: 'Will I not be dying soon?' He wrote to a close disciple: 'We will meet again in the Pure Land of Padmasambhava.'

He had intended to return to Tibet for the fourth time, to Shechen Monastery, but had to abandon his plan. He decided instead to go on retreat for three and a half months in a spot facing the Tiger's Lair in Bhutan, one of the sites most blessed by Padmasambhava.

After this retreat, he seemed in better health. He visited some of his disciples who were on retreat and spoke to them of the ultimate master, who is beyond

death or any physical manifestation. The queen mother of Bhutan invited him to Kalimpong in India. Rather than flying, he insisted on making this exhausting journey by road, which allowed him to visit an old disciple on the way and to give him valuable advice and enough food for a year.

Soon after his return to Bhutan, he once again showed signs of illness. He was unable to eat or drink for twelve days. Three times he said that he did not have long to live. Three days before he died, he wrote on a scrap of paper: 'I will depart on the 19th'. Trulshik Rinpoche, his friend and closest disciple, arrived from Nepal, for what proved a happy meeting. The next day, the nineteenth day of the Tibetan month (27 September 1991), at dusk, he asked those around him to help him sit up and then entered a peaceful meditation. In the early hours of the morning, his breathing stopped and his mind merged into absolute space.

That is how the extraordinary life of Khyentse Rinpoche ended, a life which, from his early youth, he devoted entirely to study, practice and teaching. Wherever he happened to be, day or night, he displayed an inexhaustible fund of goodness, humour, wisdom and dignity, devoting all his energy to the preservation and practice of Buddhist teaching in all its forms.

At the request of his disciples in Tibet and throughout the world, his body was preserved for one year using traditional embalming methods. Then he was taken from Bhutan to the Nepalese monastery of Shechen. He was left there for several months to allow more people to pay homage to him. For the first seven weeks, every Friday – the day of his death – the Tibetan community and monks gathered spontaneously to light a hundred thousand butter lamps on the stupa of Bodhnath, a few steps from Shechen Monastery.

Finally, in November 1992, his body was cremated near Paro, in Bhutan. The ceremony lasted three days. This was an unprecedented event in the country. More than one hundred grand lamas, the royal family and ministers, five hundred Western disciples and a crowd of about fifty thousand took part.

There are no words to explain the death of a being who attained such great perfection. The sorrow of a disciple cannot be compared to that caused by the loss of a parent or friend. We felt as if the sun had vanished from the world. The Dalai Lama said: 'All of us who are his disciples should express our gratitude by practising'. Dilgo Khyentse Rinpoche's death, like that of other teachers, was his final lesson, a teaching about impermanence:

'Never forget that your life passes like a flash of lightning in the summer sky or a gesture of the hand. Now that you have the opportunity to practise dharma, do not waste a single instant on anything else, but devote all your energy, all your efforts, to practising dharma.'

The Status of Tibet
Historical Background and Perspectives

The Chinese government says that Tibet has been part of China since the Yuan dynasty, in the mid-13th century. These Yuans, however, were not even Chinese. They were Mongols. It is ironic to find that according to Beijing, Chinese sovereignty over Tibet is historically based on the short-term influence of the invaders of their own country! When Kublai Khan, grandson of Genghis Khan, invited the great Tibetan lama Chogyal Phakpa (1235–80) to perform Buddhist initiations, the emperor conferred the title of Ti-shi or 'imperial preceptor' on his spiritual master.

In his fascinating book *The Fate of Tibet* (1999), Claude Arpi, who has had access to a great many documents from American, British and Russian archives, studies the human and political influences that led Communist China to invade Tibet in 1950. He wrote: 'Modern Chinese historians have used these titles conferred by the Mongol Khan as a pretext to justify and perpetuate their control and "sovereignty" over their weaker neighbour, Tibet […]. Going by the Chinese logic, the one nation that could claim the "ownership" of Tibet is Outer Mongolia, but even during the Communist regime, they never asserted such a wild claim… During this [later] period, though the Ming emperors kept some sporadic diplomatic ties with the Tibetan rulers, the Chinese Government did not exercise any authority or influence over Tibet.'

During some comparatively short periods, under the Ching dynasty for example, Tibet certainly was an area under Chinese influence. Before the rise of Communism, however, Tibet was never regarded, in any official Chinese document, as being part of China. The authority that looked after Tibetan affairs also managed relations with Mongolia and Russia. Vice versa, there were also brief periods of Tibetan domination during which Xian's Chinese court paid taxes to the king of Tibet.

In the early 20th century, everyone recognized Tibet's independence. In 1903, Lord Curzon, the Viceroy of the Indies, declared that Britain regarded the pretended Chinese sovereignty over Tibet as a constitutional fiction.

In 1913 the British organized a conference in Simla, India, to establish the legal status of Tibet. One article of the Simla Convention signed in 1914 stated that 'The Government of China engages not to convert Tibet into a Chinese Province. The Government of Great Britain engages not to annex Tibet or any portion of it.' The Chinese delegate initialled the draft convention but did not sign the final text. The British lost patience and separately signed the convention with Tibet. That same year, the Tibetans drove out the last Chinese troops stationed in their country. There was no further Chinese presence in Tibet until 1950.

Since then, the London Jurists' Conference, the Strasbourg Permanent People's Tribunal and the Geneva International Commission of Jurists have unanimously concluded that Tibet had the status of a country occupied by a foreign power. After studying the contemporary situation, the International Commission of Jurists declared in 1960 that 'Tibet demonstrated from 1913 to 1950 the conditions of statehood as generally accepted under international law. In 1950, there was a people and a territory, and a government which functioned in that territory, conducting its own domestic affairs free from any outside authority.'

When China invaded Tibet in 1950, it did so, according to Chinese communiqués, in order to liberate millions of Tibetans from slavery and the influence of 'Western imperialists'. Even the idealist Nehru, then Prime Minister of India, speaking before his parliament, wondered what Tibet was to be liberated from and said this was not clear to him. In fact, this 'liberation' of Tibet was only the first step in a vast plan of territorial conquests. Claude Arpi writes: 'When they took over China, the Communists had maps ready showing large parts of Korea, Indochina, Inner Mongolia, Burma, Malaysia, Eastern Turkestan, India, Tibet, Nepal, Sikkim and Bhutan as part of China.'

Concerned at the invasion of Korea on the same day as that of Tibet, on 25 June 1950, the world paid little attention to events in Tibet. This marked the beginning of a silent genocide. More than one million Tibetans, out of a population of six million, died from execution, torture, famine, bloodily suppressed rebellions and exhaustion in forced labour camps.

The United Kingdom and India advised the United Nations General Assembly not to react, in order, so they said, to avoid large-scale conflict. The Office of the General Assembly therefore decided, on 24 November 1950, to defer examining the proposal to put the invasion of Tibet on the agenda. As Claude Arpi points out, Tibet was sacrificed.

Most countries, however, certainly regarded China's attack on Tibet as aggression. This became evident during the plenary debates of the United Nations General Assembly in 1959, 1961 and 1965. In Resolution 1723 the UN 'solemnly renews its call for the cessation of practices which deprive the Tibetan people of their fundamental human rights and freedoms, including their right to self-determination'. On that occasion, Frank Aiken, the Irish representative, said: 'For thousands of years, or for a couple of thousand years at any rate, [Tibet] was as free and fully in control of its own affairs as any nation in this Assembly, and a thousand times more free to look after its own affairs than many of the nations here.'

During the 1965 United Nations debate, the Indian representative said that people must face up to the truth that the Chinese Government was determined to make the Tibetan people disappear. Ever since, and with remarkable courage, India has constantly offered hospitality to refugees from the Roof of the World, their government-in-exile and their leader, the Dalai Lama.

Even if no government today recognizes Tibet as an independent country occupied by a foreign power, many parliaments are quite unambiguous in doing so. When these resolutions refer to Tibet, they include the entire Tibetan territory, as it was in 1949 before the Chinese cut it up into five regions. The so-called 'Tibet Autonomous Region' (or TAR) makes up no more than about one third of the country. The other regions have been incorporated into Chinese provinces.

We may ask in what way these historical facts could facilitate dialogue between China and Tibet. First of all, they are evidence of the scale of the concessions made by the Dalai Lama in order to reach a settlement and find some common ground. We know that the Dalai Lama is not calling for independence but for autonomy within China so that the people of Tibet and its culture can survive. The Dalai Lama has also stated on numerous occasions that if he returned to Tibet, it would be as a simple monk and that he would not take up any political office. It would be up to a secular and democratically elected government to administer Tibet.

Deng Xiaoping declared seventeen years ago: 'Everything is open to discussion, apart from the total independence of Tibet.' On 6 July 2000 the European Parliament adopted a resolution calling on the governments of the Member States 'to give serious consideration to the possibility of recognizing the Tibetan government in exile as the legitimate representative of Tibet if, within three years, the Beijing authorities and the Tibetan government in exile have not, through negotiations organized under the aegis of the Secretary-General of the United Nations, signed an agreement on a new Statute for Tibet.' This resolution sends out a very clear signal to Beijing: it is China's intransigence that has prevented and continues to act as an obstacle to dialogue with the Tibetan government-in-exile.

China seems to have four major concerns: its unity, stability, prosperity and image. Its prosperity has increased markedly, at least in the towns. Its unity and stability are precarious because they are maintained by force. Its image is a disaster. The best way to remedy this sad state of affairs and to improve its more than dubious international reputation would surely be to recognize the legitimate aspirations of a people it has been oppressing for fifty years.

Red Flag on the Roof of the World
The Chinese Invasion

Perhaps it was karma, or a natural stage in the evolution of a civilization isolated for a uniquely long time; perhaps personal intrigues and power struggles between the great monasteries played a part in the blindness of the Tibetan authorities of the day, and their failure to grasp the severity of the Chinese threat soon enough. The danger lay in the apparent inability to see or understand, and above all the apparent refusal to do anything, in the conviction that a long history guaranteed permanence. Yet the oracle of Nechung had given clear warnings, and the 13th Dalai Lama had been even more explicit in his testament. Certainly, the exceptional combination of circumstances in the aftermath of the Second World War and the upheavals that followed in the countries immediately bordering Tibet did not make the Tibetan authorities' task any easier, and they were moreover enmeshed in a regency, always a very delicate period on the Roof of the World.

And even if the senior officials responsible for the country's security sincerely believed that the gods were with them, neither the profound piety of the people, their rites or their prayers counted for much against a large and battle-hardened army commanded by leaders determined to seize control of a territory long referred to in Chinese annals as 'The Western Treasure House'. Properly prepared, planned and executed, the invasion of Tibet was nevertheless anything but a walkover for the invaders. Climate and geography were harsh obstacles in themselves, but the Tibetans fought hard, too, often with the strength of despair, in the hope of containing the huge wave rolling over their land. But the contest was too unevenly matched. The forces of resistance held out for as long as they possibly could, before retreating and attempting to tell their tale, in the face of the indifference of the international community, the incomprehension of India, and the fundamental reticence of a young Dalai Lama rooted in the philosophical principle of non-violence.

From that moment, the invasion was as good as a death sentence for China's western neighbour, perched so close to the sky that some could almost have forgotten that it was part of the world of men. Fought at the altitude of the gods, in an immensity of solitude and light, the struggle between the Tibetan snow leopard and the Chinese dragon belonged in the realm of myth. But the price was paid by men.

A half-century of foreign, military and colonial occupation leaves profound marks on both the flesh and the spirit of a people. That does not mean that they resign themselves or submit. The landscape itself, however strong, does not emerge from the ordeal unscathed. Pillaged, prey to futile attempts at domestication that flout the most elementary principles of respect, it retains an impenetrable grandeur at its core, as if the peaks were laughing at human pretensions under their

cloak of snow. Far from successfully chaining the latent forces of sovereign nature, the enforced, brutal modernization programme remains a superficial veneer, at the mercy of the least crack in its surface.

The threat to the inhabitants is more immediate: it is a question of time, because human life is measured on a different scale from the mountains of the Himalayas. This is where the political game begins, in which the power struggle redraws the destiny of the country and of those who dwell there, according to the turn of events. In this game, the Tibetan regents of the 1950s had neither the trump cards nor the knowledge necessary to avert the horrors that were coming. It is here, too, that the dossier on Tibet has become a prime example of the contradictions of a global society, crossing from the end of a century that was also the close of a millennium, into a new century, the 21st, and the dawn of a new millennium, a symbolic reference point for the future.

Culture and tradition, economic interests and political rectitude, a sense of history and justice, decolonialization and liberation, conservation of environments and species, survival of a language which is at once history and memory, the safeguarding of a people threatened with annihilation, on the frontiers of the real and the imaginary, the meeting place of beauty and a spiritual vision, where sky and earth come together – all these aspects come together in the fortunes and misfortunes of Tibet, like the many facets of a finely polished diamond. The Chinese invasion forced the hidden country to draw closer to the rest of the world, to take its place among those who had dreamed of it or known nothing of it. The condition, always, is that it must be free to bear its torch aloft. Silencing Tibet, and keeping silent ourselves, means becoming an accomplice, and assuming a responsibility which makes us all accountable, now and in future, for the failure to come to the aid of a people in danger.

Human history is such that the race seeks to defy time, as history testifies. The wheel turns and invasions come and go. But as the years have passed, the means of destruction have become so great that losses have rapidly become irremediable. In this sense, time is pressing for Tibet – a country that is both the stuff of legend and a reality so real that it quickly turns into a questioning of reality. But let us never forget that a political dispute was the trigger for its present crisis, and that only a political solution, arrived at through peaceful dialogue, can allow the people of Tibet to be masters of their own destiny, and the country to remain the oasis of peace and light that every one of us needs.

Ani Pachen (1933–2002)
Princess, Nun and Warrior

Blue sky and snow-covered peaks, one could almost believe oneself in the Land of Snows. We are in India, at Dharamsala, the Tibetan capital-in-exile. Behind their smiles and their proverbial gentleness, most of the Tibetans we meet have a tragic tale to tell. Ani Pachen, sitting in her small, dark, icy room, bears on her lined face the marks of the twenty years she spent in prison: 'I was a young girl when I was arrested, an old woman when I came out!' Her eyes fixed on mine, she continues:

'After my father's death I fought against the Chinese soldiers who were invading our country. At the end of a short but fierce resistance battle I was captured. I spent twenty-one years in prison. For over a year, I was handcuffed and fettered, day and night.

During interminable interrogations, I was often hung head down from the ceiling and beaten with bludgeons, chains and metal rods.

I was thrown into total darkness in a tiny cell for nine months. Only the singing of birds told me when it was daybreak. I often fainted for lack of food. In any case, the little we were given to eat was too rotten to be called food. But I went on meditating. Most of my companions in captivity died.

For thirteen months, day and night, I wore fetters on my feet and handcuffs on my wrists. Without even a semblance of a trial, my sentence was extended by several years because, they told me, my spirit remained faithful to the Dalai Lama and to the Tibetans in exile!

During these dark years, all my close relations were executed. When I came out of prison I found that I was the only surviving member of my family. So in the end, you might say I was lucky!

Among the countless tortures the Tibetans have endured, let me give you some examples, taken from different regions of Tibet:

In Kham the Chinese crucified a lama with nails. First they gouged out his eyes, slit his ears and broke his teeth. Afterwards they slowly cut him to pieces. First the fingers, then half an arm, the whole arm, the skin of his body, and so on until he died. All the inhabitants of the surrounding area had been forced to attend this

torture. It was so horrible that several spectators, knowing that they were certainly going to suffer the same fate, preferred to kill themselves by jumping off a bridge.

In Amdo, at Pakhul, the Chinese oppression was so cruel that finally the population rose in revolt. The Chinese arrested the leaders, a man called Lhundrup and his son Yudak. They buried them standing, with only their heads emerging, then they pounded the earth with sledgehammers. As the earth compacted round the victims' bodies, first their eyes started from their sockets, then blood spurted from their mouths, followed by the ruptured organs that they vomited up. There too, the crowd was forced to watch their terrible suffering.

In central Tibet, I met Lama Chigyal, who originally came from Kongpo. The Chinese had tied his arms behind his back, then attached the rope to the saddle of a horse which they drove off at a gallop. He came out of it alive but with multiple fractures.

Another time, when I was incarcerated in the infamous Drapchi prison, near Lhasa, all the prisoners – there were a hundred of us – were taken to the cemetery, to attend the execution of several of our companions. Before shooting them the Chinese insulted the condemned and enumerated their "crimes". Then they threatened us: "If you don't change, this is the fate that awaits you." Eleven people were put to death that day, including four women.

The horrifying report of a mission of enquiry that the Chinese had consented to admit provoked an outcry from international organizations. Thanks to pressure from them, I was at last set free.

I used to hate the Chinese because they were the butchers of the Tibetan people. Then I came to understand that Communist ideology does not leave any room for love and compassion. I also realized that Mao, in making himself responsible for the deaths of sixty million people, had created such bad karma that he would eventually suffer for it immensely. I pray that never, in any of my future lives, will I be capable of inflicting the least suffering on anyone at all.

I came to understand that my own situation was the result of negative acts that I myself had committed in the past. None but a fully enlightened Buddha can see and understand the hidden causes of the situations we live. The waves of events come and go like birds in the sky. When I was tortured, I believed that all beings suffer and that the only way to be relieved from suffering is to master one's mind. That is how to achieve inner peace. If I struggle when I am oppressed by an enemy, he takes on even more importance in my mind, which is then invaded by negative emotions. These only increase my suffering.

So I tried to meditate on emptiness, beyond the notions of good and evil. Everything dissolves into emptiness.

Despite all the suffering that we Tibetans have undergone, we are always determined to resist in a non-violent way and to work on developing our compassion even more. We are fighting for a just cause. If we resisted with arms, that would only cause more suffering. Gandhi's example showed the power of non-violence and justice. These things are what made Indian independence possible. That is how we too should go on struggling to the end. But the citizens of the world must help us!'

FREEDOM AND MINDFULNESS

According to Buddhism, freedom is to be master of oneself. In fact, mastery of one's mind comes only when we free ourselves of ignorance and subjection to negative emotions. It is sometimes thought that to follow all our impulses is a form of freedom. But by acting that way, we remain at the mercy of all the unbridled thoughts that are constantly streaming through our mind. Inner freedom consists, therefore, of freeing ourselves from this enslavement. Far from curtailing our freedom, the mastery of our mind allows us to take our lives in hand instead of giving in to our usual tendencies and to mental confusion.

To enjoy genuine freedom, we must free ourselves from the dictatorship of the self and all its conflicting emotions. If we relentlessly fight what displeases us and obsessively crave what pleases us we will be frustrated at every turn. The outside world will never match up to our capricious expectations.

To be free also means being able to follow the path that leads to Enlightenment. To that end, we must detach ourselves from all external adversity, all events or circumstances that could distract us from that goal. We must also free ourselves from the inner adversity that takes the form of laziness, mental distraction and habits that constantly divert us from spiritual practice and delay our progress.

Freedom as a source of happiness, of enduring plenitude, is intimately linked to altruism. All beings have exactly the same aspirations and therefore the same right to avoid suffering and enjoy happiness. According to Buddhism, this fundamental truth applies not only to man but to all living beings. If we are to respect this right, this freedom necessary to others, altruism must free itself from the shackles of self-centredness.

Freedom also means renouncing, freeing ourselves of ordinary preoccupations with gain or loss, pleasure or pain, praise or blame, fame or anonymity. Shabkar celebrates that freedom in this poem:

'When I stay, I have nothing to be attached to,
When I leave I have nothing to leave behind.
Wherever I am, no one says "Where have you
 been? Where are you going?"
I, the renunciate yogi, am happy,
And sing this song of joy.

I have raised my head,
And seen the cloudless sky.
It made me think of absolute, boundless space,
I have felt a freedom
Without middle or end,
Free of any partial views.

I have seen the world and living beings
As possessing the same nature,
The Buddha-nature which has awoken in me,
Which is naturally present in all beings.

I have known the state of freedom
From attraction and repulsion,
From the hope of reaping fruit
And the fear of failure.
I have let go.'

But the ultimate freedom is surely that of Enlightenment:

'The source of phenomena of samsara and nirvana
Is the true nature of one's own mind:
An immense expanse that is an empty brilliance,
Completely free of taking things as real.
This I have realized.
If I look towards the one who realizes this,
– One's own awareness –
It is like the sky;
Set free, beyond clinging
In the unborn expanse of the ultimate nature of mind.'

Silent Mountains
The Agony of Tibet's Natural Environment

In 1981 I set off to lead the first two American expeditions allowed into the back-country of Tibet since the Chinese invasion three decades earlier. For a photographer, it was the chance of a lifetime. Before 1981 the remote parts of Tibet were shrouded in mystery. All that modern naturalists knew about the region came from reports at least three decades old. 'I have never seen so many varieties of birds in one place,' wrote British explorer Kingdom Ward in 1920. 'One great zoological garden,' Joseph Rock wrote in a 1930 *National Geographic* article. 'Wherever I looked I saw wild animals grazing contentedly.' In the thirties, a German traveller named Dalgleish reported sighting a herd of ten thousand chiru, a Tibetan antelope now rarely seen. In the forties, Leonard Clark reported, 'Every few minutes, we would spot a bear or a hunting wolf, herds of musk deer, kyangs, gazelles, bighorn sheep, or foxes. This must be one of the last unspoiled big-game paradises.'

This glory was what I had come to see. For an exorbitant fee – $50,000 to guide several naturalists for three weeks in the Amnye Machen mountains of northeast Tibet – our Chinese hosts promised 'a wealth of rare birds and animals... thick virgin forests where deer, leopards, and bear thrive, while the grasslands and the gravel slopes near the snow line area live with hordes of gazelles, wild asses and rare musk deer.' For three weeks we walked – over a hundred miles in all. We saw virtually nothing. The wildlife had disappeared.

My other trek that year was to the Tibetan side of Mount Everest. I drove over a thousand miles of back roads without seeing a single wild large mammal. My negative results confirmed those of Jetsun Pema who had led a delegation the previous year that travelled 8,000 miles overland. She made the trip for the Tibetan government-in-exile in Dharamsala, India, whose head of state is her brother, the Dalai Lama. 'On long journeys,' she wrote, 'you used to see more gazelles, deer and antelope than people. Now, in three months of extensive travelling in Tibet, I did not see any of these creatures.'

Before the arrival of the Chinese, Tibet had its own separate language, religion, currency, government, and postal system. It also had the most successful system of environmental protection of any inhabited region in the modern world. There were no parks or wildlife preserves in the Western sense. Formal protection of wildlife and wildlands was unnecessary in a land where devout Buddhist compassion for all living beings reigned supreme.

Tibetan Buddhism essentially prohibits the killing of animals. Children are taught from birth that all life is sacred. The Buddhist ethic pervades all aspects of Tibetan culture. 'I have never seen less evidence of hatred, envy, malice and uncharitableness,' wrote British India's Trade Consul in Tibet, Hugh Richardson, after living in Lhasa in the 1940s. 'The Tibetan system produced a people who in the upper levels were self-controlled, intelligent, often deeply learned, capable, unpretentious, dignified, humane and friendly. The majority of people made efforts to live as much as possible with nature, not against it.'

The 1950 invasion of Tibet, justified on false grounds that Mao's China was simply restoring historical borders, was in many ways the consummation of China's long-standing desire to gain control of Tibet's natural resources. The Chinese know Tibet as Xizang, which translates as 'western treasure house,' a name that was born in the ancient myth that Tibet contained gold and other riches.

After the invasion, China set out to 'liberate' Tibet by systematically destroying its culture. Farmers were forced into collectives and required to grow winter wheat instead of the traditional barley. The policy produced bumper crops for a few years, before depleting the soil and ruining the harvest. To make matters worse, China brought much of the wheat home to feed a population cut off from other sources of grain as a result of the 1959 break with the Soviet Union. Tibet was plunged into famine, the first in recorded history, which lasted through 1963. Another period of famine followed from 1968 to 1973.

The invaders made a sport of shooting indiscriminately at wildlife. In 1973, Dhondub Choedon, a Tibetan now in exile in India, reported that, 'Chinese soldiers go on organized hunts using machine guns. They carry away meat in lorries and export the musk and furs to China.' Important habitat for vast herds of wild animals was soon overgrazed as the Chinese forced nomadic families into communes to raise livestock for export instead of their own subsistence. Tibetans, including the children, were forced to kill 'unnecessary animals' such as dogs, that were considered 'parasites,' as well as moles and marmots that vied with humans for grain and dug up valuable grazing land. Children were given a quota for small animals to kill that, if not met, resulted in beatings and other forms of punishment.

At the end of the first two trips in 1981, I joined several of the scientists who had travelled with me at a press conference in Beijing. We laid out the facts for the reporters. 'The wildlife of this region has been decimated,' said Rodney Jackson, whose snow-leopard studies formed the basis of a *National Geographic* cover story in June 1986. 'We came to Tibet because of inaccurate information given us by the Chinese about the presence of wildlife in an area they charged us dearly to visit. This, plus attitudes that endorse irresponsible wildlife depletion, can adversely affect China's friendship with other nations if they are allowed to continue.'

The story was never published. An Associated Press correspondent in the United States later told me that they couldn't afford to run 'unnecessarily negative China material' that might put their Beijing bureau in jeopardy.

According to official documents, $54 billion of timber has been cut within the borders of old Tibet since 1959. As Tibetans do not use much wood for fuel or to frame ordinary houses, the majority of this timber was destined for China. The deforestation was aided by the forced labour of thousands of Tibetan prisoners in the southeastern part of the country. In Amdo, nearly 50 million trees have been felled since 1955, and millions of acres at least 70 per cent cleared, according to the Dalai Lama's exiled government in India.

Since my last journey to Tibet in 1993, a few parks and preserves have been created, but with little true progress toward environmental protection. In the vast Changtang Nature Preserve, tens of thousands of rare Tibetan antelope are being slaughtered every year for their valuable wool. Despite the good efforts of many organizations now concerned with the Tibetan environment, there are ever fewer wild animals and trees, yet ever more prisoners and paper promises.

Tibet on the Rack

'There is very little room in business and politics for moral justice and moral principles. That is the reason why we see more and more suffering in the world.'
His Holiness the Dalai Lama

A country in the sky with the world at its feet, Tibet sets us dreaming with its mystery and the infinity of its high windswept plateaux. Yet the 21st century dawns on its death agonies. The true inheritance of the 'glorious peaceful liberation of Tibet' begun by the Chinese Communists in May 1951 is the destruction of a thousand-year-old culture, the slaughter of 1,200,000 Tibetans – a sixth of the population – and the razing of 6,254 temples. Of those 1,200,000 Tibetans who died violently, 175,000 died in prison, 156,000 were summarily executed, 413,000 died of starvation during one of the 'agrarian reforms' of which Marxist theoreticians are so fond, 92,000 died under torture and nearly 10,000 killed themselves, despite suicide being forbidden by the tenets of Buddhism.

Tibet is the largest high-altitude ecosystem in the world and the biggest reservoir of water in Asia. The largest rivers of Asia, vital to the lives of hundreds of millions of human beings, rise there: the Yangtse, the Yellow River, the Brahmaputra, the Irrawaddy, the Salween, the Indus. Its control of them enables China to throw a menacing shadow over the Indian subcontinent. Tibet's geographical position makes it a unique platform for launching a nuclear offensive against India and Russia. Tibet lends itself to every kind of use. China's colonial exploitation has drained it of life. The deforestation, which has so far destroyed over forty per cent of the country's forests, is criminal. It is now banned in areas where

nothing remains, but continues where trees still grow, and in ten years' time it will have incalculable repercussions as far away as the Bengal plain where hundreds of millions of people live. The felling of forests, abusive exploitation of minerals for the benefit of the Chinese settlers, pollution of the rivers by irresponsible extraction of uranium deposits, nuclear bases at ground level in the north: Tibet, the mirror of the gods, is China's dustbin.

Tibet has suffered the loss of its spiritual leaders, its people are gradually being submerged in a host of Chinese colonists, its fauna decimated, its mineral wealth overexploited – well might Mao have thought that China would gain more from Tibet than it would give to it.

Today the Roof of the World has become the gate of hell. The Communist government has reached the final phase of its extermination of the Tibetan people. It has always claimed that 'the glorious peaceful liberation of Tibet put the Dalai Lama and his whole clique to flight'. The message is clear: the Communist government in Beijing wants not just a Chinese Tibet but a Tibet without Tibetans. It is moving the largest possible number of Han Chinese to Tibet with the aim of making it demographically impossible for the Tibetans to preserve their culture, much less rebel. In the Kongpo region, there are twenty-five Chinese for each Tibetan. Arable land has been overrun, and Tibetans, who can no longer find work, are treated as subhuman.

Arbitrary arrests continue (the penalty for shouting 'Freedom for Tibet' in a Lhasa street is a ten-year prison sentence), as do non-consensual surgical sterilizations of young Tibetan women. The Tibetans live through their ultimate tragedy robbed of the means of expression. Chinese is the official language. The Tibetan language, banned since 1987, is becoming the language of the uneducated. Licences to teach Tibetan have gradually been withdrawn until only a handful of schools remain where it may be taught. Tibetan writing, a world cultural treasure and one of only thirty modes of writing in the world, is sinking to a mere pinpoint. Television is an insidious weapon: more than a hundred transmitters have been built to put out Chinese programmes.

Lhasa's fate is already sealed: according to a recent count, 85 per cent of its population is now Chinese. The historical Tibetan centre accounts for only 3 per cent of its area. The holy city has been transmogrified into a sprawling agglomeration of suburbs. Everything possible is used to pervert young people. Karaoke bars flourish on every street corner. At nightfall, the city turns into a vast brothel. A thousand young Chinese prostitutes work the countless bars where young unemployed Tibetans come to get drunk. Amid the chaos of intolerance and violence that is modern-day Lhasa, there is a small oasis of peace in the city's heart: the temple of Jokhang, the cynosure of Tibetan veneration. The Jokhang embodies the profound values in which Tibetans believe with all the force of their prayers. Even here, the old Tibetan city has been razed in front of the temple. The authorities from Beijing carried out the clearance as an anti-riot measure. Demonstrations always started in the vicinity of the Jokhang Temple, from the 1950s onwards. Those who protest are predominantly monks and nuns. Many of them would rather die, tomorrow if not today, than be silent.

The monasteries are regarded as hotbeds of counter-revolution and the police regularly raid them, accompanied by teams of political re-educators. The Communist government has never seriously entertained the idea of a resumption of spiritual life in Tibet. The monks are puppets. Everything about the so-called 'autonomous' region of central Tibet is a front. The people are shackled, forbidden to pronounce the very name of the Dalai Lama. Anyone who commits the offence of calling for his return is treated like a dog and thrown into prison. The penalty for anyone who dares to demonstrate in the cause of Tibetan independence is exemplary, summary execution: a bullet through the head, fired at close quarters. This type of execution has the economic advantage of providing organs for sale. The condemned person's family has to pay for the bullet....

For his part, the Dalai Lama travels the world spreading his message of peace and universal responsibility: 'Human beings must wake up.' Routinely, whenever a country receives his visit, the Communist Chinese government protests through diplomatic channels and tries to exert pressure through economic blackmail. The Dalai Lama believes that the goal common to all religions, and one that every individual can try to find for himself, is to cultivate tolerance, altruism and love. In his view, if the authentic Buddhism of the lamas of Tibet disappears from the earth the loss will create a disequilibrium that will affect all of us and we will have to share responsibility for it. Nobel Peace Laureate in

1989, the Dalai Lama, with the Tibetan government-in-exile, has proposed that Tibet should be a peace sanctuary. He raised this at a time when the Chinese Communist government was dumping nuclear waste in Lake Kokonor in Tibet, one of the largest lakes in Asia, and on the surrounding steppes. Who will answer for such irresponsible acts in a generation's time? Fooled by the lure of temporary gain, blinded by the illusion of an economic miracle, no government on earth dares react and imperil its relations with China. Yet the world is getting smaller, the actions of each of us are the responsibility of all of us. And indifference becomes complicity....

KARMA
THE FRUITS OF FREEDOM

'My actions are my possession,
My actions are my legacy,
My actions are the womb that gives birth to me.'
Anguttara Nikaya (words of the Buddha)

Karma means 'action'. It is only one aspect of the laws of cause and effect, the one that concerns experiences of happiness and suffering. Some forms of karma are evident: hatred gives rise to torment and craving to dissatisfaction. Other, more subtle manifestations relate to the long-term influence of our thoughts, our words and our actions on the experiences of our consciousness.

The influence of karma appears in the form of various propensities and experiences. The specific nature of the concept of karma is to give our thoughts and our acts a value that will determine the suffering or happiness we experience sooner or later. So there is no 'good' and 'bad' as such; there is only the good and bad that our actions, words and thoughts create in terms of happiness and suffering.

Even if we can approximate the expression of these karmic propensities, which are translated by emotions, moods and a particular temperament, with what some people call the influence of the subconscious, the very concept of karma goes beyond this psychological interpretation of personality. In fact these propensities not only affect our mental world but also the perceived world. Consciousness and the world of phenomena are not intrinsically separate entities.

Because they are interdependent they shape each other, like two knife blades that sharpen each other. Buddhism does not conceive of any external reality that is totally independent of consciousness. The idea of a boundary between the objective and the subjective is imaginary.

We must distinguish between 'collective karma', which is the general way in which a group of beings, humans for example, perceives the world, and 'individual karma', which corresponds to the diversity of personal experiences in the context of this shared vision.

The knowledge of karma is essentially pragmatic. It consists in distinguishing between actions that should be performed and those that should be avoided in order to relieve suffering and build enduring happiness. Karma is not, therefore, a question of fate: we are the result of a large number of consciously taken decisions (whether advisedly or not), and we are at a crossroads at every moment.

We can transform a karmic process before an action has produced its effects, just as we can intervene before a stone thrown in the air falls on our head. In this way we can counter hatred with love and patience, greed with detachment and jealousy with joy in the happiness of others.

If we feel there is nothing outside this life span, then there is little difference between the Buddhist approach and a general psychological analysis that regards individual happiness as the ultimate purpose of existence. The concept of karma therefore acquires its full significance when we envisage a continuous flow of consciousness from one existence to another. In this case, the propensities accumulated by consciousness will also influence the experience of future lives.

In the end, all these propensities are based on ignorance, a perception of phenomena that does not reflect their true nature. According to Buddhist analysis, phenomena have no intrinsic characteristics. The most powerful means of melting the ice of these propensities in the sun of knowledge is to recognize the emptiness of phenomena that appear as the infinite unfolding of an illusion or a dream. Those who have entirely dissolved their karma have also eradicated any negativity from the flow of their consciousness and drawn aside all the veils of ignorance. This is what is called Buddhahood.

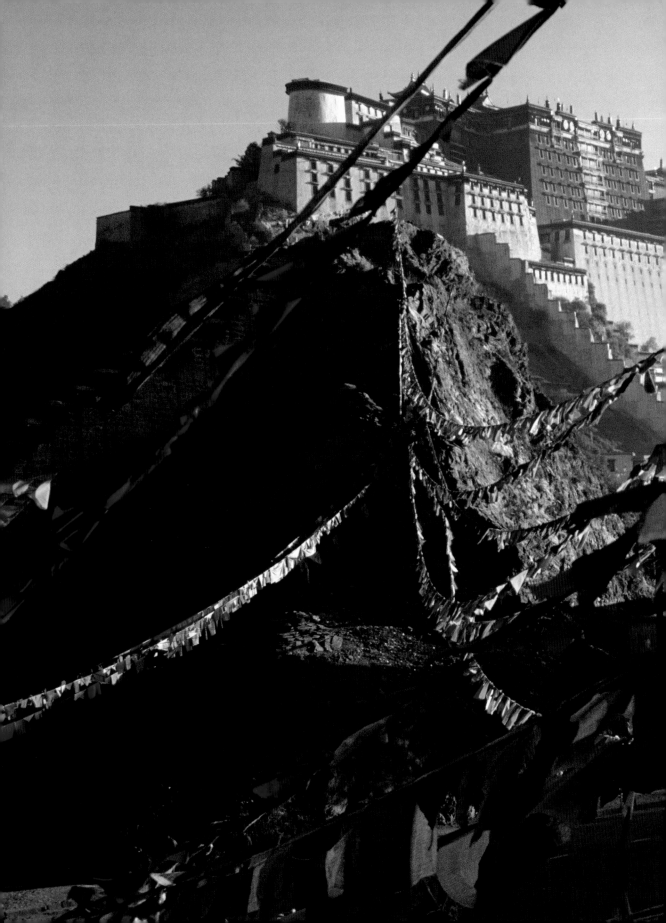

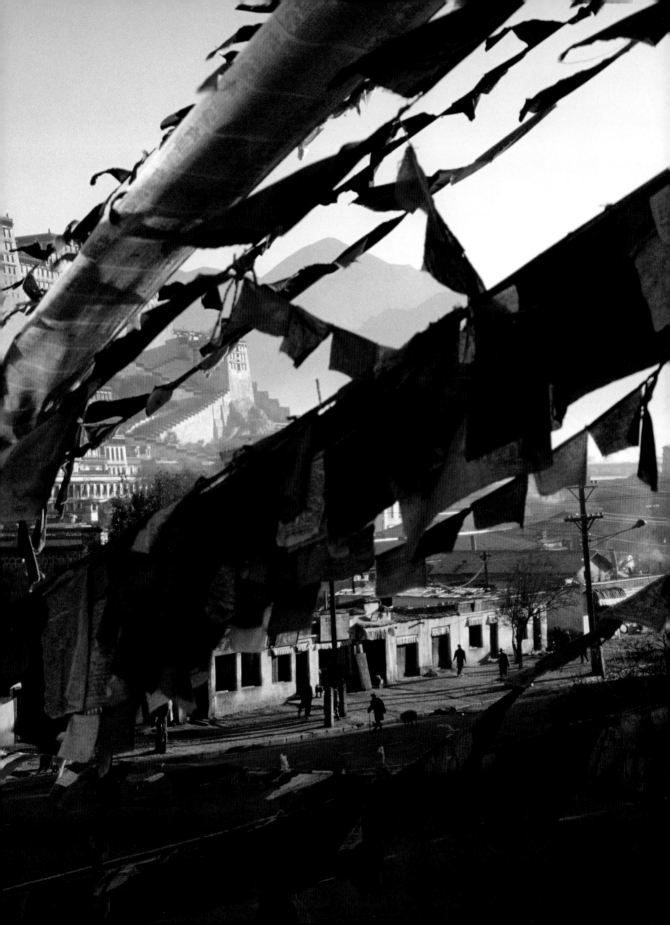

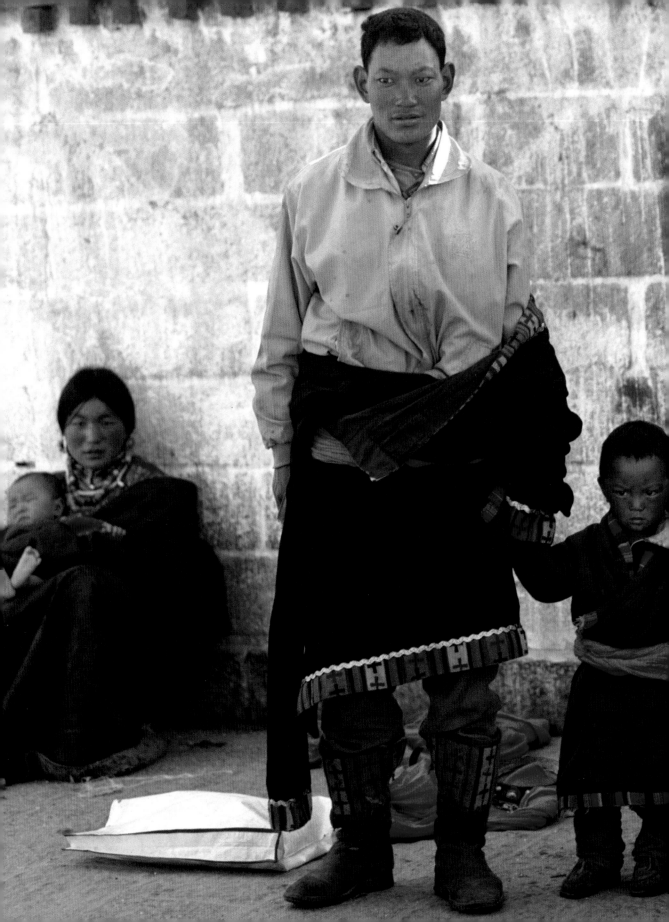

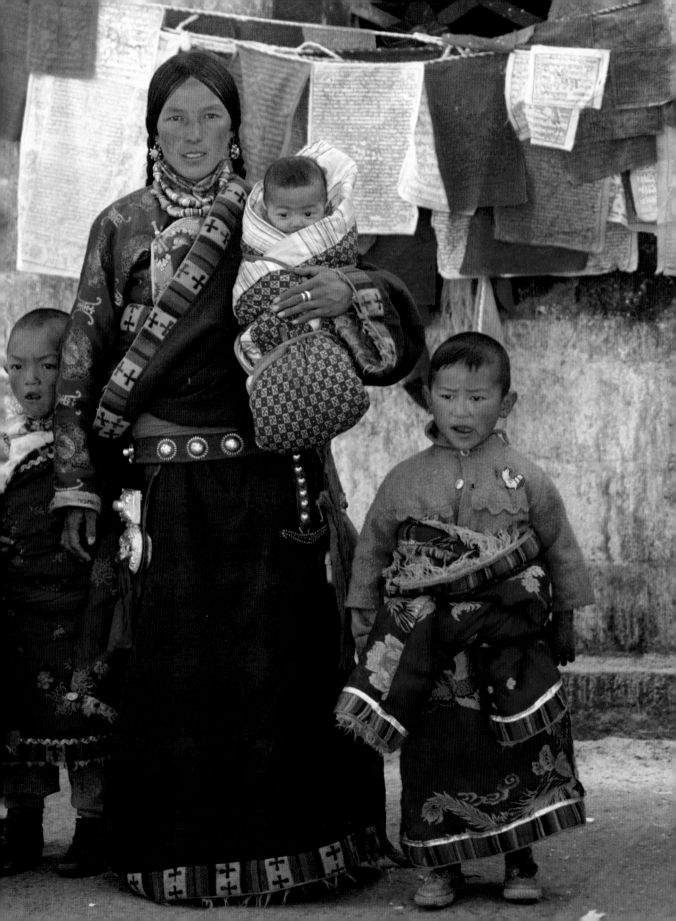

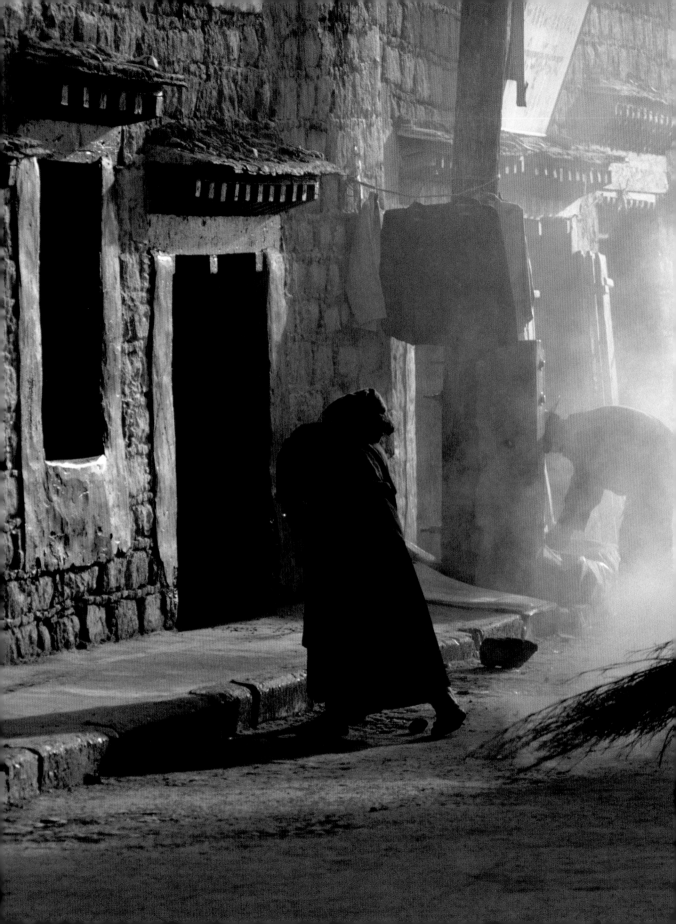

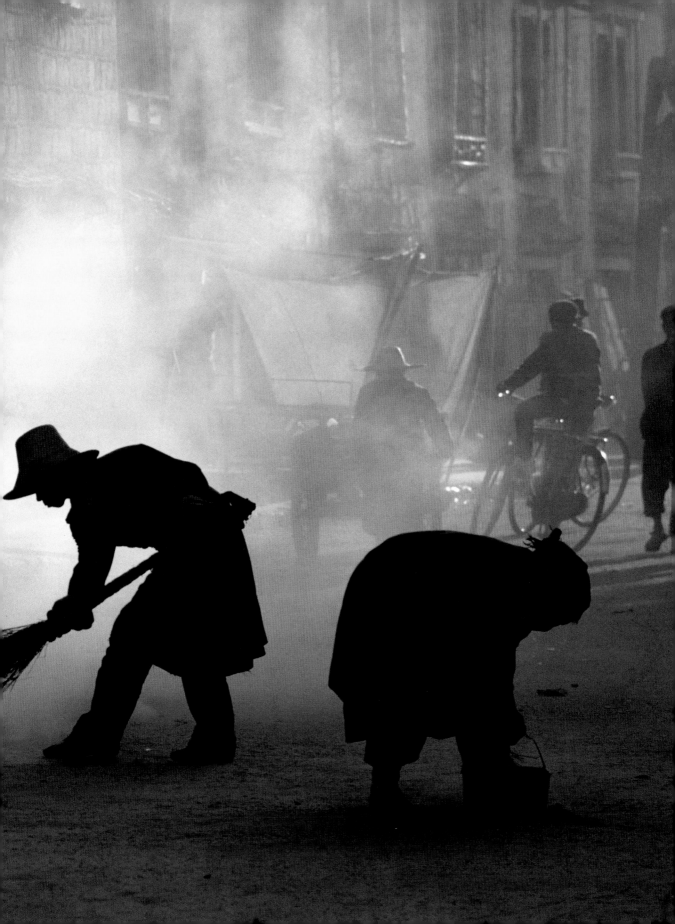

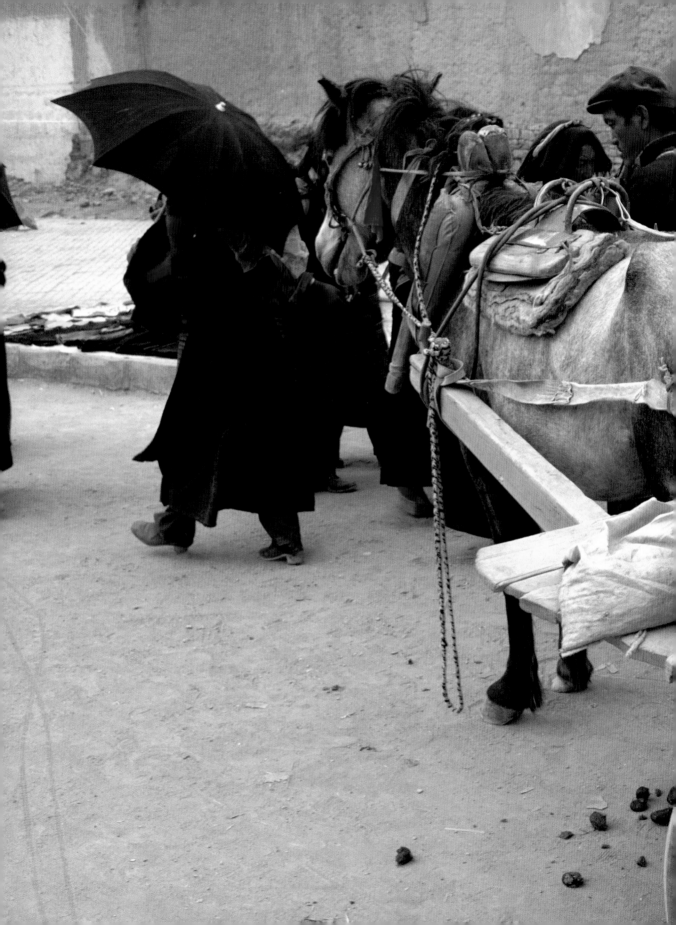

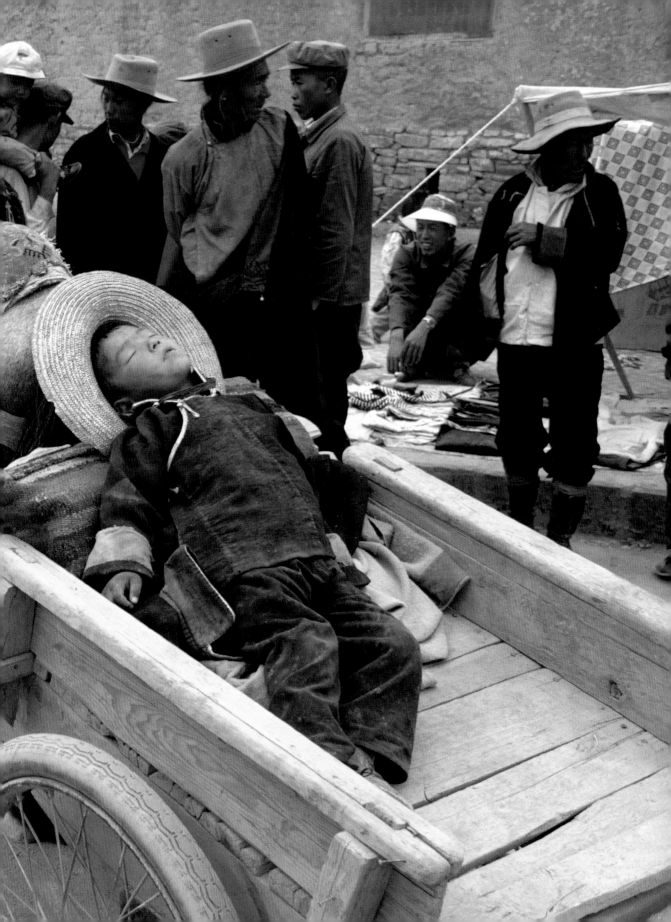

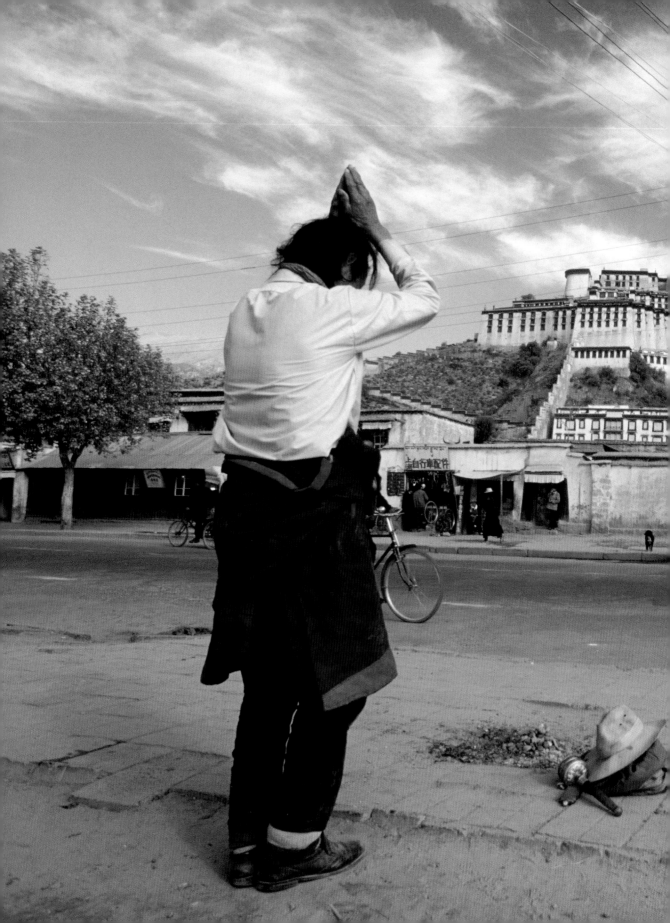

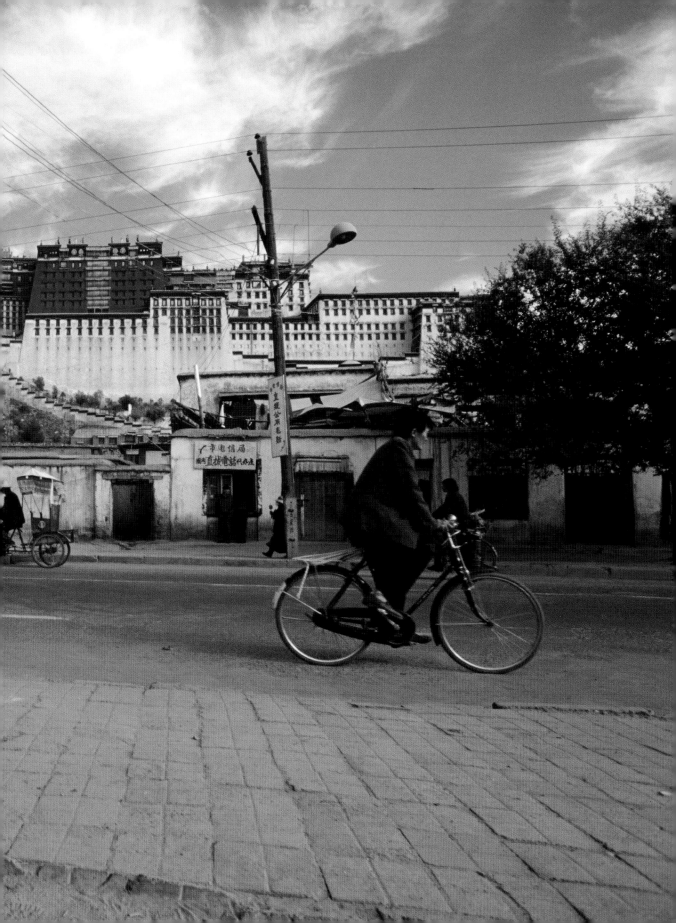

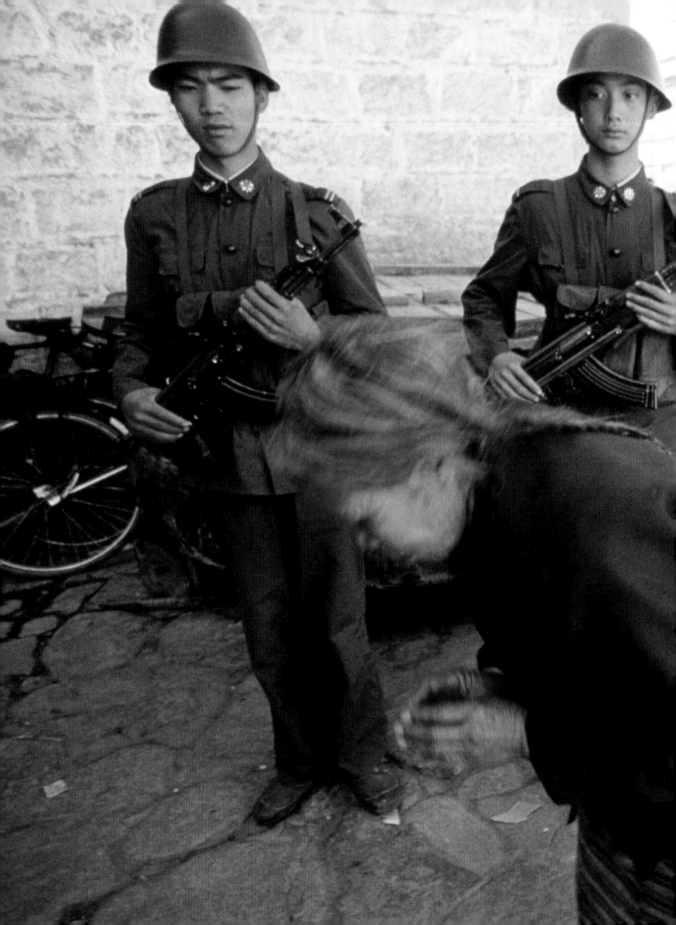

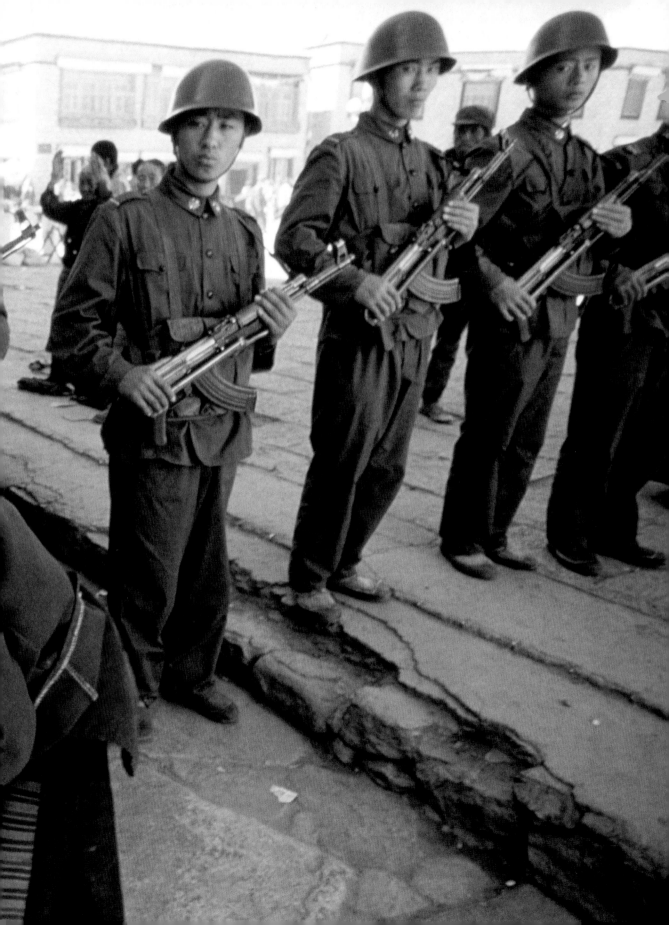

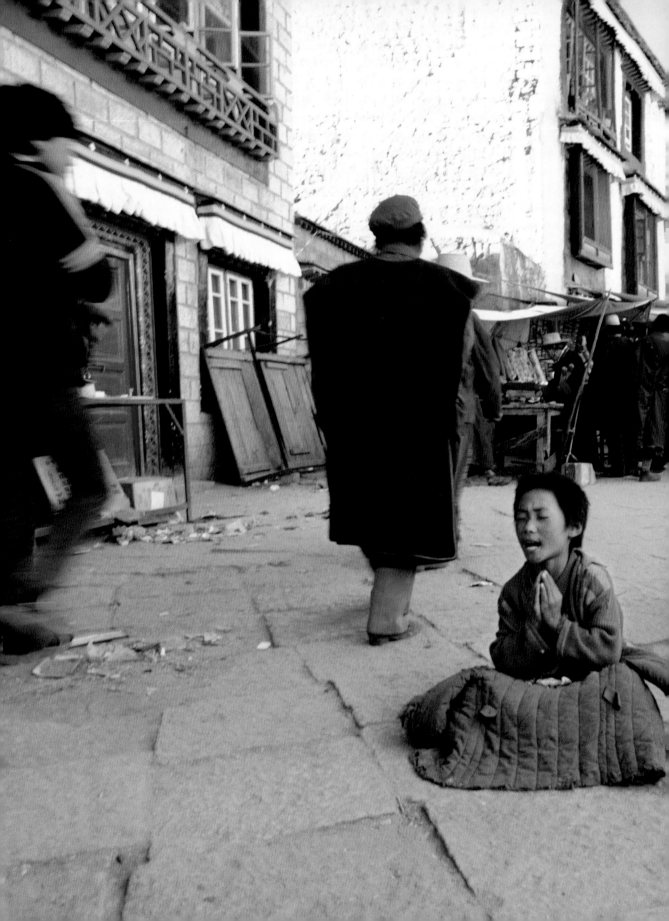

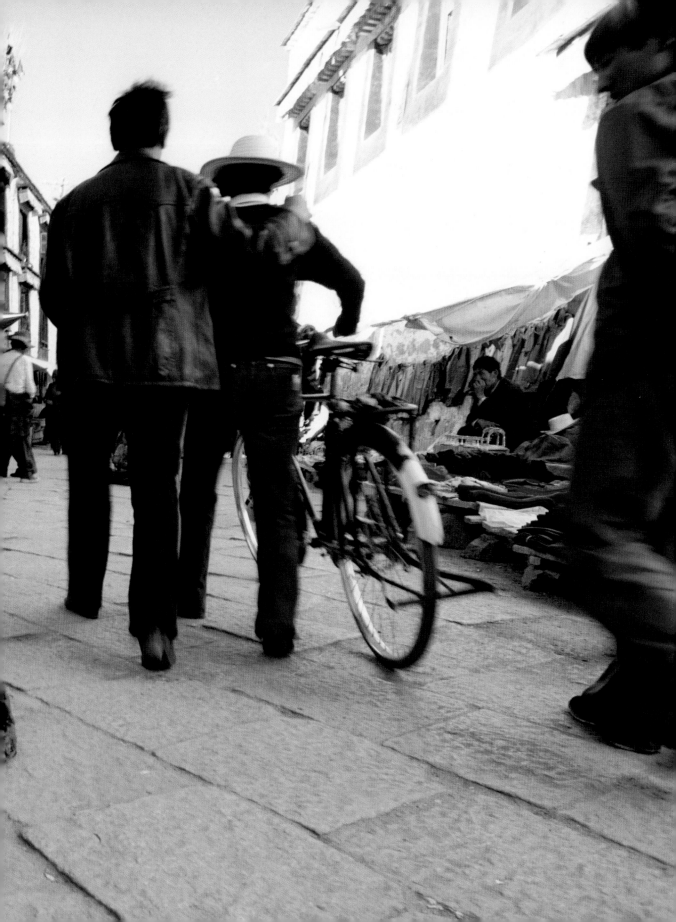

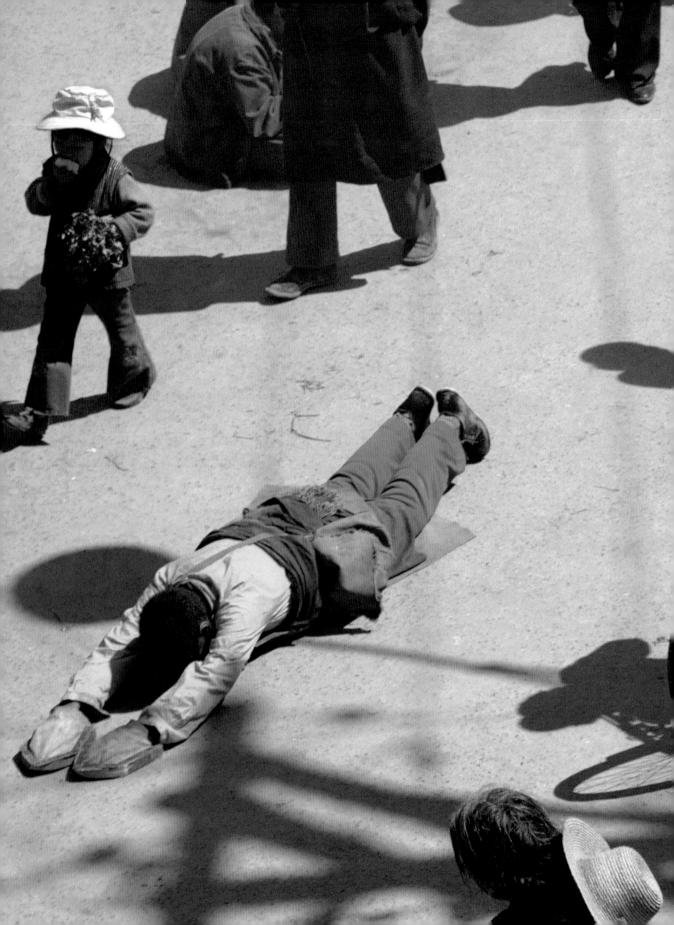

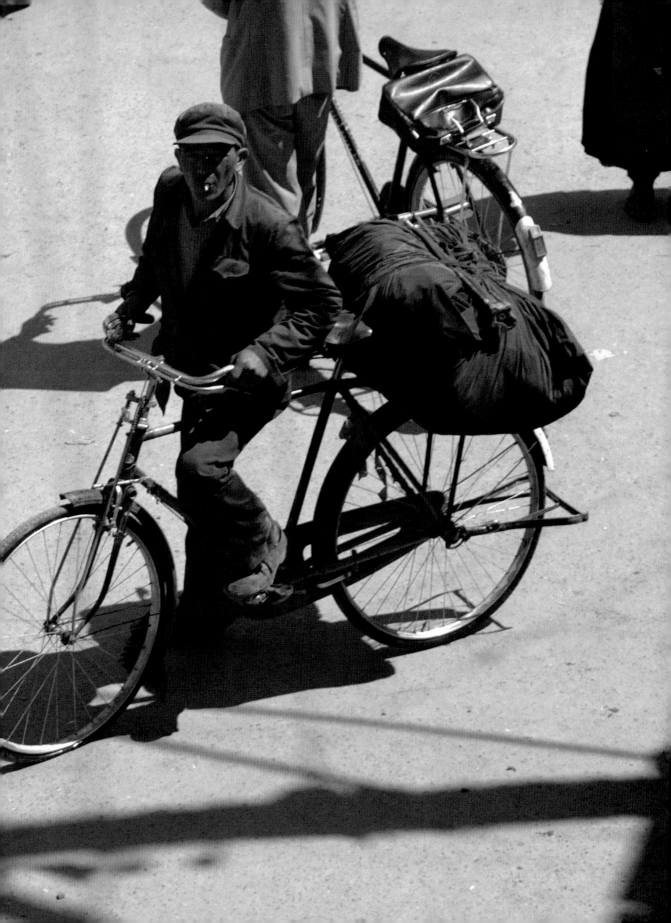

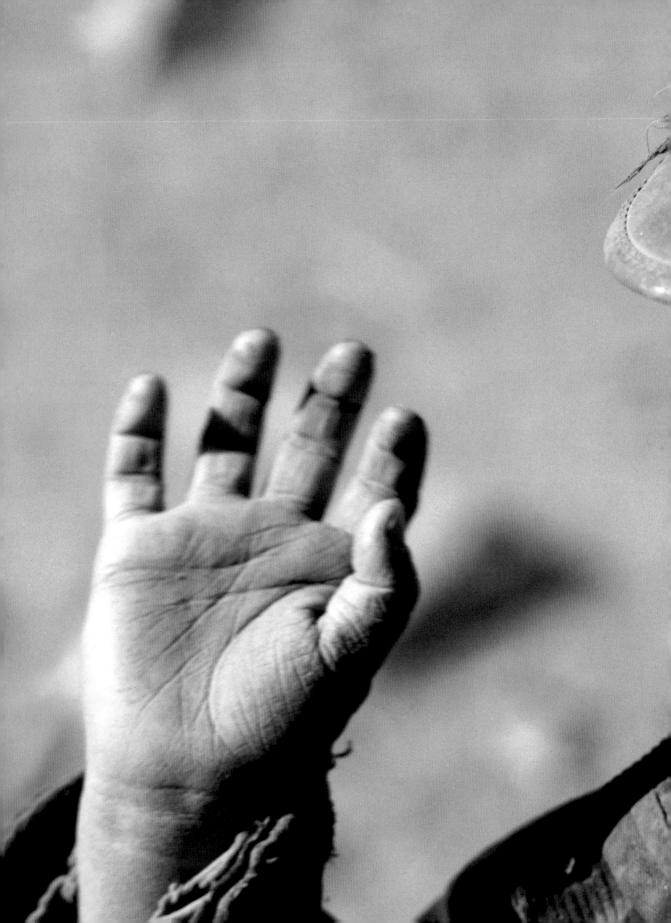

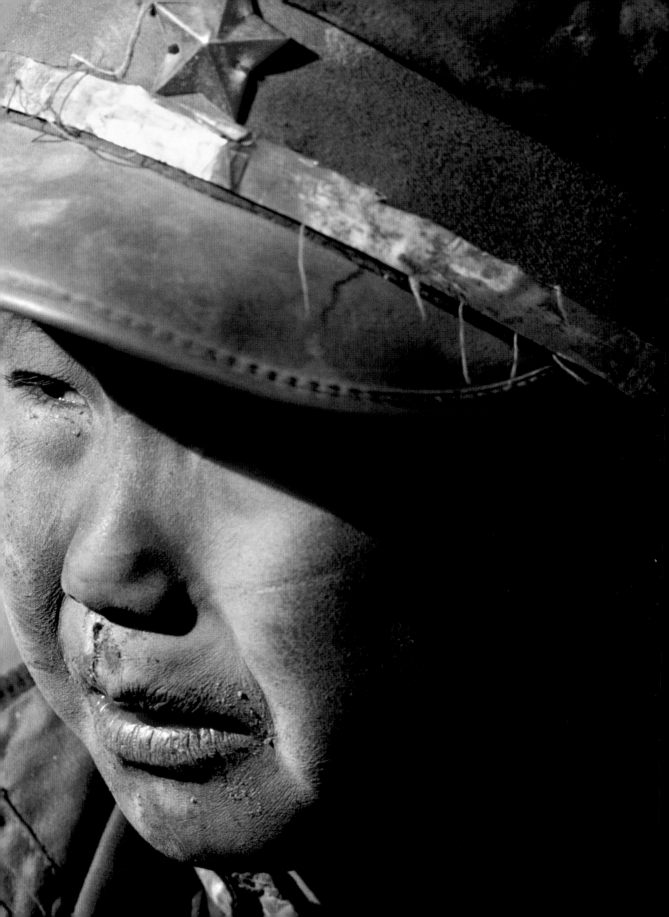

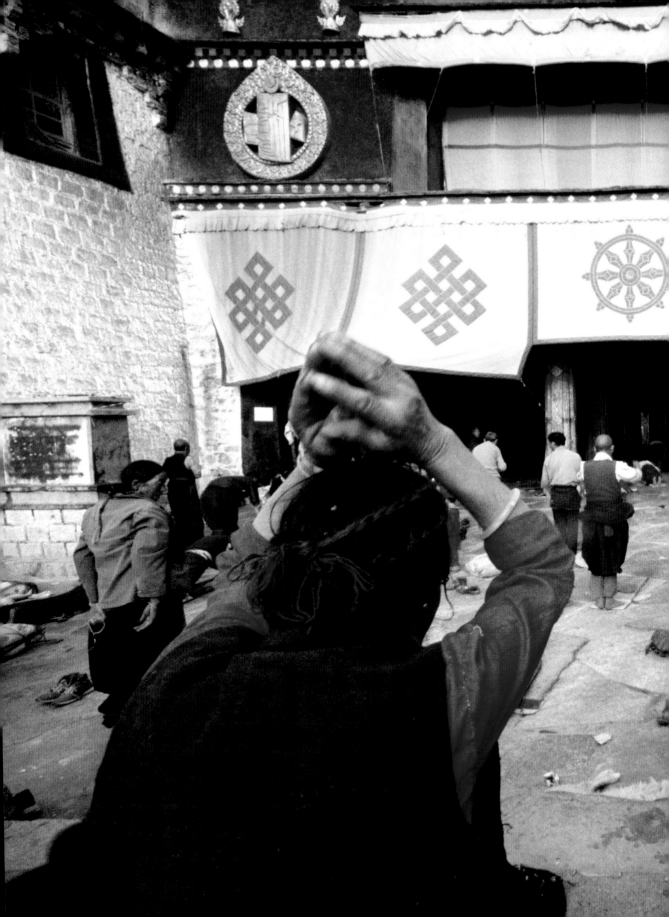

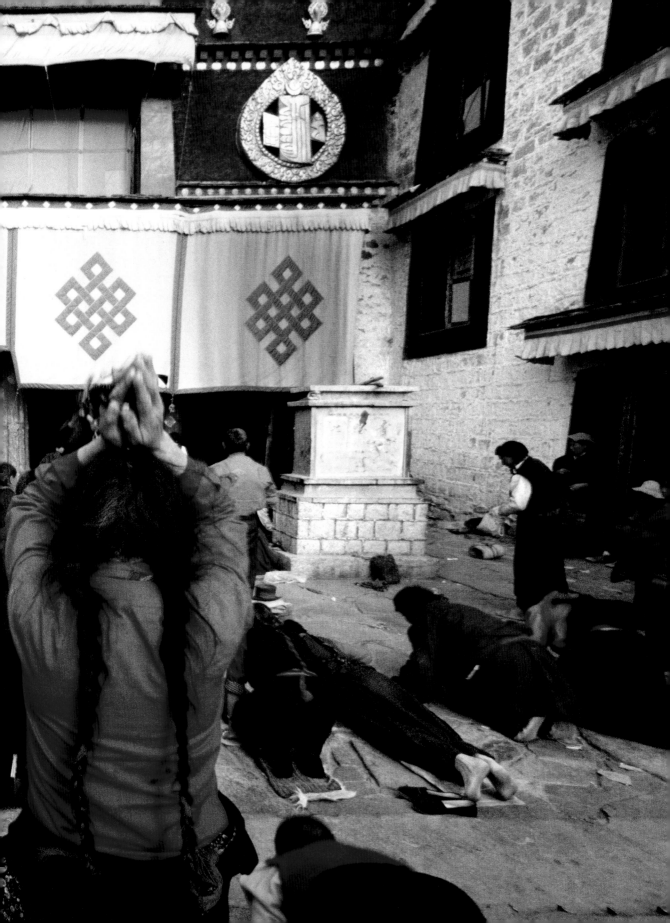

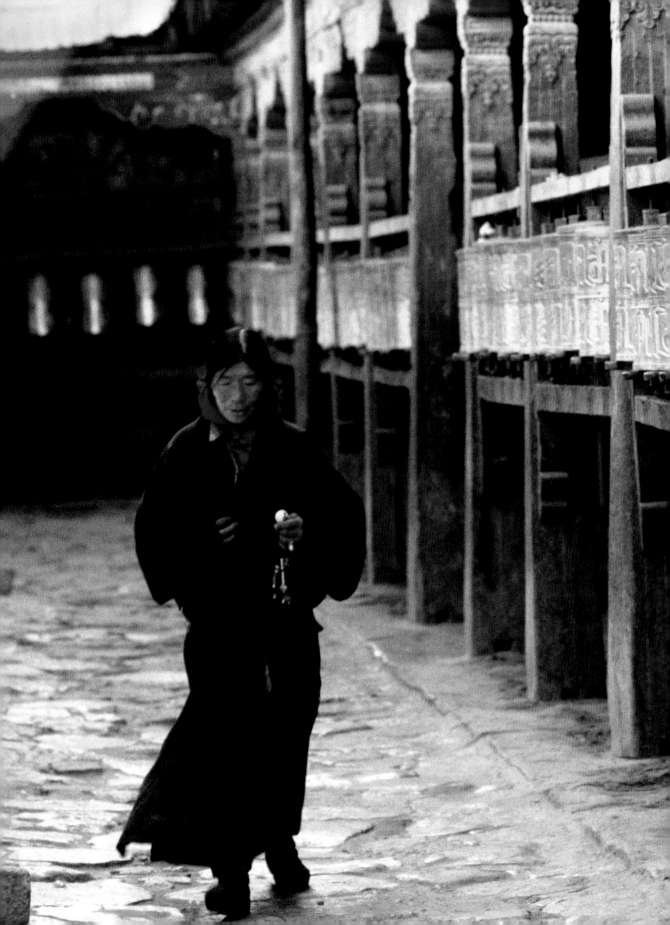

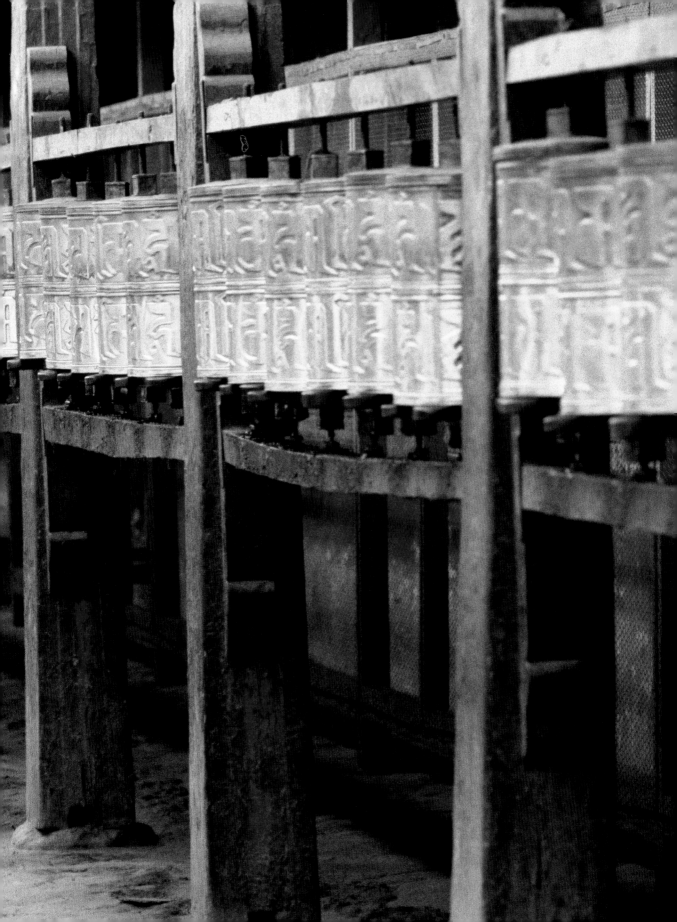

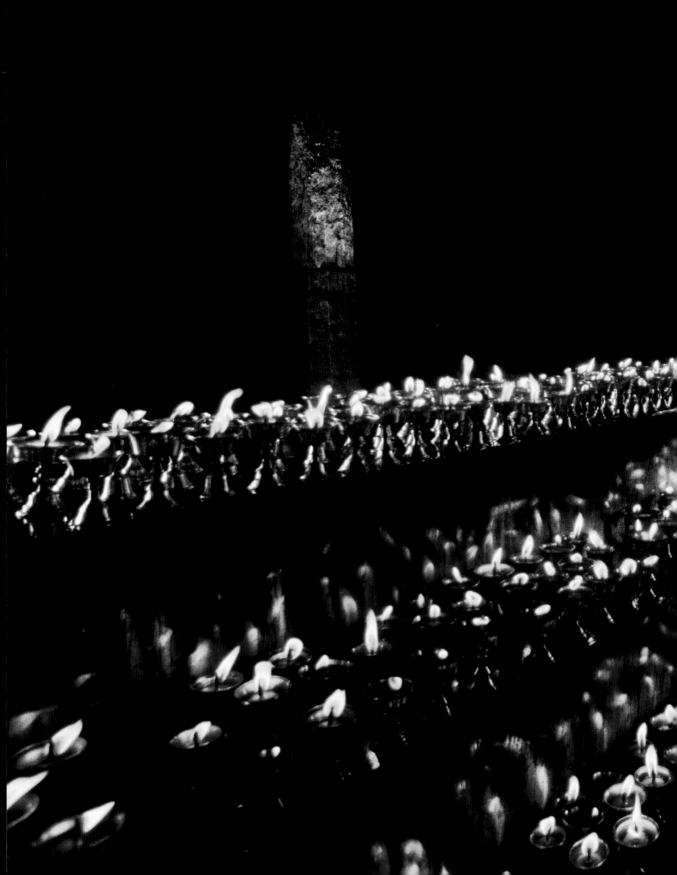

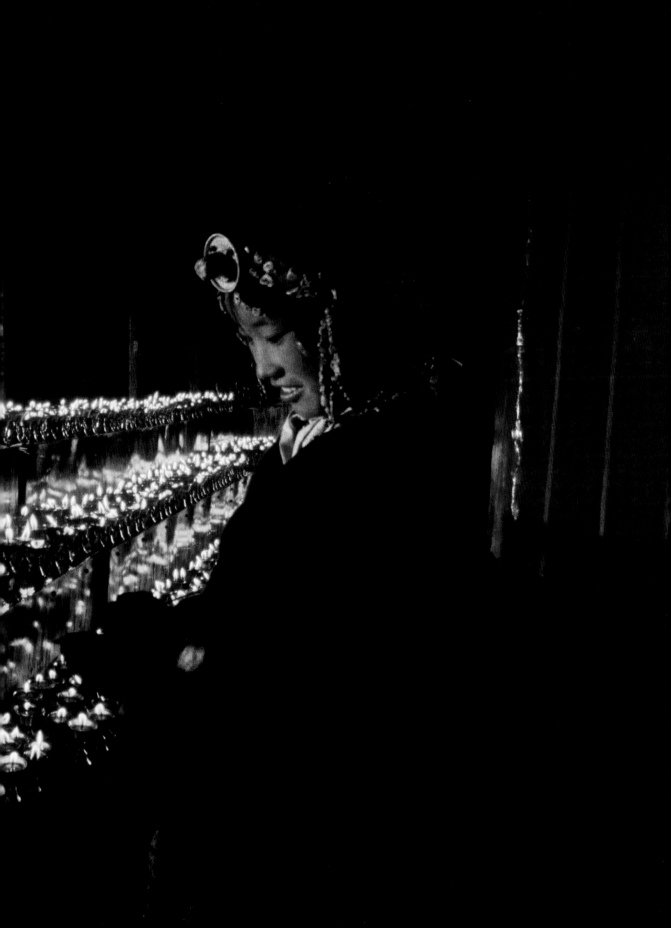

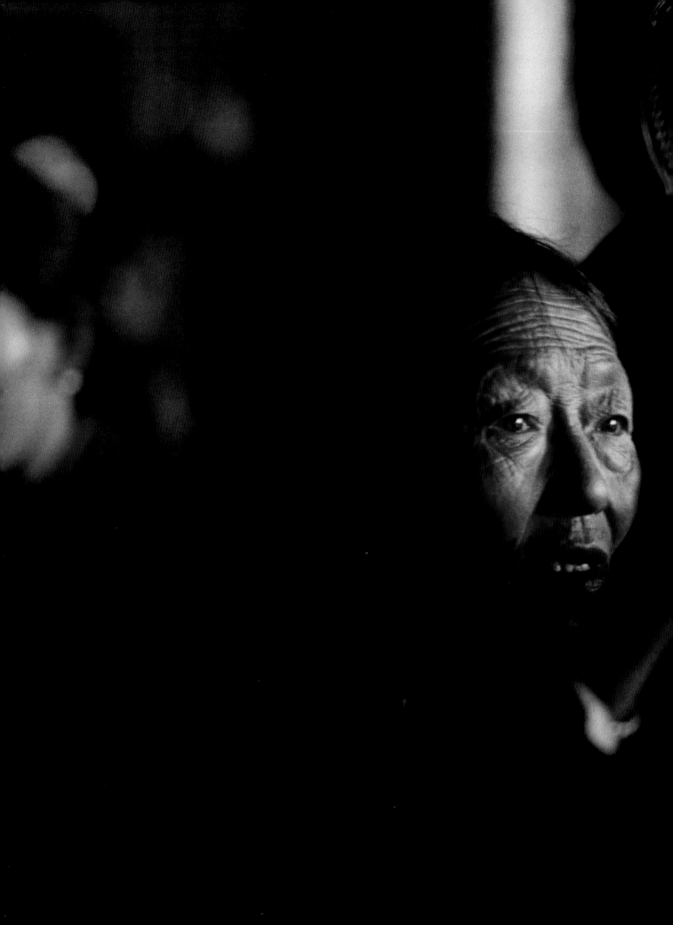

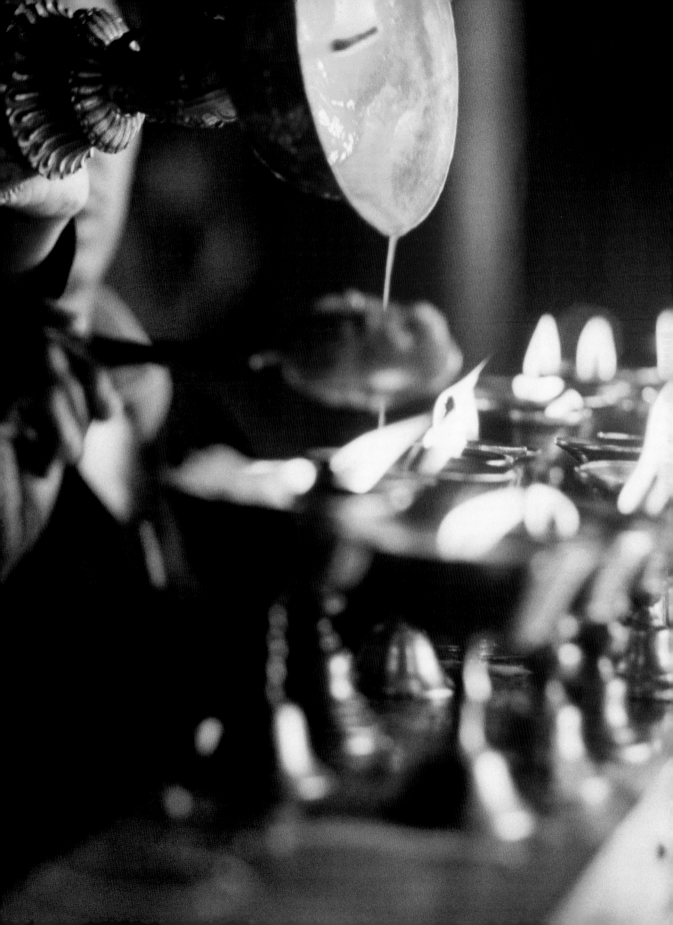

From Life to Life
The Buddhist Concept of Rebirth

In Buddhism, the phenomenon of rebirth is linked to the continuity of the flow of consciousness, which is not restricted to our present life.

When they hear the word reincarnation, many people think it means that when the body dies, part of the self remains and returns in a new body. According to Buddhism, however, the 'self' is but an illusion and cannot therefore 'reincarnate' itself. The relationship between the continuum of consciousness and the self is the same as that between a river and its name: it is simply a conceptual designation with no existence of its own.

Rebirth, in Buddhism, is therefore not a metempsychosis in which an eternal soul, regarded as a distinct and real entity, acts as a support for the 'self'.

If the self does not exist as such, we may well ask what this impermanent principle that passes from existence to existence actually is. In fact, it is a function and not a concrete entity that is perpetuated. A particular flow of consciousness possesses qualities that result from actions, words and thoughts, a person's state of ignorance or knowledge, and which distinguish it from another flow of consciousness. This function could be compared to a wave or a swell that flows along even though the mass of water does not travel along with it. So it is not an entity that is reborn, only the repercussions of actions, words and thoughts that have modified the parameters of the flow of consciousness. Rebirth is simply the result of the laws of cause and effect applied to conscious phenomena.

According to Buddhism, there are six worlds of rebirths. These states are neither *more* nor *less* real than our present state. It is sometimes said that hatred creates a true 'hell' for ourselves and those around us. We must not underestimate the consciousness's faculty to create a world that looks just like what we call 'reality'. Our mind is perfectly capable of amplifying certain experiences and being tricked by various situations. So it is quite easy to imagine that it can experience states of existence that are very different from the human world but that seem just as concrete to it. During our present life it is, therefore, important to acquire enough mindfulness to avoid finding ourselves, after death, in the various dream worlds of suffering. Buddha said that there is no tangible hell but that our mind can solidify things until they take on the appearance of hell.

Among these six realms, the human state is fortunate because the suffering it involves is sufficient to make us want to escape from it but not excessive enough to take away our freedom to do so.

The liberation from samsara and the attainment of Buddhahood mean the end of karmic rebirths, but not of those that are the result of love and compassion for beings.

Every being has the possibility of freeing itself from samsara and achieving Enlightenment, but samsara as a global phenomenon never ends. According to absolute truth, however, neither samsara nor nirvana has any existence of its own.

Is it possible to be a Buddhist without believing in rebirth? His Holiness the Dalai Lama often speaks of two types of spirituality: secular and religious. The first consists of developing, throughout life, altruistic love, compassion, tolerance and other fundamental human values. This kind of spirituality can be inspired by the values of Buddhism without requiring adherence to the body of Buddhist teachings.

The Buddha said that beings experience countless rebirths within the cycle of existence, samsara. During one of the night watches at the end of which the Buddha achieved Enlightenment under the Bodhi tree, the acquisition of the 'eye of knowledge' enabled him to review the course of his earlier lives and those of all beings.

The Buddha also said that we must not 'accept his words out of simple respect for him, but rediscover their truth through our own experience'. That does not mean we should reject the Buddha's words simply on the basis

that our present state of ignorance does not allow us to comprehend them. In Buddhism, there are three types of correct proof. The first is based on direct perception (seeing a fire, for example), the second on logical inference (if we see smoke, we deduce that there is a fire and will find it if we go to the right place) and the third on valid testimony, in this case, the testimony of someone like the Buddha who has attained Enlightenment.

In some cases, we only have access to valid testimony. We use this kind of proof all the time in our daily life. For instance, when scientists tell us about atoms, we are quite incapable of seeing these particles but we trust the matching findings of a number of serious scholars. In the case of rebirth, we must therefore trust in the accounts of the Buddha and many other remarkable beings who followed him and who, over the centuries, have said that through their own experience they acquired direct knowledge of the continuity of the flow of consciousness.

Unless we envisage a continuity of states of existence, many factors that are essential to the path towards Enlightenment may seem absurd. The very concept of karma, the idea that we are the result of a large number of actions freely performed in the past and the architects of our future, would become quite meaningless. Bodhicitta, the aspiration to full Enlightenment in order to be able to free beings from the vicious circle of existences, would no longer have any meaning. The same would apply to what is called the 'dedication of merits': dedicating the positive energy produced by our practice to the Enlightenment of all beings.

Furthermore, if we did not achieve liberation in this life, all would be over. At the end of his path, a Bodhisattva may achieve Enlightenment within a particular existence. But we cannot journey along the path that led him to it, from beginning to end, with no preparation, in the space of a single lifetime. The Buddha Shakyamuni often said that his Enlightenment was the fruit of merits and knowledge accumulated during three incommensurable eras. The fact of believing in rebirth will therefore convince the practitioner that the spiritual path he is travelling will lead to his goal and that he must progress with the help of all the energy at his disposal, without becoming discouraged.

We can put many aspects of Buddhism, in particular those relating to the profound 'contemplative science', to good use without necessarily being a practising Buddhist. This knowledge of the mind based on the contemplative experience is valid for all beings, whether believers or atheists. But the Buddhist path towards Enlightenment acquires its full meaning only if we envisage a continuity of the flow of consciousness throughout different existences.

For all these reasons, denying the possibility of past and future states of existence is regarded as the archetype of what Buddhism calls a 'false view'. It is regarded as false because it runs counter to the way an enlightened being sees things.

The Immutable Diamond
The Tale of a Remarkable Rebirth

Throughout this book we have followed the childhood, life and death of a spiritual master, Khyentse Rinpoche. But the story is far from over.

The cave of Maratika, east of Nepal, is the sacred site where Guru Padmasambhava saw the vision of Amitayus, the Buddha of Infinite Life. On 28 December 1995, an unusual number of lamas, monks and disciples from several different countries happened to gather together there. At the head of a colourful procession of monks and laymen, each carrying a lighted stick of incense, Trulshik Rinpoche, a lama aged seventy-two at the time, waited, scanning the sky. The hum of a large helicopter soon broke the silence of the mountains. One of the twenty-two passengers was the young incarnation of Khyentse Rinpoche, discovered not long before.

When the child, aged two and a half, appeared in his mother's arms, Trulshik Rinpoche offered him a long white scarf. As though perfectly familiar with traditional custom, the child returned the scarf to the lama and put it round his neck.

This was not an ordinary meeting, because it was Trulshik Rinpoche who, from his isolated monastery at the foot of Everest, had identified the young boy as the incarnation of his beloved master Dilgo Khyentse Rinpoche.

Trulshik Rinpoche was Khyentse Rinpoche's most senior and accomplished disciple, so after Khyentse Rinpoche's death in

1991, his close disciples turned to him to rediscover the teacher's incarnation. Since that moment, Trulshik Rinpoche had experienced dreams and visions that clearly indicated the identity of the reincarnation. One morning, just before dawn, he dreamed that twenty-five golden stupas were appearing in a vast plain separating Shechen Monastery from the monastery of Kanying Shedrup Ling in Nepal. He saw quite clearly that these stupas contained the relics of Khyentse Rinpoche. As he was wondering which was the main stupa, one of them appeared in front of him. A marvellous bird of unknown species came out of the window in the upper part of the stupa and began to sing. Trulshik Rinpoche approached and held a ceremonial white silk scarf in front of the bird. At once the twenty-five stupas lined up in procession and, following the first one, headed towards Kanying Monastery and entered it.

In another dream (or rather a vision, since Trulshik Rinpoche modestly tells us, 'it was a dream but I was not sleeping'), Khyentse Rinpoche appeared to him and chanted a poem that revealed the child's year of birth, the name of his parents and the place where he could be found. Trulshik Rinpoche did not want to attach too much importance to this vision, but instead of vanishing in the next few days it became increasingly clear and present in his mind. He kept the details to himself until April 1995, when he sent a letter to

Rabjam Rinpoche, Khyentse Rinpoche's grandson. According to Dilgo Khyentse Rinpoche's poem, he wrote that the father of his reincarnation was 'Immutable Diamond', Mingyur Dorje, and the mother was 'Glorious Torch', Paldrön. Their son, born in the Year of the Cock, north-east of Shechen Monastery, was, according to the poem, 'the undoubted reincarnation of Paljor' (one of Khyentse Rinpoche's names).

Little research was needed. It turned out that the personal name of Chogling Rinpoche, a close disciple of Khyentse Rinpoche, was indeed Mingyur Dewei Dorje and that of his wife Dechen Paldrön. They had a son, born on the tenth day of the fifth month of the Year of the Cock, on 30 June 1993, the birthday of Padmasambhava. So a messenger was sent to Trulshik Rinpoche, who replied that there was no need to search further. The child was indeed the rebirth, the *Yangsi*, literally 'come back to existence'. It is worth noting that Trulshik Rinpoche did not know the personal names of the child's father and mother because the father was himself a lama and therefore known only by his title. The same applied to his wife.

The Dalai Lama confirmed that this was indeed Khyentse Rinpoche: 'I have full conviction,' he said, 'that this young child is the true incarnation of Khyentse Rinpoche.' On 29 December, a simple yet moving ceremony was therefore held in the cave of Maratika. Trulshik Rinpoche read the child the name – Urgyen Tenzin Jigme Lhundrup – the Dalai Lama had given him and performed a long-life ritual in his honour. The disciples that were present, some of whom had travelled a long distance on foot, felt that the sun had begun to shine again over the whole world. They saw this as an answer to the prayer the Dalai Lama had written some days after Khyentse Rinpoche left us:

> 'The more others need help,
> The more you love them spontaneously.
> To bring maturity to all beings from this
> dark age and free them,
> Quickly show us the beautiful aspect of
> your incarnation!'

The full circle had been drawn. In December 1997 the enthronement of the young Yangsi Rinpoche in Shechen Monastery attracted nearly fifteen thousand people of forty different nationalities and more than one hundred eminent lamas representing all the schools of Tibetan Buddhism. Since then, the child has studied in Shechen and Bhutan and, like a flower that gradually reveals its beauty as it blossoms, has developed qualities that make one hope that, like his predecessor, he will be able to work for the benefit of all beings.

Rabjam Rinpoche, grandson of the deceased master, tells us: 'When Khyentse

Rinpoche died, I did not feel that he had really gone but rather that he had excused himself for a few moments. That is why, when I learned he had returned in visible form, I was rather disconcerted. I found it difficult not to remember Khyentse Rinpoche's majestic stature. Suddenly I found myself in the presence of this joyous and active young child. But in his company I soon rediscovered many ways of being, qualities, sometimes even insignificant details that reminded me to a surprising extent of Khyentse Rinpoche. Other striking events, for instance when he recognized people who had been close to him in his preceding life, made me even more convinced. I am simply happy to witness such moments.'

MAY I BE A BRIDGE, A BOAT, A SHIP
THE BODHISATTVA'S VOW

The Bodhisattva's vow is an undertaking to devote himself, not just during this life but also during all future lives, to relieving the suffering of beings and guiding them towards Enlightenment, the supreme remedy for suffering.

It is a heroic vow, for even though we could conceivably renounce a vow that concerned only our own good, how could we dare to renounce a vow that concerned the infinity of beings, or even just postpone it? That is why Bodhisattvas are called the 'heroes of Enlightenment'.

Just as he who carries a heavy load does not linger on the road, the Bodhisattva will never cease endeavouring to attain his goal, putting all the resources of his body, his words and his mind to work in the service of beings. He will express this determination by sublime vows, which will totally commit him to the ideal of altruistic love and compassion:

'May I be protector for those without one, a guide for all travellers on the way; may I be a bridge, a boat, a ship, for all who wish to cross the water. May I be an island for those who seek one, and a lamp for those desiring light; may I be a bed for all who wish to rest and

a slave for all who want a slave. May I be a wishing jewel, a magic vase, powerful mantras and great medicine. May I become a wish-fulfilling tree and a cow of plenty for the world.

Just like space and the great elements such as earth, may I always support the life of all the boundless creatures. And until they pass away from pain, may I also be the source of life for all the realms of varied beings that reach until the end of space.'

The Bodhisattva's first step is to become aware of the immense and enduring suffering of beings and realize that everyone, without exception, aspires to happiness. He sees that despite their ceaseless efforts they continue to turn their backs on their own well-being and rush into unhappiness. That is the result of ignorance. When he thus contemplates the infinite suffering of beings, the Bodhisattva can only feel immense compassion. But compassion alone is not enough.

This is when the Bodhisattva realizes how powerless he is. Unable to relieve his own suffering and cure his own ignorance, how could he relieve that of others? He stands on the edge of samsara like a crippled mother who can only watch powerlessly as the torrents of the river carry her child away. However great her motherly love, she cannot save him. The Bodhisattva has to find the means of creating this power.

He or she must then embark on the path towards Enlightenment. There is only one goal here: to find, through this supreme knowledge, the means of saving living beings from suffering for once and for all.

Motivation and determination play an important role. Like an irrigation channel, they collect and concentrate the energy of our actions. If our only ambition is to satisfy our immediate desires, at best that is all we will manage to do. But if we are constantly inspired by the desire to liberate our fellow beings, in the end we will achieve this great ambition.

The Bodhisattva's quest thus unites knowledge of the ultimate nature of mind and phenomena to the universal compassion that springs from this wisdom. These two aspects are vital to achieving this objective, just as the bird needs two wings in order to fly.

Music on the Roof of the World
The Music of Tibetan Buddhist Ritual

All schools of Tibetan Buddhism accord an important place to music, both vocal and instrumental, in the various rituals that punctuate monastic life.

At a very early age, novices start to learn the texts that form the basis of the rituals of the community to which they belong, and, little by little, they begin to join in the recitations, prayers and chants of their elders. An important role is played by the 'singing master', who intones the chants and conducts the choir by striking *rolmo* cymbals. Under his direction, the different rituals follow one another, alternating between long passages of recitation, sometimes delivered at a very rapid tempo, psalmody which follows simple melodic and rhythmic models, and 'vocalized' chant (*yang*).

Systems of musical notation (*yang-yig*) have evolved to conserve the traditions relating to these solemn chants, in which the melodic line is prolonged by meaningless syllables inserted between the syllables of the text. Curved lines above syllables are used to indicate changes in pitch, timbre or dynamics, and to mark caesuras or pauses, while little circles, usually below text syllables, are used to mark drum and cymbal beats.

In some monasteries, particularly in the Tantric Colleges of Gyuto and Gyume, the monks have developed a distinctive style of singing called the 'Tantra voice', which enables them to produce very deep notes accompanied by a separate, audible harmonic of that note. This skill fascinates some Western musicians, who know it as 'biphonic singing' or 'throat-singing', and often use it in works that bear no relation to its origins.

Shaken instruments: These include the handbell (*drilbu*) with a sceptre-shaped handle (*dorje*), the small hourglass-shaped drum (*damaru*), the bell with out-turned rim (*shang*), which is the Bönpo equivalent of the Buddhist *drilbu*, and cymbals with a small central boss (*silnyen*), which have a crystalline sound that is thought suitable for musical forms of worship, and for rituals that concern deities with a peaceful nature.

Struck instruments: The large frame drum (*nga*) and cymbals with a deep central boss (*rolmo*) are used to beat out the musical rhythm. Other instruments which count as 'struck' are the wooden semantron (*gandi*), which is only used for summoning the monks to the ceremony of confession and other monastic rituals, and small heavy cymbals with a high sound (*tingshak*).

Blown instruments: These are played in pairs of identical instruments to ensure continuity of sound. They include conches (*dung*), trumpets (*kangling*), long, telescopic trumpets (*dungchen*) and oboes (*gyaling*), which are played using the circular-breathing technique.

Secular music: Tibetans sing for all sorts of reasons, establishing a rhythm for communal work, celebrating annual festivals or marriages, or for dancing (the 'song-and-dance' genre). Despite the multiplicity of dialects, there are some perennial themes in Tibetan poetic language, which is full of imagery recalling 'the blue of the sky', 'the brightness of the full moon', 'the bitterness of the north wind', 'the eagle's flight' and 'the hum of bees'.

Songs (*she*) often speak of love, such as the following, attributed to the 6th Dalai Lama:

> When the season of flowers is over
> The turquoise bee does not fret.
> Having vowed to be parted from my love,
> Why should I fret?

Similar songs are also found in the Nangma and Toshe repertoire of central Tibet, which is nowadays the most popular form of Tibetan music, both for Tibetans in exile and those under Chinese rule.

There are also more learned forms, such as songs of religious inspiration (*mgur*), the most famous of which are associated with the guru and poet Milarepa.

The epic of King Gesar: The epic cycle of the life of King Gesar was handed down by specialist singers, usually men. Wandering bards, wearing a distinctive hat, took up positions in nomadic camps or villages, usually

in winter, and would devote hours, even days, to recounting the exploits of the legendary hero, from his miraculous birth, his accession to the throne of Ling, his victories over the enemies surrounding the country, to his descent into Hell. The captive audiences heard prose narrative interspersed with verse sung to a limited repertoire of melodies that matched the main characters and character-types in the saga.

Different versions of the saga were written down for the first time in the late 19th century, first by hand, then in printed form in Tibet, and these eventually became widely available. This led to the gradual disappearance of the travelling bards, but also to the adaptation of selected episodes of the story to the stage. Even so, there remain some amateur performers who, although they are not true bards, can sing the melodies of the epic with the aid of a printed text.

Ache Lhamo: The style of musical drama known as *lhamo* (goddess) or *ache lhamo* (sister-goddess) owes its name to the female characters who appear in its prologues, but little is known of its origins. According to tradition, it was created by the holy man and bridge-builder Thangtong Gyalpo (1361–1485 or 1385–1464). The 6th Dalai Lama made a major contribution to the development of *lhamo* theatre by encouraging the creation of semi-professional troupes of performers.

The modern repertoire consists of no more than a dozen works of a religious and didactic nature, which used to be performed in the courtyards of large monasteries or in the palaces of the local nobility, and in Lhasa during the midsummer festival of *Shoton* (curdled milk or yoghurt).

The most characteristic feature of Ache Lhamo music is the very ornate singing of *namthar* or biographies (literally 'lives of perfect liberation'), during which the singers act out different characters in a falsetto voice that is very popular with audiences. In the past, the only accompaniments to the narrations and singing were big double-headed frame drum and cymbals, but recently there has been an increase in the use of small instrumental groups, including six-stringed lutes, fiddles, flute and dulcimer. Sometimes modern performances even feature Western instruments, such as guitars or synthesizers.

Tibetan music at the dawn of the third millennium

Since the second half of the 20th century, whether in exile or on their native soil, Tibetans have had to swim in cultural waters that are alien to their own. They have had to use foreign languages (Hindi, Nepali, English, Chinese) and have heard other forms of music which have to some extent influenced their own musical traditions. While music in the monasteries has remained faithful, as far as possible, to the old models, this has not been the case with secular music. Due to recently formed institutions (national or regional troupes under Chinese control, TIPA among Tibetans in exile, in India or the West), the fragile regional music forms are becoming folkloricized, a process which has resulted in some genres disappearing, repertoires growing less varied, and new instruments being adopted. A composite style is being created, mingling Indian intonations with a Chinese spirit (and vocal style), as well as influences from jazz, pop, rock and rap.

As a Rainbow Forms in Space
Sacred Rituals and Dance

The magnificent rituals of Tibetan Buddhism often last a day or more, and can last up to nine days and nine nights without interruption, in the case of the annual ceremonies called *drupchens*, meaning 'great accomplishment'.

These ceremonies are sometimes accompanied by the creation of a mandala, which the monks mark out elaborately using coloured powder and which represents the Pure Land of a deity. At the end of the ritual, the mandala is erased as a reminder of the impermanence of all things. The powders are collected up and thrown in a river, so that all the creatures that inhabit it and all those who drink its water will be blessed.

On some occasions, the ceremonies conclude with dances, which are themselves a form of teaching through images. In these dances, the world is transfigured, negative forces are vanquished, beings awaken to their true nature and are delivered from suffering. The monks regard these dances as a form of meditation and a spiritual communion with the lay community that is closely associated with the monastery.

The dances 'liberate' simply by being seen, just as sacred music liberates with its sound, a spiritual teacher with his touch, a sacred substance with its taste and meditation with thought. Here, 'to liberate' means to free from the yoke of mental poisons, such as hatred, desire, ignorance, pride and jealousy, which destroy our inner peace and that of others.

It is said that on a few exceptional occasions the Buddha manifested himself on Indian soil in the form of deities who performed a thousand sublime dances that symbolized the many facets of their activities for the good of beings. These dances, which were performed during initiation ceremonies, were spontaneous, unhesitating and uninhibited. It is said in the *Tantra of the Wheel of Time*: 'Without fear, without hesitation and without effort, divine gestures, unknown dance movements and songs never heard before will spring forth from the expanse of mind.'

In Tibet, the tradition of sacred dances or *cham* dates back to the introduction of Buddhism in the 9th century. When Guru Padmasambhava was about to consecrate the ground to prepare it for building the first Tibetan monastery, it is said that he flew in the sky, dancing with majestic movements and rendering the demons of the earth powerless. The place onto which his shadow was projected during this miraculous dance determined the position of Samye Monastery.

Over time, the dances became codified and were taught to adepts, to whom their significance was explained. This tradition was faithfully maintained by being passed on from teacher to student and subsequently enriched by the visions of the great sages, who continued to breathe a new spirit into the art of dance.

One example of this is the acrobatic and whirling dance called the 'Heroes' Dance' or *pacham*, which was inspired in the 15th century by the grand master Pema Lingpa's vision of Guru Padmasambhava's paradise. He described it as follows: 'A palace of light vast as the sky rose up on the summit. At the centre of the palace, in a space of scintillating dots and interlaced rainbows, sat the

Lotus-Born Master, surrounded by a retinue of awareness-holders and male and female deities, dancing with a myriad of movements and singing in melodious voices. They formed a kind of splendid cloud, bringing good to living beings in inconceivable ways.' As the commentator Lochen Dharmashri wrote:

'The dance must spring forth from emptiness, free of attachment,
As a rainbow forms in space.'

The festival that is traditionally held in Tibet on the tenth day of the fifth month of the lunar calendar (June) is one of the great events of the year and attracts the faithful in their thousands. Inspired by Dilgo Khyentse Rinpoche, this festival was re-introduced in Shechen Monastery in Nepal, the land of exile (where it is held in April), and then in Tibet in 1985. About a hundred dancers, all monks, take part. The monastery holds several hundred costumes made of shimmering brocade and masks fashioned by local artists.

A crowd of believers and spectators assembles for the event. Tibetans will walk or ride for days to attend this much-anticipated ceremony, and they camp outside the monastery, studding the green fields with their white tents. The nomads are dressed in thick sheepskins and the women decorate their hair with coral, turquoise and amber, and shelter their children, cheeks reddened by the wind, inside the folds of their capes.

The dances can at times look rather disconcerting, although they can be explained once we understand their symbolism. In one dance, four dancers clothed and masked like skeletons symbolize the death of the self and the path of the mind towards knowledge. The skeleton's outer appearance is a reminder of the impermanence of all things and an incentive to spiritual practice.

The dance of the Eight Manifestations of Guru Padmasambhava, which recalls the advent of Buddhism in Tibet, is the culminating moment of the festival. Nearly two hundred monks take part, while the faithful look on and marvel. Padmasambhava leaves the temple in a splendid procession and takes his place on a throne erected in the centre of the courtyard under a canopy of multicoloured silk. The people prostrate themselves before him and his retinue, offering ceremonial white silk scarves. Then, in an atmosphere of intense fervour, the Eight Manifestations of Padmasambhava begin to dance, one by one. At the end of the leaping dance of the wrathful form of Dorje Drollö, who subdues the negative forces that prevent peace in the world, Padmasambhava and his retinue return in procession to the temple in an apotheosis of music and religious faith, accompanied by banners fluttering in the wind. The shifting crowd of visitors disperses as evening approaches; the courtyard, once teeming with activity, is soon deserted. Night falls and calm is restored to the monastery.

A Master of Dance

Drudi is a thirty-five-year-old monk who was born near Shechen Monastery, in eastern Tibet. At that time, Chinese oppression was particularly cruel and even the most anodyne forms of religious activity, such as the murmuring of prayers, were brutally punished. After the slight liberalization that followed Mao Zedong's death, Drudi took his monastic vows in front of the ruins of Shechen Monastery. The restoration of the monastery began in the early 1980s, inspired by Dilgo Khyentse Rinpoche. Old monks who had been forbidden any form of religious practice for more than thirty years could once again discreetly share their knowledge. Among these were masters of the sacred dances. Thanks to their teaching, Drudi became an expert in all the aspects of this art. After completing his training, he went to spend seven years in Nepal to pass on his skills to the two hundred and fifty monks of Shechen Bodhnath Monastery, near Kathmandu. While keeping an eye on his students, he explained the basic principles that make cham a 'danced meditation'.

As is the case for all spiritual practices, a dancer must practise his art in three key stages. First he must act from a sense of altruism: his vow to attain Enlightenment for the benefit of all beings. Next he must dance with perfect concentration. Finally, he must conclude the dance by dedicating his merits to the good of all beings.

During the dance, the dancer must clearly visualize the deity he is representing and think with confidence that since Buddha-nature is present in every being, he himself is the deity. Avoiding any attachment to appearances, he must remain mindful that the outside world is like a dream, an illusion. He must keep his mind lucid, vigilant, serene and free from attachment.

Physically, he must faithfully represent the postures and expressions of the deities of the mandala. As the 5th Dalai Lama explained: 'The dancer must make his robes move like a great garuda bird gliding through the skies, shake his hair as the snow leopard shakes his turquoise mane, give his body the grace of the tiger that stretches itself in the Indian jungle; his movements must be sweeping and majestic, marked by ease and grace, clear and precise.' It is also said that the dancer must move as though his feet were drawing a lotus on the ground, using gestures that resemble the

beating of the eagle's wings. His speech must consist of continuously repeated mantras.

It is not enough for a good dancer to know the meaning of the dances he performs; he must also have genuine experience of meditation. A great spiritual teacher from Mindroling Monastery, from which Shechen draws its tradition, wrote:

'The movements of the dance
Are a reflection in the mirror
of Enlightenment.'

So it is not surprising that the best dancers are often spiritual teachers. When these teachers take part in dances, their spiritual maturity is reflected in the grace and power of their movements. There is still talk in Shechen in Tibet of a monk who, when embodying wrathful divinities, symbols of a heightened form of compassion, had such a strong meditative presence that the public began to tremble as soon as he entered the arena where the dance took place.

Some repetitive dances, like the 'root-dance' drawn from the Nyingma tradition, which is performed inside the temple by twenty-one dancers wearing black headdresses, can last up to seven hours at a stretch. In this case, it is not the dance that changes, but the dancer's mind.

Finally, after the dance, the dancer dedicates the merits he has created so that he himself and all beings under the sky will be freed from suffering and its causes and attain Buddhahood. Dedicating the merits of our actions is like pouring a drop of water into the ocean: the drop will endure as long as the ocean itself. Spiritual practice that is not dedicated to the good of all beings is like a snowflake that falls on a hot stone and instantly evaporates.

The Tibetan Children's Village
Education First

'Dear children, you are all human beings. You are not plants or flowers that fade in the heat of the sun or are destroyed or scattered by hail or tempest. Unlike plants, you can take hold of your own destiny. Whatever physical sufferings you have to encounter, you must always keep an honest heart and a strong, stable mind. You must gain knowledge and fight with the weapons of law and justice. Dear children, you are at the dawn of your life. Become stronger, day after day, without wasting your precious time!'
His Holiness the Dalai Lama speaking to the TCV

The Tibetan Children's Village, commonly known as the TCV, was created in 1960, shortly after the Chinese invasion of Tibet and the flight to India of His Holiness the Dalai Lama, followed by 100,000 refugees.

The village was set up near the Indian city of Dharamsala, at the foot of the Himalayas, to help young Tibetans who were either orphans or in extreme need. We had to cope with a huge influx of children from the refugee camps. It was a very hard time. We had to struggle day by day to survive, to find work and food. We also had to give meaning to our lives again and rebuild our self-confidence. Our people were suffering from malnutrition and lived in miserable conditions under tents, spending their time breaking stones to build roads.

Tibetan education in exile started in the 1960s. At the beginning we had only four schools. Today, after four decades, there are eighty schools spread across India, Nepal and Bhutan where around 30,000 students are currently studying and 44,000 have already graduated. A recent survey confirms that over 99 per cent of Tibetan children are receiving education.

So, although we have lost our country, yet in exile, due to the far-sightedness and compassion of H.H. the Dalai Lama, education has been and still is our top priority. The deep changes initiated by His Holiness to democratize the community in exile is one more reason for our young generation to be educated, so that they will be able to have sound judgement and take responsibility for the future destiny of the Tibetan people. We also have the responsibility of finding occupations for our school and college graduates both inside and outside the community.

In Tibet itself, ever since China invaded the country in 1949, the authorities have done literally nothing to improve the quality of education. By any standards the picture is extremely bleak. The entire system of education in Tibet is geared towards indoctrinating the children politically, socially and culturally. Chinese authorities arbitrarily detain Tibetan children, usually in deplorable conditions, and hold them for months and years without any semblance of due process. They refuse to educate Tibetan children in their mother tongue, thus violating the educational and cultural rights of the children to be Tibetans. Teachers routinely employ corporal punishment in a manner that often constitutes torture as defined by international law. Most Tibetan children lack access to an adequate education because of high fees, the scarcity of schools in remote regions and their families' inability to pay bribes or lack of 'connections'. They sometimes study in separate, poorer quality primary schools from those of their Chinese counterparts, and in mixed schools they face discrimination in various forms. They also suffer from poor access to healthcare due to the absence of adequate medical facilities, particularly in rural and nomadic regions. Even where facilities exist, the high cost of healthcare makes them inaccessible for Tibetans.

As a consequence, more and more desperate families urge their children to undertake the dangerous trip across the Himalayas so that they can receive a

proper education in the TCV. Every month we welcome around sixty children or teenagers fleeing Tibet in hiding. Knowing only how to read Chinese but despised by the Chinese, they are full of uncontrollable aggression, and our first duty is to give them back a sense of dignity by teaching them about their own culture.

Materially it is not easy. Sometimes we have only one bed for two or three children, and the classrooms are too crowded. Our main problem is building new schools. Most of our thousands of children cannot go back to see their families and we must take care of them on a daily basis, all year round, until the end of their studies. We need funds to give them food, clothes and education, even during school holidays. The work of the TCV extends well beyond school education!

Of course, everything we have achieved up until now could not have happened without the blessings and constant guidance of the Dalai Lama, the generosity of our many sponsors from forty-two different countries around the world, and the charitable agencies who have stood by our side over the past forty years. Our heartfelt gratitude also goes out to the government of India and her great people for their generosity and for being such gracious hosts to the Tibetans, who lovingly call this country their 'home away from home'.

The values of Tibetan education

Even though we have lost our country, we are a people knit together by common values and culture. In exile we inevitably undergo a process of assimilation, and the very existence of the Tibetan language, which is the vehicle of our values and culture, is at risk. This is why we defend it and consider that it is essential to teach our children in their mother tongue. We have created school books which take into account Tibetan culture

as a whole and teach a wide range of subjects directly related to Tibetan reality.

At the same time we want to give our children a modern education. Since 1993 we have had classes in computer science and communication technologies. We are also creating a special school for the most gifted children.

But our ideal in the TCV is not only to make our children good students, it is also to help them become good human beings. Therefore we give them a modern education rooted in the human values of Buddhism, the religion which inspires all our thoughts, words and actions, while avoiding blind faith, which has no meaning, and superstition which leads people astray. In the Tibetan education system we give a lot of importance to the responsibility of each individual in the harmonious development of their life.

The basic unit of our villages is the 'family', whose atmosphere we try to recreate through the feeling of duty, solidarity and setting a good example to others. Compassion is the essence of the Buddha's teaching, and we teach children, from an early age, to care about all sentient beings. We apply it inside our schools by helping, for example, our Indian neighbours. Old people are also part of the 'families' inside the village. They are looked after by children who provide them with care, food and company. In that way old people can also take part in the life of the village and pass on the living memory of our traditions to our children.

The Tibetan culture must be preserved by all means. It carries human, spiritual and moral values which are part of the world's heritage and have a lot to offer the whole of humanity. As citizens of the world conscious that all nations are interdependent, we wish in particular to help develop peace in the world through teaching the universal and indispensable values of compassion and tolerance.

The Case for Tibetan Independence

The struggle for Tibetan independence is fast approaching a profound crisis. The very question of Tibetan identity, not just as a nation but even as a fact of history, is under assault. Jiang Zemin has demanded that the Dalai Lama not only give up Tibetan independence but also the very concept that a free Tibet has ever existed in the past. The fact that Tibet has, for periods of its history, been conquered by foreign powers or that some Tibetan ruler used foreign military backing to gain political control of the country makes no difference to its rightful status as a free nation. There is probably no country in the world that has not at one time or another been under the rule of another. Few, if any, of the UN member states could claim independent statehood if they had to demonstrate a history of continuous and uncompromised independence.

Few people in the world are so distinctly defined by the kind of land they live in as the Tibetans. Tibetan national identity has not just been created by history, nor only by religion, but has its roots deep in the Tibetan land. Tibetans are people who live, and have always lived, on the great Tibetan plateau, high above and apart from the rest of the world. The passage to Tibetan-inhabited areas from the surrounding lowlands of Nepal, India and China is not only unmistakable and dramatic but clearly a transition to a unique world. In addition to this, very early in their history, Tibetans managed to transcend this merely environmental affinity to create a powerful national identity through the unification of the various kingdoms and tribes throughout the plateau.

Today, behind the facade of discos, karaoke bars and three-star hotels, the Chinese government's chillingly unambiguous self-styled 'Merciless Repression' and 'Strike Hard' policies are being rigorously enforced. The forced labour camps (*laogai*), the police, the Public Security Bureau (PSB or *gonganju*), the People's Armed Police (PAB), the army, the *danwei* 'mutual watch' system, implemented through work units, re-education teams, neighborhood security departments and omnipresent informers, all operate freely and openly. They are unfettered by anything remotely resembling independent courts, a free press, civic bodies, independent watchdog organizations, moral or religious voices, the presence of even a single representative of the world media, or rambunctious university students. Even in the worst governed countries of the world one usually finds some such institutions, frustrating if not preventing the kind of absolute tyranny that Chinese leaders practice with impunity in Tibet.

In 1998, Chen Kuiyuan, then Tibet's Communist party secretary (the most powerful authority figure in Tibet) came out very clearly and declared that the enemy to integrating Tibet fully into China was the Tibetan cultural identity. The Tibetan language is now being actively discouraged and even threatened with extinction by Chinese official policies. In just one instance of the implementation of this policy, in June 2001, three thousand nuns were expelled from Serthar Monastery in Eastern Tibet, and their one thousand eight hundred living quarters were razed to the ground. They are now roaming all over the country, with nowhere to

live. The young Karmapa, a Chinese-approved incarnate lama, has been forced to flee to exile in India, as has Agya Rinpoche, the Beijing-appointed abbot of Kumbum Monastery. The boy Panchen Lama recognized by the Dalai Lama has, as the world knows, disappeared without a trace.

The hope for any kind of autonomous status under China is not realistic because it assumes that the Chinese system is flexible enough or tolerant enough to accommodate different political or social systems within it. One can envisage autonomous areas within, let us say, a nation like India, because of its functioning multicultural and multiracial make-up, and its democratic institutions, such as its constitution, free press, elections and an independent judiciary to prevent the government or a dominant group from suppressing the rights of another group.

The 'one nation, two systems' granted to Hong Kong is an exception primarily because it is decidedly advantageous to Beijing. In fact, if China had not made that concession it would probably have damaged confidence in Hong Kong's economy and caused a crippling economic disaster for China. Unlike the citizens of Hong Kong, Tibetans passionately feel and know that they are different in every way from the Chinese, culturally, racially, linguistically, and even temperamentally. Economic improvement in the lives of Tibetans in Tibet, even if it did happen (which it hasn't in any sense that is meaningful to the Tibetans themselves) would not change their feelings in this regard.

There is certainly no denying that the situation inside Tibet is grim, especially when we take into account the fact of Chinese immigration. Yet no matter how grave this immigration is, this is not entirely an irreversible condition. Stalin forced large-scale immigration of Russians into small non-Russian nations like Lithuania, Latvia and Estonia. It was generally thought in the world that these countries were finished. But now these small nations are free, flying their own flags, speaking their own language and living in freedom.

The main, but often unspoken reason why most people feel that independence is not possible is their unconscious acceptance of the permanence of China's power. This is, needless to say, not a very Buddhist attitude. After all, one of the primary observations of the Buddha was the impermanence of all phenomena. The Western media's self-serving depiction of China as a dynamic modern country with an exciting ever-growing economy certainly contributes to the general acceptance of China's invincibility. The reality of China is a nation in profound crisis. All the noise and fanfare of China's economic miracle is in fact covering up a deep and profound malaise. China's attempts to avoid the former Soviet Union's problems by its hard-line anti-democratic policies could at best merely postpone the inevitable consequences of fifty years of disastrous Communist rule. The scale of official corruption and incompetence is staggering. An alarming decline in agriculture, increasing water scarcity, catastrophic environmental degradation and rampant official exploitation of farmers have caused a massive population shift from the countryside to already congested cities. Social unrest is

rampant in ailing factories and in the countryside. Large-scale demonstrations and rioting by Chinese farmers and jobless workers are so common now that the police have given up trying to arrest the participants and are concentrating on putting the leaders in prisons or forced labour camps.

As Simon Leys, one of the best contemporary China-watchers, puts it, the Communist Party, 'now cynical and completely discredited, is simply turning into a mafia of opportunists who are incompetent in all matters not directly related to their personal advancement.' The possibility for anarchy and chaos is very real. In such an eventuality, windows of opportunity for the realization of Tibetan independence would certainly open up. Of course, we will have to seize such moments decisively and forcefully. The Chinese, no matter how weak or in disarray, are definitely not going to hand Tibet back peacefully or willingly.

At the same time, achieving *Rangzen* does not merely depend on waiting for China to self-destruct. Tibetans could effectively contribute to that process by bringing about destabilization inside Tibet and by organizing international economic action against China. Even on an individual level we can actively contribute by not buying Chinese products.

Right now, Tibet enjoys unprecedented attention and world sympathy that is quite remarkable. The fact that this does not automatically translate into political support for the Tibetan cause is certainly unfortunate. Yet, the opportunity of transforming this international goodwill for Tibet into active support for the Freedom Struggle is more than

a possibility. It does not require great imagination to see that we could badly damage Chinese commercial and diplomatic interests all over the world, just through peaceful activism – if we first clearly defined our objectives and stuck to them. The real battles for national freedom are fought in local and mostly desperate struggles, by people prepared to give up not just respectability and careers, but even their lives. The indomitable struggles of Aung San Suu Kyi and Nelson Mandela inspire freedom-loving people all over the world far more than, let us say, the well-intentioned efforts of diplomats, career activists or even the Secretary General of the UN to ensure what can essentially be described at the preservation of the *status quo*.

What must be done?

1. An active confrontation of Chinese tyranny. We must seek effective ways to challenge this tyranny, both inside Tibet and all over the world, even if that entails Chinese reprisals and retaliations. The struggle within Tibet could be greatly revitalized if we on the outside provided more than just sympathy, and instead joined hands with those inside by sharing funds, ideas, trained personnel and new technology.

2. The deeds and sacrifices of patriots must be adequately acknowledged. We have so far shamelessly failed to repay the sacrifice and deeds of many heroic men and women who put the needs of their country and people above that of their own lives.

3. Democracy must be fundamental to the freedom struggle. Only in a truly

democratic Tibetan society will creativity, fresh thinking, and new leadership not only emerge but also be valued and effective. Though a start has been made with implementing democracy in exile, much more needs to be done.

4. The patron-seeking mentality must be eliminated. Though we certainly need help and support from different nations and people, we must not rely entirely on any one or other of these to become our patrons. It is not a question of not taking help, but of differentiating between necessary aid and pathetic dependency. Furthermore, every nation has its own agenda, which could be in contradiction to or simply not in accord with ours.

5. Tibetan society must become dynamic and progressive. This is certainly not a criticism of Buddhism, which encompasses the most profound philosophical and scientific thought with the humblest of folk beliefs, but merely emphasizes how Tibetans have clung to superstitions and traditions which are not only backward and harmful but against the teachings of the Buddha himself. We must consciously attempt a modernization of our society in the style of the Meiji Restoration in Japan, or the Bengal Renaissance.

6. Tibetan politics must be secularized. Though Tibet must and will always remain a Buddhist nation, the function of the government must in effect be secular, and limit itself to the realm of politics with the defence of the nation's sovereignty, and the security and the welfare of the people as its first priority.

7. National policy must be formulated realistically. As Buddhists, we Tibetans must renounce violence except as an instrument of national defence or a means to ensure the very survival of the Tibetan people. The great 13th Dalai Lama's statement at the conclusion of his Political Testament should be our guide: 'Use peaceful means when they are appropriate; but where they are not appropriate, do not hesitate to resort to more forceful means.'

8. Tibetan sovereignty is sacred, irrevocable and paramount. Tibetan freedom is not a bargaining chip, an expedient or a strategy. It is our sacred goal. Too often in our history we have given up our long-term, even fundamental, interests for temporary expediency. This was the case for instance with the '17 Point Agreement'. In 1951, the Americans were ready to recognize Tibetan independence if the Tibetan Government were to renounce the 17 Point Agreement. We can indeed live as good friends with the Chinese, but only after we have regained the freedom and independence of our country. The paramount need of the moment is for the Tibetan people not to compromise their principles on the issue of independence, even in the face of obstacles and persecution. In order for Tibetans to preserve their identity, culture and religion, the hope of a free Tibet must always be preserved.

As the Chinese writer, Lu Xun, said: 'Hope can be neither affirmed nor denied. Hope is like a path in the countryside: originally there was no path – yet, as people walk in the same spot again and again, a way appears.'

The Future of Tibet
by His Holiness the 14th Dalai Lama

The situation in Tibet, already very grave, is getting steadily worse, whether we look at our culture in general or Buddhism in particular. Moreover, the environment is being seriously damaged and human rights are being constantly abused. In short, Tibet is a victim of cultural genocide. Despite that, the spiritual strength of the Tibetan people does not weaken and they demonstrate a remarkable determination to preserve their culture in defiance of the circumstances.

If one considers only what is happening in Tibet itself one is bound to feel deep despair. Yet, fundamentally, I remain optimistic. Things change, and the People's Republic of China is no exception to that rule. Comparing the present situation to what it was like fifteen or twenty years ago, one notices some striking differences, especially among the intellectuals who are sympathetic to my efforts to find a solution acceptable to both parties involved, and who support my approach.

An increasing number of Chinese intellectuals are showing an awareness of the situation in Tibet. No human being, witnessing injustice and suffering, can help feeling concerned and showing sympathy.

The principal preoccupations of the Chinese are economic development, stability and national unity. Yet neither force nor oppression can lead to real stability. The Chinese continue to impose very severe restrictions in Tibet and apply a policy of intense repression. This attitude encourages only negative feelings.

So I believe that the 'middle' way that I have chosen is the only one that can guarantee the country's stability and unity. We wish for an entente cordiale with China. For her part, China must guarantee the free expression of our culture and reparations for the damage done to it. The Chinese never stop saying that everything is going well in Tibet, and that the Tibetans are perfectly happy there. Only a few exiles, they claim, are doing their best to create problems abroad. But if the Tibetans were as happy as that in Tibet, what reason would I have to deny their claims? On the contrary, I would have every cause to rejoice.

As things stand, exile is an advantage, because it makes us free to pursue our ideals. It is forty years since we chose exile in order to be able to give concrete expression to our deepest aspirations and preserve the practice of Buddhism and of Tibetan culture. We have succeeded in safeguarding these in all their authenticity and we have continued to make education our priority.

Since the Chinese are our human brothers and sisters, we have every reason to be concerned about their fate. That is what compassion is. It does not depend on the attitude of the person for whom we feel it. Being concerned about the fate of someone because he is well disposed towards us is not compassion. Even if he is hostile, another

person is a human being like me who dreads suffering and naturally aspires to happiness, and he has every right to flee from suffering and to look for happiness. It is thinking like this that leads us to feel concerned about the happiness of another person. That is the basis of true compassion.

Compassion goes hand in hand with the notion of interdependence, that is, the idea that one thing cannot exist except in relation to another. Everything that happens in our lives results from a large number of causes and conditions. No change, no event can produce itself without a cause, or come about as the result of one single cause. Therefore it is clear that our happiness and our suffering are intimately linked to the happiness and the suffering of others. The well-being of humanity is linked to the environment, the happiness of the individual to his state of mind. These complex relationships must be taken into account before we can see what should be done and what should not. The need to receive and give love and tenderness proves our interdependence. If our happiness did not depend on other people, if it could exist on its own, love would have no reason to exist.

The reasons why I continue to maintain a non-violent position, even though some people recommend a more violent form of resistance against China, are spiritual in nature but they are also practical. From a conceptual point of view, I think that love is an integral part of real human nature. Resolving a conflict with reason rather than force gives the sense of acting justly and produces profound satisfaction. The use of violence is bound to engender long-term resentment in the other person – unless he is exceptionally wise – and that resentment will be the source of new conflicts. It is hard to impose a change on anyone without first changing his state of mind. It is by presenting valid arguments in a spirit of good will that one is able to change someone's attitude, not by force.

The history of mankind demonstrates that the use of violence has always led to new acts of violence. Violence is like a too-powerful drug which conquers illness but destroys the patient's health with its side effects. By contrast, non-violence is in profound harmony with our nature.

Whether we like it or not, China and Tibet have always been neighbours and always will be. It is essential therefore for our two countries to think of each other as close friends and to help each other. Chinese and Tibetans should reflect on the advantages that they could both gain from this. We Tibetans have suffered a great deal already. What would be the point of making our problems worse by using violence? The most important thing is good will. That is my view of things.

Excerpt from an interview given
in Dharamsala, India, 1998

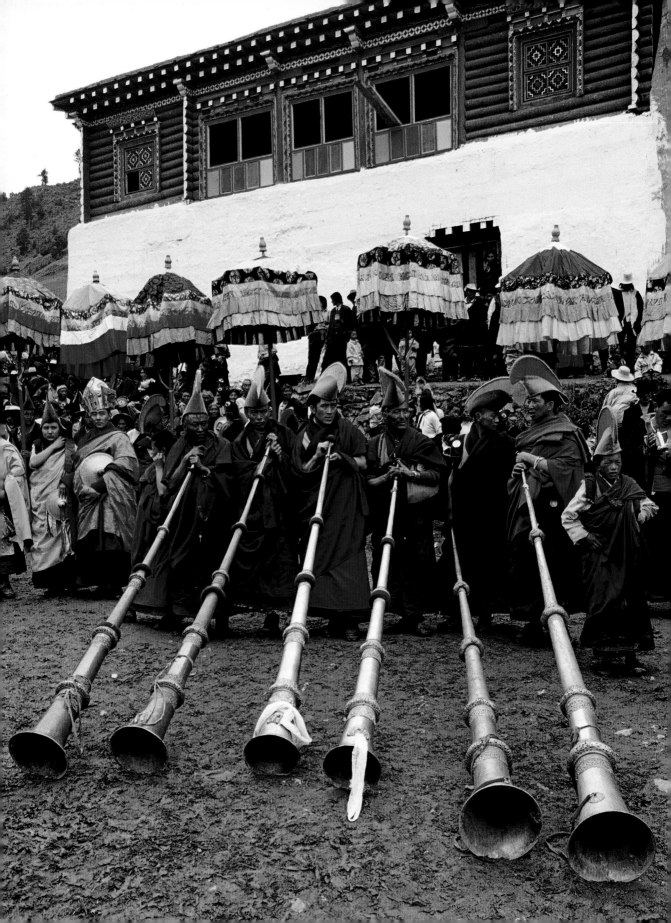

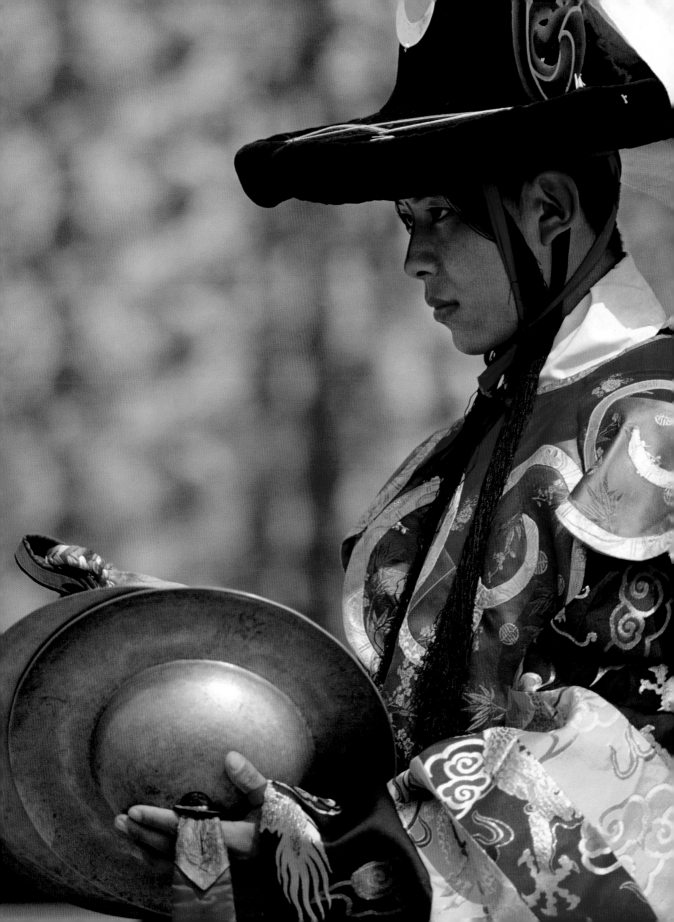

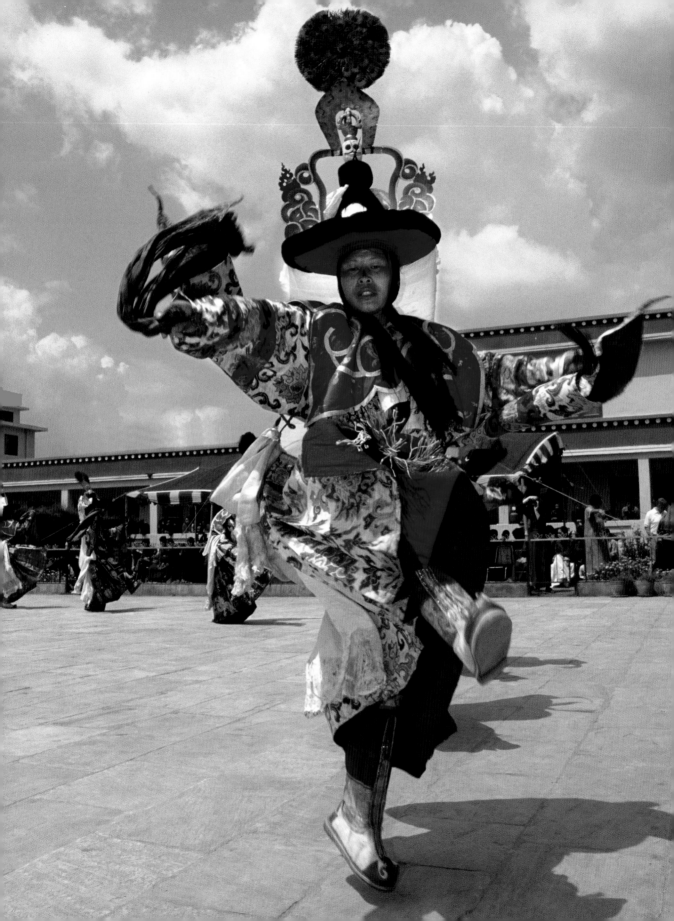

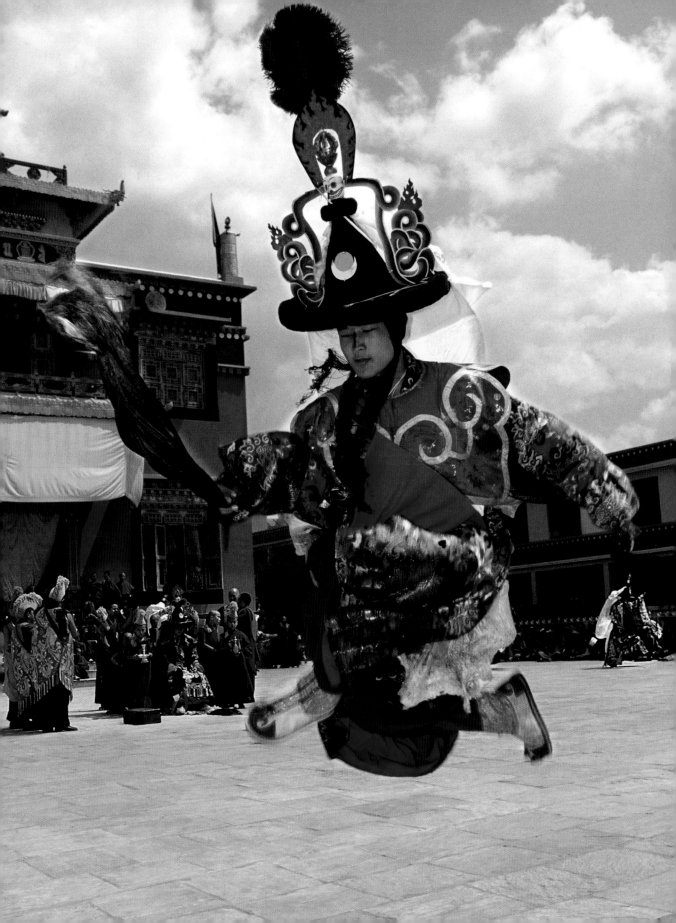

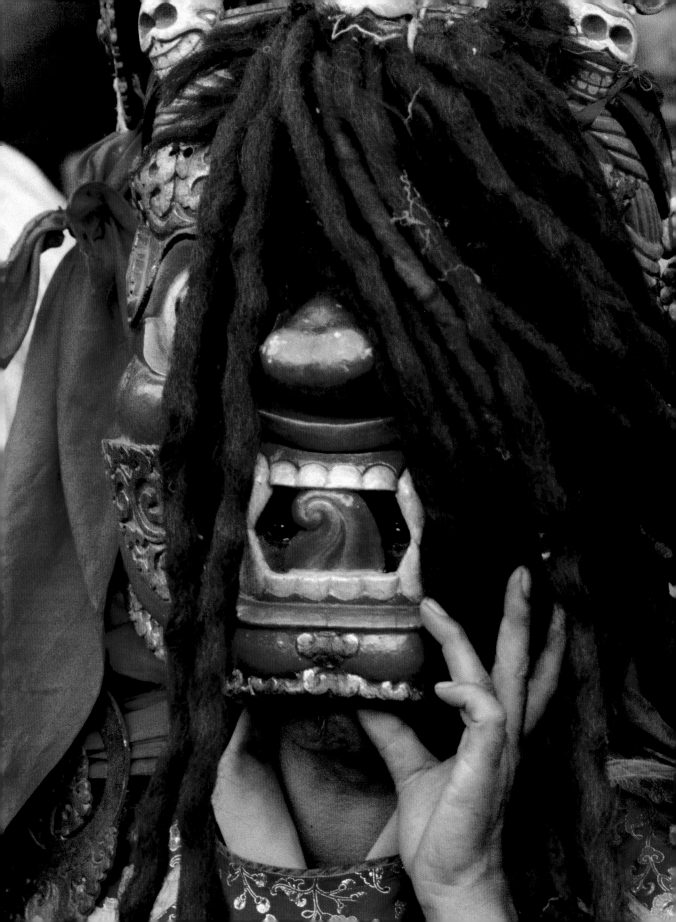

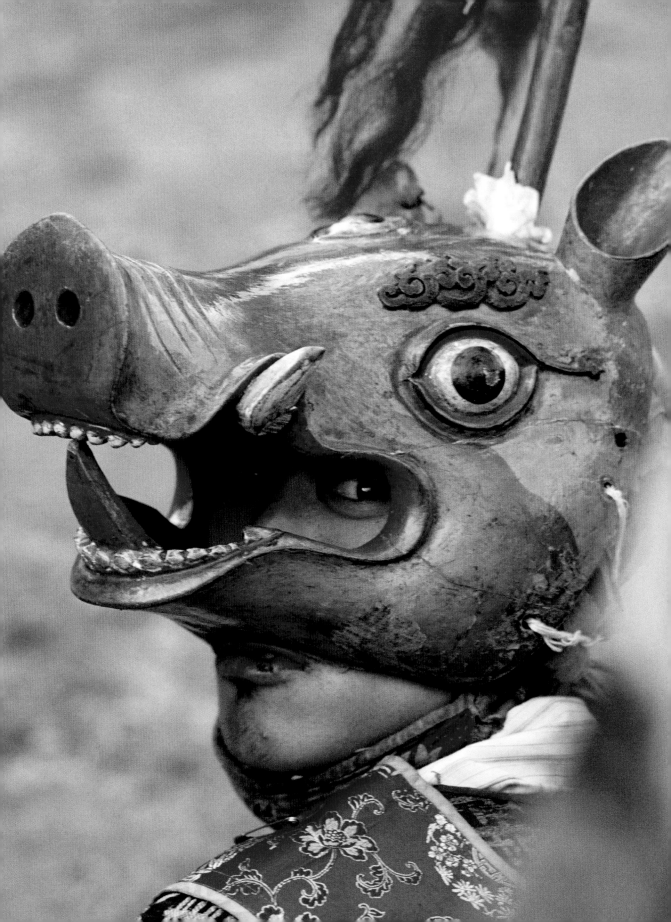

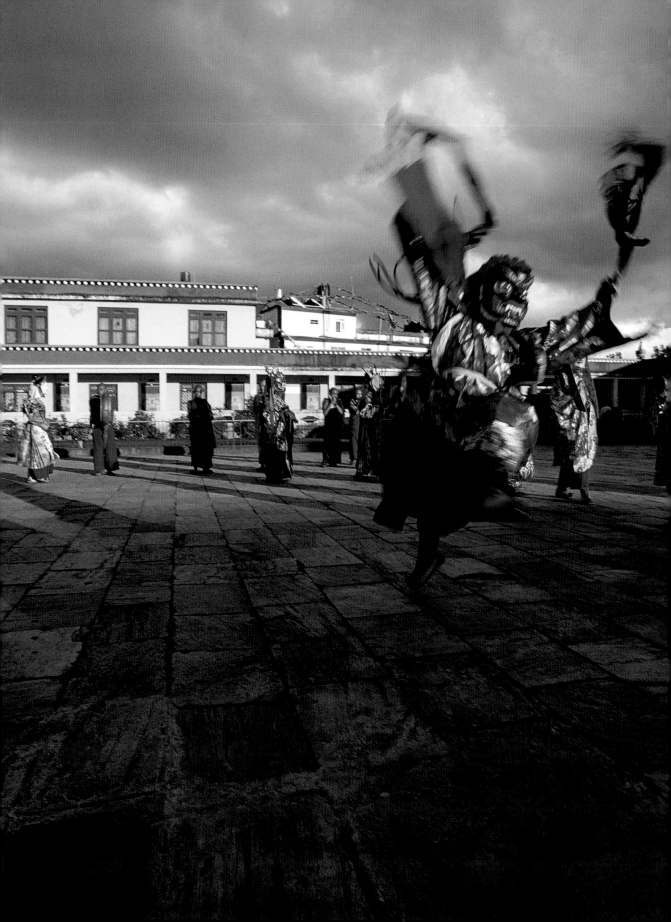

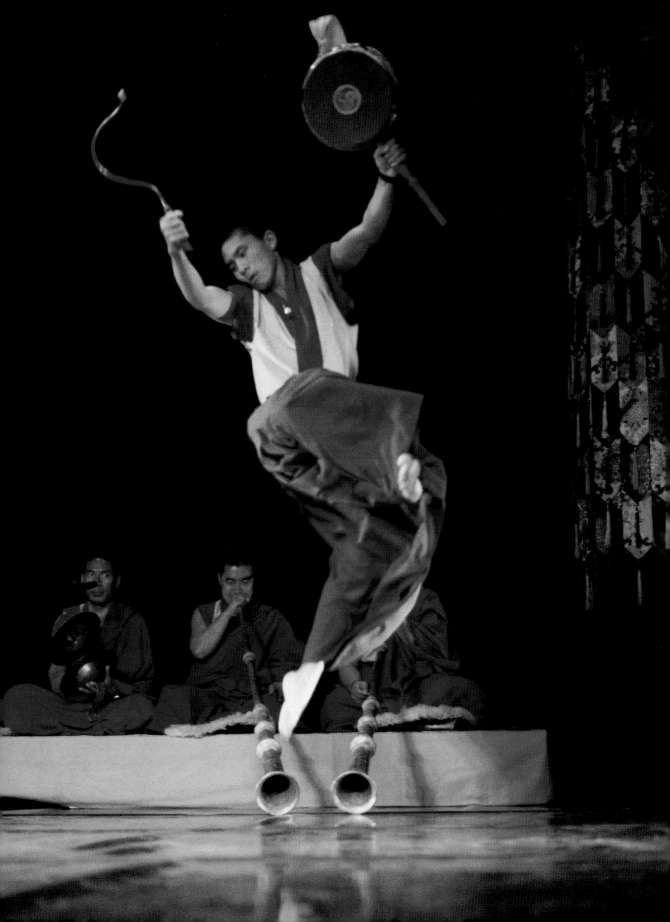

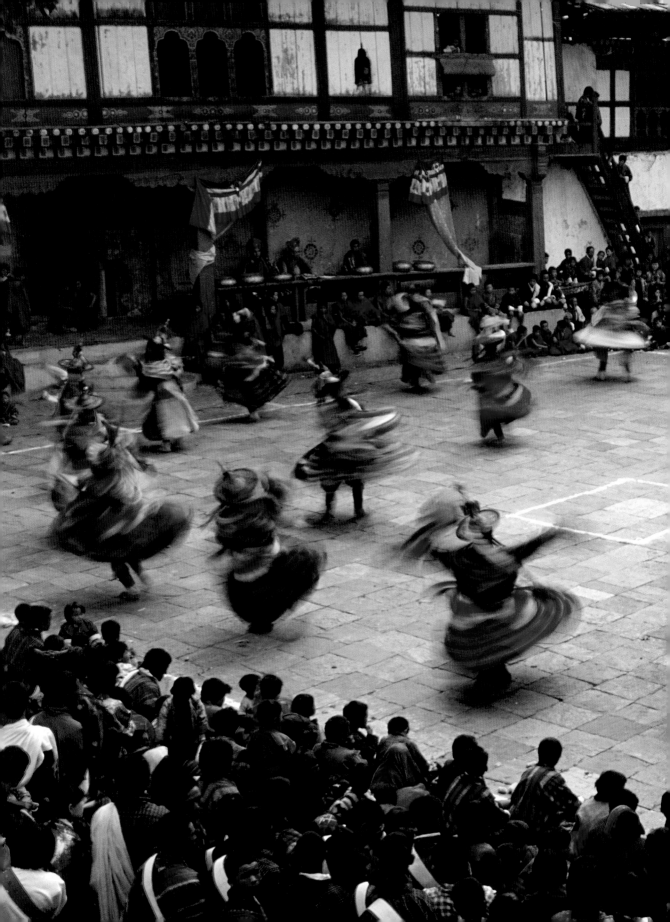

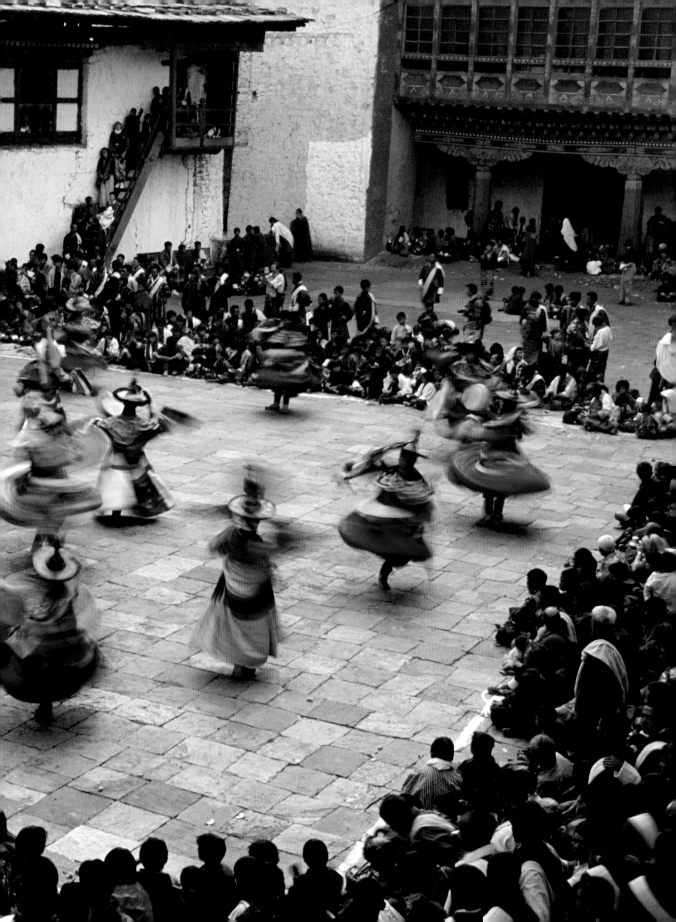

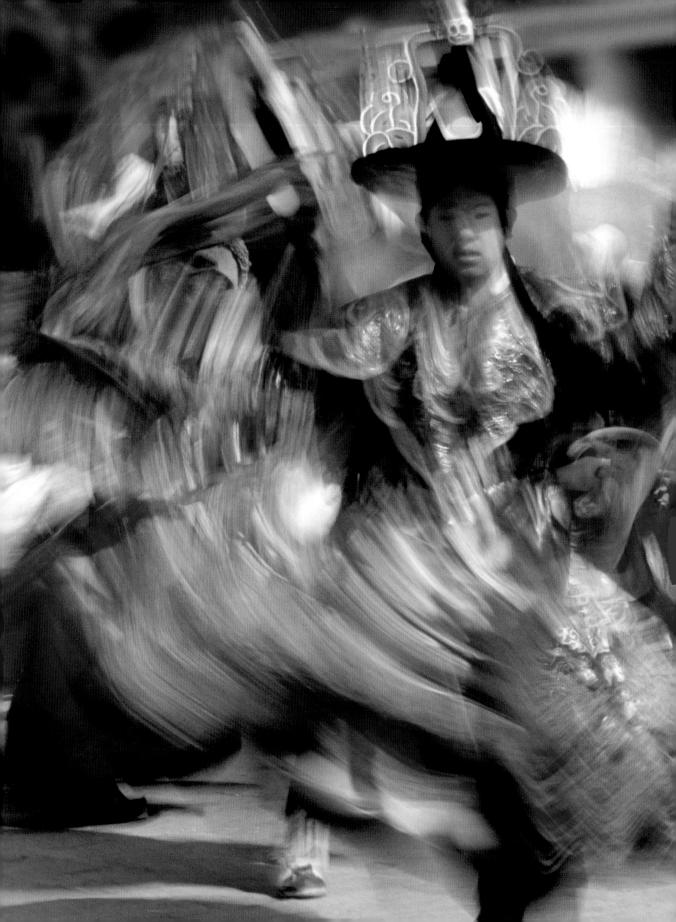

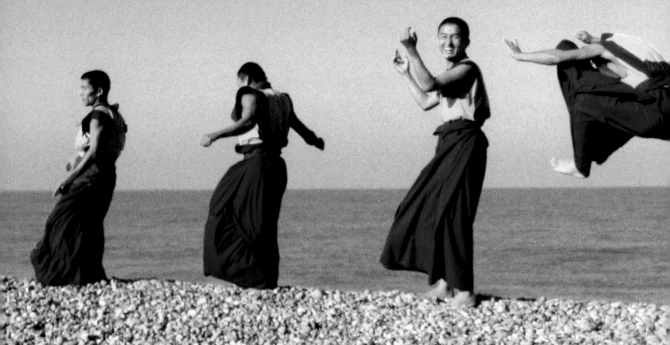

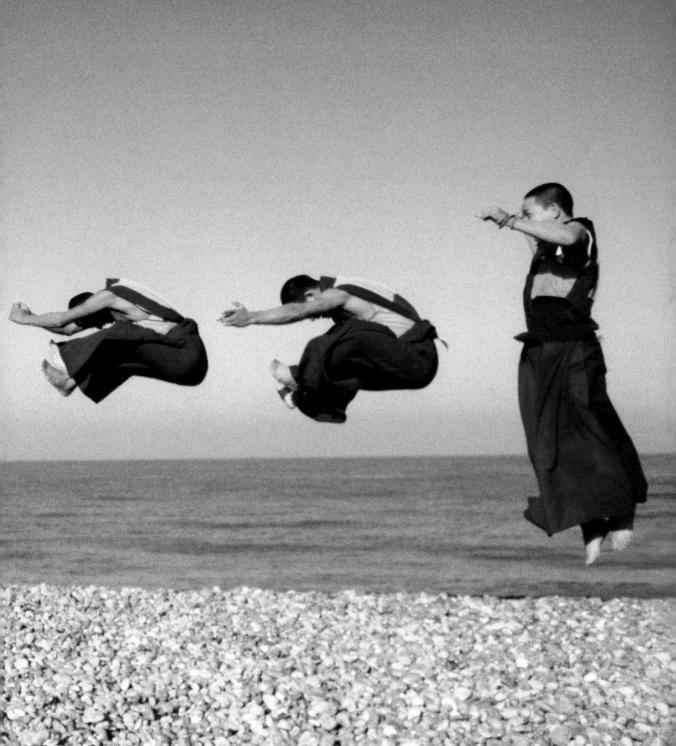

Towards a Century of Dialogue
by His Holiness the 14th Dalai Lama

Among the six billion or so inhabitants of this earth, there are many who call themselves Christians, Jews, Muslims, Buddhists or something else, simply because it is their parents' religion. In reality, those who practice a religion from the bottom of their hearts are rare. It seems likely that a majority do not really accord any real importance to religion, but we ought to respect their point of view. Wanting all the world to be believers would be in vain.

At the same time, there are all sorts of religions, each with their own practices and metaphysical views. Some wish that there was only one – their own, of course – but their attitude is unrealistic. We all have different natures and aspirations, and religions only reflect this diversity. It is inevitable, even, that it should be so. Personally, I am a Buddhist monk, I have faith in Buddhism because I have studied and practised it, and I naturally think that Buddhism is the path that suits me best. But how could I dare to claim that it is the best path for everybody? Inflexibility and narrow-mindedness never engender anything good. The rejection of other religions leads to intolerance and fanaticism, even to violence and persecution. We see tragic examples of this every day.

One of the causes that leads us towards these excesses is, in my opinion, our superficial attitude. Too often we are content to say: 'I believe in this or that religion.' But believing in a religion is not enough to fathom all its depths. The important thing is to go through a true and profound inner experience. When one truly practises a spiritual path and harvests the fruit of it, then one sees clearly how other paths, too, can bring great benefits.

Intolerance is also due to the fact that, all too often, representatives of the different religious faiths know little or nothing about other traditions. Each remains in his corner, without any wish for dialogue. However, inter-religious meetings and better knowledge of different spiritual paths would put an end to narrow points of view.

These days there is said to be a great enthusiasm for Buddhism, especially in its Tibetan form. Some people are only attracted by its novelty or exoticism. They say to themselves: 'This is something different, strange, exciting.' But it goes without saying that a simple search for novelty does not produce any lasting outcome.

Others take a serious interest in the content of Buddhism, its philosophy, ethics and meditation techniques. They study and practise these in order to transform themselves inwardly. More and more of them rejoice in finding in Tibetan Buddhism many ways of assuaging negative emotions such as greed or hatred, and developing love and compassion. I think that these people will stay with their newfound beliefs and will certainly benefit from them.

It is obvious, of course, that people should satisfy their deepest aspirations and adopt the path best suited to their own natures. I also believe that we can find elements in other religions that inspire or allow us to deepen our own faith. Christian brothers and sisters have told me that they have found Buddhist contemplative practices a useful means of putting Christ's teaching into better practice. In a similar way, I am convinced that Buddhists have much to learn from Christians, particularly in the realm of service to others.

Despite everything, it is wiser, in general, to follow the spiritual path and customs of one's own country, those practised by one's ancestors and with which one grew up. This is why I am always apprehensive about talking about Buddhism in the West. I am afraid that it may incite some people to change their religion too hastily.

Be that as it may, the essential thing for any human being is to lead a happy and meaningful life. For a life to have meaning, it must contribute to the happiness of others. Wanting to be happy in isolation while others suffer is meaningless. Human society is characterized by our dependence on one another. When a person is rich, for example, how can they feel fulfilled if those around them are destitute? Doing as much as possible for other people is a way to realize one's own happiness.

I often call the 20th century 'the century of violence'. This violence has had one benefit at least: it has forced mankind to mature. Nowadays, we talk more often of compassion and non-violence. If we make a real effort, the 21st century could be the century of dialogue. This is my dearest wish.

Excerpt from a moral teaching
given in France, 2000

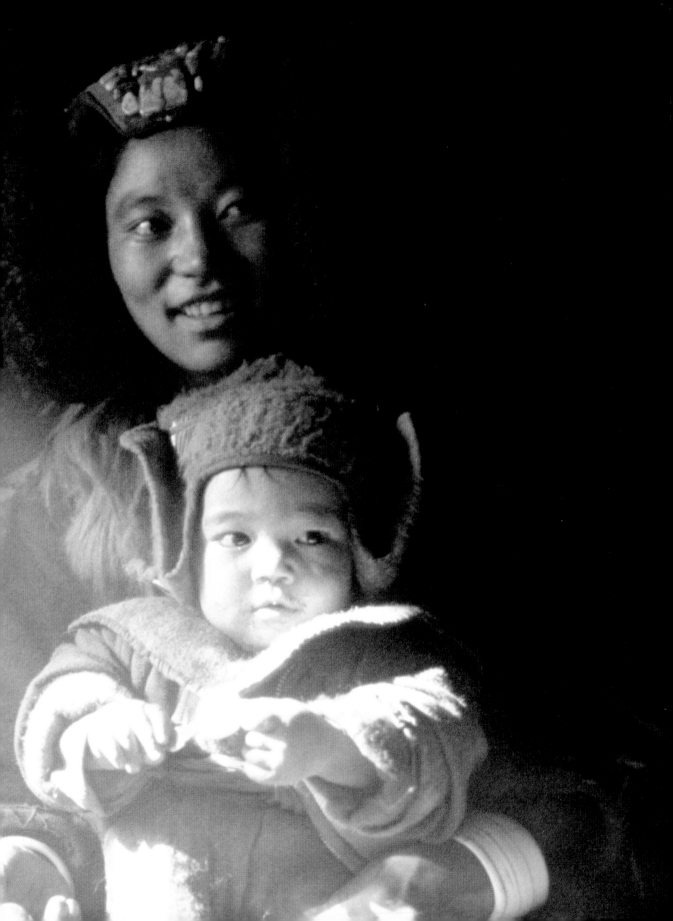

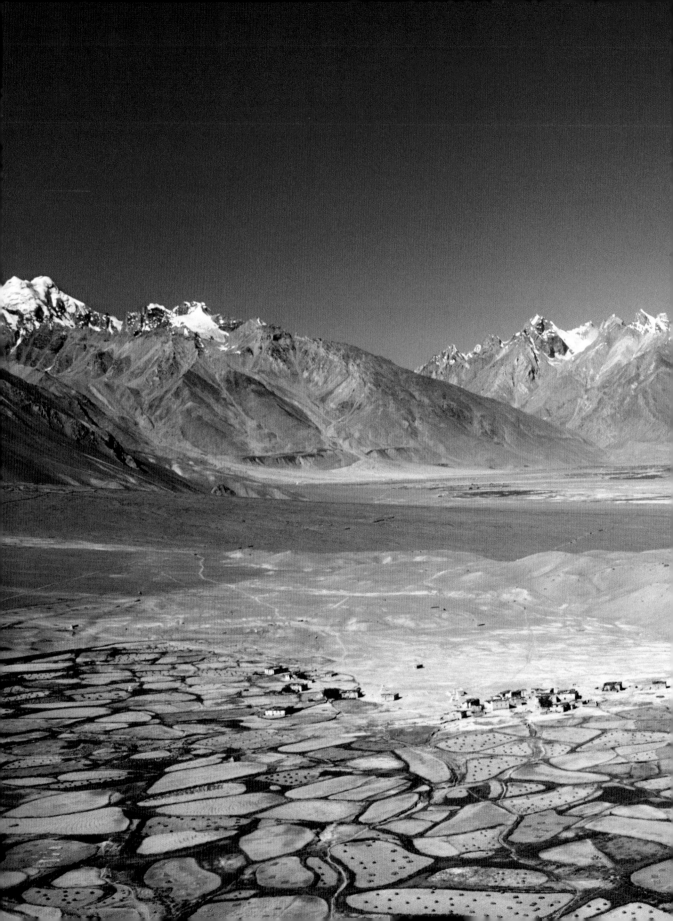

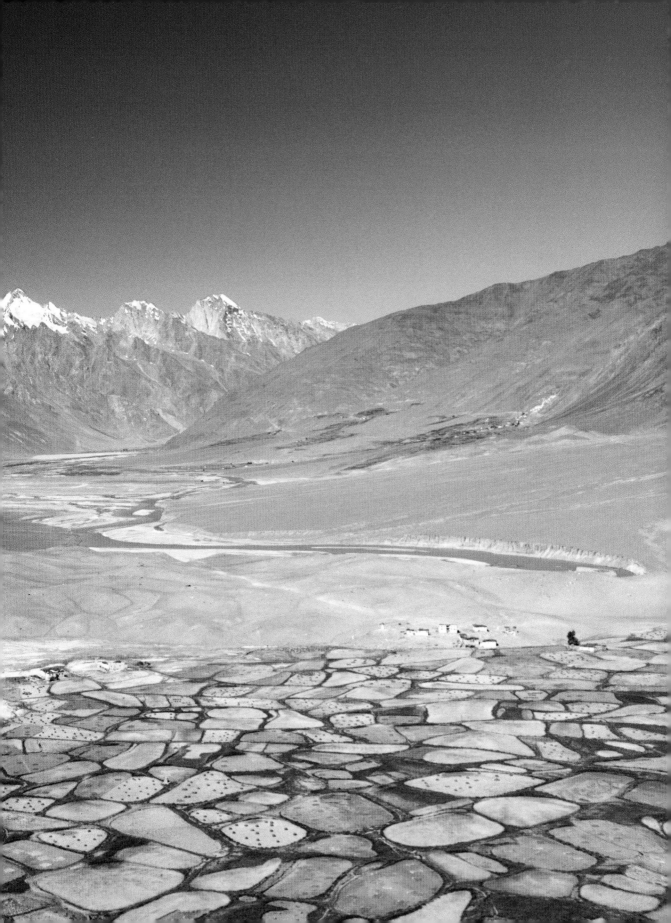

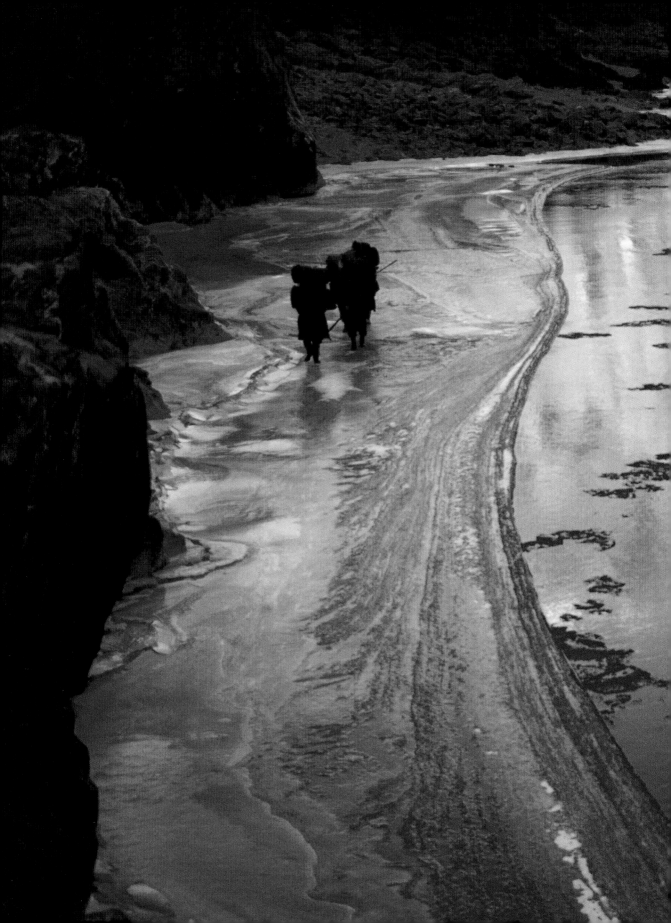

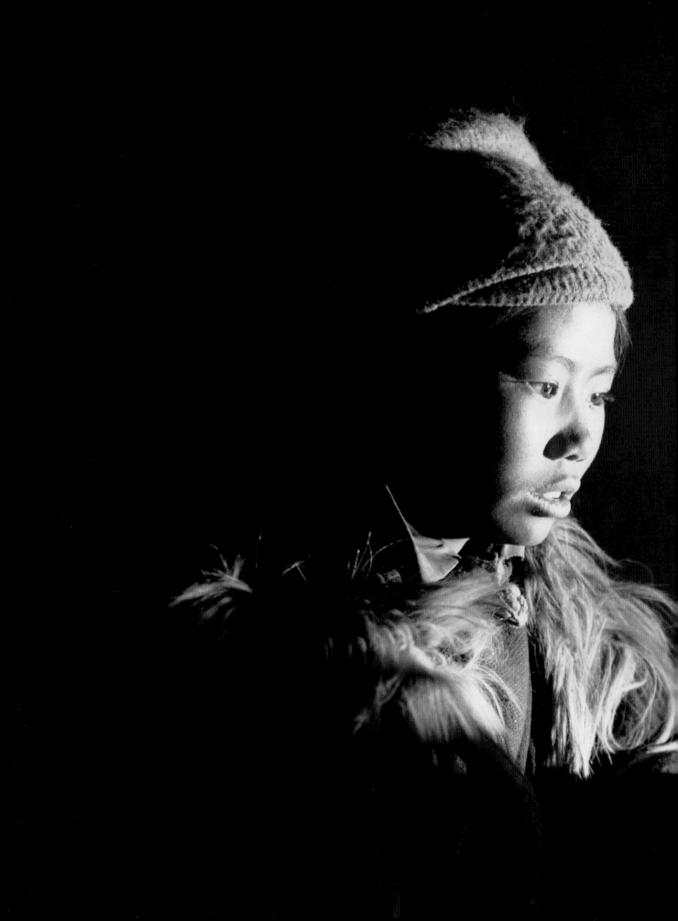

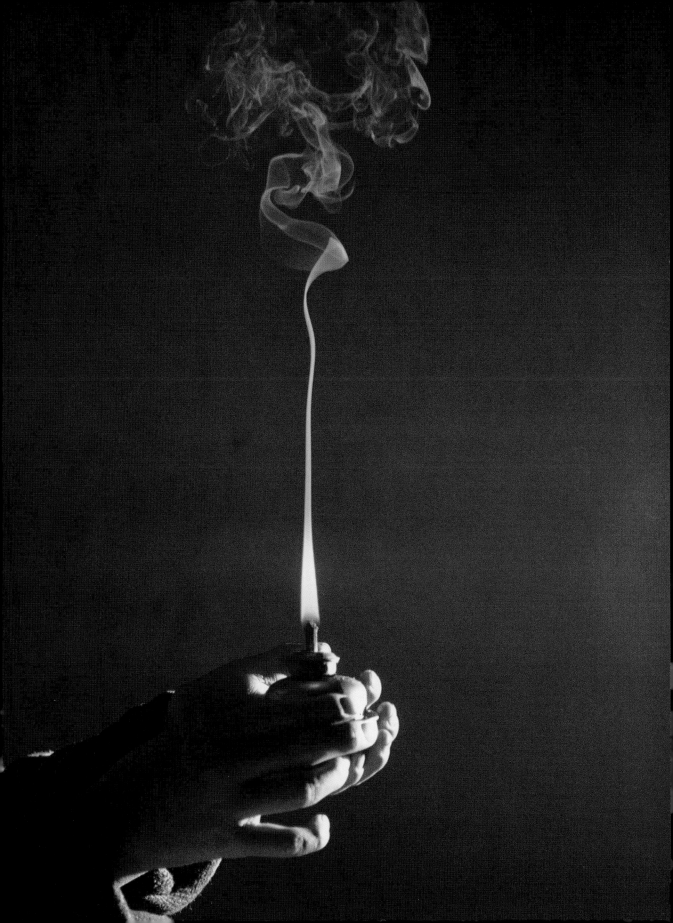

'As long as space endures,
And as long as there are living beings,
May I too remain
To dispel the misery of the world.'

Shantideva's prayer

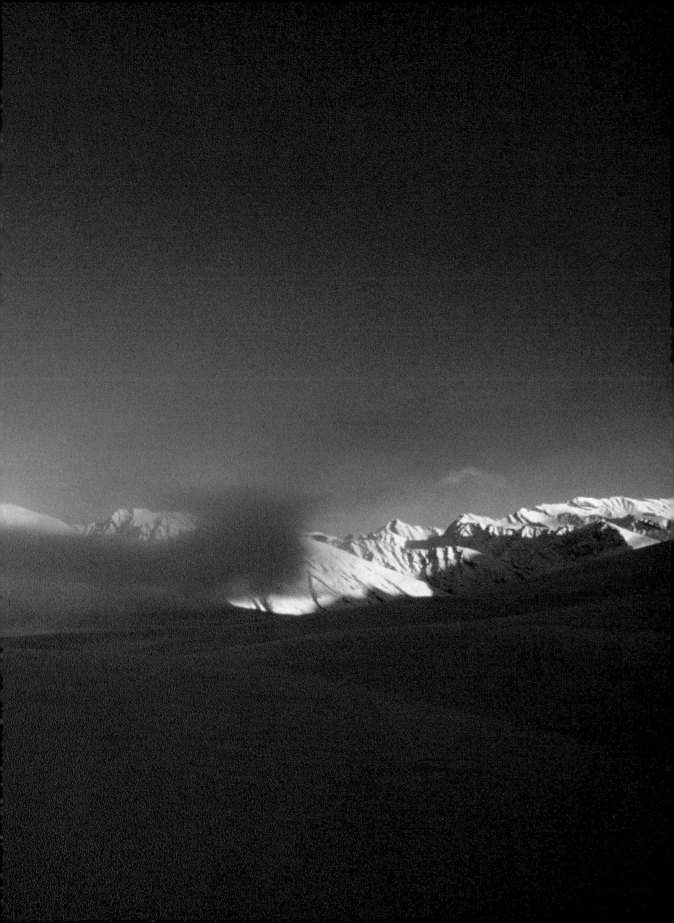

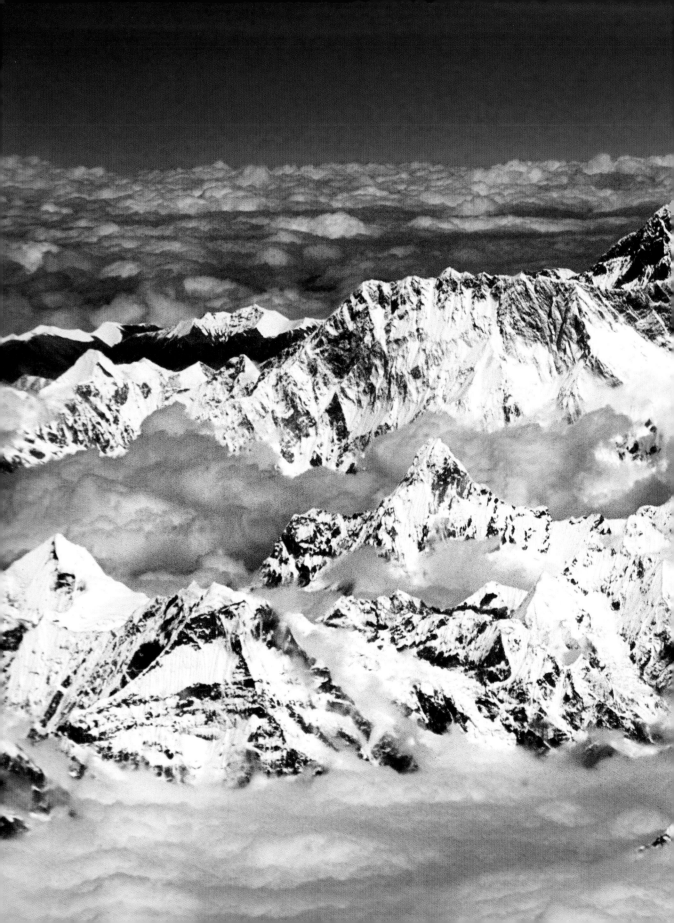

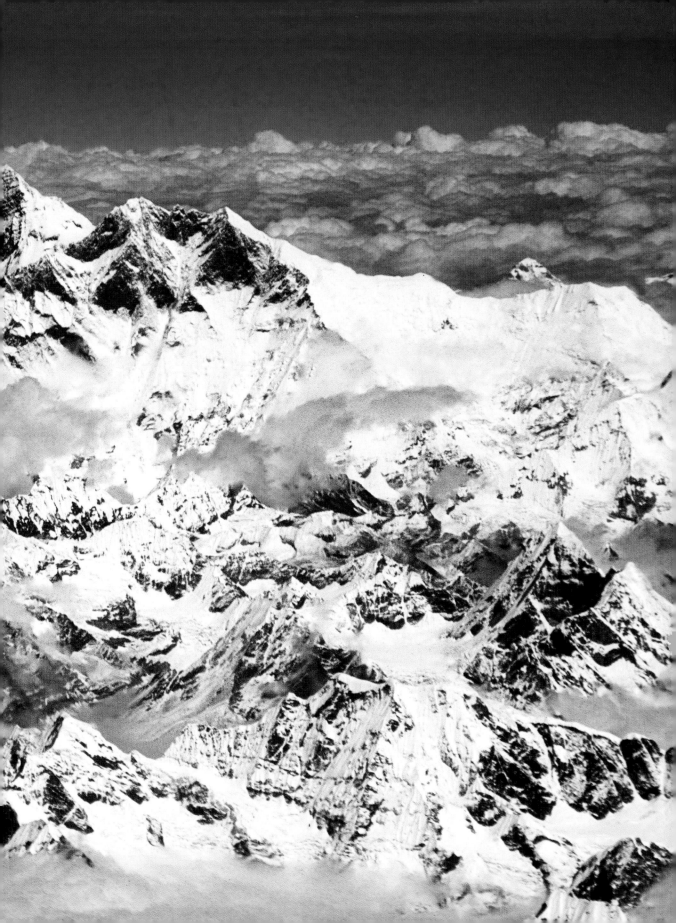

About the Authors

His Holiness the 14th Dalai Lama Tenzin Gyatso, spiritual and temporal leader of the Tibetan people, was born on 6 July 1935 in Taktser, a small village in north-eastern Tibet, to a peasant family. At the age of two, His Holiness was recognized as the reincarnation of his predecessor, the 13th Dalai Lama, the Buddha of Compassion, Avalokitesvara. His enthronement took place on 22 February 1940 in Lhasa. The Tibetans call His Holiness by the name of Yeshin Norbu, or Kundun, 'Presence'. On being awarded the Nobel Prize for Peace in 1989, His Holiness reaffirmed 'our conviction that with truth, courage, and determination as our weapons, Tibet will be liberated,' and that 'our struggle must remain non-violent and free of hatred.'

Monisha Ahmed received a doctorate in social anthropology from Oxford University for her thesis on traditional weaving in Ladakh. She is co-founder of the Ladakh Arts and Multicultural Outreach Trust and works with the artists and craftswomen of Ladakh.

Matthew Akester is an independent researcher, specializing in the history, geography and monuments of central Tibet.

A former student of Sogyal Rinpoche, **Philippe Cornu** teaches at INALCO (National Institute of Oriental Languages and Civilizations) in Paris. He specializes in Buddhism and has translated many traditional Tibetan and Chinese texts into French, and is also the author of *Dictionnaire encyclopédique du Bouddhisme*. He gives regular lectures on the teachings of Sogyal Rinpoche and takes part in the work of the Buddhist teaching centre RIGPA Nice.

Jigme Douche is a calligrapher and graphic artist who specializes in the writing of central Asia and is an authority on Tibetan calligraphy. Since 1980, his discovery of Tibetan culture has led him to study both the theory and practice of this disappearing script. He is currently working on Tibetan calligraphy as an art of Dharma, and on keeping this artform alive.

Olivier and Danielle Föllmi, together with their four children of Tibetan origin, divide their lives between the Alps and the Himalayas. Olivier has been photographing the Himalayas for twenty-five years, and his images have been seen all over the world and have won prizes including the World Press award. An emergency doctor and anaesthetist, Danielle has set up health and nutrition programmes in Tibetan schools. With the aim of combining tradition and progress, they founded HOPE, an educational charity for the Himalayas. They have produced fourteen books and are keen to raise international awareness of Tibetan cultural heritage. www.follmi.com

Mireille Helffer is an honorary director of the CNRS and a curator at the Musée Guimet, Paris. A specialist in ethnomusicology and the music of the Himalayas, she has travelled widely in Nepal, Ladakh and among Tibetan communities in exile. She has published works on the songs of the Gesar saga and on musical instruments, as well as the liturgical music of Tibetan Buddhist monasteries. She is currently studying the musical traditions of the Shechen Monastery.

David P. Jackson is a professor at the University of Hamburg. An authority on Tibet, he has written several works on Tibetan painting.

Jamyang Norbu is one of the best contemporary Tibetan writers, known for essays on Tibetan culture and politics. His novel *The Mandala of Sherlock Holmes* won the Crossword Book Award. An ethnomusicologist and director of the Tibetan Institute of Performing Arts, Norbu lectures on Tibetan culture and the struggle for Tibetan independence. He is a founder member of the Mustang resistance movement, from the Tibet–Nepal border.

Corneille Jest is an anthropologist and honorary research director at CNRS. He studies the lifestyle and economy of the peoples of the Tibetan region and the Himalayas, and works to preserve the architectural heritage of those areas.

Jetsun Pema is former Minister for Education in the Tibetan government-in-exile and the younger sister of the Dalai Lama. She devotes her life to the care of around 25,000 children at the Tibetan Children's Village (TCV), a foundation she has headed since 1964. In 1994, the Kashag, the ministerial council of the Tibetan government, gave her the honorary title 'Mother of Tibet', to show the gratitude of the people towards one who has done so much to protect Tibetan culture and religion in exile.

Claude B. Levenson is a translator and journalist with a background in Oriental Studies. Since 1984 she has published many articles on the Tibetan cause, translations of the teachings of the Dalai Lama, and a dozen books on Tibet, including a biography of the 14th Dalai Lama.

A doctor and Tibetan scholar, **Fernand Meyer** is director of studies at the Ecole Pratique des Hautes Etudes, Paris. He is the former clinical chief of the hospitals of Paris and research director at CNRS (on the environment, society and culture of the Himalayas), and his publications include *Le système médical tibétain*. Dr Meyer is an authority on Tibetan medicine from a Western viewpoint.

Following many years of campaigning for Greenpeace, **Clara Osel** has spent over twenty years living with Tibetan lamas in the Himalayas, primarily in Nepal. A talented photographer, she also works on humanitarian projects in Tibet.

An anthropologist and historian, **Françoise Pommaret** is a CNRS researcher. She is considered an authority on Bhutan, where she has worked for twenty-two years as both a researcher and consultant. She is currently in charge of the Education Bhutan project, financed by the French Ministry for Foreign Affairs.

On his first trip to India in 1967, **Matthieu Ricard** met some remarkable Tibetan spiritual masters. After finishing his thesis in cellular genetics in 1972, he settled in the Himalayas where he became a monk. He currently lives in the Shechen Monastery, and is the French interpreter for the Dalai Lama. He has spent thirty years photographing spiritual masters, monastery life, and the art and landscapes of Tibet, Bhutan and Nepal.

Janet Rizvi has a doctorate in history from Cambridge University and is a writer and researcher. She is a specialist in the western Himalayas and particularly Ladakh, where she has lived for two years.

Mountain photographer and adventurer **Galen Rowell** set up the photo agency Mountain Light, Inc. together with his wife. Taken all over the world, his pictures have been exhibited in many prestigious galleries. He has led expeditions to several Himalayan peaks and his published works include *My Tibet*, with His Holiness the Dalai Lama.

E. Gene Smith studied under a Tibetan lama, then moved to India in 1968, where he joined the Library of Congress field office. A travelling archivist, he is passionate about conservation and has saved a rare and endangered collection of original writings by the Buddha, twelve centuries of Tibetan Buddhist masters, and early commentaries by Indian Buddhists. Considered by many as the most learned contemporary scholar of Tibet, in 1997 he co-founded the Tibetan Buddhist Resource Center in Cambridge, Mass.

Bibliography

Arpi, Claude, *The Fate of Tibet: When Big Insects Eat Small Insects*, New Delhi, 1999

Cabezón, José Ignacio and Jackson, Roger R., *Tibetan Literature, Studies in Genre*, Ithaca, NY, 1996

Cornu, Philippe, *Tibetan Astrology*, trans. Hamish Gregor, Boston, 1997

Cornu, Philippe, *Dictionnaire encyclopédique du Bouddhisme*, Paris, 2001

Cornu, Philippe, *Guide du bouddhisme tibétain*, Paris, 1998

Cornu, Philippe and Longchenpa, *La liberté naturelle de l'esprit*, Paris, 1994

Cornu, Philippe, *Padmasambhava, la magie de l'Éveil*, Paris, 1997

Cornu, Philippe, *Tibet. Culture et histoire d'un peuple*, Paris, 1998

Crook, John and Osmaston, Henry (eds), *Himalayan Buddhist Villages: Environment, Resources, Society and Religious Life in Zangskar, Ladakh*, New Delhi and Bristol, 1994

Dalai Lama, *Ethics for the New Millennium*, New York, 1999

Dalai Lama, *Freedom in Exile: the Autobiography of the Dalai Lama*, New York, 1990

Dalai Lama and Cutler, Howard C., *The Art of Happiness: a Handbook for Living*, London, 1998

Dalai Lama and Rowell, Galen, *My Tibet*, London and Berkeley, 1990

Dilgo Khyentse Rinpoche, *The Heart Treasure of the Enlightened Ones*, Boston, 1993

Dilgo Khyentse Rinpoche, *One Hundred Pieces of Advice*, New Delhi, 2002

Dilgo Khyentse Rinpoche, *The Wish-Fulfilling Jewel*, Boston, 1998

Douche, Jigme and Ricard, Matthieu, *Rainbows Appear: Tibetan Poems of Shabkar*, Boston, 2002

Dussaussoy, Dominique, *Le fou divin: Drukpa Kunley, yogi tantrique tibétain du XVIe siècle*, Paris, 1982

Föllmi, Olivier, *Les bergers de l'hiver*, Paris, 1999

Föllmi, Olivier and Douche, Jigme, *L'horizon des dieux*, Paris, 1998

Föllmi, Olivier, *Homage to Tibet*, London, 1996

Föllmi, Olivier, *Bhoutan. Le temps d'un royaume*, Paris, 1993

Föllmi, Olivier, *Le fleuve gelé*, Paris, 1996

Föllmi, Olivier, *Where Heaven and Mountains Meet: Zanskar and the Himalayas*, London, 1999

Goepper, Roger and Poncar, Jaroslav, *Alchi: Ladakh's Hidden Buddhist Sanctuary. The Sumtsek*, London and Boston, 1996

Helffer, Mireille, *Les chants dans l'épopée tibétaine de Ge-sar, d'après le Livre de la course de cheval*, Geneva and Paris, 1977

Helffer, Mireille, *Mchod-rol, les instruments de la musique tibétaine*, Paris, 1994

Jackson, David Paul, *A History of Tibetan Painting: the Great Tibetan Painters and their Traditions*, Vienna, 1996

Jackson, David Paul and Jackson, Janice A., *Tibetan Thangka Painting: Methods & Materials*, London, 1994

Jest, Corneille, *Dolpo: communautés de langue tibétaine du Népal*, Paris, 1975

Jest, Corneille, *Tarap, une vallée dans l'Himalaya*, Paris, 1974

Jest, Corneille, *Tales of the Turquoise: a Pilgrimage in Dolpo*, trans. Margaret Stein, Ithaca, NY, 1998

Jetsun Pema with Van Grasdorff, Gilles, *Tibet, My Story: An Autobiography*, Shaftesbury, Dorset, 1997

Kossak, Steven M. and Singer, Jane Casey, *Sacred Visions: Early Paintings from Central Tibet*, New York, 1998

Levenson, Claude B. and the Dalai Lama, *Ainsi Parle le Dalaï-Lama*, Paris, 1994

Levenson, Claude B., *Le chemin de Lhassa, voyages au Tibet*, Paris, 1985

Levenson, Claude B., *La Chine envahit le Tibet: 1949–1959*, Brussels, 1995

Levenson, Claude B., *La messagère du Tibet. Le retour du Panchen-Lama*, Arles, 2000

Levenson, Claude B., Hamani, Laziz and the Dalai Lama, *Symbols of Tibetan Buddhism*, trans. Nissim Marshall, Paris, 1996

Levenson, Claude B. and Ginet, Pierre-Yves, *Tibet. Un peuple en sursis*, Arles, 2000

Meyer, Fernand, *Gso-ba rig-pa: le système médical tibétain*, Paris, 2002

Midal, Fabrice, *Les mythes et dieux tibétains*, Paris, 2001

Moorcroft, William and Trebeck, George, *Travels in the Himalayan Provinces of Hindustan and the Punjab*, 1st ed. London 1841, new ed. Karachi, New York and Oxford, 1979

Nakao, Sasuke and Nishioka, Keiji, *Flowers of Bhutan*, Tokyo, 1984

Norberg-Hodge, Helena, *Ancient Futures: Learning from Ladakh*, San Francisco, 1991

Norbu, Jamyang, *The Mandala of Sherlock Holmes*, London, 2000

Patrul Rinpoche, *Words of My Perfect Teacher*, London and San Francisco, 1994

Pommaret, Françoise (ed.), *Lhasa, lieu du divin. La capitale des dalaï-lama*, Geneva, 1997

Pommaret-Imaeda, Françoise, *Bhutan*, trans. Elisabeth B. Booz, Hong Kong, 1994

Pommaret-Imaeda, Françoise, *Forteresse bouddhique de l'Himalaya*, Geneva, 2002

Pommaret-Imaeda, Françoise and Schicklgruber, Christian, *Bhutan: Mountain Fortress of the Gods*, London and Vienna, 1997

Radhu, Abdul Wahid, *Islam in Tibet: Tibetan Caravans*, trans. Jane Casewit, Louisville, KY, 1997

Rhie, Marylin M. and Thurman, Robert A. F., *Wisdom and Compassion*, London and New York, 1991

Ricard, Matthieu, *The Spirit of Tibet: the Life and World of Khyentse Rinpoche, Spiritual Teacher*, New York, 2001

Ricard, Matthieu (trans.), *The Life of Shabkar: the Autobiography of a Tibetan Yogin*, Ithaca, 2001

Ricard, Matthieu, *Dancing Monks of Tibet*, Boston, 2003

Ricard, Matthieu and Revel, Jean-François, *The Monk and the Philosopher. East meets West in a Father–Son Dialogue*, trans. John Canti, London, 1998

Ricard, Matthieu and Trinh Xuan Thuan, *The Quantum and the Lotus: a Journey to the Frontiers Where Science and Buddhism Meet*, New York, 2001

Rizvi, Janet, *Ladakh, Crossroads of High Asia*, New Delhi and Oxford, 1983

Rizvi, Janet, *Trans-Himalayan Caravans: Merchant Princes and Peasant Traders in Ladakh*, New Delhi and Oxford, 1999

Rowell, Galen, *In The Throne Room of the Mountain Gods*, London, 1977

Rowell, Galen, *Mountains of the Middle Kingdom*, San Francisco, 1983

Shantideva, Acharya, *The Way of the Bodhisattva*, Boston, 2000

Smith, E. Gene, *Among Tibetan Texts: History and Literature of the Himalayan Plateau*, Boston, 2002

Snellgrove, David and Skorupski, Tadeusz, *The Cultural Heritage of Ladakh*, 2 vols., New Delhi, vol. I, 1977, vol. II, 1980

Stein, R. A., *Tibetan Civilization*, trans. J. E. Stapleton Driver, London, 1972

Stevens, John, *Sacred Calligraphy of the East*, Boulder and London, 1981

Thich Nhat Hanh, *Old Path, White Clouds: Walking in the Footsteps of the Buddha*, Berkeley, CA, 2001

Captions

pp. 2–3. Prayer flags are everywhere in the Tibetan world. They can be seen wherever the wind blows. Travellers put them up on the mountain passes, villagers fix them to the roofs of their houses and at the entrances to villages and monasteries. The prayers of compassion printed on the coloured cloths are carried through the valleys on the wind, spreading constructive and beneficent energy. O.&D.F.

pp. 4–5. A stormy day in late August, on the plain of Zanskar, at 3,500 metres. A chapel on a hill, backing on to a large chorten, overlooks the village of Pipiting. In the autumn, the villagers harvest the barley and wheat in the fields, and hunt for berries in the thickets on the hillsides above the village. The snow-capped summits are 6,500 metres above sea-level. O.&D.F.

pp. 8–9. Situated in the great loop of the Brahmaputra, one of the last places on earth to remain unexplored until the late 20th century, the snowy peak of Namchak Barwa rises to 7,756 metres. Here the majestic river, called the Tsangpo in Tibet, plunges into the mountains to emerge one hundred miles further on and 2,700 metres lower down. It was not until 1998 that American explorers discovered the 'Hidden Falls' whose existence had long been suspected. M.R.

 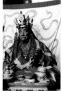

p. 10. Dilgo Khyentse Rinpoche (1910–91), one of the great masters of Tibetan Buddhism. Hermit, scholar, poet and artist, he was one of the principal custodians of Tibet's spiritual culture and one of the teachers of the 14th Dalai Lama. He was the supreme model of a spiritual teacher, a being whose inner journey had led him to an extraordinary depth of wisdom. He was a fountain of love and wisdom for all who went to him. M.R.
p. 15. Khyentse Rinpoche during a ritual in Bhutan. The elements of his costume and the objects used all have a symbolic meaning which aids meditation. The crown with five skulls, for example, represents the death of the five poisons of the mind: hatred, desire (greed), ignorance, pride and jealousy. M.R.

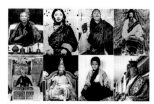

p. 16. Teachers of yesterday and today. From left to right and from top to bottom: Dzongsar Khyentse Chökyi Lodrö (1893–1959), his wife Khandro Tsering Chödrön, Dujom Rinpoche (1904–87) at Samye Monastery in the 1950s, and Dilgo Khyentse Rinpoche (1910–91) in the Tibetan province of Amdo in 1954 (photographers unknown).
p. 17. The 5th Dzogchen Rinpoche (1872–1935) in eastern Tibet, the great yogi Thokden Shakya Shri (1853–1919), the reincarnation of Dzongsar Khyentse Chökyi Lodrö (born 1961) in Darjeeling in 1969 (photo M.R.), the 16th Karmapa, Rigpai Dorje (1924–82), in Sikkim in 1966 (photo Arnaud Desjardins).

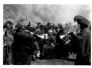

pp. 18–19. In 1985, after thirty years of exile in India, Dilgo Khyentse Rinpoche is met by two monks playing *gyaling* on his return to the ruined Shechen Monastery in eastern Tibet. M.R.

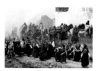

pp. 20–21. Ready to offer their traditional white scarves, the monks and lamas of Shechen hurry to the monastery gate to take part in the celebrations held to welcome Rabjam Rinpoche, the monastery's abbot, who has come from Bhutan to visit them. M.R.

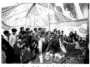

pp. 22–23. A crowd of faithful followers rush to receive the blessing of Pewar Rinpoche, one of the last spiritual teachers still active in eastern Tibet in 2001. Their faces express the unshakable devotion of a people who remain unbowed and determined to resist even after decades of Chinese repression and propaganda. M.R.

pp. 24–25. Despite torrential rain, a crowd of nomads press round the entrance to a tent to meet a spiritual teacher who has returned to eastern Tibet after many years in exile, following the Chinese invasion. They stay to gaze at the teacher for hours without tiring. M.R.

pp. 26–27. A double rainbow appears above the monastery of Palpung (Kham, eastern Tibet) at the moment of Dilgo Khyentse Rinpoche's arrival in 1988. To the Tibetans, rainbows are good omens. This is the only monastery in the region that the Chinese Communists did not destroy. More than 6,200 monasteries have been razed throughout Tibet. M.R.

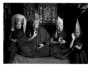

pp. 28–29. At the end of several months of teaching in Nepal in 1973, Khyentse Rinpoche poses with Trulshik Rinpoche, the abbot of the monastery where he was staying. They are flanked by Rabjam Rinpoche (right) and Trunang Gyaltrul Rinpoche, believed to be the reincarnations of two of Khyentse Rinpoche's teachers. Each wears one of the hats of the four schools of Tibetan Buddhism to emphasize Khyentse Rinpoche's non-sectarian approach. (Photo Marilyn Silverstone/Shechen Archives/M.R.)

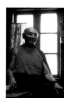

p. 30. Kangyur Rinpoche (1897–1975), one of the great Tibetan teachers of the 20th century. He lived in seclusion for many years then crossed Tibet from east to west, teaching all who asked him. He was a visionary teacher and left many writings. He left Tibet before the Chinese invasion, thus safeguarding a veritable treasure-house of texts, and lived in Darjeeling in India, where his many disciples included a number of Westerners. M.R.
p. 31. Jigme Khyentse Rinpoche, the youngest son of Kangyur Rinpoche. He exemplifies an extraordinary combination of filial love and total confidence in his spiritual teacher. M.R.

pp. 32–33. An elderly nun lives in this little hermitage beside a waterfall just outside Paro Taktsang in Bhutan. The only means of access is a ladder carved from a tree trunk leaning against the rockface. Paro Taktsang (Tiger's Lair) is one of the most sacred sites in the story of Padmasambhava: he is said to have flown there, riding on a tigress's back. O.&D.F.

pp. 34–35. The Tsangpo (Brahmaputra) seen from the hill of Hepori, near Samye in central Tibet. Founded in the 8th century by Padmasambhava and Shantarakshita under the patronage of King Trisong Detsen, the monastery of Samye was the first large Buddhist monastery built in the Land of Snows. M.R.

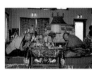

pp. 36–37. As spiritually accomplished as he is, the Dalai Lama still receives instruction from eminent spiritual teachers from all the schools of Tibetan Buddhism. Here, Dilgo Khyentse Rinpoche (1910–91), one of his principal spiritual mentors, transmits an initiation to him. Dharamsala, India, 1991. M.R.

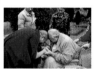

pp. 38–39. Before parting, the Dalai Lama and Khyentse Rinpoche touch heads as a sign of their spiritual communion. Khyentse Rinpoche gave the Dalai Lama the teaching he desired over a period of more than ten years. On such occasions the two great teachers often spent a week or two together. This picture records their farewell at their last meeting, not long before Khyentse Rinpoche's death. M.R.

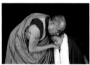

pp. 40–41. The Dalai Lama meets Khyentse Rinpoche again, some years later, but this time in the shape of a small boy who has just been recognized as the reincarnation of the late teacher. M.R.

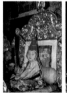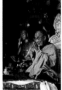

p. 42. The young reincarnation of Khyentse Rinpoche on the day of his enthronement at the Shechen Monastery in Nepal, in 1996. Nearly 15,000 of the faithful, from more than forty countries, gathered for the occasion. M.R.
p. 43. His Holiness the 14th Dalai Lama on the day he inaugurated the new Shechen monastery at Bodhgaya in India. M.R.

p. 44. A woman and her child in the crowd of the faithful. M.R.
p. 45. The young reincarnation of Khyentse Rinpoche, Yangsi Urgyen Tenzin Jigme Lhundrup, at his window, watching the festival of sacred dances in the courtyard of the Shechen Monastery (in a position similar to that of his predecessor on page 10). M.R.

pp. 48–49. In Zanskar's high valley, a villager from Shii drives his goats into the byre to protect them from snow leopards. Evil spirits are thought to roam at night and no one dares go out once darkness has fallen. O.&D.F.

pp. 50–51. In September, on the plain of Zanskar, the thermal winds become violent because the rocks are still overheated while the high peaks are already covered in ice. The plain is swept by stormy gusts and it becomes very difficult to walk from Zongla to Padum against the wind. O.&D.F.

pp. 52–53. At the northern boundary of Ladakh, to the west of the Depsang plains, two glaciers, each 70 kilometres long, join to form a single glacier, its front more than 50 metres high and several kilometres wide. Crossing the Depsang plains, at 5,400 metres, was a terrible ordeal for the caravans plying the Trade Route, who had to cross the Karakoram pass on the way from Yarkand to Leh. O.&D.F.

pp. 54–55. In the low light of evening, a horseman returns to the summer camp at Dorshen in Ladakh. The lifestyle of the herders of Rupshu is ancient but precarious, for they are entirely dependent on their flocks and the grazing. In winter they take refuge beside a salt lake which is usually spared by the snow. O.&D.F.

pp. 56–57. In the sunset, in the isolated mountain pastures of Lhubu, in occupied Tibet, two children play near the family tent made of a coarse cloth woven from yak's wool. The large dog, tethered by a heavy chain, is essential to protect the camp from wolves and snow leopards. O.&D.F.

pp. 58–59. In the broad valleys of Rupshu, in Ladakh, a caravan of yaks and herders migrates to a new camp. They move on four times a year, when the animals have eaten all the grass in one area, and pitch camp in another valley with a water supply, where the grass is still green. O.&D.F.

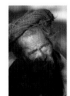

p. 60. A monk wears his hair in the traditional style of his order, in a village in the Barbung valley in Nepal, at the foot of the Dhaulagiri massif. O.&D.F.
p. 61. The house of the headman of the village of Yulchung overlooks the steep banks of a gorge where the Zanskar river thunders by. The dramatic Zanskar range allows geologists to study the zone where the massifs of Central Asia meet the Indian subcontinent and the effects of continental drift. O.&D.F.

pp. 62–63. Built on the mountainside at 3,600 metres, the Karsha Monastery overlooks the Zanskar plain. The white residential blocks are the cells of the monastery's hundred and fifty monks. Above them, with their outer walls painted ochre, are the chapels where the monks pray. O.&D.F.

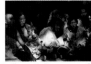

pp. 64–65. Bodhgaya is the greatest of Buddhist holy sites, the place where the Buddha attained Enlightenment over 2,500 years ago. Here the Dalai Lama gave the Kalachakra, the 'initiation of peace in the heart', in 1985 and 2002. 400,000 pilgrims from all over the world, exiles from Tibet and the Himalayas, came to hear his teachings and join in his prayers. O.&D.F.

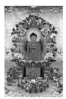

p. 66. The Buddha Shakyamuni, 'neither a saint, nor a prophet, nor a God, but an enlightened being'. M.R.

p. 87. Detail from a series of paintings on cloth (*thangkas*) relating the life of Buddha Shakyamuni, and his former lives when he was progressing towards Enlightenment. The model for these paintings, executed in the 'Karma Gardri' style, was designed by the great teacher Situ Panchen Chökyi Jungne (1699–1741). M.R.

pp. 88–89. Map of Tibet, painted in Nepal by Tenzin Norbu, an artist from Dolpo. It shows Tibet as it was before being divided into five after the Chinese invasion in 1950. The five regions are now the Autonomous Region of Tibet, Qinhai, Gansu and two districts added to the Chinese provinces of Szechwan and Yunnan.

pp. 90–91. The 14th Dalai Lama, accompanied by a large number of monks, prays beneath the Bodhi tree, where the Buddha attained Enlightenment 2,500 years ago. This site, in Bodhgaya in northern India, is also known as 'the Diamond Throne of India'. It has become the chief place of pilgrimage for Buddhists from all over the world. M.R.

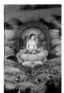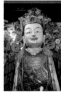

p. 92. The miraculous birth of Guru Padmasambhava, in a lotus on Lake Dhanakosha, in the form of an eight-year-old child. M.R.
p. 93. Guru Padmasambhava, the Lotus-Born, is venerated as the Second Buddha in Tibet. He came there from India in the 9th century and brought Tibetan Buddhism to full bloom. The construction of this immense statue, which is in the Paro Kyishu Monastery in Bhutan, was inspired by Dilgo Khyentse Rinpoche. M.R.

pp. 94–95. Representations of the deities of Tibetan Buddhism are highly symbolic. The two eyes, for instance, represent wisdom and the wish to act for the good of all living beings, while the smile represents compassion. O.&D.F.

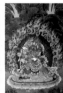

pp. 96 and 97. The guardians of the Dharma (the Buddhist tradition) are for the most part evil spirits subdued by Padmasambhava when he came to Tibet. He made them swear to cease from doing harm to living beings and to protect the Buddha's teachings. M.R.

p. 98. In the little chapel of a house in Zanskar, this statue of a Buddha is protected by a ceremonial white silk scarf, called a *katak*. Statues are greatly venerated as a symbol of the body of the Buddha, just as writings represent his word and stupas his mind. Even a broken statue or a piece of one will be treated with respect. Once a statue has been consecrated by a spiritual master, it will bring blessings, and will be placed on an altar, either at home or in a temple, and offerings will be made to it. O.&D.F.
p. 99. The moon rises on a September evening above the Kali Gandaki valley in Mustang. The arid terrain, the limpid sky and the silence of the valleys turn Himalayan moonrises into magical events. O.&D.F.

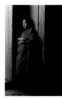

p. 114. At the dzong of Wangdipodrang, a villager watches young monks relaxing. He is wearing the kho, the robe traditionally worn by men. O.&D.F.
p. 115. A young monk at the dzong of Tongsa in central Bhutan. O.&D.F .

pp. 116–117. Two young monks playing in a courtyard of the dzong of Tongsa. Monastic life is often very lively and joyous, especially in Bhutan where the tradition is still very much alive. O.&D.F.

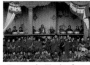

pp. 118–119. During the Tsechu festival at Gantey Monastery in Bhutan, the monks enjoy the tomfoolery of a young monk who is cheerfully clearing the crowd out of the courtyard to make room for religious dances. O.&D.F.

pp. 120–121. At the dzong of Tongsa, under a porch that protects them from the rain, young monks eat their communal meal, supervised by a teacher whose task it is to maintain discipline. Meals always start with a prayer of devotion to the Buddha, sung very melodiously. O&DF.

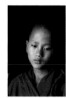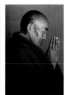

p. 122. A young Bhutanese monk at the dzong of Tongsa. O.&D.F.
p. 123. To be a monk in occupied Tibet demands fierce determination: every action is scrutinized by Chinese officials, and any reference to the Dalai Lama is punished by a prison sentence. Informers spy on every activity and monasteries are regularly stormed by re-education teams. O.&D.F.

pp. 124–125. Sikkim is dominated by the 4,000-metre face of Kangchenjunga, the third-highest mountain in the world and one of the most daunting in the Himalayas. Its summit is 8,586 metres above sea-level. In the Sikkimese language, the name means 'the five treasures of great snow'. O.&D.F.

pp. 126–127. During the summer rains, the Paro valley at Thimphu in Bhutan reflects a typical view of Bhutan, a country of mist and mystery. A humble land, it is the only one in the Himalayas governed according to the precepts of Tibetan Buddhism. O.&D.F.

pp. 128–129. At 4,000 metres, this temporary rope bridge laid across with stones leads to the monastery of Phuktal, one of the jewels of the Himalayas. A monk carries a wicker basket laden with stones which will be used to build a more solid bridge that will allow animals to cross. O.&D.F.

pp. 130–131. A mountain crest coloured by the light of the setting sun above the little chorten at Shade in Zanskar. The chorten (or stupa in Sanskrit) is a symbolic structure found in Tibet, made up of five symbolic shapes (square, circle, triangle, goblet, flame) arranged on a vertical axis (from Earth to Sky) and representing the five elements (Earth, Water, Fire, Air, Ether). A chorten is a bridge from the temporal world of sensory perception to the realm of timeless knowledge. A depository of spiritual influence, it radiates peace and happiness. O.&D.F.

pp. 132–133. Accompanied by the monks of Phuktal Monastery, a Tibetan teacher reaches the isolated village of Shade to conduct an initiation. Despite the vertiginous path, he cannot dismount from his horse because the monks, wishing to honour him, are doing their best to save him any exertion. But for the teacher, a refugee normally living in southern India, and not used to the horses and old-fashioned saddles of Zanskar, this journey is a serious ordeal. O.&D.F.

pp. 134–135. Dusk on the slopes of Kangla Gachu (6,000 metres) in Bhutan. There are countless unclimbed peaks, and very often it is forbidden to climb them, because the villagers believe they are the homes of local divinities. The Bhutanese have a great respect for the natural environment, and when they burn rubbish they add incense to it as an apology to the mysterious spirits of the valley. O.&D.F.

pp. 136–137. Motup, a boy of twelve, goes to school in Ladakh, a twelve-day walk along the Frozen River of Zanskar. His father and a caravan of villagers go with him, sleeping in caves at minus thirty degrees. In winter the Frozen River, 130 kilometres long, is the only road out of Zanskar, whose valleys are cut off by the snow. O.&D.F.

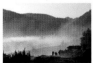

pp. 138–139. An autumn morning in the valleys of Gantey in Bhutan. Little bigger than Switzerland, Bhutan is very rural and ninety-five per cent of the villagers own their land and their houses, decorated with religious paintings. Their main crops are rice, wheat and buckwheat. O.&D.F.

p. 140. There are few roads suitable for wheeled traffic in Bhutan, because of the steep mountains, dense vegetation and frequent heavy rains which score the slopes with ravines. On the only road that crosses the country from east to west, there is one straight stretch, two kilometres long, the remaining thousand kilometres being a succession of bends. Most of the villages are accessible only on foot. O.&D.F.
p. 141. On Zanskar's Frozen River, the air bubbles formed by eddies get caught in the ice. To walk safely on the river and judge the ice's thickness, it is necessary to sound the ice with a stick at every step, and listen to the resonance. Zanskari boots are made of skins and their high legs make them ideal for walking on snow, but they are less practical on ice because they slip. O.&D.F.

pp. 142–143. From the time they learn to walk, the children of Zanskar help with the family's work: spinning wool, looking after younger children when the parents are in the fields, following the animals and picking up their dung which is dried and used as fuel. Parents pin amulets to infants' bonnets to guard them against sickness and evil spirits. O.&D.F.

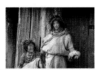

pp. 144–145. These two herdswomen from Kham, in occupied Tibet, have come into 'town' – a village where trucks occasionally pass – for a break. Winter or summer, the herders never take off their goatskin coats with the fleece linings, but cope with the changing temperatures by regulating their exertions. O.&D.F.

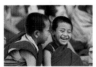

pp. 146–147. One of the most important functions of a monastery is education. The novices rise at 5.30 a.m. and study until nightfall. The discipline seems strict, but it doesn't stop the children from exhibiting rare strength of soul and *joie de vivre*. The young people do not take their monastic vows until they are twenty, which leaves them plenty of time to choose their path in life. M.R.

pp. 148–149. In a cookshop in Lhasa, two Tibetans chat over a glass of *chang*, millet beer. Despised and unable to earn a living, young Lhasans retreat into boredom and the consolations of alcohol. O.&D.F.

pp. 150–151. After thirty years of exile in India, Khyentse Rinpoche is reunited with one of his friends, a great scholar from Eastern Tibet. Before they part again, and as a sign of their spiritual communion, they touch heads. M.R.

pp. 156–157. In winter access to Ladakh is blocked by snow in the Zozi pass which leads to the south side of the Himalayas and to Kashmir. Ladakh and its terraced fields are rarely covered by snow. The climate is very dry and temperatures in the shade can vary from zero to minus thirty degrees. Out in the sun, it is scorching hot. O.&D.F.

pp. 158–159. Zanskar lies to the north of the main Himalayan range, which provides shelter from the intemperate climate further south. Its barley fields are irrigated by streams fed by glacier meltwater. Because the supply is irregular from one season to the next, villagers are elected each year to ensure that water is shared equitably between the mosaic of fields. O.&D.F.

pp. 160–161. The fields of Zanskar are transformed into a palette of colours in autumn. First the peas are bundled together and dried. Then the wheat is gathered and trodden by animals to thresh it. Finally, the families harvest the ripe barley which is their staple diet. O.&D.F.

pp. 162–163. Although isolated in the high Zanskar valley, the hamlet of Shii is wealthy. The grass is rich, the beasts healthy and butter abundant. The fields are well watered by streams from two valleys and the sunshine is perfect, even in winter. Recalling the Buddha's doctrine, chortens protect the village with their beneficent presence. O.&D.F.

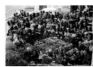

pp. 164–165. The festival of Gustor at the Karsha Monastery in Zanskar is an opportunity for people from isolated villages to meet for some fun and to exchange news during the long winter. It also gives parents a chance to spy out future marriage partners for their children. The women wear the *peyrac*, the headdress of silver, turquoise and coral inherited from their mothers when they marry. The *peyrac* symbolizes the cobra, who shielded the Buddha. O.&D.F.

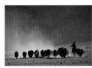

pp. 166–167. The yak is a valuable animal for the herders of Rupshu in Ladakh. It carries the family's goods each time they move to fresh grazing. Tents are woven from its wool and the female, the dri, gives milk from which cheese is made. When it dies, its skin becomes a mat, the horns spice-boxes, and the tail a fly-swatter. As Buddhists, the herders do not kill their yak except in rare circumstances when food supplies are very scarce. O.&D.F.

pp. 168–169. For all its usefulness, the yak is a wilful beast and hard to domesticate. For Bhutanese peasants who live at low altitudes, leading their yaks to alpine pastures is often hard work. The yak is well adapted to life above 4,000 metres and has no fear of the cold: indeed it is liable to settle down for a rest while crossing a freezing stream. O.&D.F.

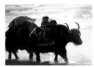

pp. 170–171. When moving to new pasture, the herders of Rupshu in Ladakh put their children on the backs of the yaks, wedged between the bags. A nervous animal, the yak can easily take a child's eye out with a toss of its horns, so the children learn to stay alert at an early age. O.&D.F.

pp. 172–173. On the high plateaux of Changtang, at 5,000 metres, a Tibetan herdsman leads his yaks to graze on frost-covered grass. Winter makes the man fully aware of the precariousness of his life and that of his herds. O.&D.F.

pp. 174–175. The old village of Gya in Ladakh had to be abandoned when the spring dried up. In past times, Ladakhi villagers stayed devoted to the valley headman, who lived in the Khar, the manorial house overlooking the valley. Nowadays many village people make their homes near streams and fields to make life easier. O.&D.F.

pp. 176–177. Rupshu herdsmen suffer the worst winter they have ever known in camp at Tasapuk. Snow lies over the entire valley, and the animals, unable to graze, grow weak and die of hunger and cold. The life of the nomadic herdsmen of the high plateaux is precarious in the extreme. Their survival rate is one of the most lowest of all the populations of the Himalayas. O.&D.F.

pp. 178–179. In the village of Charkha in Dolpo, this young mother is introducing her baby son to snow. The boy is wrapped in a shawl that she wove herself, and she has fixed a Tibetan Buddhist symbol to his bonnet to protect him with the positive energy it radiates. O.&D.F.

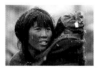

pp. 180–181. The monastery of Minyag, in Kham, at 3,840 metres, was entirely rebuilt by local villagers, following its destruction by soldiers of the Red Army. It belongs to the Nyingma school of Tibetan Buddhism. An old master teaches there, with the aid of some monks. Pilgrims shut their horses up in the inner courtyard at night to protect them from wild animals. O.&D.F.

pp. 182–183. Situated where the high Tibetan plateaux give way to the Chinese plains of Szechwan, the Minyag Konka massif is battered by extremely turbulent weather patterns. A caravan of horses reaches the Minyag Monastery in morning mist rising out of the valley. O.&D.F.

pp. 184–185. A father, accompanied by other villagers, takes his son to school in Ladakh, a twelve-day walk via the Frozen River of Zanskar. The cold (minus thirty degrees) freezes the waterfalls and the surface of the river, and the walkers must test the ice with sticks. O.&D.F.

p. 186. After taking his son to school in Ladakh, Lobsang Tundup and his companions return to their village in Zanskar along the only possible route, the Frozen River. A blizzard takes the caravan by surprise. Exhausted, they must press on to the mouth of the canyon to escape the thaw and avalanches. O.&D.F.

p. 187. On the lonely Jumlam road in Zanskar, frost has formed this icy hand, hanging from a rock. O.&D.F.

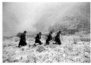

pp. 188–189. In October, among moraines covered in thin, slippery ice, four young women from the village of Thsumi carry food from the Minyag Monastery to the base camp of Minyag Konka, the sacred mountain of Kham. Tibetan women often present a more forthright and lively face to the world than their reticent menfolk. O.&D.F.

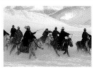

pp. 190–191. In their winter camp at Tasapuk in Ladakh, herders leap on to horseback to try to snatch a *katak*, a silk scarf, dropped on the snow. If they succeed, it is a sign that the coming year will be favourable. This celebration of Tsechu, on the sixth day of the first month of the Tibetan calendar, is the only major winter festival. O.&D.F.

pp. 192–193. After a short halt on the banks of the Frozen River, these Zanskari villagers warm their hands round the dying embers before setting off again on the ice. They will walk until evening and spend the night in a cave. The journey takes them twelve days. Rings are worn just as frequently by men as by women, and the dark red wool coats protect them from the cold, falls on the ice and sparks from the fire. O.&D.F.

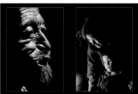

p. 200. This old man from the village of Surle, in the high Zanskar valley, does not know how old he is. Judging by the four generations that follow him, he must be around eighty. Though he is crippled, he is still useful to his family, sitting up on the roof in summer and acting as a scarecrow to keep sparrows off the corn. O.&D.F.

p. 201. In Himalayan society, from the time a child can walk, its mother's love is not expressed by hugs and kisses. Parents prefer to surround the child with a happiness that makes it confident and independent. O.&D.F.

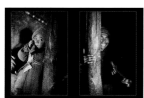

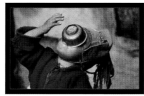

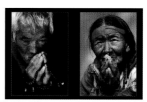

p. 202. Like all Zanskari children, this little boy loves to watch life in the winter kitchen from the central pillar that holds up the house. Behind the post, stained by the fingers of generations of children, he can play with the shadows thrown by the paraffin or oil lamp. The winter shelter is like a cellar, very dark and unheated. The family spends the coldest winter months there, fully dressed. It is only zero degrees there, while it is minus thirty outside. O.&D.F.

p. 203. Sitting in the middle of the room, Ltopden serves *chang* (millet beer) to his guests with a copper ladle during an evening which has seen them drink several rounds already! On practically every evening during the winter, neighbours take turns to meet at each others' houses to drink, laugh and sing. The party goes on all night, each one gradually collapsing on to his neighbour's shoulder to sleep where he is. O.&D.F

p. 210–211. A Zanskari child licks his bowl of sugared rice pudding clean, such is his enjoyment of the feast. It is a rare treat because both sugar and rice have to be imported from the plains, and it also has to be cooked for a long time at this altitude (where boiling point is around 80°C). O.&D.F

p. 218. This old man prays for the happiness of all living beings, in his wooden kitchen in the little village of Ura in Bhutan. O.&D.F.

p. 219. During the 'initiation of peace in the heart', the Kalachakra, given by the Dalai Lama in the Kinnaur valley, this woman honours her spiritual master with her prayers. O.&D.F.

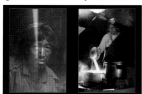

p. 204. A herdsman from Sharkha in Dolpo, sitting in his summer tent where a ray of sunlight falls. O.&D.F.

p. 205. A nomad woman beside her hearth. A hole has been made in the centre of the yak-skin tent to let out the smoke from the fire of dried dung which burns in the fireplace day and night. M.R.

p. 212. In the village of Ura in Bhutan, a child enjoys the company of his grandfather, who prays quietly. O.&D.F.

p. 213. A statue of the Buddha Shakyamuni in the chapel of a monastery in Zanskar. The Buddha's right hand is shown making a symbolic gesture called 'taking the earth as witness'. After the Buddha had achieved Enlightenment under the Bodhi tree, Mara the temptress came to test him one more time. 'How dare you believe you have reached Enlightenment?' she asked. 'How can you prove it? Who will act as witness?' The Buddha stretched out a hand to the earth and said 'I take the earth as my witness'. At that moment, the ground shook. O.&D.F.

p. 220. In the former royal palace at Mustang, this young servant girl from Lo Manthang is a ray of sunshine. O.&D.F.

p. 221. A young Tibetan woman near Darjeeling in 1968. This gaze, both clear and joyful, is a notable trait of Tibetans. M.R.

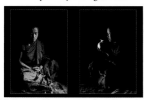

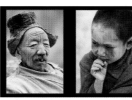

p. 206. A young Bhutanese monk meditates in the schoolhouse of the Tongsa Monastery. O.&D.F.

p. 207. This little girl from a village of Barbung, in lower Dolpo, drinks by the light of a ray of sunlight falling into the dark wooden kitchen. Out of consideration for other people she will pour the water into her mouth without touching the family jug with her lips. O.&D.F.

p. 214. White with dust, this man is repairing a stretch of the road which leads to the monastery of Phuktal. He has lost his earring, an ornament popularly believed to prevent a person being reincarnated as a donkey. Maintaining the road is a duty shared by all the villagers attached to the monastery. O.&D.F.

p. 215. Gusts of autumn wind sweep across the plain, kicking up dust. This Zanskari child is playing out of doors, but an argument has made him cry. O.&D.F.

p. 222. Part of a collection of seventy-nine paintings on cloth (*thangkas*) illustrating The Quadruple Treatise, a basic text of Tibetan medicine and the most important commentary on it from the late 17th century. From top to bottom, like a cartoon strip, it represents the principles of taking the pulse for medical or divinatory purposes. M.R.

p. 241. Another *thangka* from the same series as the preceding illustration. The three figures show the network of vessels at three levels: superficial, median (showing the blood vessels) and deep (showing the skeleton). M.R.

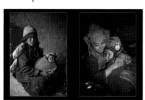

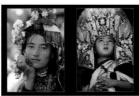

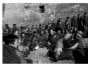

p. 208. A Zanskari mother has wrapped her baby in a wool blanket filled with dried goat's dung which serves as his bed. The village will wait five years before celebrating his birth because he has only a one-in-two chance of surviving to the age of five.

p. 209. Sisterly harmony. Zanskari children rarely quarrel among themselves because they have so few personal possessions that there is nothing to be jealous of. Even while they are young, the older children look after the younger ones like second parents, developing intensely loving relationships. O.&D.F

p. 216. A Dardan girl, from the Da valley. The Dardans, most of whom live in the steep-sided Indus valley between the Kargil valley in India and the Skardu valley in Pakistan, are the most northerly Buddhist population in the Himalayas. O.&D.F.

p. 217. Recognized as the 9th reincarnation of Lhangpo Rinpoche, the spiritual head of the Korzok Monastery in Ladakh, this little boy will in future preside over the festival at the monastery. His Tibetan parents live in Darjeeling, 2,000 kilometres to the east. O.&D.F.

pp. 242–243. On the meadowland outside the Shechen Monastery in eastern Tibet, lamas and monks wait to meet Khyentse Rinpoche, on his return to Tibet after thirty years in exile. M.R.

pp. 244–245. A forest of prayer flags, of the kind seen everywhere in Bhutan – on the hills, in clearings, on the tip of rocky peaks, at river confluences and near temples. The people print them with woodblocks, take them to a lama to be blessed, and fix them to bamboo poles. The flags are replaced with new ones once or twice a year. M.R.

pp. 246–247. In eastern Tibet (here in the Minyak region), entire hills are often covered with prayer flags. M.R.

pp. 248–249. Clouds of incense smoke rise above the plain outside the Shechen Monastery in Tibet. The offering is made to ensure the prosperity of the monastery and the lay community that lives around it. Nomadic horsemen gallop round the cairn on which the incense has been laid, calling noisily on the local deities: *Ki ki soso la gyalo* ('May the gods be victorious!'). M.R.

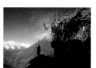

pp. 250–251. An elderly monk gazes at the Khumbu valley from the cliff overhanging the Thangboche Monastery in Nepal. Behind him, prayer flags hanging from a bamboo thicket fly in the wind. M.R.

pp. 252–253. A gust of wind stirs the prayer flags, and reveals a glimpse of Nyima Lhamo, a young Tibetan refugee, deep in prayer. 300,000 others from the Buddhist Himalayas and the Tibetan diaspora gathered together in January 2002 in Bodhgaya, the most sacred site in the Buddhist world. They spent ten days gathering and giving out positive energy, intended to combat the world's forces of destruction. 'Where there is a will, there is a way,' said the Buddha. The pilgrims hope to have sown a few seeds of peace. O.&D.F.

p. 254. Khyentse Rinpoche administers the first Buddhist vows, called vows of refuge, to a group of novices who have recently joined the community. At the end of the ceremony, he cuts the last lock of hair left on their shaven heads and gives them new names. The novices receive a complete education at the monastery and take monastic vows, if they wish to do so, only when they reach the age of twenty. M.R.
p. 255. During a rite at the Shechen Monastery, a monk walks between the rows with a long stick of incense. Tibetan incense is made of a hundred aromatic and medicinal ingredients, mixed with consecrated substances. It is used as an offering. M.R.

pp. 256–257. After the death of Dilgo Khyentse Rinpoche in September 1991, on each Wednesday (the day of his death) for seven weeks the Tibetan community and the monks united their efforts to assemble an offering of 100,000 lamps on the stupa of Bodhnath, near the Shechen Monastery. M.R.

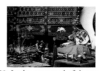

pp. 258–259. In the courtyard of the temple of Paro Kyishu in Bhutan, Khyentse Rinpoche performs a fire ceremony (*jinsek*), a ritual offering during which a certain number of substances are offered to the deities of the mandala visualized in the fire. There are four kinds of fire offerings, corresponding to four types of enlightened activity (pacification, growth, attraction and subjugation). M.R.

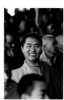 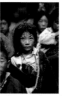

p. 260. The smile of a young incarnate lama, Dakpo Tulku, shines amid the throng of monks. M.R.
p. 261. A nomad girl from Kham, eastern Tibet. M.R.

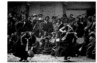

pp. 262–263. During the public rehearsal of an annual festival of sacred dances, the dancers do not wear masks or costumes but add multicoloured scarves to their monastic dress. M.R.

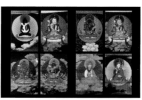

p. 264. From left to right and top to bottom. 1. The primordial Buddha, Samantabhadra ('Universal Perfection'), who symbolizes absolute knowledge; 2, 3 and 4 and p. 265, 1 and 2. The Buddhas of the 'five families', who symbolize the five wisdoms. These are the purified aspects of the five poisons (ignorance, hatred, greed, pride and jealousy); 3. Vajrasattva, the Buddha of purification; 4. Guru Padmasambhava, the Lotus-Born Master. M.R.

pp. 266–267. This halo of five colours appeared at the moment when Khyentse Rinpoche arrived at the Dzongsar Monastery in Kham, eastern Tibet. For Tibetans, this phenomenon is a good omen. M.R.

pp. 268–269. Round the stupa of Swayambunath, in the Katmandu valley, the statue of the Buddha is protected from monkeys by railings, which are also padlocked because of the thefts of antiquities carried out by professional thieves. O.&D.F.

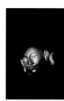 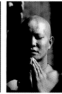

p. 270. A ray of sunlight entering through the chapel window of the monastery of Lingshed in Ladakh illuminates this statue of the Buddha. O.&D.F.
p. 271. On arriving in Lhasa, a young monk from Changtang prays fervently outside the sacred temple of Jokhang, after two years of prostrating himself along dust tracks. O.&D.F.

pp. 272–273. Prayer flags are a feature of every Tibetan landscape, on mountain passes, on the roofs of houses and monasteries, in a windy valley. The wind's energy spreads the prayers of compassion that are printed on the flags and worn away by time. O.&D.F.

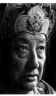

p. 274. This portrait of Dilgo Khyentse Rinpoche reflects the unique mix of profundity, inner strength and wisdom that characterizes a true spiritual teacher. M.R.

p. 275. A young incarnate lama, Jigme Khyentse Rinpoche, looks at an offering of butter lamps. The light of these lamps symbolizes knowledge, which disperses the darkness of mental confusion. M.R.

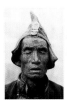

p. 276. Deeply moved, this monk prostrates himself before the temple of Jokhang in Lhasa, which he has reached after a three-month journey. Jokhang represents to him the hope of a renewal of spiritual life after years of suffering in his occupied homeland. O.&D.F.

p. 277. When saying goodbye to a respected friend, one puts one's hands together and speaks words that can be translated as 'I salute the enlightened being budding within you'. The handshake, a recent import, is never firm in the Western way but very gentle, more like a caress. The touch reinforces friendship and very often, when people shake hands, they continue to hold them throughout the whole conversation. O.&D.F.

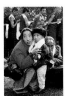

p. 278. Opening a school for young refugees at Bir, in India, the Dalai Lama is moved to speak to an overwhelmed boy who has just recounted the drama that his family in Tibet is still living through. O.&D.F.

p. 279. His people welcome the Dalai Lama to Dharamsala, his place of exile in India, on his return from the Earth Summit in Rio de Janeiro in 1992. Seeing the Dalai Lama is always a deeply emotional experience, especially for those who have never seen him before, like this child with his mother. O.&D.F.

p. 283. An extract from the Lalitavistara Sutra, a biography of the Buddha. The image below the text shows a Buddhist monk leaving for India to spread the sutras.

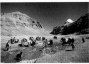

pp. 288–289. Located in the far west of Tibet, one of the most sacred mountains to both Buddhists and Hindus is Mount Kailash (literally 'the Silver Mountain'), known to the Tibetans as Kangka Tise or 'the White Mountain of Snow'. To make a complete circuit of the mountain, Tibetan pilgrims leave at 3 a.m. and finish the 65-kilometre journey by nightfall. At 5,860 metres altitude, they go through a mountain pass. Some pilgrims take twenty days to make the journey, prostrating themselves along the route. Foreign visitors take a more relaxing three days. Here are the guides who drove our little group's fifteen yaks, on the morning of the first day. M.R.

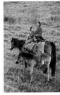
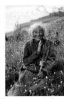

p. 290. A nomad woman from eastern Tibet and her child on their way up to the high pastures. M.R.

p. 291. Once they have passed middle age, Tibetans spend most of their days in prayer. In a flower-filled pasture at 4,500 metres altitude, this serene nomad woman turns her prayer wheel and repeats mantras. M.R.

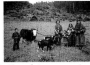

pp. 292–293. Nomads in a pasture in eastern Tibet. The yaks calve at the beginning of summer, the only time that the females have enough grass to eat to feed their young. M.R.

p. 294. A monk from Shechen Monastery looks out at the great high plateaux, on his way to Amnye Machen mountain on a pilgrimage. M.R.

p. 295. Built into the cliff at 4,000 metres, the monastery of Phuktal in Zanskar is one of the jewels of the Himalayas. It was founded in the 12th century, and its fifty-two monks belong to the Gelukpa order. O.&D.F.

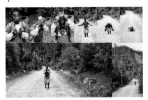

pp. 296–297. This villager from Kham has spent more than three years making his pilgrimage to Lhasa, over 1,000 kilometres away. He prostrates himself every three paces, touching the earth with his brow, bowing to the image of his spiritual leader, the Dalai Lama. O.&D.F.

pp. 298–299. At Ganden, a pilgrim walks round and round the monastery to express his devotion. O.&D.F.

pp. 318–319. The Potala in Lhasa is the residence of the Dalai Lamas. It was founded in the 7th century, and the principal period of construction was in the 17th. It is the largest building in Asia, containing more than a thousand rooms. Pilgrims hang up prayer flags at the foot of the hill, as a means of expressing their respect and gratitude towards their spiritual leader in exile. O.&D.F.

pp. 320–321. This family has made a pilgrimage from Amdo to Lhasa to worship in the temple of Jokhang. In honour of the occasion they have all put on their best clothes. O.&D.F.

pp. 322–323. Sweeping the busy little street of Bar Khor in Lhasa. It goes right around Jokhang Temple, and pilgrims walk around it, praying as they go. O.&D.F.

pp. 334–325. A little boy has fallen asleep waiting for his father to sell his butter in the weekly market in Shigatse, Tibet. O.&D.F.

pp. 326–327. A pilgrim joins his hands above his head, over his forehead and over his heart, as a sign of respect to the body, word and mind of the Buddha. He prostrates himself on the ground, resting on the five points of his body (the forehead, two hands and two knees), believing that this will cleanse away the five poisons that chain us to the cycle of existence: hatred, desire, ignorance, pride and jealousy. When he stands, he slides his hands along the ground, believing that he is gathering and taking on the suffering of all living beings. He now stands purified, welcoming the blessing and compassion of the Buddhas. O.&D.F.

pp. 328–329. October 1989, Lhasa, Tibet. Chinese soldiers in Bah Khor, the street that circles the Jokhang Temple. © Springer-Liaison / FSP

pp. 330–331. The decision to go on a pilgrimage often takes a family away from home for months on end, given the distances that separate them from the holy places. To survive, they beg along the way, reciting prayers, as here in the street of Bar Khor in the centre of Lhasa. Passers-by give willingly: it's a way of taking part in a holy act and also acquiring merit for themselves. O.&D.F.

pp. 332–333. A pilgrim prostrates himself in one of Lhasa's main thoroughfares, the street leading to Jokhang Temple. The population of Lhasa is now eighty-five per cent Chinese. The historic Tibetan old town covers only three per cent of the city's area. O.&D.F.

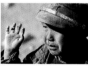

pp. 334–335. A child from the village of Sakya in Tibet. O.&D.F.

pp. 336–337. Before entering the Jokhang Temple, pilgrims prostrate themselves for hours at a time on the huge flagstones at the door. The awnings shield them from the sun and are decorated with one of the eight signs of good omen and, at the centre, the Wheel of the Law, recalling the doctrine of the Buddha and the Middle Way. O.&D.F.

pp. 338–339. The main chapel of the Jokhang Temple is surrounded by an inner courtyard, which pilgrims cross praying on their prayer wheels. Engraved with the mantra *Om mani padme hum*, which invokes to the Buddha of compassion, these copper wheels are filled with printed prayers. Turning the wheels in the direction of the turning stars, from left to right, increases the intensity and beneficent effect of the prayers. O.&D.F.

pp. 340–341. Inside the temple of Jokhang in Lhasa, a woman from Kham lights a series of butter lamps, murmuring a prayer. The lamps all shine with the faith of the pilgrims. O.&D.F.

pp. 342–343. A Tibetan making a pilgrimage to Lhasa makes an offering of butter lamps before worshipping in Jokhang Temple. Buddhists do not prostrate themselves before a god, but instead pay homage to the Enlightenment that the Buddha personifies. The act of prostration is an antidote to pride and calls for the Buddha's blessings, so that our ignorance may be lifted and we may also, one day, attain Enlightenment. M.R.

p. 364. The monks of the Shechen Monastery in Kham, eastern Tibet, play spectacular telescopic metal trumpets (*dungchen*, literally 'large conches'), which can be up to four metres long. M.R.
p. 365. A young singing master plays *rolmo* cymbals which are made of an alloy of five metals and are very resonant. An instrument with an especially beautiful sound becomes a monastery treasure, to be looked after with great care. Shechen Monastery, Nepal. M.R.

pp. 366 and 367. Dance of the Golden Libation (*serkyem*). Twenty-one dancers wear large black headdresses surmounted by a sun and a moon, and carry silver mirrors on their breasts. They dress in brocades and multicoloured scarves and also wear a black apron embroidered with a terrifying face. The dance is intended to bless the monastery's parvis; during the annual festival, it will become the mandala inside which the dancers will perform. M.R.

pp. 368 and 369. Masks symbolize the qualities of the animals they represent – strength, courage or swiftness – qualities which are needed to progress along the spiritual path. The masks are made of layers of fabric glued onto a sculpted clay mould. The facial features are shaped using red-hot iron spatulas, then the mask is painted. O.&D.F

p. 370. Dorje Drollö, one of the manifestations of Padmasambhava. The culmination of the annual festival of sacred dances is the representation of the eight 'manifestations' of Padmasambhava, a historic dance celebrating the arrival of Buddhism in Tibet. Padmasambhava manifested this wrathful face in Bhutan, at Paro Taktsang, 'the Tiger's Lair', in order to subdue the local demons and gods and hide a number of 'spiritual treasures' for the good of future generations. M.R.
p. 371. The monks of Shechen have presented their sacred dances in the West a number of times. The dances do not become a mere 'folk-art' spectacle when performed in a Western theatre but grippingly encapsulate all the strength and essence of the true cham. The sacred is above all a state of mind. The monks remain what they are and there is no discontinuity between meditation and dance: if there were, the dance would become a futile gymnastics display, a soulless spectacle. M.R.

p. 372–373. The Dance of the Black Hats (*shanag*) during the festival of Tsheshu at the Wangdiphodrang dzong. These major monastic festivals, with their colour, beauty and profundity, fascinate the local villagers, even if the symbolism sometimes escapes them. O.&D.F.

pp. 374–375. 'The dance must spring forth from emptiness, free of attachment, as a rainbow forms in space,' wrote Lochen Dharmashri. *Cham* is a type of colourful dance in which the art of masks and costumes becomes a form of prayer. Whether slow or lively, these dances possess a gently impressive serenity. While the voice of the singing master rings out in an astonishingly low register, accompanied by cymbals, trumpets, oboes and drums, the dancers twirl around, their costumes undulating. M.R

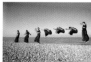

pp. 376–377. On a bright winter morning, some monks jump for joy at the sight of the ocean. They will throw themselves up in the air again that evening, on the stage of a theatre in Brittany, France, defying gravity. M.R.

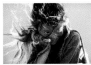

pp. 380–381. This little girl, from the Lhubu pastures near the Ganden Monastery in Tibet, holds a rope of plaited wool decorated with a multicoloured pompom, which she uses to drive her herd of goats. O.&D.F.

pp. 383–383. Mount Kailash, seen in the distance from the banks of Lake Manasarovar in western Tibet. At 4,600 metres above sea-level and with an area of 320 square kilometres, Lake Manasarovar is the highest freshwater lake in the world. It is also called 'the Invincible Turquoise Lake', 'Anavatapta', 'Lake of Eternal Freshness' and 'Lake of the Divine Lotus'. M.R.

pp. 384–385. In the four-house hamlet of Surle, 4,000 metres above sea-level in Zanskar's high valley, a young mother is proud of her first child, all of whose clothes she spun and wove herself. O.&D.F.

pp. 386–387. The plain of Zanskar, seen from the Stonde Monastery at 3,700 metres, stretches to the foot of the Great Himalayan Range, the summits of which, at 6,500 metres, partly block the monsoon clouds. Some 12,000 peasants people fifty little villages scattered throughout three valleys. Each family has its own cob house and terraced fields. O.&D.F.

pp. 388–389. Lake Kokonor in northern Tibet is one of the largest lakes in Asia. O.&D.F.

pp. 390–391. Zanskar's Frozen River never freezes completely because of its current. Only the surface freezes or, more often, when the cold makes the water level drop, the banks collapse. Walking on the ice requires caution and vigilance. The river runs at the bottom of a deep canyon and the sun reaches it for just a few hours a day. O.&D.F.

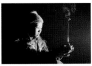

pp. 392–393. Chonzon, a Zanskari girl, lights her brick kitchen with an oil lamp. She is showing off her goatskin cloak, which protects her and keeps her warm. She is seventeen years old. O.&D.F.

pp. 395–395. A herdsman drives his flock in the valley of Tsokar, the White Lake, in Ladakh. Walking in the silence of these pure mountains imparts a sense of eternity. O.&D.F.

pp. 396–397. At sunrise, on the Karas road, a caravan crosses the Pensi pass at 4,400 metres. The nomads are able to leave Zanskar by this route in the spring, walking at night on the frozen snow and sleeping during the day, when the heat makes progress on the snow impossible. The eight-day journey beneath the stars is magical. O.&D.F.

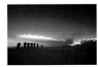

pp. 398–399. The summit of summits, pinnacle of the Roof of the World, known to the West as Mount Everest. Those who live close to it have for centuries called it Sagarmatha ('the ocean's brow') in Nepalese, or Jomolangma ('goddess of the glaciers') in Tibetan, and know it as the palace of the Five Sisters of Long Life. It rises to 8,848 metres above sea-level in the middle of the Himalayan range, which is 2,400 kilometres long. M.R.

Glossary

Actions, negative and positive: an action is said to be positive when it benefits another, and negative when it harms others and the doer. Every physical, mental or verbal action is like a seed which will produce a fruit, a consequence which will be lived at some later date, often even in a future existence.

Appearances: the worlds of external phenomena. Although these phenomena appear to us to have a real existence, their true nature is void of inherent reality. The gradual transformation of our way of perceiving and understanding these appearances corresponds to different stages on the path towards **Enlightenment**.

Attachment: its two principal aspects are attachment to the reality of the **self** (ego) and attachment to the reality of external phenomena.

Awareness: nature of a **mind** that is not dual and is totally liberated from confusion.

Bardo: Tibetan word meaning 'intermediate state'. It can refer to various states, including the states of dreaming and waking and the moment of death, but most often it signifies the intermediate state between death and rebirth.

Bodhisattva: one who follows the path of **compassion** and is dedicated to reaching **Enlightenment** in order to be able to deliver all living beings from the cycle of existence, **samsara**.

Buddha: one who has dispelled the two **veils** – the veils of afflictive emotions and of dualistic perception – and developed the two knowledges – the knowledge of the ultimate nature of all things and the knowledge of the multiplicity of phenomena.

Buddha-nature: not an 'entity' but the ultimate nature of pure **consciousness**, totally free from the **veils** of **ignorance**. Each being has the potential to reach a state of perfect knowledge of the nature of mind. In a sense, it is Buddhism's concept of the 'original goodness' in all beings.

Compassion: the desire to liberate all living beings from suffering and the causes of suffering (negative **actions** and **ignorance**). It is the complement of love (the wish for all beings to know happiness and the causes of happiness), of altruistic joy (rejoicing in the qualities of another) and of equanimity, which extends these feelings to all beings without distinction, friends, strangers and foes alike.

Consciousness: Buddhism distinguishes between several levels of consciousness: manifest, subtle and very subtle. The first corresponds to the functioning of the brain; the second to what we intuitively call consciousness, in other words the ability to examine our own nature

and exercise free will. The third, and most important, is called the 'fundamental luminosity of mind'.

Dharma: a word of many meanings. At its broadest, it signifies everything that can be known. Most often, it denotes the totality of the teachings of the Buddhas and great teachers. There are two aspects to this: the dharma of the scriptures, which underpins these teachings, and the dharma of realization, which is the outcome of spiritual practice.

Duality/dualism: in Buddhism, these terms refer to the distinction between subject (**consciousness**) and object (mental images and the external world), between oneself and another. The disappearance of duality is one of the characteristics of **Enlightenment**.

Emptiness: the lack of intrinsic reality of animate and inanimate phenomena, their true nature, but not nothingness. True knowledge of emptiness goes hand in hand with the emergence of **compassion** towards all living beings without exception.

Enlightenment: synonymous with the condition of being a **Buddha**, Enlightenment is the ultimate accomplishment of spiritual growth, supreme inner knowledge, allied to infinite **compassion**. Perfect understanding of both relative existence (the way things appear to us) and of ultimate existence (their true nature), of the mind and of the world of phenomena. This knowledge is the fundamental antidote to **ignorance** and therefore to **suffering**.

Idealism: a group of related ideas according to which the phenomenal world is only a projection of the mind.

Ignorance: erroneous manner of conceiving of beings and things, attributing to them real, independent, solid and intrinsic existence.

Illusion: all ordinary perceptions, distorted by ignorance.

Impermanence: there are two kinds, gross and subtle. Gross impermanence refers to visible changes. Subtle impermanence is the fact that nothing remains the same for more than the shortest conceivable moment of time.

Intrinsic existence: a property attributed to phenomena, allowing them to be independent objects, existing on their own, and endowed with properties belonging wholly to them.

Karma: Sanskrit word meaning 'action', usually translated as 'causality of actions'. The Buddha taught that the destinies of beings, along with their joy, their suffering and their perception of the universe, are not due to either chance or the will of an all-powerful entity but are the

outcome of their past actions, words and thoughts. Similarly, their future is determined by the positive or negative quality of their present actions. Collective karma defines our general perception of the world, while individual karma determines our personal experiences.

Liberation: liberating oneself from suffering and the cycle of existence. It is a step towards the ultimate achievement of Buddhahood.

Logic: means of valid knowledge (*pramana* in Sanskrit, *tsema* in Tibetan). 'Conventional' valid knowledge is distinguished from absolute valid knowledge. The first informs us about the appearance of things and the second allows us to apprehend the ultimate nature of things. Both are valid in their own contexts. Their domains cover everything that can be perceived directly or deduced by inference, and everything that can be concluded on the basis of valid testimony.

Meditation: process of familiarizing oneself with a new perception of things. Analytical meditation can take as its subject something on which to reflect (the notion of **impermanence**, for example) or a quality one wishes to develop (such as love or **compassion**). Contemplative meditation allows us to recognize the ultimate nature of mind and to remain in that nature, beyond conceptual thought.

Middle Way (Madhyamika): the highest philosophy of Buddhism, so-called because it avoids the two extremes of negation and affirmation of the reality of phenomena.

Mind (see also *consciousness*): for Buddhism, mind, in its ordinary form, is characterized by illusion. A succession of instants of consciousness gives it an appearance of continuity. In its absolute form, mind is defined by three characteristics: **emptiness**, clarity (faculty of knowing everything) and spontaneous **compassion**.

Negative emotions or *disturbing emotions (klesha* in Sanskrit*):* every mental event, born of **attachment** to the self, that troubles our mind, clouds it and makes us lose control of it. The most important of these are desire (greed), hatred, ignorance, pride and jealousy, and they are the causes of **suffering**.

Nirvana: the end of **ignorance** or illusion and, consequently, of **suffering**. There are several levels of nirvana, depending on whether one adopts the teachings of the Lesser Vehicle or the Greater Vehicle.

Path: the spiritual journey which allows us to liberate ourselves from the cycle of existence, and then to attain Enlightenment.

Phenomena: the things that appear to the **consciousness** by way of the senses and the **mind**

Rebirth, reincarnation: successive states experienced by the flux of **consciousness**, states punctuated by death, **bardo** and birth.

Samsara: the cycle of existence, marked by **suffering** and the frustration engendered by **ignorance** and the afflictive emotions it causes. It is only by knowing **emptiness** and thus dispelling all **negative emotions** that one may recognize the nature of mind and free oneself from samsara.

Self, ego: despite the fact that we are a flux in constant transformation, interdependent with other living beings and with the world, we imagine that an unchanging entity exists within us which we need to protect and satisfy. Analysis of this 'self' reveals that it is a fiction.

Suffering: the first of the Four Noble Truths, which are: 1) the truth of suffering, which we need to recognize as omnipresent in the cycle of conditioned existences; 2) the truth of the causes of suffering – the **negative emotions** we need to eliminate; 3) the truth of the Path (spiritual development) that we must travel in order to achieve liberation; and 4) the truth of the cessation of suffering, resulting from spiritual training, or **Enlightenment**.

Sutra: the words of the **Buddha** transcribed by his followers.

Truth – absolute or relative: relative, or conventional, truth corresponds to our empirical experience of the world, and absolute truth to the result of final analysis, whereby phenomena are stripped of **intrinsic existence**.

Veils (two): these obscure **duality**. The veil of disturbing emotions, the obstacle to liberation, is the effect of the poisons of ignorance, desire and hatred; the cognitive veil, the obstacle to omniscience, is ignorance of the ultimate reality of phenomena.

Vision, meditation, action: vision is direct, nonconceptual understanding of the empty nature of all phenomena. Meditation is the action of familiarizing oneself with this **emptiness**, integrating it with one's mind-stream. Action is the altruistic behaviour that results.

Wisdoms (Five): five aspects of Enlightenment: equalizing wisdom, mirror-like wisdom, discriminating wisdom, all-accomplishing wisdom, and wisdom of ultimate reality. These five wisdoms can only be actualized after the two veils which prevent Enlightenment have been dispersed: the veil of emotions that cloud perception and the veil masking knowledge of the ultimate nature of phenomena.

Index

Our very great thanks

To those whose integrity
and wisdom have guided
and inspired us,
our Buddhist family

To those whose joyfulness
and generosity have provided
the images in this book,
our Himalayan family

To our many wonderful friends,
for their constant encouragement
and their invaluable help,
our Western family

To those closest to us, for their
unwavering and loving support,
our birth family

To those whom we hope
are united by this book,
the authors

Picture credits

All the photographs are the work of Olivier & Danielle
Föllmi and Matthieu Ricard with the exception of these
images:
pages 16–17 B&W photos © Shechen Archives;
pages 28–29 photo Marilyn Silverstone/Shechen Archives;
pages 336–37 photo Michaël Springer (Gamma).

The photographs by Olivier & Danielle Föllmi (marked
O.&D.F. in the captions) are available from the RAPHO
agency in Paris: www.rapho.com
The photographs by Matthieu Ricard (marked M.R. in the
captions) are available from the VU agency in Paris:
www.agencevu.com
All calligraphy is by Jigme Douche.
For more information about the authors and their work, visit:
www.follmi.com, shechen.12pt.com and
www.himalayanart.org

Translated from the French *Himalaya Bouddhiste*
by Lorna Dale, Francisca Garvie, Barbara Mellor and Mary Whittall

For Harry N. Abrams, Inc.
Jacket designed by Michelle Ishay and Neil Egan

Library of Congress Cataloging-in-Publication Data

Föllmi, Olivier, 1958-
 Buddhist Himalayas / photographs by Olivier & Danielle Föllmi & Matthieu Ricard ;
with a contribution by the Dalai Lama.
 p. cm.
 Includes bibliographical references and index.
 ISBN 978-0-8109-3489-4 (original hardcover edition)
 ISBN 978-0-8109-8405-9 (reduced-size paperback edition)
1. Buddhism-Himalaya Mountains Region-Pictorial works. 2. Buddhism-China-Tibet-
Pictorial works. I. Föllmi, Danielle. II. Ricard, Matthieu. III. Bstandzin-'dzin-rgya-mtsho,
Dalai Lama XIV, 1935- IV. Title.
BQ400.H542 F65 2002
 294.3'095496-dc21
 2002008849

HNA
harry n. abrams, inc.
a subsidiary of La Martinière Groupe
115 West 18th Street
New York, NY 10011
www.hnabooks.com